Welcome to Fotolog™
October 31, 2005 4:59am EDT

farkasmarko 2s ago
Port Byron, NY, USA

happystar 1s ago
Sao Bernardo do Campo, Brazil

abdo nono 51m ago
casablanca, Morocco

procurado net5m ago
saitama, Japan

sandyn5 17s ago
GiRoNa, Spain

kakazinhah 2m ago
sydney, Australia

Fotolog™ Stats
2,007,945 **Fotolog Members**
65,648,271 **Photos**
139,425 **Photos Today**

Newest Fotologs	Some of the Most viewed All Time	Gold Camera Members of the Hour

war 1 30m ago
Lima - callao, Peru

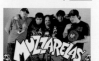
interiorama 30m ago
Limeira, Brazil

macktastic 30m ago
Stockholm, Sweden

puyo puyo 32m ago
-, United Kingdom

angelicaxxx 14h ago
SP, Brazil

hams 10h ago
Blumenau - SC, Brazil

julyzinhaa 6h ago
Nikity, Brazil

pellegrini 18h ago
Munich, Germany

hornyfunky 16h ago
Modena, Italy

personal music 39h ago
New york City, NY, USA

1st 60h ago
Manaus, Brazil

fael 9h ago
bhrockcity, Brazil

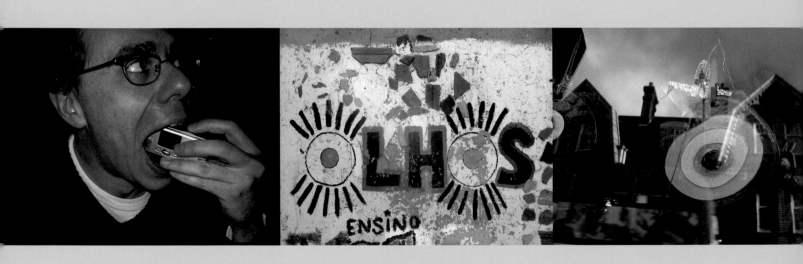

fotolog.book

EDITED BY **ANDREW LONG**

WITH ADDITIONAL TEXTS BY

NICK CURRIE

A GLOBAL SNAPSHOT FOR THE DIGITAL AGE

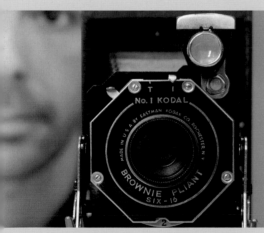

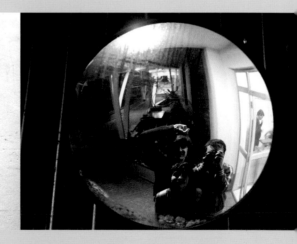

WITH 1001 ILLUSTRATIONS IN COLOR

Thames & Hudson

First published in 2006 in hardcover in the United States of America by
Thames & Hudson Inc., 500 Fifth Avenue, New York, New York 10110

thamesandhudsonusa.com

Library of Congress Catalog Card Number 2005923455

ISBN-13: 978-0-500-51251-7
ISBN-10: 0-500-51251-5

Printed and bound in Hong Kong by Sing Cheong

CONTENTS

LOOK AROUND YOU

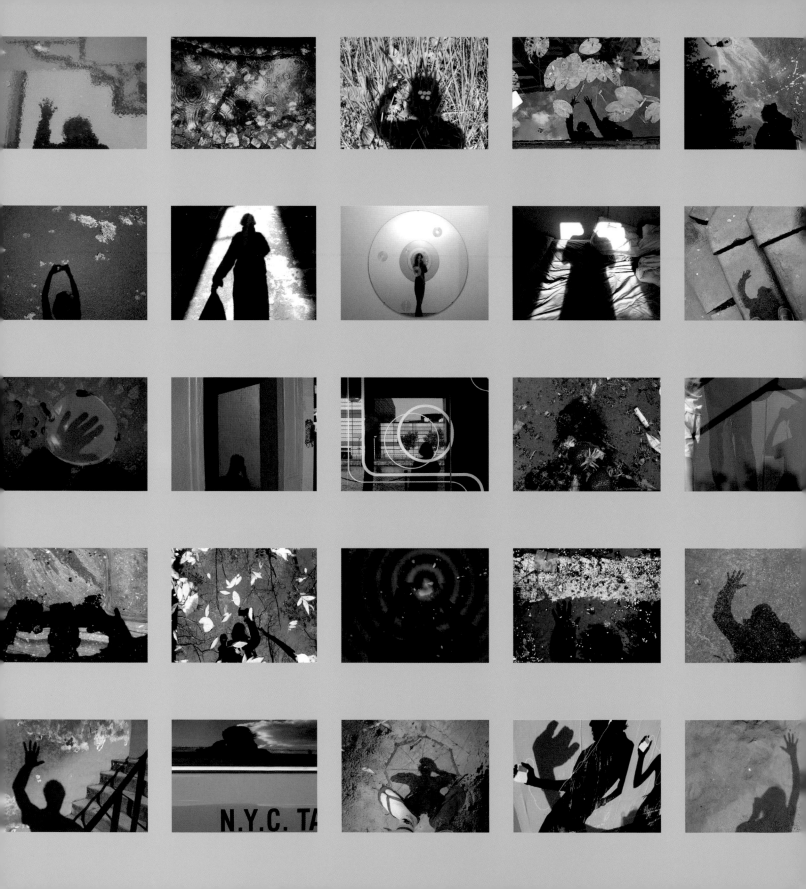

PREFACE
BY NICK CURRIE

'**I WANT TO KNOW** WHAT YOU LOOK LIKE. **I WANT TO SEE** YOUR FACE AND USE YOUR EYES'

HOW CAN I TRUST YOU IF YOU WRITE TO ME, but do not include the URL of your photoblog? How can I tell, first, what your face looks like? Isn't that enormously important? Secondly, without a photoblog I cannot know if your perception of the world is stale or fresh. I cannot know if you look around you, and, if you do, what you're looking at, and how.

I cannot know how you dress, and whether it would be appealing to undress you. I cannot know to what canon of beauty you subscribe unless I can subject you to rigorous style analysis. You may be a brilliant writer, and you may have a weblog stuffed with lively wordplay and interesting opinions. But the world is already full of opinions, of commentaries on commentaries, glosses on glosses, and spins on spins.

Photos, in a world where the word-snake dines on its own tail, give me hope. Maybe photos can break the ever-narrowing vicious circles of language. Break them with textures, colours, forms; the peculiarly irreducible specificities of the visual world.

I want to know what you look like, and what the world around you looks like.
It's tremendously important to me, because in the end I don't care a fig about whether you pronounce in favour of this or that book, film or record, or what life has taught you.

Don't tell me, show me. I want to look at the new shapes you're seeing, viddy the texture of your lips and the colour and condition of your teeth. I want to see your face and use your eyes, damn it, because mine are always stalling and failing.

You have no choice but to start a photoblog.
It's a course requirement in the art school of life.

with a pinch of salt

isthisyou
Commuting, United
Kingdom

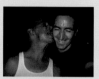
angelissima
Mostly, NJ USA

adam_pants
New York, NY, USA

eduardo_dacosta
Liege, Belgium

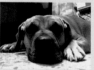
50mm
under the stars, India

rosapomar
Lisbon, Portugal

ponpon
Paris, France

garydann
Philly, PA USA

eliahu
London, United Kingdom

terrybrogan
Los Angeles, CA USA

nysama
13h ahead, Tokyo, Japan

bea_trix
Graz, Austria

02/19/04

WE ARE HERE (for along)

isthisyou @ 2004-02-19 12:55 said: Ha ha! What?

selfmademug @ 2004-02-19 12:55 said: Thank God I can finally orient myself.

along @ 2004-02-19 12:58 said: haha! actually...I hail from the next town over. http://vis.sdsc.edu/research/images/orion/stereo/top_1.jpg

anamorphosis @ 2004-02-19 23:41 said:
good to know. i was feeling a little lost there for a bit.

plcm @ 2004-02-20 08:26 said: it's amazing how small we are...

elizinha_nit @ 2004-02-20 12:36 said: congratulations!!!! kisses!!

meire @ 2004-02-20 13:22 said: let me get my glasses...

NOT SO LONELY PLANET
INTRODUCTION BY ANDREW LONG

along @ 2006-01-01 00:01 said:

*'Fotolog'? Hmmm. Well, it's simple. Memorable enough. Sounds like...'catalogue',
'analogue', 'dialogue'... So what is it, like a photo diary?*

Exactly. Fotolog.net is a place where you can keep your own daily photo diary – a very
public diary, if you want it to be. And it seems a few people do. From a handful of
members at the beginning, in May 2002, the website has grown almost ten-thousandfold:
at the time of publication Fotolog.net had just over two and a half million members
from every country of the globe. They've posted nearly ninety million photos.

Why do they do it?

Lots of reasons. Most Fotolog members – or 'Fotologgers', as they immediately took to
calling themselves – have a free account, which allows them to post one picture a day.
(Members who pay a small monthly fee can post up to six photos a day.) Just one photo
per day makes for a kind of natural diary entry: people post images of the commuters,
the graffiti or the sunrise they saw on the way to work that morning; snapshots of
their children or spouses at work or play; or maybe personal meditations on the nature
they see around them, in the city park, in their backyard. A Fotolog page becomes a
de facto weblog: your eyes – your vision – out there in the open for the world to see.

Fotolog members, though, use their Fotolog pages as much more than just diaries.
Name any kind of image and you'll find it there, within six clicks: pouting, preening
and often powerful self-portraits; landscape studies, from Death Valley to the Scottish

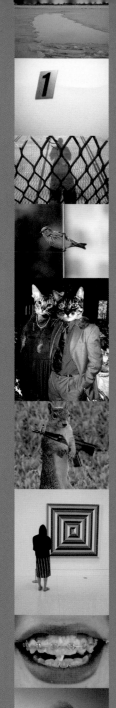

Highlands to the Himalayas; extended essays on the buzzing streets and nightclubs of city life; faded and scratched photos from old family albums; sympathetic visual dialogues between two (or more) photographers, living thousands of miles apart; captivating art portfolios; documentary photographs of homeless men and women, records of civil protest, and reportage on natural disasters and terrorist attacks. The list goes on. And includes pets. Boy, will you see pets.

I like pets. OK. So how did all this come about?

Fotolog was the brainchild of Scott Heiferman — a young entrepreneur who was then simultaneously starting up Meetup.com, another popular website devoted to bringing people together. Heiferman had been posting pictures daily on his personal weblog since 2001, but was searching for an easier, more interconnected way to share them with his friends and family. Most of the people he knew didn't have their own blogs, and sending out group emails with jpeg attachments was cumbersome and kind of annoying. While designing a simple, efficient user interface — the same one Fotolog uses today — Heiferman reached out to two friends to build this new endeavour with him: one, still known only as Spike, was the site's founding developer, and Adam Seifer (who had co-founded sixdegrees.com) is now Fotolog's CEO. Together they designed and coded the site, and took it online in their time off, basically from their living rooms. At first it was just aimed at a hundred or so friends and family members, with the expectation that, if it worked and people liked it, it could be something to build on.

So, I guess...

Yeah. It worked. People liked it. Within three months Fotolog had 150 members, mostly from the New York area and the West Coast, but also a few from London, Amsterdam and São Paulo. It grew steadily from there, through what now seem like old-school methods: word of mouth and email. No advertising, no gmail-style invitations, no hip aura. And no press coverage, at least for the first twelve months. Then in May 2003 an

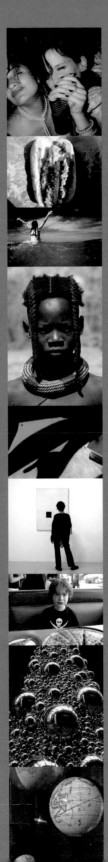

article on the 'new' phenomenon of photoblogging appeared in *The New York Times*, mentioned Fotolog.net and a few prominent Fotolog members like Laura Holder (lauratitian – see page 28) and cypher (that's Adam Seifer, one of the founders), and the expected happened: Fotolog page views – and new accounts – spiked instantly. The site took off from there, growing at exponential rates, fuelled in large part by a huge influx of Brazilian members in mid-2003. Fotolog has hit some financial and technological speed bumps with all this growth, and rival sites like Flickr.com have cropped up. But today, with more than two million members and a healthy growth rate, Fotolog aims to be the photo-sharing site for the rest of the world. It just might succeed.

We'll see. But why a book?

Glad you asked. This book is not really about that stuff. Not about big business or big technology or the big World Wide Web – it's about pictures. Monumental landscapes and tiny curios. Blazing colour abstracts and black-and-white candids. Mysterious close-ups and spellbinding panoramas. Gorgeous pictures that make you say, 'Yes, that's exactly right.' Startling images that make you think, 'My God, how can that be?' And perhaps the most moving genre: plain, deeply honest portraits of family. A mother looks into her children's eyes for clues about herself; a daughter examines the face of her grandfather in the kitchen or her mother at a window, searching for some truth – any simple fact – that might briefly illuminate the outside world. These are the kinds of pictures that communicate, instantly, to understanding eyes halfway around the world. They're the photos that can make me think it's not such a lonely planet we're living on.

What's more, you encounter Fotolog photos, thousands of new images daily from every corner of the globe, in a milieu that's about as close to unmediated as it gets. The people who use Fotolog are not photojournalists; most are not even professional photographers. So ***fotolog.book*** won't show you pictures that newspaper moguls

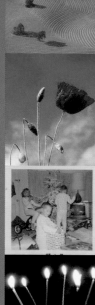

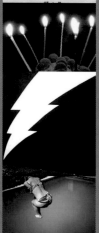

deem newsworthy, images that marketeers use to make money, or photographs that gallerists judge to be Art with a capital 'A'. You will see the world through the fresh eyes of accountants, zoologists, firemen, architects, students, Web designers, cooks, musicians, health workers. The photographers who weave the fabric of Fotolog are regular men and women from all walks of life who love taking pictures—true amateurs. This book is an anthology of their work.

Got it. But why all the categories?

Apart from the group logs that everybody can post to, such as fotocats, sad_bikes, tattooland, bathroomgraffiti, and hundreds of others, Fotolog is boundaryless—it's not carved up into themes or categories that could end up feeling restrictive or exclusionary. But when the editors—longtime Fotolog members ourselves—embarked on thousands of hours of Web surfing (aided by a larger band of equally dedicated Fotolog users) to select the images you see here, we quickly settled on a themed approach. For one thing, it provided focus. Freeform Fotolog surfing is delightful, but books have a finite number of pages. We wanted to do more than reproduce random photos or Fotolog pages, and we wanted to offer a new window into Fotolog. To highlight as many different kinds of Fotolog images as we could, in a way that would be engaging and make sense, we needed some structure. So in these pages, yes, many disparate images are asked (politely, we trust) to take on the added responsibility of representing, say, New York, or the Animal Kingdom, or the landscapes of the world. We're confident the similar settings don't overwhelm the photographers' singular visions. You be the judge.

I'll let you know. There's also a bunch of writing in there.

Yes. Each Fotolog page has a guestbook, where other members can leave comments about how Great! or Niiiiiice! or Wicked! your picture is. Thankfully, many Fotolog members (even ones who fall back on one-word compliments every now and then) are

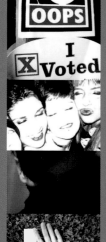

really thoughtful commenters. Just like the photos, some of the most interesting, funny and revealing comments have been selected to accompany the pictures. With real estate at a premium on every page, giving the photos enough breathing room took precedence, so some have no comments at all. But of course you can always go to Fotolog.net and type in any picture's URL to read what everybody had to say about it. Happy surfing.

The short texts opening several chapters and the longer essays on photoblogging and words versus images are by the razor-sharp writer Nick Currie, aka Momus, the indie musician, artist and provocateur. Nick was a pioneer photoblogger, posting photos daily on the Web as early as 1998. We came across some of his writing about photoblogs on his site (www.imomus.com), and knew immediately that we had to have his unique voice to help illuminate the byways of what he calls 'the great tureen of digital *pho*'. He was gracious enough to accept our invitation.

Indeed. So anything else I need to know?

Just this: the selection of photographs in ***fotolog.book*** obviously represents a minuscule percentage of the images in the Fotolog archives. A book like this can never be comprehensive and would suffer from trying to seem so. We hope our choices reflect the best nature of Fotolog: the earnest, and sometimes heartbreaking documents, the surprising humour, the ordinary made extraordinary, the pursuit of happiness. This anthology is only one version, one telling of the story of Fotolog from a multitude of possible tellings. We believe it to be an interesting and entertaining version, but we also hope it offers more than that. We hope it can begin to answer two questions: why it has now become more important than ever that we see for ourselves exactly what the 21st century looks like, and why we are compelled to share those daily visions, revisions and revelations with each other, and the world.

Thank you for looking with us.

ANDREW LONG, BROOKLYN, NY, USA, 2006

THIS IS THE TIME, AND THIS IS THE RECORD OF THE TIME

IT WAS 1998 THAT I SAW my first digital still camera close up. Toog was visiting me in London with his Japanese friend Kohei, a 'designerhead neat freak' with a gentle manner, a quiet voice, a cool haircut and a Sony Mavica. It was big and clunky, this digital Box Brownie. You'd shove a floppy disk between its teeth, and the camera would chew, grind, then painfully spit out a photo file to the disk every time you pressed the shutter release – a floppy could only hold a single uncompressed image, so you had to carry a stack of them around with you. But Kohei's photos were nice. They were very flat, very grey, very empty: mostly graphics he'd seen on walls and illuminated traffic-island bollards; alien views of a country that, to him, must have seemed very fresh and very strange.

On my next trip to New York I bought a little Panasonic on Times Square and began taking pictures for my website; pictures of tours, pictures of America, pictures of Japan. The camera was slim and lithe enough to fit in a coat pocket and switched on quickly, so it was great for spontaneity. The resolution, though, was lousy, so you tended to go for high graphic impact rather than subtlety or detail. When the Panasonic broke down in 1999 I graduated to Fujifilm Finepix cameras, which I've stuck with ever since, enjoying their warm colour balance and macro capabilities.

I've always kept diaries and I've always taken photographs, but only recently have they become one and the same thing. Since 1998, whenever I want to know what any given year, month or day felt like, I go to my digital photo folder and, instead of reading, look. My diary has become exclusively visual. Lost things and people are restored to me, and feel less lost.

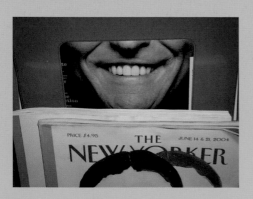

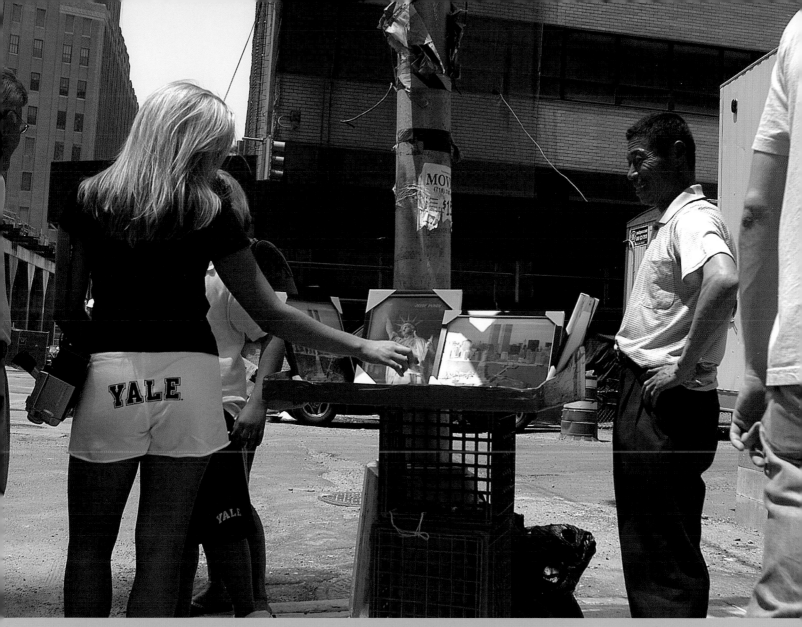

bsamp @ 2003-06-27 01:27 said:
look at his face...hahaha. He's almost drooling.
Wow, what a nice Yale.

1015 @ 2003-06-27 14:04 said:
nice bumper sticker

sharonwatt @ 2003-06-28 13:13 said:
there's some joke about entry requirements here,
but you know, I'm not gonna make it......

NEW YORK, NEW YORK

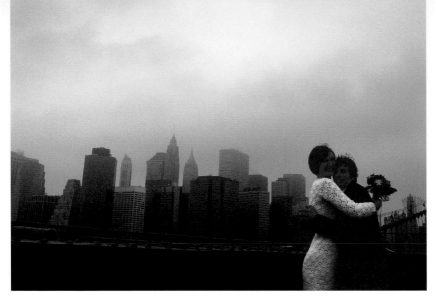

*above: www.fotolog.net/**eshepard**/?pid=1697786*

macwagen @ 2003-10-22 09:05 said:
now that's just plain beautiful, damn it.

pro_keds @ 2003-10-22 09:15 said:
love da love

*below: www.fotolog.net/**sharonwatt**/?pid=91618*

beebs @ 2003-05-02 09:53 said:
what's the streak of bubblegummy pink on top?
i like the puzzle.

sharonwatt @ 2003-05-02 13:11 said:
It's a pink pen. (what else would you find in my hands?)

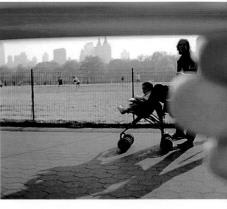

*below: www.fotolog.net/**meadows**/?pid=1574596*

sharonwatt @ 2003-10-16 22:53 said:
Southside Semitic Cyan

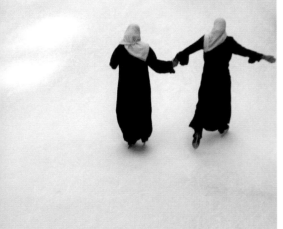

*above: www.fotolog.net/**honeycut**/?pid=7131486*

squaremeals @ 2004-03-04 18:03 said:
I'm glad they get to have some fun.

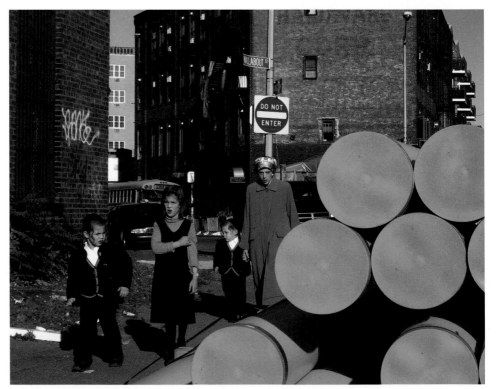

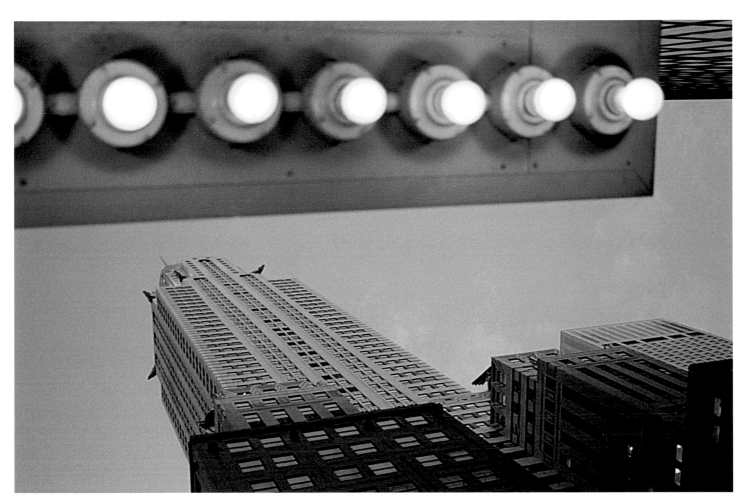

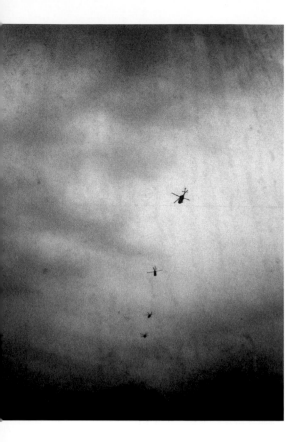

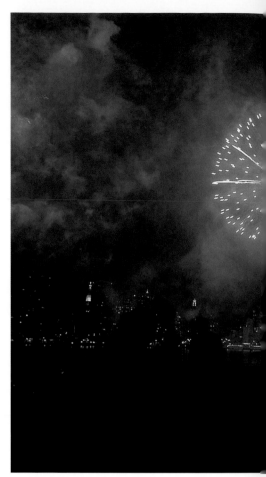

www.fotolog.net/*eshepard*/?pid=2218193

super8mm @ 2003-11-12 01:38 said:
this is the end...
beautiful shot, my friend...

caveat @ 2003-11-12 02:18 said:
wow!
and then you see the two tiny red lights
in the bottom right corner and the world
hums you a tune.

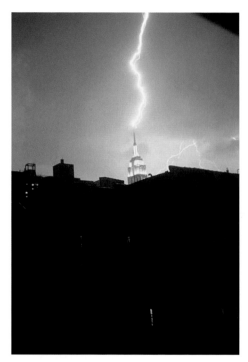

www.fotolog.net/*ox99*/?pid=316265
greenpoint, brooklyn

zazatem @ 2003-07-08 00:54 said:
This almost looks underwater.
Ethereal.

www.fotolog.net/*ekavet*/?pid=152231

bsamp @ 2003-05-25 10:47 said:
is it real?

lena @ 2003-05-25 11:42 said:
IS THAT REAL?!!!!!!!!!

ekavet @ 2003-05-25 15:07 said:
It's very real...
The camera I used (Cosina 35mm) has no timed-
exposure setting. I just had to basically time the shot
by the amount of activity around the Empire State
Building. Two rolls of film for just one shot.

bklyn95 @ 2003-05-30 08:57 said:
Weegee lives.

mrscharming @ 2003-06-03 11:16 said: gasp

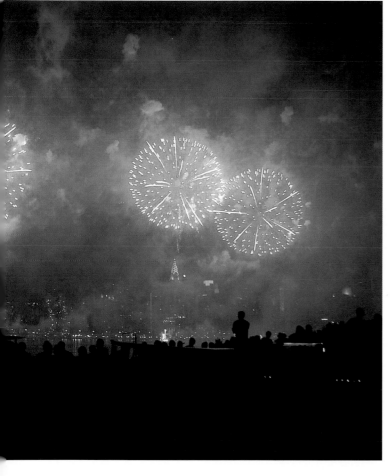

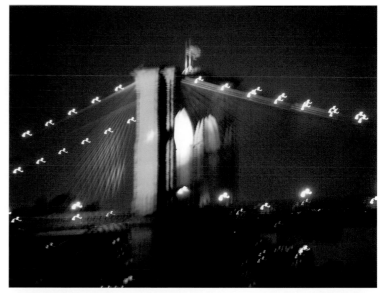

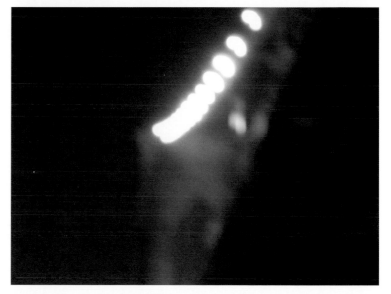

*above right: www.fotolog.net/**along**/?pid=151732*

*right: www.fotolog.net/**meadows**/?pid=7580117*
brooklyn bridge

along @ 2004-03-16 22:58 said:
no, that would be the deepest
essence of the Brooklyn Bridge.
Slight difference.

left: *www.fotolog.net/johnnyphoto/?pid=8099929*

poet @ 2004-08-25 13:52 said:
at that very moment Nick discovered a set of
keys in his pocket that weren't his.

armadilliz @ 2004-08-25 19:34 said:
great bold shapes! hey, when are we going to
go shooting?? I can learn a thing or 2 from you,
I reckon!!

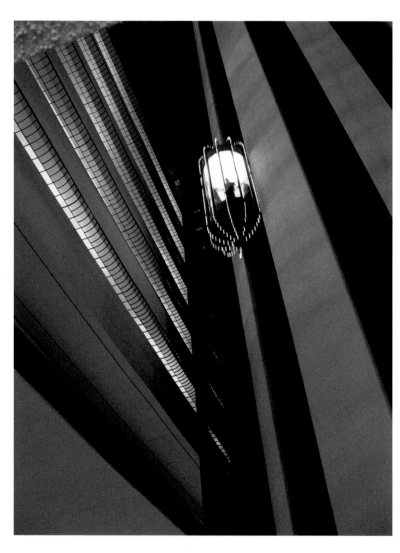

*www.fotolog.net/**johnnyphoto**/?pid=7860272*
love this place.

mindyhertzon @ 2004-06-24 01:09 said:
i love that place too.
meet you at the top!

la_vie_en_rouge @ 2004-06-24 01:15 said:
Oh maaaaaan.
I totally dig everything
about this pic, the lines and angles,
the silhouette of the lift rider,
and the lights/blur of the lift.
WOOOOOOW.
Fantastic, Johnny!

*www.fotolog.net/**johnnyphoto**/?pid=8194575*
**Spent a good three hours shooting this night
(mostly due to the long exposures, 15–30
seconds). But it was worth it. Being close to it
you can see small specks of paper?, moths?
flying around inside. It is beautiful but
haunting at the same time.**

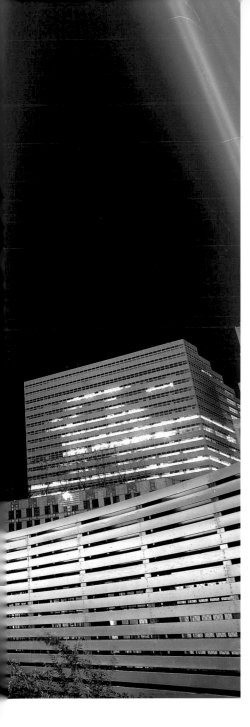

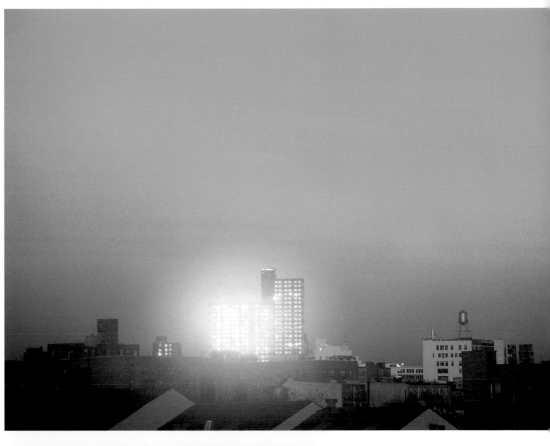

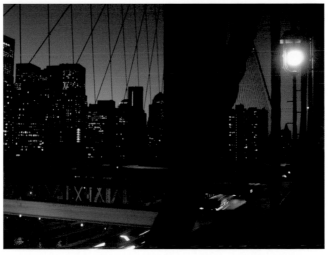

danito @ 2004-10-13 00:47 said:
one of those pictures that make you sigh...

above:
after the gold rush

youzoid @ 2004-03-13 10:28 said:
does the office need to be this brightly lit?

bytefactory @ 2004-04-08 00:32 said:
wow!!! very classy.
this is my hood – little korea right?

anon_ms_b @ 2004-04-08 00:38 said:
you so good...

anon_ms_b @ 2004-04-08 00:38 said:
sorry, didn't read bytefactory's
comment till AFTER I posted,
I swear...

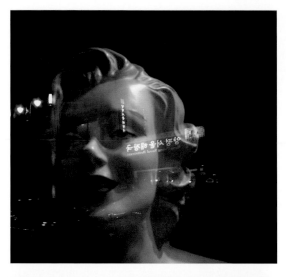

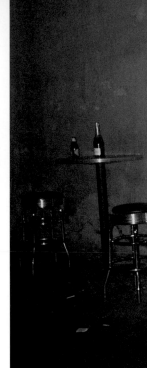

cookieb @ 2004-09-30 00:57 said:
lucky catch? nice.

pixietart @ 2004-09-30 01:38 said:
all about the kicks

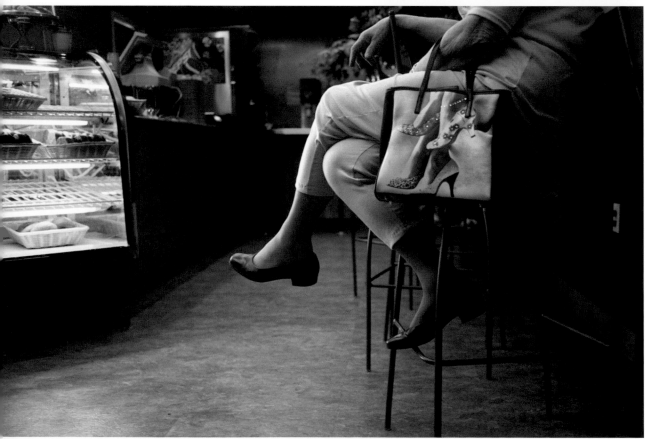

michale @ 2003-10-08 02:48 said:
she seems so alone there.

anideg @ 2003-10-08 06:10 said:
where do you come across these people?
absolutely amazing. you should comment
on your catch – situate us a bit!

oldlace @ 2003-12-12 23:37 said:
that little face is a diamond. she could cut
through anything with those eyes.

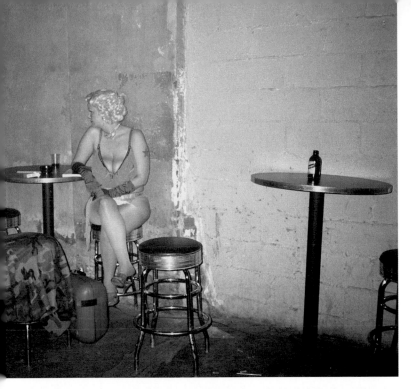

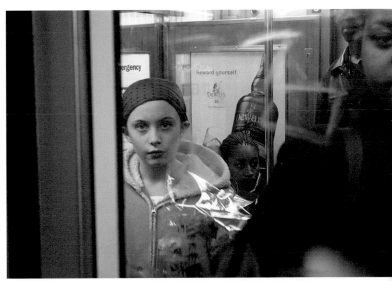

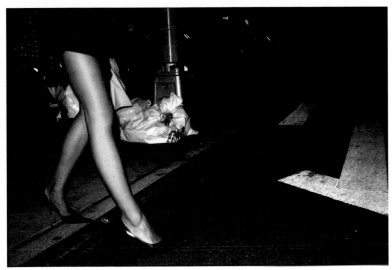

along @ 2003-09-26 17:13 said:
eurotrash and regular american trash. love this

beebs @ 2003-09-27 11:33 said:
hawwwwwt. those heels and legs are divine.

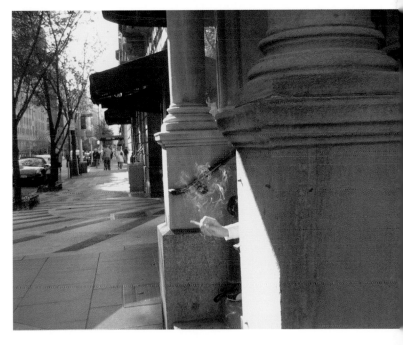

hillsbells @ 2003-10-29 17:07 said:
Are they debating whether to hijack the truck or go shopping?

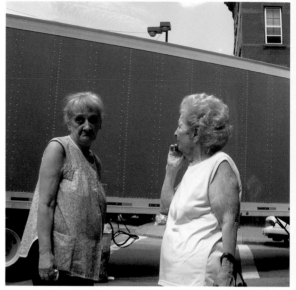

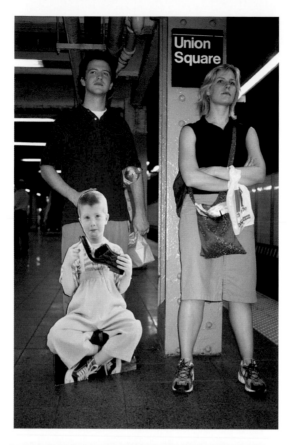

right: www.fotolog.net/**toddfisher**/?pid=5253861

beebs @ 2004-01-24 23:39 said:
the perfect modern breeders. cardboard children are quiet and flawless.

davidgarchey @ 2004-01-27 05:40 said:
Happy couples have children

below: www.fotolog.net/**ribena**/?pid=7917325

armadilliz @ 2004-07-05 10:43 said:
oooh, i need some new furniture –
I'll be right there...

meadows @ 2004-07-05 19:16 said:
such beautiful order to the chaos

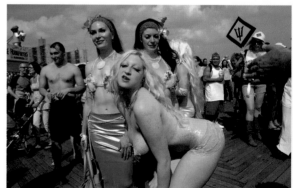

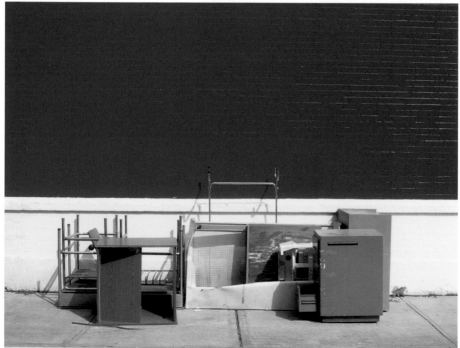

above: www.fotolog.net/**colorstalker**/?pid=8079363
**Mermaid Parade, Coney Island. Rules the same as Fotolog.
No bare nipples (women) & genitalia covered, please.**

location_iceburg @ 2004-06-29 02:28 said:
snarls allowed ;)

oldhamedia @ 2004-07-05 23:20 said: Bare nipples are
allowed, since the lawsuit a few years ago, but no one seems
to want to tempt the law. I went topless 2 years ago,
although I was covered in tons of pearls.
I'm going to organize a cadre of costumed photobloggers to
march in the 2005 parade, so get in touch if you wanna be
in the parade with us, June 25th, 2005.

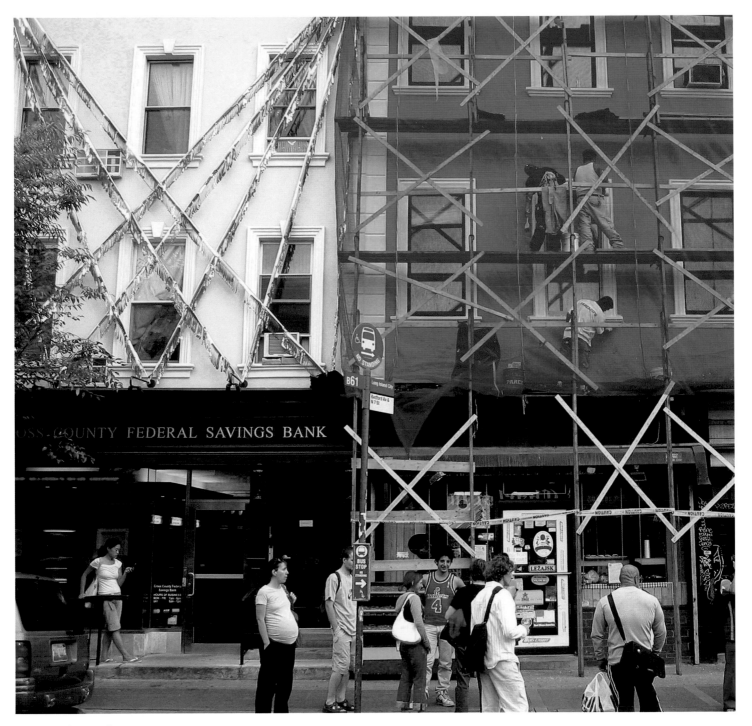

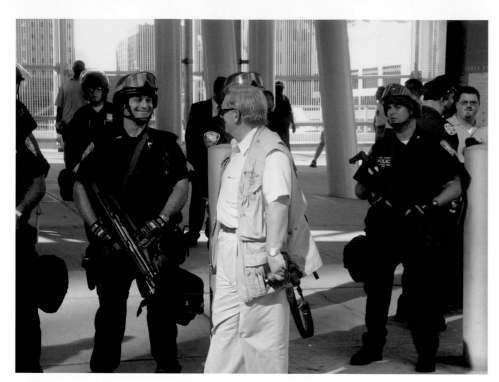

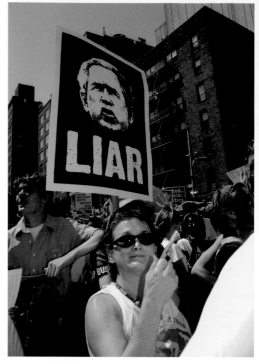

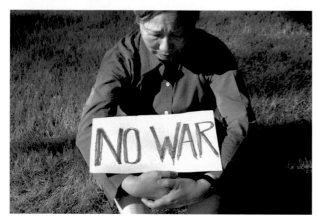

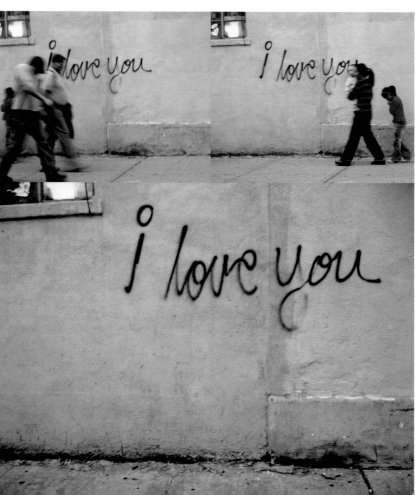

top: www.fotolog.net/__x_o__/?pid=7778243

this 'photojournalist' seemed awfully chummy with all the cops there [protest of the RNC, at Ground Zero]…until I noticed he would walk right through lines of the cops while they were barricading areas. and then i heard him calling cops by their first names…and realized he was a cop, photographing protesters' faces just like the other cops using video cameras.

of course, it IS legal for police officers to lie to you, don't forget that.

0x99 @ 2004-09-04 19:50 said: damn.

above: www.fotolog.net/__colorstalker__/?pid=8518740

This was shot at the Great Lawn in Central Park after the march. It had been expected to be a flashpoint of violence between cops & protesters because the city had denied a permit to hold a rally there. It turned out to be a peaceful gathering on both sides.

kandykorn @ 2004-09-02 21:18 said: easily the most powerful photo i have seen from the RNC photos on the log. no question.

*opposite, top right: www.fotolog.net/**colorstalker**/?pid=8544000*

Tonight at Madison Square Garden, George W. Bush will accept the Republican Party's nomination for President of the United States. If the past is any guide, what he says he has done & will do is not going to bear any resemblance to what he has actually done or what he really plans to do.

rinascita @ 2004-09-03 09:37 said:
I happen to be reading *1984* for the first time right now. Talk about topical.

WAR IS PEACE
FREEDOM IS SLAVERY
IGNORANCE IS STRENGTH

I'm surprised this isn't on a Bush/Cheney campaign poster.

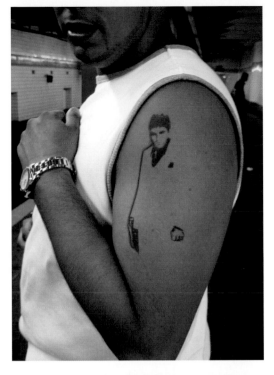

*opposite, bottom right: www.fotolog.net/**pixietart**/?pid=8583944*

honeycut @ 2004-09-22 15:40 said:
i love you too

oldlace @ 2004-09-22 15:40 said:
thanks pixie. i love you too!

*left: www.fotolog.net/**eshepard**/?pid=295765*

ableakney @ 2003-07-01 09:20 said:
'Say 'ello to my little friend!'

lauratitian @ 2003-07-01 09:44 said:
wouh! nice...i love the incomplete...

beebs @ 2003-07-01 12:28 said:
that's some serious dedication to 80s-era Pacino.

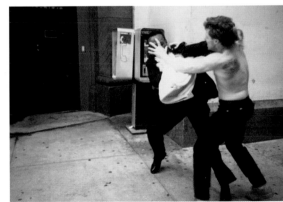

*above: www.fotolog.net/**ekavet**/?pid=75960*

irieday @ 2003-05-09 23:13 said:
that doesn't look like fun.

aerial @ 2003-07-10 20:46 said:
fear = anger

*left: www.fotolog.net/**along**/?pid=7639421*

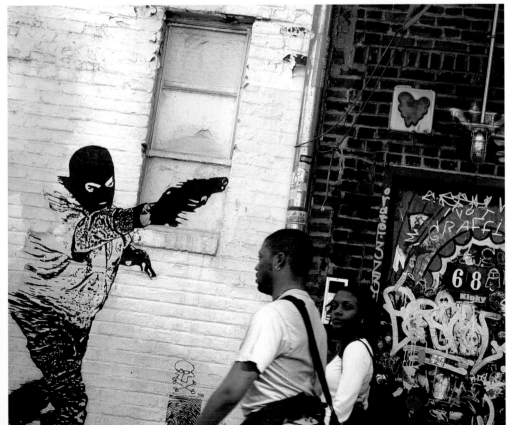

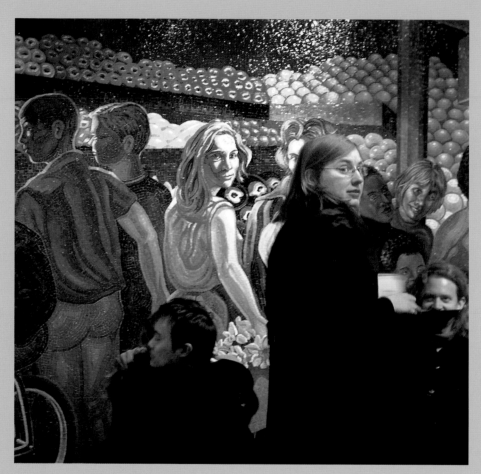

www.fotolog.net/**lauratitian**/?pid=7131788

jandolin @ 2004-03-03 22:38 said:
Everyone is so in proportion. Now that would be a great
painting too.

www.fotolog.net/**lauratitian**/?pid=8195906

grantbw @ 2004-07-13 12:02 said:
you don't miss much

frank_bklyn @ 2004-07-13 12:11 said:
bursting with fruit flavors

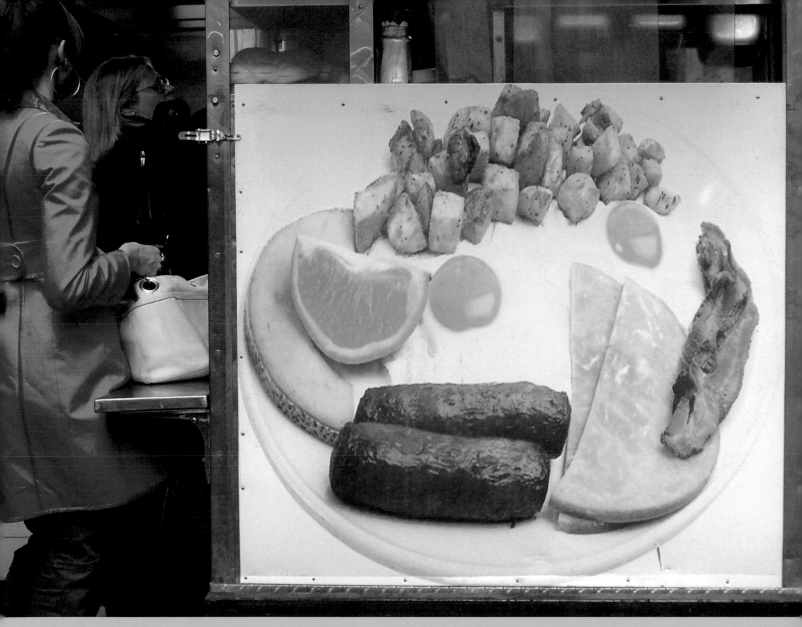

zenbomb @ 2004-04-10 17:27 said:
hey, fruit! that's healthy.

sarahdee @ 2004-04-13 17:07 said:
not one, not two, but three pork products on one plate!
run little piggies!

/lauratitian

suzannasugar @ 2004-10-20 18:11 said:
I hope that is from napping in a beach lounger

sharonwatt @ 2004-10-21 04:15 said:
I'm sure there's someone out there who has a foot
AND squid fetish

*below: www.fotolog.net/**lauratitian**/?pid=8308592*

jaimew @ 2004-07-28 20:18 said:
you may have a future as a fetish photographer.

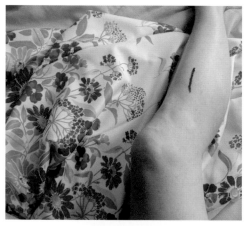

*above: www.fotolog.net/**lauratitian**/?pid=7890196*

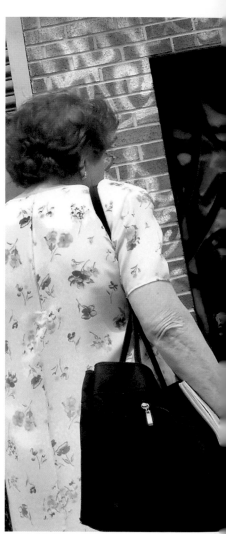

angelissima @ 2004-07-14 14:34 said:
butt out!

www.fotolog.net/*lauratitian*/?pid=45631

kdunk @ 2003-03-24 10:44 said:
i love a long stride

eshepard @ 2003-03-24 10:49 said:
i like librarians and that's got to be one

digiruben @ 2003-03-24 16:10 said:
oh-so-retro feel to this. :)

www.fotolog.net/*lauratitian*/?pid=306982

pro_keds @ 2003-07-03 09:23 said:
williamsburg hipsters, circa 2052.

garydann @ 2003-07-03 09:25 said:
u know they just tagged up that wall and those
handbags are filled with markers and spraypaint...
cool. i love gangsta chix. H O T!!!

jungalero @ 2003-07-05 18:06 said:
'Now remember Gladys—you cover my back
after I kick the door in. Got it?'

strangerswcandy @ 2003-07-28 10:32 said:
dear katharine – rest in peace

zenbomb @ 2003-07-28 10:53 said:
looks like katharine's biting mystery girl's finger.
I like when you incorporate these subtle absurdities.

squaremeals @ 2003-05-30 10:18 said:
Sexy girl, sexy guy (David), and clueless guy
in between.

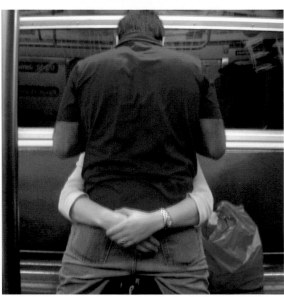

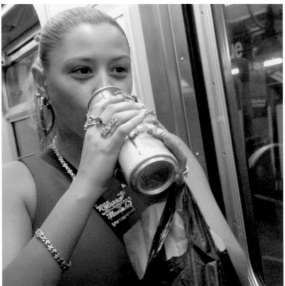

0x99 @ 2004-08-10 22:42 said:
the unquenchable thirst. hot.
hey lauratitian, don't you ever think
of wearing less jewelry?? :)

palmea @ 2004-08-10 22:55 said:
now that's some hardware

hihihi @ 2003-10-14 16:20 said:
must be love...

sk8rsherman @ 2003-05-03 14:36 said:
yo, he selling like a madman

brainware3000 @ 2003-05-03 20:31 said:
those are definitely some quality phones.

virginie @ 2003-05-04 05:37 said:
the woman on the advertisement seems
very interested by products!

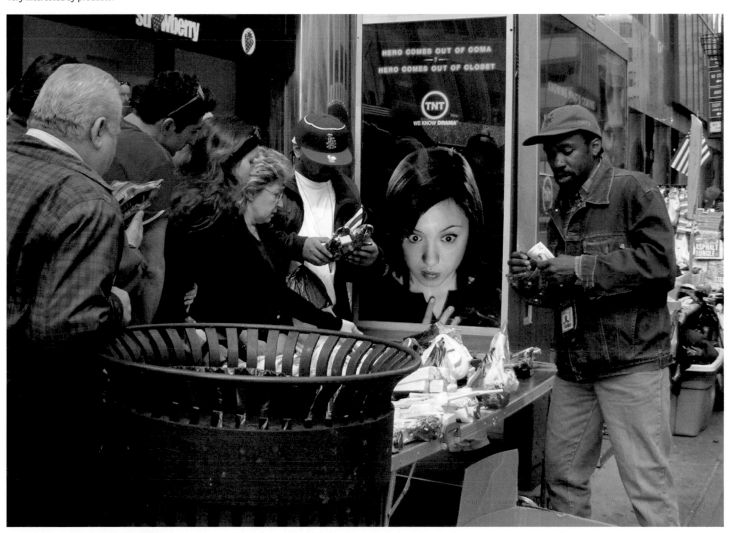

pixietart @ 2004-09-17 10:56 said:
ooooooh that kind of lake scares the bejeebers
out of me! great photo

oh, spring.

moredogseat @ 2004-04-06 13:02 said:
holy crap!
uber nice lines
i almost want it to be a backboard
for a basketball hoop

zenbomb @ 2004-04-06 13:10 said:
lost in this one, and I don't mind.

eshepard @ 2004-04-06 13:16 said:
a la dogseat, slam-dunk

kandykorn @ 2004-04-06 17:43 said:
day-dreamy

national @ 2004-04-11 18:57 said:
I'm dizzy.

jkh_22 @ 2004-12-08 18:14 said:
maritimemekko

jkh_22 @ 2004-11-06 16:40 said:
for the first time, i read this and thought:
chevre au lait
beauty, this.

neene @ 2004-11-06 20:07 said:
having a little color seizure right now

www.fotolog.net/**lauratitian**/?pid=9648519

ribena @ 2004-12-10 16:51 said:
no one does trash the way lauratitian does trash.

lauratitian @ 2004-12-10 17:02 said:
(waiting for someone to say white trash)

www.fotolog.net/**lauratitian**/?pid=8079690

trimtab @ 2004-06-24 15:15 said:
hah! what an odd find...like a Magritte painting,
but I love the non-parallel planes
made to feel flat. great job.

www.fotolog.net/**lauratitian**/?pid=92470
a new baby bag is born every 6 minutes

lauratitian @ 2003-05-02 14:01 said:
it's kind of gross, this picture

hoyumpavision @ 2003-05-02 14:19 said:
Congratulations! I guess since it's pink, it's a girl.
So, does that make her a bag lady?

jkh_22 @ 2003-05-02 15:38 said:
oy...will that bag ever see its original shape
again???

www.fotolog.net/**lauratitian**/?pid=7809934

eshepard @ 2004-05-07 14:12 said:
if i see this in a year it wood
bring back some nice mammaries

wobman @ 2004-05-13 13:09 said:
She's sort of flat. :-)

opposite:
www.fotolog.net/**lauratitian**/?pid=6793902

zenbomb @ 2004-02-26 13:27 said:
the scream.

zenbomb @ 2004-02-26 13:28 said:
damn.

anomalous @ 2004-02-26 13:47 said:
Finally, the real essence of
television captured on film.

along @ 2004-02-26 17:48 said:
the medium IS the message.

www.fotolog.net/**lauratitian**/?pid=133575
flat sundae

frank_bklyn @ 2003-05-19 09:48 said:
mr softee got creamed

angelissima @ 2003-05-19 11:38 said:
I like how the cherry didn't roll away.

lauratitian @ 2003-05-19 11:49 said:
Frankbklyn: or, Mr Creamy got Soft...?

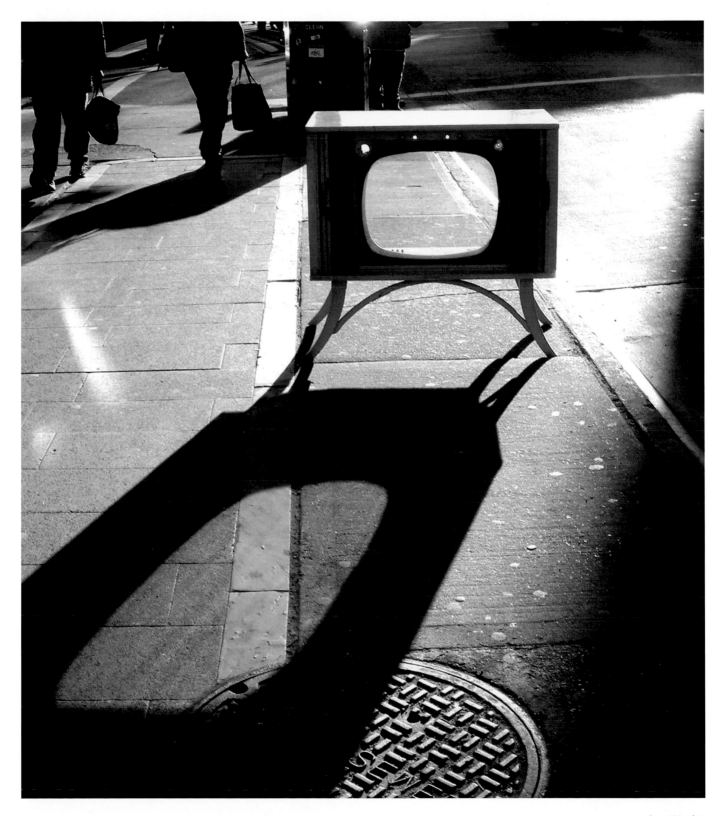

THE WEB, WITH ITS COLOURFUL CONTENTS, IS A KIND OF HUGE LIGHT BOX, A BACKDROP TO THE CLUTTER OF THE WORLD

I LOVE HOW SLIDES LOOK ON A LIGHT BOX. Now it seems the light box has joined the other technologies aped by the Internet. There's some software that makes thumbnail images look like slides lying on a light box.

The Web, and especially the Web as a light box with an array of slides slipping all over it, is—another metaphor!—a vast patissier's window full of cakes. I gobble the daily fare of amateur patissiers worldwide thanks to the invention of the photoblog.

*below: www.fotolog.net/**pavement_pix**/?pid=1923948*
*from www.fotolog.net/**hihihi***
'tu me fais sourire'
(It was there exactly as you see it!)

luisacortesao @ 2003-10-31 16:07 said:
:) et oui, c'est vrai

bun045 @ 2003-11-30 07:49 said: **funny!**

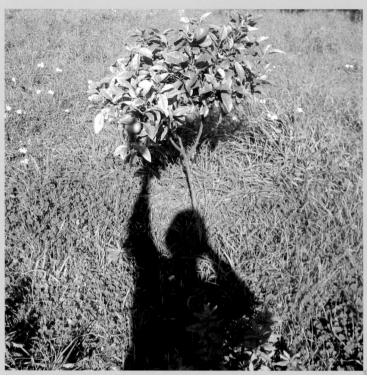

*www.fotolog.net/**luisacortesao**/?pid=10896377*

santivazquez @ 2005-04-01 16:48 said:
great photo!!! did your shadow get the oranges?

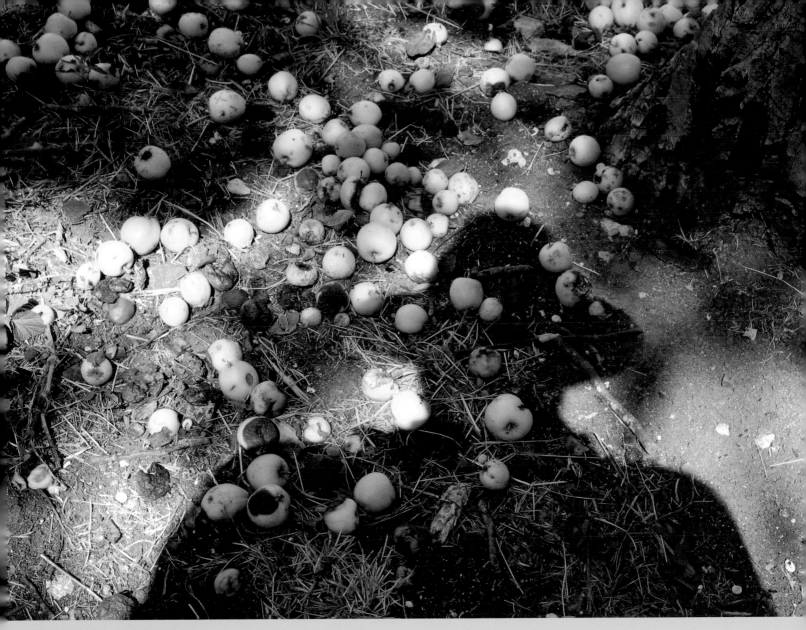

urbanmermaid @ 2003-08-24 14:14 said:
Fantastic shot!! It seems very ominous —
like there is going to be trouble for those
ground apples if that cowboy is wearing boots :)

arto @ 2003-08-24 14:22 said:
He'd seen it all before. Death, decomposition,
the sweet smell of decay. This time it was different.
This time it was apples.

EXTRA ORDINARY

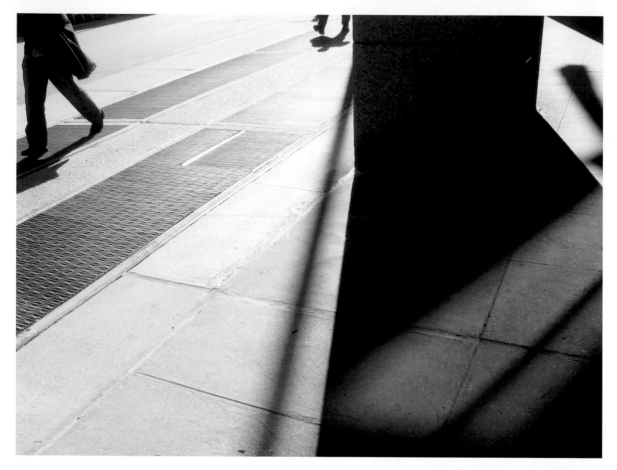

gabbo @ 2003-10-27 17:34 said:
very urbanbusinessgraywonderful!

lawroberts @ 2003-10-28 17:24 said:
Great series! Excellent use of light,
line and shadow. I especially
like the angles employed, the
sense of motion and the
croppings on the subjects.

chewing_gum @ 2003-10-10 17:09 said:
Oh la la! Absolutely one of my
favourites! And even some little
spots of chewing gum ;)

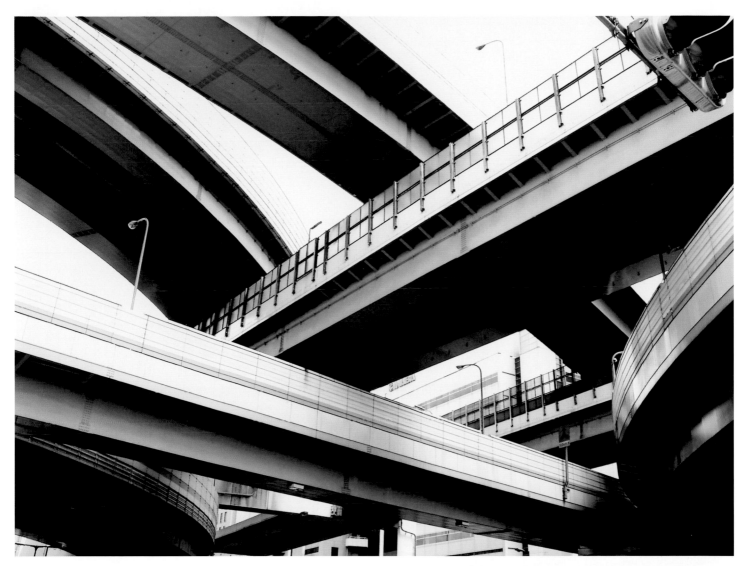

www.fotolog.net/**palla**/?pid=458576

buster @ 2003-07-27 20:21 said:
beautiful, intricate image, delicately colored.

wolfey @ 2003 07 27 20:43 said:
Fantastic. Why do people build things like this?
Because we are crazy.

0x99 @ 2003-07-27 22:22 said:
wow. reminds me of Piranesi.

palla @ 2003-07-27 23:25 said:
Piranesi!!!

www.fotolog.nct/**hihihi**/?pid=7865205

johannaneurath @ 2004-09-20 14:36 said:
ohhhhh...tip top mister
and somehow very postmodern ;)

neene @ 2004-06-18 18:22 said:
joy explosion

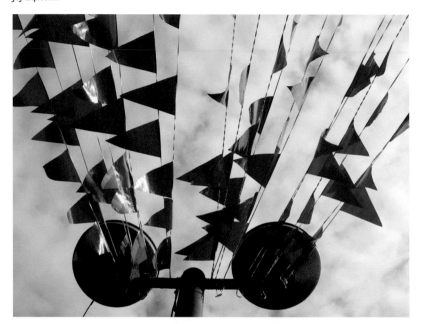

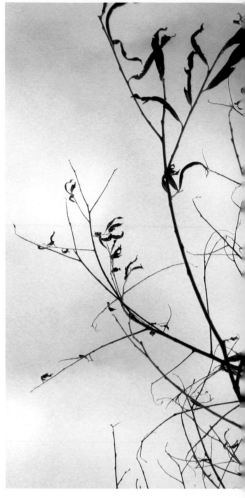

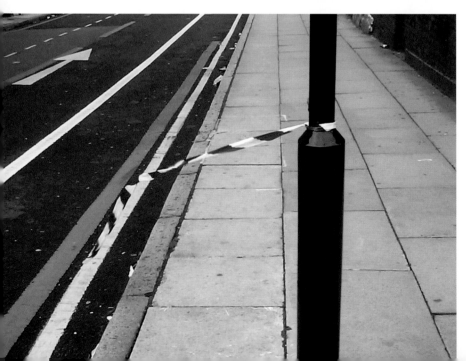

left: www.fotolog.net/**hihihi**/?pid=8476849

virgorama @ 2005-07-07 17:51 said:
poignant...perfect

grantbw @ 2005-07-07 18:03 said:
nice to see something beautiful
from your country today

francinette @ 2005-07-08 17:20 said:
All is blowing in the wind, isn't it?

below: www.fotolog.net/**luisacortesao**/?pid=8889097

right: www.fotolog.net/**ignatz_mouse**/?pid=7830026

bevophoto @ 2004-09-07 07:18 said:
wow! a poetic installation, and so proud

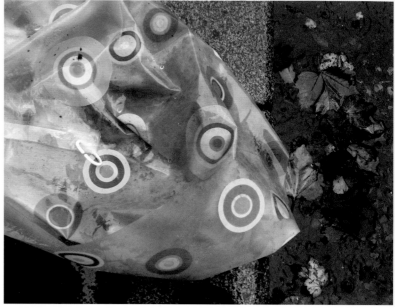

www.fotolog.net/*johannaneurath*/?pid=1973665
Reighton Road, London E5

jdiggle @ 2003-11-02 17:43 said:
Art deco Hanna style! It is almost as if whoever designed
those tiles was using these leaves for inspiration...
mind you don't slip on that banana skin...!

hihihi @ 2003-11-02 17:46 said:
oh la la la...super!

sharonwatt @ 2003-11-04 21:07 said:
Do you ever think some things are made just
for your eye to see...?

www.fotolog.net/*hihihi*/?pid=1997109
In response to johanna

mattpaper @ 2003-11-04 15:57 said:
This is really superb. I love the range of colours you have
found in such a small area. Your french is pretty good too—
where did you learn it? :)

www.fotolog.net/*hihihi*/?pid=1793582

squaremeals @ 2003-10-26 14:21 said:
Cool weather = warm colors.

www.fotolog.net/*hihihi*/?pid=1211133

www.fotolog.net/*pavement_pix*/?pid=4855709

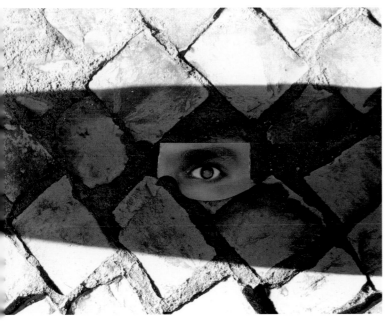

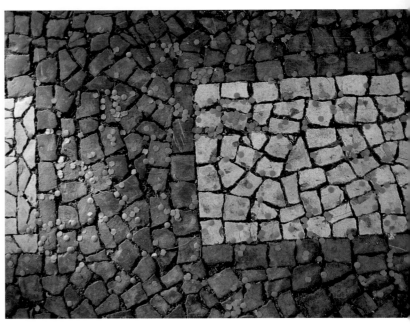

www.fotolog.net/luisacortesao/?pid=344629
on the street this morning (looking down #3)

addadada @ 2003-07-10 17:51 said:
no really...what a cool FOUND OBJECT find! wow...

luisacortesao @ 2003-07-10 17:55 said:
thanks! it was there, looking at me

www.fotolog.net/pavement_pix/?pid=6682616
from www.fotolog.net/luisacortesao

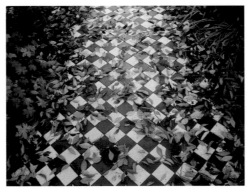

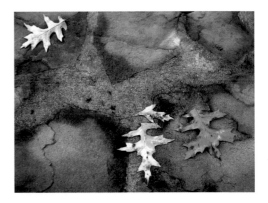

www.fotolog.net/johannaneurath/?pid=1884558
spilled milk and leaves

raceystacey @ 2003-10-30 03:40 said:
How gorgeous! Hope you didn't cry over
the spilled milk...

www.fotolog.net/yohoho/?pid=6085563

www.fotolog.net/kandykorn/?pid=8442573

beebs @ 2004-11-30 23:29 said:
oooh, like lime jello cemented.

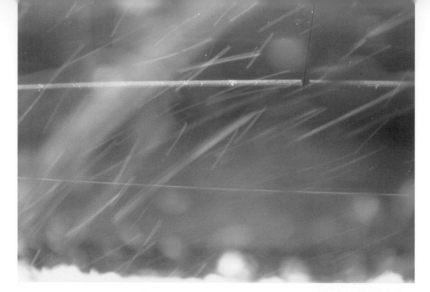

*left: www.fotolog.net/**nishimuratsutomu**/?pid=5692702*
It lies quiet, little by little.

*left, centre: www.fotolog.net/**yukihisa**/?pid=7723498*

*left, bottom: www.fotolog.net/**soli**/?pid=1913914*

hope @ 2003-10-31 12:04 said:
A kind of magic or common water (snow?)?

soli @ 2003-11-01 03:12 said:
Just a flash through raindrops

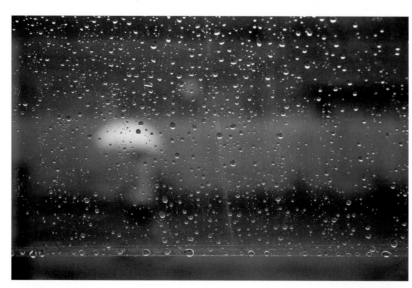

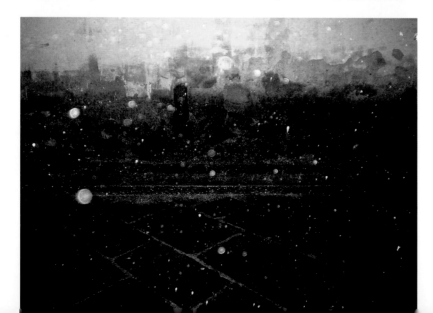

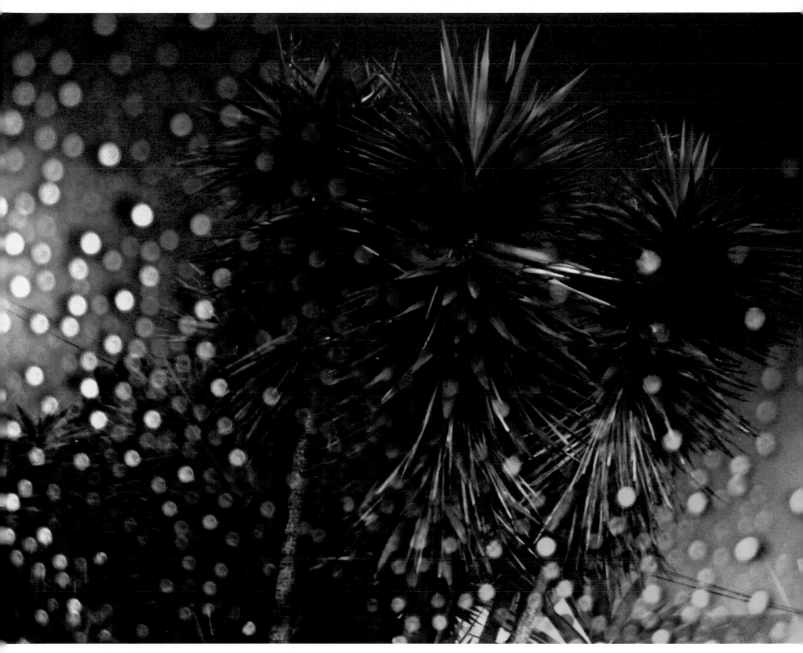

world_o_randi @ 2004-12-08 16:58 said:
tropical sexy goodness.

jeanieforever @ 2004-12-08 17:06 said:
oooh, lovely – palms look like pines – makes for a great
xmas card!

colorstalker @ 2004-12-09 00:45 said:
brings back the spattery strong smell of california rain

right: www.fotolog.net/**heif**/?pid=7945401

lauratitian @ 2004-10-31 18:32 said:
why is this sooooo pretty?

far right: www.fotolog.net/**yellow_n_blue**/?pid=7628495

below: www.fotolog.net/**luisacortesao**/?pid=9697958
**the sky was incredible
(back in Lisbon)**

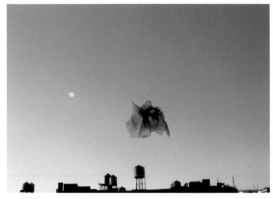

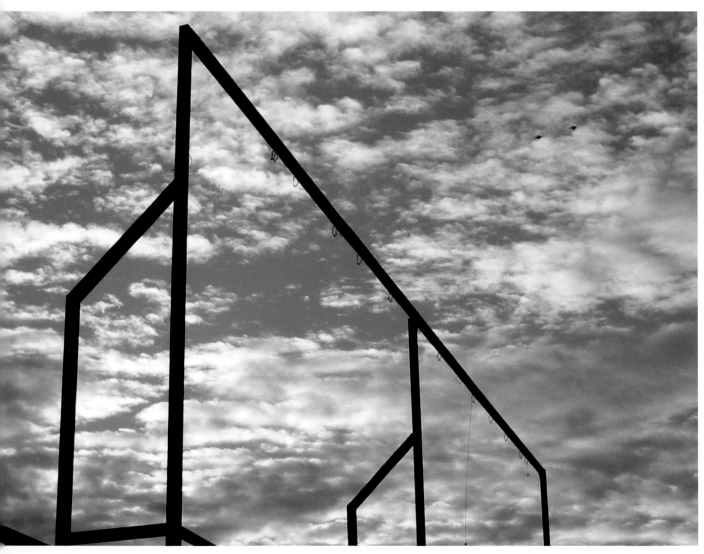

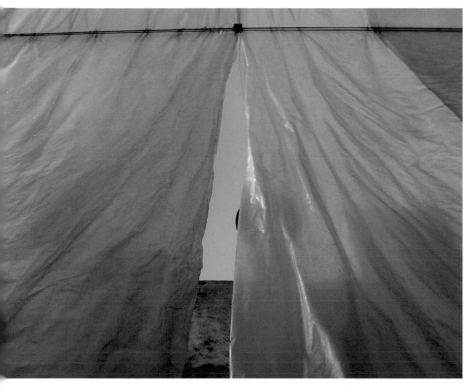

*www.fotolog.net/**luisacortesao**/?pid=463940*
clothesline

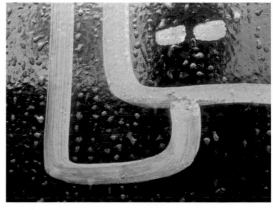

*above: www.fotolog.net/**luisacortesao**/?pid=2546155*
today, midday

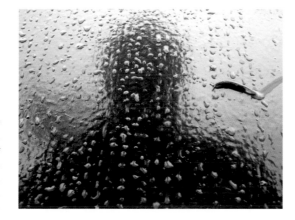

*www.fotolog.net/**hihihi**/?pid=3294270*

cespenar @ 2003-12-11 17:32 said:
marvelous. i've lost my sense of
dimension there.

goon @ 2003-12-11 17:48 said:
beautiful drops and er...slug.
love the colors

*right: www.fotolog.net/**hihihi**/?pid=3294795*

sixeight @ 2003-12-11 17:41 said:
ha...perfect. love your blue eyes.

www.fotolog.net/**along**/?pid=7193971

youzoid @ 2004-03-05 12:11 said:
what do those buttons do?

sharonwatt @ 2004-03-05 13:21 said:
ouch, that sliver at the left, that boxette down right!

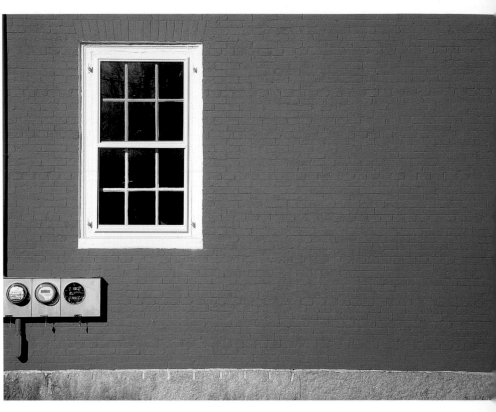

www.fotolog.net/**pattern**/?pid=7779228

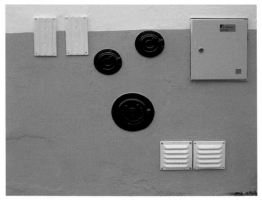

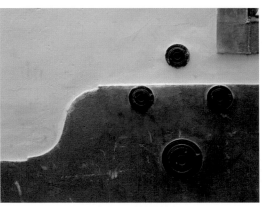

*above: www.fotolog.net/**johannaneurath**/?pid=7713874*

*above right: www.fotolog.net/**luisacortesao**/?pid=8506361*
porto brandão

*right: www.fotolog.net/**hihihi**/?pid=7656379*
stringbeanjean @ 2004-05-05 20:00 said:
i am calmed.

above: www.fotolog.net/**hartofocus**/?pid=7964506
Homage to Mondrian III

left: www.fotolog.net/**grantbw**/?pid=3794446
West 23rd Street, between 6th and 7th Avenues

tienna @ 2003-12-23 12:54 said:
In the thumbnail it looks like an Ikea kitchen!
Interesting.

right: www.fotolog.net/**grantbw**/?pid=3334624

greeny @ 2003-12-12 15:09 said:
Nice image...love the splash of green.
What is the angled black at the border?

grantbw @ 2003-12-12 15:14 said:
Took the shot looking upwards, so had pretty
strong convergence. Used Photoshop to 'correct'
the perspective, and instead of hiding my tracks by
cropping, decided to let the skewed borders show.

hazelmotes @ 2003-12-12 16:04 said:
The skewed borders are great, puts you off
balance...almost gives me the feeling of falling
backward (in a Hitchcockian way).

juliyap @ 2003-12-12 16:05 said:
This reminds me of a game that I loved when
I was little called Mouse Trap. Either that
or the housing project in Austria.

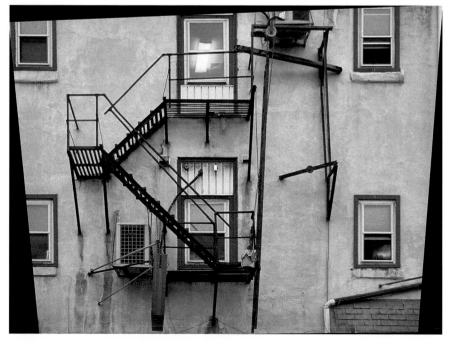

www.fotolog.net/*finalshot*/?pid=7631584
windows series of the slaughterhouse ruin

watershots @ 2004-04-04 11:11 said:
incredible — love this light that you've captured.

*below: www.fotolog.net/**beebs**/?pid=8920282*

pro_keds @ 2004-11-02 10:13 said:
rays of hope

colorstalker @ 2004-11-02 16:11 said:
epiphany in butter

www.fotolog.net/*yesterday*/?pid=7615911

tomswift46 @ 2004-03-30 07:06 said:
When morning comes to Morgantown...
Reminds me of the light in Joni Mitchell's songs...
Beautiful.

www.fotolog.net/**along**/?pid=1147932

beebs @ 2003-09-22 00:03 said: ooooooooooo!
this is light confetti. love it.

bsamp @ 2003-09-22 00:29 said:
oooooooooooooooooooooooooooo 8o0

isthisyou @ 2003-09-22 05:59 said:
i'm in love with that

sixeight @ 2003-09-22 17:07 said: wow...what is that??

along @ 2003-09-22 18:01 said: that's a bunch of
streetlamps, headlights, and taillights on Smith St. in
Brooklyn, out of focus as far as possible, and rotated
vertically

zenbomb @ 2003-09-22 18:31 said: magic, and oh-so
metaphysical.

hoyumpavision @ 2003-09-22 19:36 said: PURDY LIGHTS!
Feels like Christmas...or, um, one too many cocktails.
Weeeeeeee!

opposite: www.fotolog.net/**clarsen**/?pid=510728

below: www.fotolog.net/**nosuchsoul**/?pid=1478862
**oh, you know you're addicted to your camera
[/photolog] when you dash to grab it [nose tightly
pinched] in the middle of a err...nosebleed.
That's my sink drain.**

michale @ 2003-10-12 14:20 said: omg, sorry you're
bleeding and the addiction thing, well can't we all
relate?...great shot!!

moodywoodpecker @ 2003-10-12 17:18 said:
nice indeed. i've always found drops of nose bleed
in a sink very aesthetic...

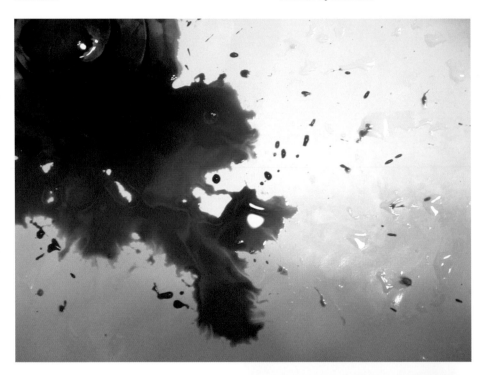

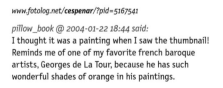

www.fotolog.net/**cespenar**/?pid=5167541

pillow_book @ 2004-01-22 18:44 said:
I thought it was a painting when I saw the thumbnail!
Reminds me of one of my favorite french baroque
artists, Georges de La Tour, because he has such
wonderful shades of orange in his paintings.

right: www.fotolog.net/**yohoho**/?pid=6073276

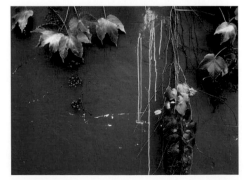

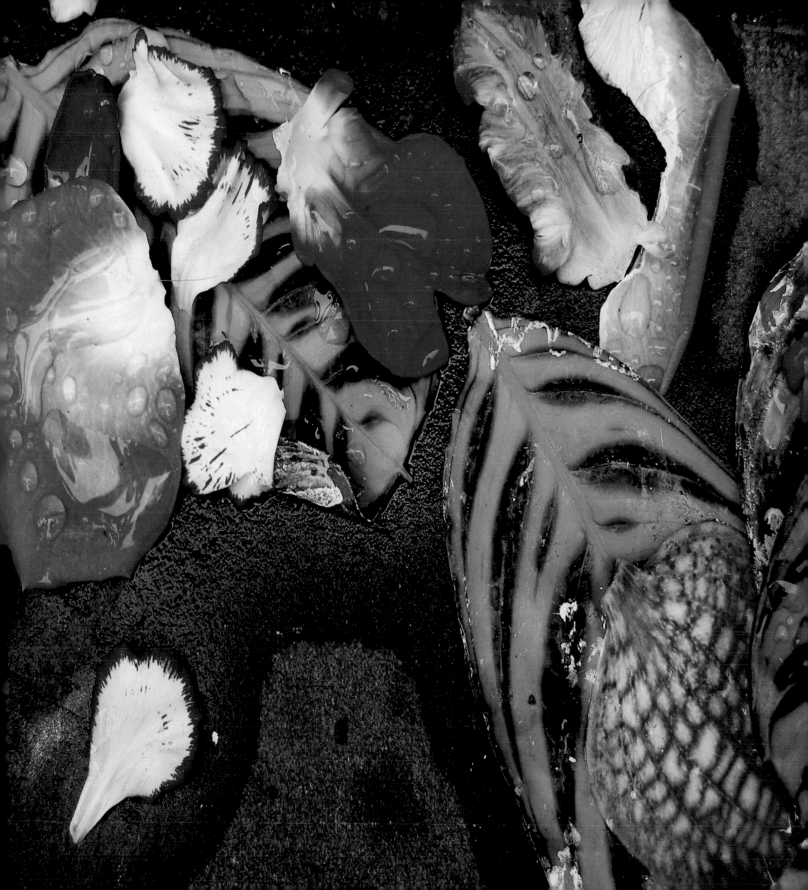

9thlife @ 2004-10-19 12:36 said:
Eyes of experience that don't judge.
Caught in such perfect colors!

eshepard @ 2004-10-19 15:11 said:
this is bananas

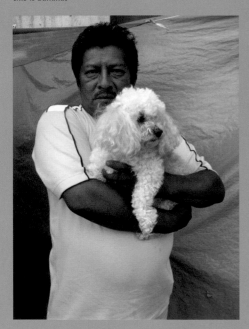

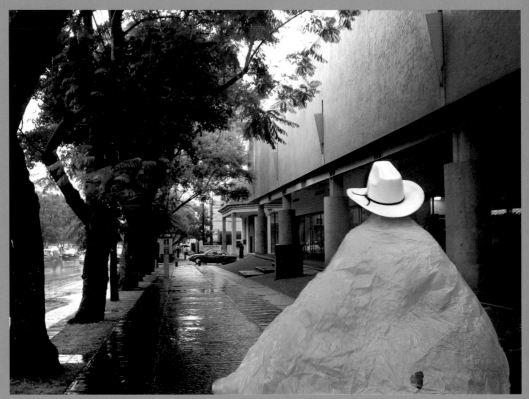

zenbomb @ 2004-06-29 03:12 said:
mythical beings inhabit your images.

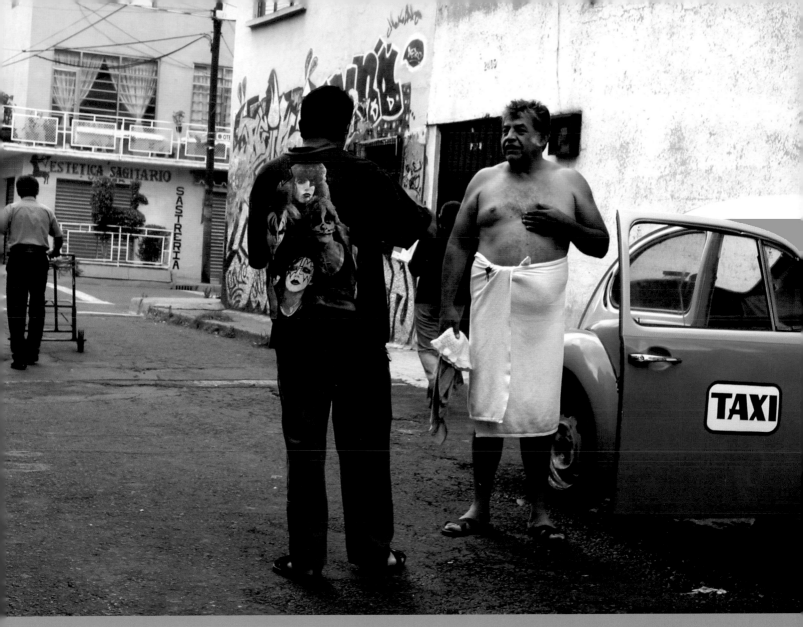

henrygee @ 2004-07-31 21:56 said:
What did the hardcore Kiss fan tell the freshly
showered cab driver?

colorstalker @ 2004-08-03 21:23 said:
comfortable in his neighborhood. great shot.

/location_iceburg

**Birdhouse maker in a tepito 'casa de la risa'
(mexico city)**

sarahdee @ 2003-06-12 14:53 said:
this man is strapped in and ready to go!
but where is he going...

mily @ 2003-06-13 00:29 said:
Is that a subterranean beard he has going on?

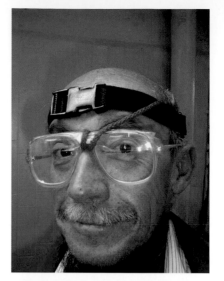

BINGO

beebs @ 2003-10-30 10:04 said:
hahaha! nice. her daughter's in purple hiding her face,
saying, 'mom, just stop, you're embarrassing me'

cypher @ 2003-11-04 17:24 said:
Perfect shot! If you look up bingo in the dictionary,
this is what you should see :)

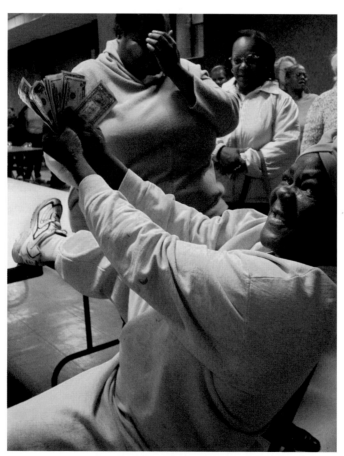

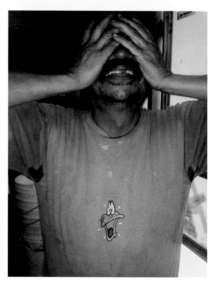

day three at the sunshine hotel

219 @ 2003-10-21 01:30 said:
usually you can't find such expression without the eyes...
way to capture the moment

squaremeals @ 2003-10-21 09:15 said:
He and Daffy are reacting to the same thing?

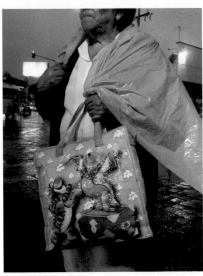

cookieb @ 2004-06-03 01:35 said:
she is like pooh a little, brave.

stitcher @ 2004-06-03 01:49 said:
I believe Pooh himself would call this a 'blustery day.'

the tiger suit

sharonwatt @ 2003-09-08 23:04 said:
the title makes this pineapple-peach dream perfect

stringbeanjean @ 2003-09-09 09:17 said:
Just LOVE it.
You are the favourite of all my favourites.
Yes sirree.

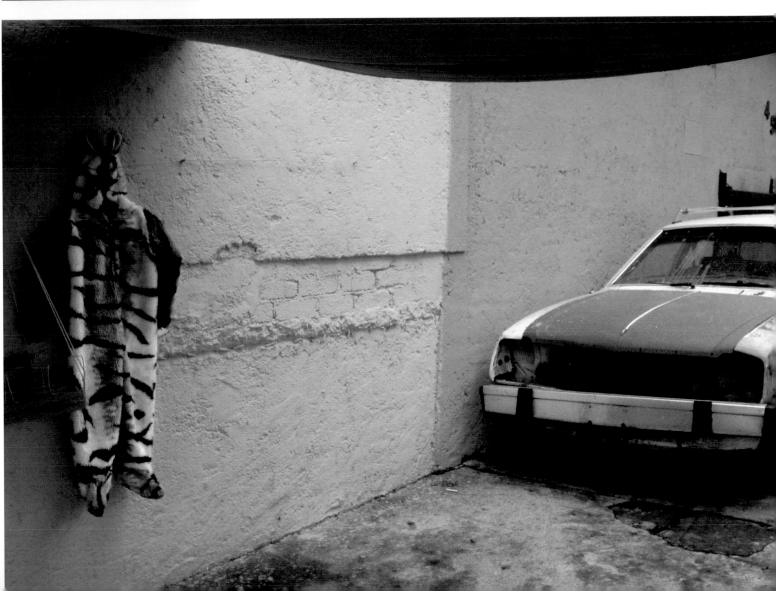

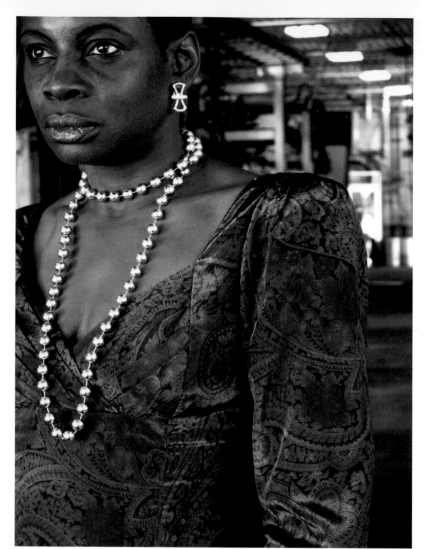

www.fotolog.net/*location_iceburg*/?pid=436186
cynthia

beebs @ 2003-07-24 17:50 said:
intriguing. between the industrial background and her intense complexity, i don't know what i'm feeling. coolness.

below: www.fotolog.net/*location_iceburg*/?pid=257027
Used lawnmower salesman (detroit)

stitcher @ 2003-06-23 18:55 said:
Incredible! Your model has such flair, style, and attitude, and you caught every last bit of it.

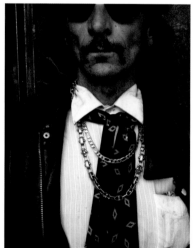

right: www.fotolog.net/*location_iceburg*/?pid=6252068
**If you would like to ask, please call Miguel.
From the US: 011-52-55-5810-2045
Within Mexico: 5-810-2045**

uvalde43 @ 2004-02-15 22:32 said:
You really bring out each subject's persona very well. I lose weight by staying away from beer, wine & cheese.

far right: www.fotolog.net/*location_iceburg*/?pid=7504164

frank_bklyn @ 2004-03-14 13:38 said:
oh no...federales!

eshepard @ 2004-03-16 01:57 said:
what did you say to him—i like your badge, how about a photo?

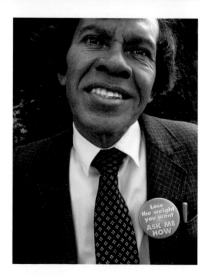

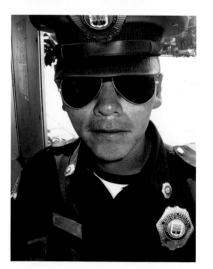

Lourdes Bradley, from the 'Lonely Giant' series.

The 'Lonely Giant' is about three expatriate Americans who live in Mexico City. All are struggling with mental illness, depression and alienation. The title of this series is taken from the title of Lourdes' animated movie script she is writing and trying to sell. The story is about a friendly Giant nobody wants around because of his size and imposing power. He sneezes and blows people down, busts sidewalks and eats everything in a village until he is finally chased away with fire and almost killed. The Giant begins an epic journey with a little bluebird who perches on his ear and whispers to him about a magic forest where maybe The Giant can find lasting acceptance and peace from cruel people.

uvalde43 @ 2004-04-19 20:04 said:
The storyline reminds me of the FRANKENSTEIN novel. Her face is full of deep feelings.

zenbomb @ 2004-04-21 03:40 said:
I'm tripped out...fully.
the story. the image. tripped.

meadows @ 2004-03-24 17:07 said:
absolutely phenomenal. both the book and the woman look like they are about to crumble.

butterbiscuit @ 2004-03-29 22:50 said:
you pen stories with light.

in clear empty bottles

mashuga @ 2003-10-15 08:22 said:
excellent portrait...little pieces of a puzzle.

some lady spilled her pancake syrup when this was taken...

colorstalker @ 2003-08-26 21:08 said:
great. no one else takes these.

mackplakt @ 2003-08-27 06:14 said:
i'm sorry if i'm wrong, but isn't this a pop-art sculpture from duane hanson???

zenbomb @ 2003-08-27 13:42 said:
ha! palpable displeasure.

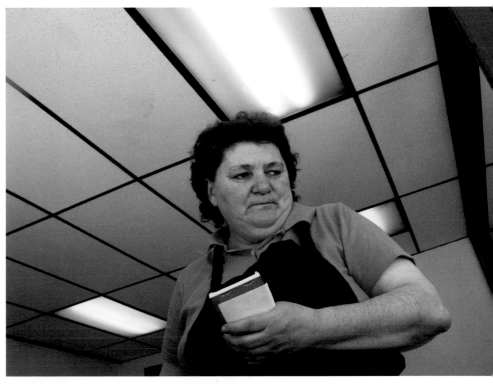

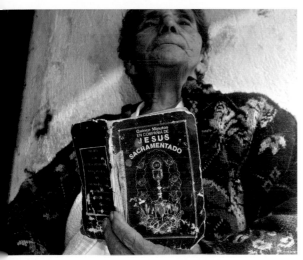

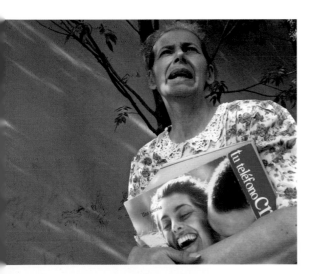

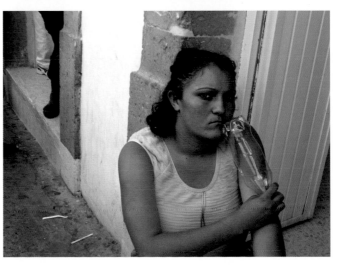

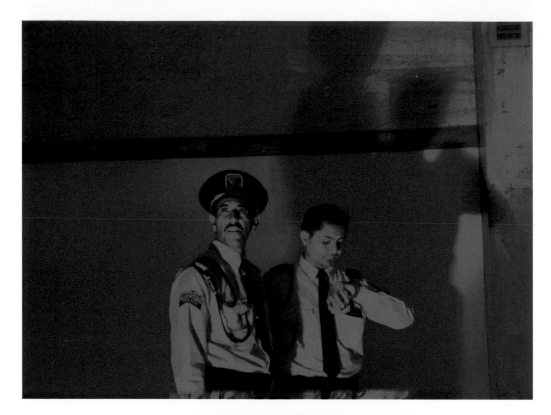

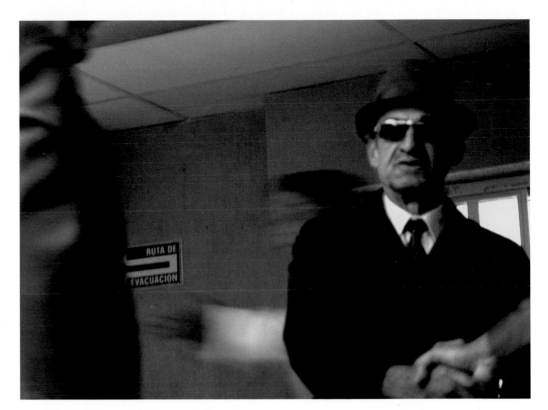

www.fotolog.net/**location_iceburg**/?pid=8093510
very important person

a_picture @ 2004-06-27 00:39 said:
men don't wear hats like that anymore

terrybrogan @ 2004-06-27 01:13 said:
careful with this guy

www.fotolog.net/**location_iceburg**/?pid=7674378
very important person

squaremeals @ 2004-04-08 09:28 said:
Great vantage point – he is set off so well
by the wonderful architectural shapes.

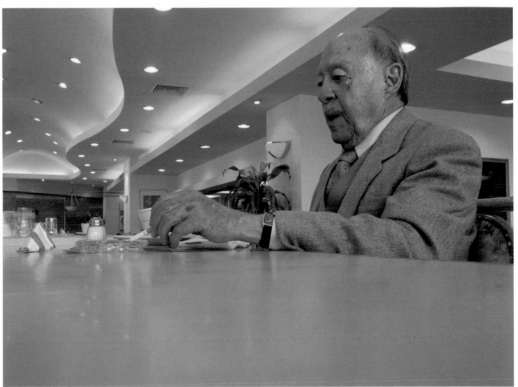

*opposite, top: www.fotolog.net/**location_iceburg**/?pid=7970404*

mr_walker @ 2004-06-05 23:15 said:
wowee. great poses to begin with, but that light!
and the shadow. sigh.
tell me this isn't staged. please.

uvalde43 @ 2004-06-05 23:37 said:
Memories of all the giant-bug '50s horror flicks.
Love this one!

*opposite, bottom: www.fotolog.net/**location_iceburg**/?pid=8378472*

colorstalker @ 2004-08-07 23:15 said:
super bad. get up & whop you.

zenbomb @ 2004-08-08 01:35 said:
he moonlights as a wrestler. damn.

amstar @ 2004-08-12 01:26 said:
i like the way the crop at the top makes me wonder
what his hands are doing.

right: www.fotolog.net/**location_iceburg**/?pid=8132416

zenbomb @ 2004-07-04 03:29 said:
the ladies call him...the silver coyote.

sharonwatt @ 2004-07-05 02:43 said:
Slick – Was there a bullet with his name on it?

far right:
www.fotolog.net/**location_iceburg**/?pid=7541240

frank_bklyn @ 2004-03-15 17:45 said:
he's like total thug and humanist rolled
into one.

pro_keds @ 2004-03-15 17:49 said:
fierce as f*ck.

connell @ 2004-03-15 19:03 said:
El Coyote! He's like urban shaman meets
Insane Clown Posse...don't you just want
to know the whole story?

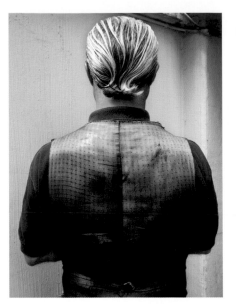

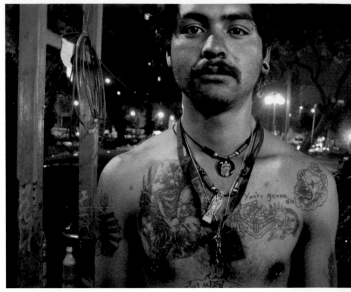

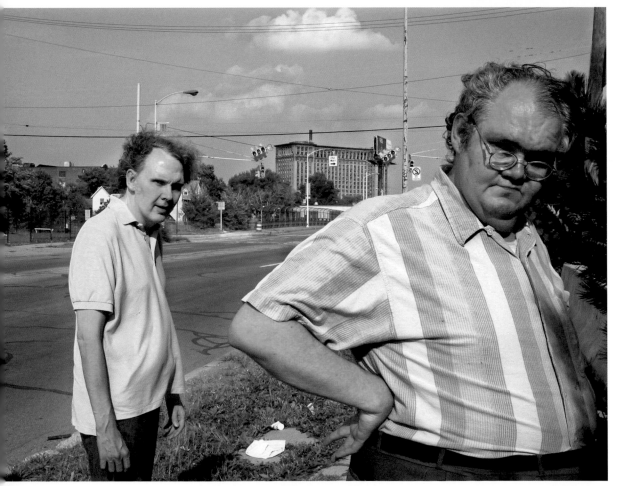

above: www.fotolog.net/**location_iceburg**/?pid=126046

wanderlust @ 2003-09-30 02:54 said:
watermelons make the best travel companions
love it!

left: www.fotolog.net/**location_iceburg**/?pid=304931
sidewalk brothers (detroit)

brainware3000 @ 2003-07-03 14:38 said:
these cats are straight out of an errol
morris documentary.

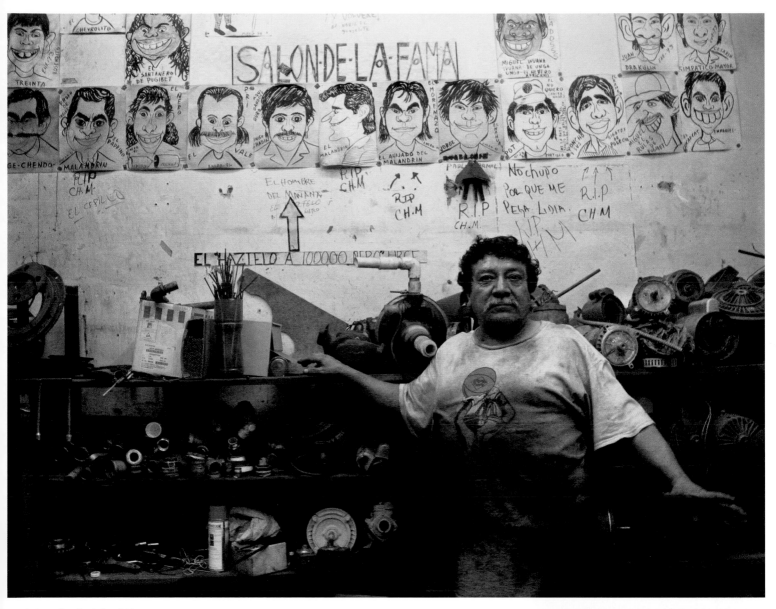

www.fotolog.net/**location_iceburg**/?pid=1002063
salon de la fama...

muta @ 2003-09-12 01:19 said:
I like the grasping hand

tangent @ 2003-09-12 01:39 said:
this is really intriguing. he looks like a car butcher —
what a character!

www.fotolog.net/**location_iceburg**/?pid=8673057

mabelle24 @ 2004-09-10 13:34 said:
eek, what happened to him?

pro_keds @ 2004-09-10 14:10 said:
'did you ever know that you're my hero?'

brainware3000 @ 2004-09-10 14:33 said:
luchadores need love too

lady feels little boy

pinksaturn @ 2004-07-07 00:54 said:
I love the heavy black outlines in this one...
especially her specs!

beebs @ 2004-07-07 01:06 said:
she's got a lil devil tapping that shoulder

a goodnight to muffin

along @ 2004-06-18 00:40 said:
in the hole.

*right: www.fotolog.net/**location_iceburg**/?pid=4518471*

angelito

anideg @ 2004-01-11 09:26 said:
angel face! so timid in his oversize clothes. cute

colorstalker @ 2004-01-11 22:33 said:
sweet smile. he's already remembering the trick in the
past tense even though he hasn't played it yet.

*below: www.fotolog.net/**location_iceburg**/?pid=588952*

nadia @ 2003-08-10 14:11 said:
is that the infamous pee dance? she has perfected it
perfectly. nice shot.

sharonwatt @ 2003-08-10 17:36 said:
I like the sexual connotations of her pose with the
official service background

mti @ 2003-08-10 20:35 said:
yeah, this shot has some twisting ambiguity
that i really love

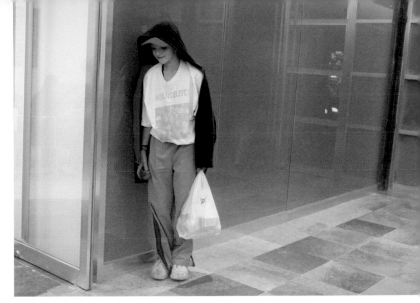

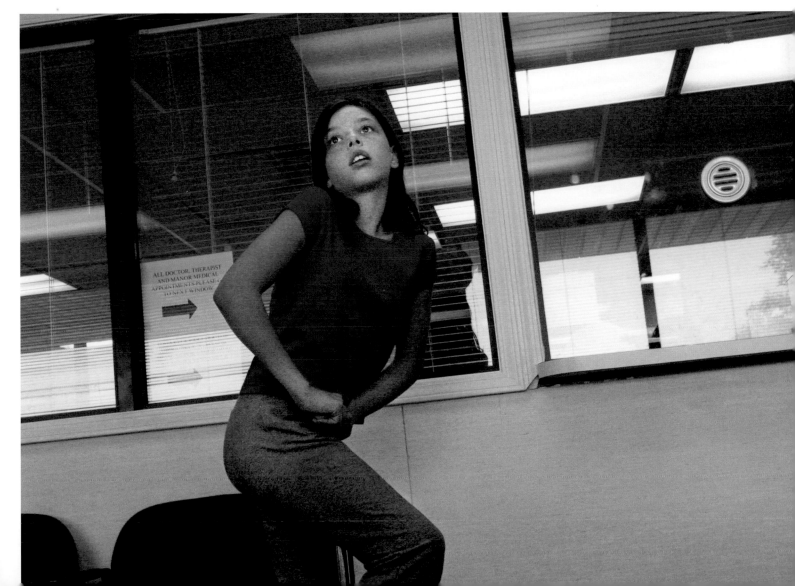

IT'S TRENDY THESE DAYS
TO USE 'FOUND' PHOTOS, I'VE NOTICED

SOME SNAPS I FOUND.

Artists and graphic designers will often find some snapshots on the street, some slides in a flea market, and incorporate the images into their work.

There's a designer in Paris who makes the sleeves for a record label who does that very effectively. He puts blurry group snaps of people in the '70s behind ugly typefaces surrounded by odd black bars and lines. Initially, you resist. But once you've seen a couple of his sleeves your irritation, your sense of a certain ungainliness turns into a recognition of 'his voice', and you begin to like it.

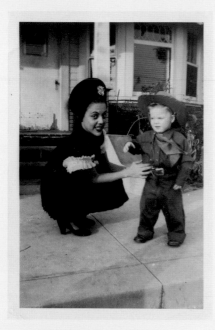

www.fotolog.net/**molly_jordan**/?pid=11752901
someone else's child

cookiedancer @ 2005-05-24 01:33 said:
This was Gary. Gary poisoned his sister. She died. We don't know what happened to him. We moved away.

anon ms b @ 2005-05-24 02:30 said:
was it an accident?

cookiedancer @ 2005-06-23 23:23 said:
Of course it was an accident...no one was watching either child...Gary and his sister, the one he poisoned.

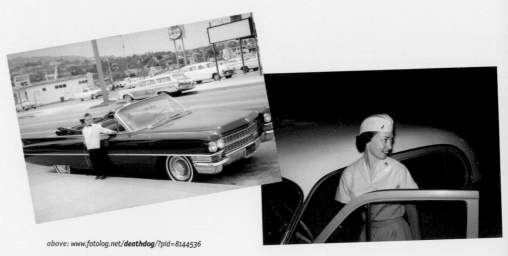

above: www.fotolog.net/**deathdog**/?pid=8144536

skip_to_my_lou @ 2004-07-23 12:10 said:
like a character from a james bond movie

youzoid @ 2004-07-23 12:59 said:
compensating for something?

geogblog @ 2004-07-23 13:20 said:
Deathpuppie in his Mr Big outfit poses beside the parental Bulgemobile.

sinistra @ 2004-07-23 13:45 said:
The young Bruce Wayne! ;)

above right: www.fotolog.net/**old_ness**/?pid=7673865

myshell @ 2004-06-19 00:13 said:
oh, i do love nurses! she looks swell.

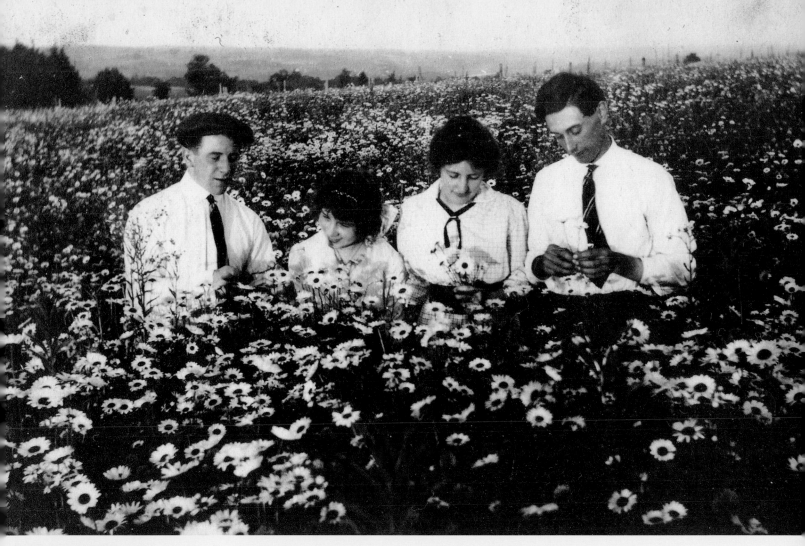

SCANNING THE PAST

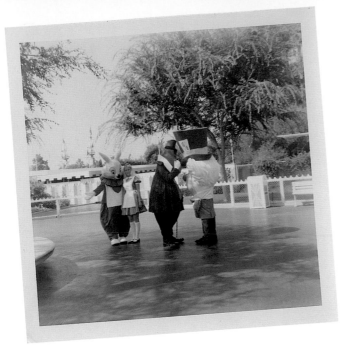

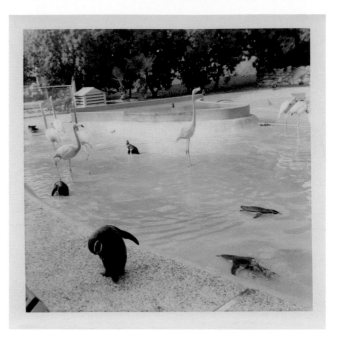

www.fotolog.net/**anonymous__**/?pid=9920303

dangerpaws @ 2005-02-24 00:01 said:
where can one get an alice in wonderland costume?
this is perfect.

anon_ms_b @ 2005-02-24 10:35 said:
grown women dressed as cartoon children...
ick

kandykorn @ 2005-02-25 11:29 said:
a superb found foto, friend

www.fotolog.net/**dbrown**/?pid=223666

lauratitian @ 2003-06-13 11:27 said: oh...oh my...oh my goodness, it's nearly
perfect. my favorite found, ever, i think...is that penguin carrying his copy of
USA Today rolled up under his non-wing? (hello, new wallpaper)

cowovermoon @ 2003-06-13 21:41 said:
don't flamingos live in Florida and penguins live in Antarctica?????

www.fotolog.net/**world_o_randi**/?pid=7670770
my love of green velour runs deep.

frank_bklyn @ 2004-06-16 10:31 said:
who's too cute?
mini-randi

brainware3000 @ 2004-06-16 10:35 said:
this is the most amazing shot i've ever seen.
it needs to be on a lunchbox

lugolounge @ 2004-06-16 10:44 said:
Randi the spider-chick

world_o_randi @ 2004-06-16 10:46 said:
if anyone knows where to attain adult-sized
underoos, please contact me.

flo_pie @ 2004-06-16 11:11 said:
wow this is the best thing i've ever seen.
i had the wonder woman underoos.

kfk @ 2004-06-16 11:15 said:
If only you were doing the splits! You are too cute!

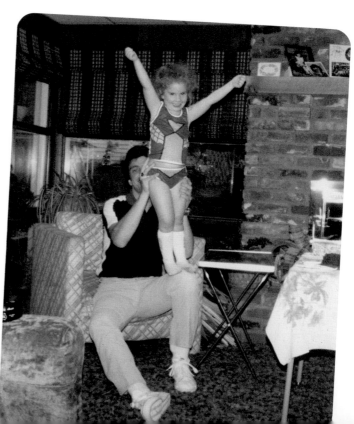

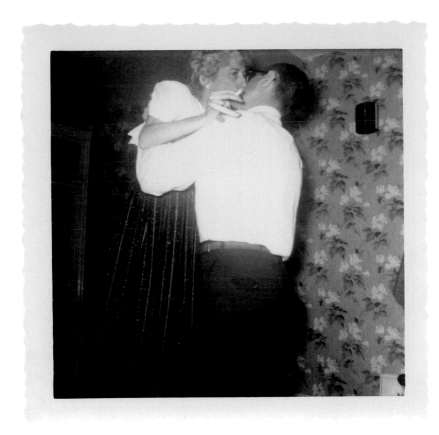

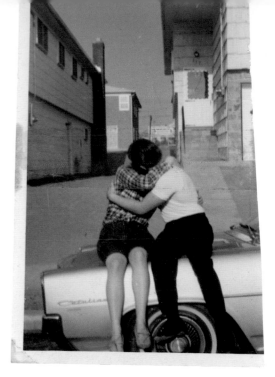

erin @ 2003-10-23 16:01 said: wonder what happened to the other half of the picture...

addadada @ 2003-10-23 16:14 said: too bad the twins aren't around nowadays for medical technology has advanced ever so far... the twins could have been separated and lived happy lives, but, alas, it was not so back then and they were condemned to a life as a circus sideshow freak...

henrygee @ 2003-10-24 12:45 said:
I can just imagine what the back seat action was like. :)

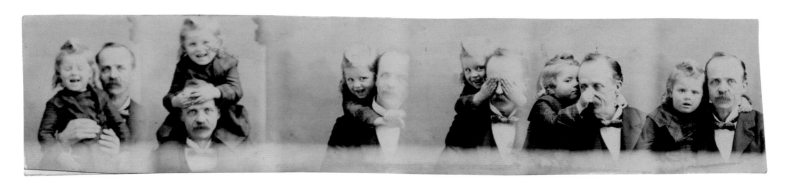

my most treasured found photo – 'about 1899'. once, while living in an urban industrial area, i woke to the screaming sirens of commercial-grade fire alarms in the warehouse next to us. before running out my door, i grabbed my cats & the cigar box this photo is kept in.

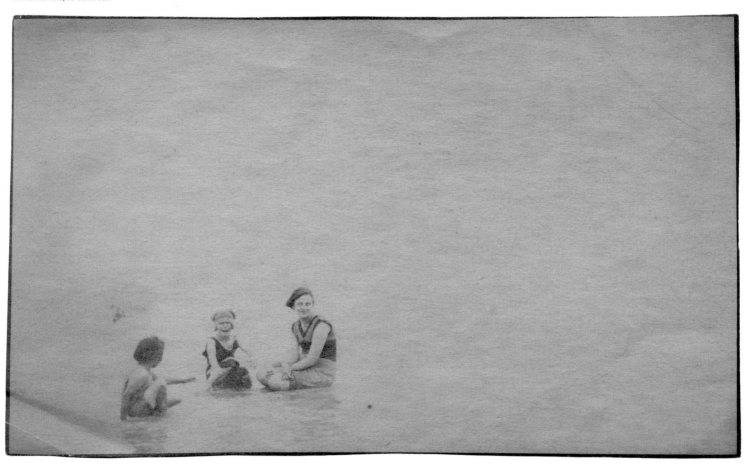

Happy Bday Little Sis!

*Thanks for letting me treat you like a doll and stuff you in a toy
carriage. Thanks for letting me ignore you when I played with my
friends while you knocked on the door pleading, 'Guys...guys...can I
come in?' Thanks for letting me embarrass you by telling over and
over again the story about you not having a lemonade stand as a
kid but rather a shark information booth. Thanks for letting me
convince you that cleaning my room was REALLY FUN. REALLY FUN.
Thanks for hanging tough with me through high school boyfriend
drama but mostly for still thinking I was cool despite having to
look at me on a daily basis with those god-awful bangs.*

Happy Bday! I love you!

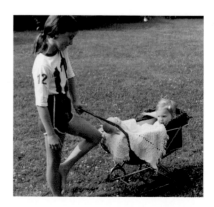

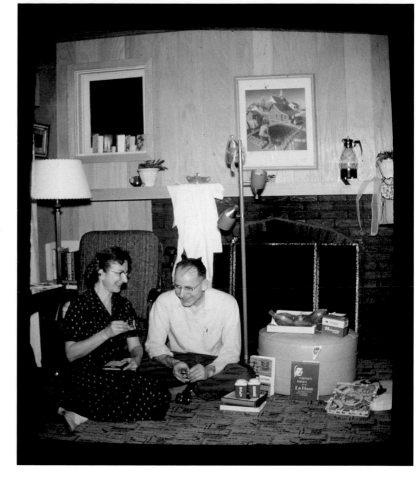

**she gave him some books in French...
he gave her salt and pepper and a
monkey-pod wood nut bowl.**

**from a stereo slide found at the
goodwill store**

geogblog @ 2004-05-19 00:13 said:
Christmas 1964 at the home of
Mr and Mrs Plywood.

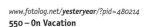

550 – On Vacation

whitebeard @ 2003-07-30 20:58 said: That looks like
Shirley, front row centre. Who else & where?

yesterday @ 2003-07-31 06:52 said: Believe it or not
that's Mom on the left and Aunt Edith on the right
of Shirley. Don't know who the person in the car is or
what year this is. It may be from Charleston Lake but
I simply don't know. I like the shoes on the guy walking
behind the car and the doll on the roof. There is a lot
more detail in this picture that doesn't show up here.
Email me if you'd like a better copy.

On Stage – This one's got me stumped...I think
the car and trailer in the background are the
same as featured in *On Vacation*.

black16 @ 2003-08-16 20:48 said:
Oh, these are all great and all the better for you
and your relatives who remember these people
and places. I've also got a box of negatives of my parents
from before the war. Now I am dreaming of digitizing
those too. I will have to quit my job just to have time
to do all the things I am dreaming about.

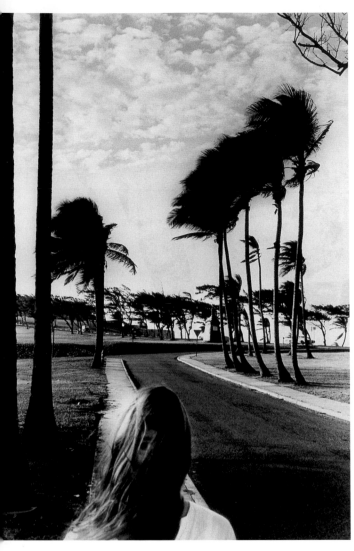

Just married and living in Old San Juan, PR. 1972

After that romantic summer in New Hampshire Yolima and Marco went to NYC where they stayed in an apartment on La Guardia Place looking south over SoHo that Marco's parents had rented for the summer. She witnessed intense generational conflicts between father and son and marital arguments between the couple. This was Yolima's first exposure to New York. Yolima felt she had entered an American sitcom, albeit a very dramatic one.

She also could not believe her eyes looking south at the World Trade Center, its windows all lit up at night against a Maxfield Parrish sky just a mile or so away.

In September they flew down to PR, where Marco had grown up as the second child of 6 children, the offspring of a pretty Irish–American lady named Betty (which was also the name of Yolima's mom) and a Jewish–American

man called K. They moved into the garage next to Marco's parents' home on Punta Las Marias, just a few steps from the beach behind a dilapidated wall where often men could be seen lurking at the women on the beach. She got seriously sunburnt; her Nordic skin wasn't used to such power and heat.

A few months later they found a lovely apartment on the Boulevard del Valle, with a patio and a balcony overlooking the ocean. Down below was 'La Perla,' a shantytown described by Oscar Lewis in his book La Vida: A Puerto Rican Family in the Culture of Poverty – San Juan and New York.

On the boulevard the wind was strong and often Yolima and Marco would take a walk on the grounds of El Moro nearby.

Marco would take his Pentax and take pictures of Yolima with her long hair blowing in the wind.

Yolima enjoyed the exotic surroundings and was thrilled to be in a place so different from her native city of The Hague.

sylvia @ 2003-05-27 03:49 said:
The picture is lovely but it's the words that make it stunning...

suzannasugar @ 2003-05-27 11:58 said:
I am overwhelmed by the beauty in this photo.

eel_03 @ 2003-05-27 13:19 said:
perfect yolima – the photo and the story leave us wanting more more more

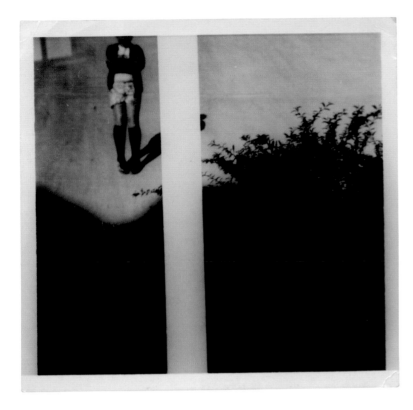

*left: www.fotolog.net/**auh**/?pid=1191174*

An old family shot. I didn't take the pic, but decided to post it because I think it's very interesting.

ribena @ 2003-10-02 20:48 said: Amazing — superb photography must be in your genes.

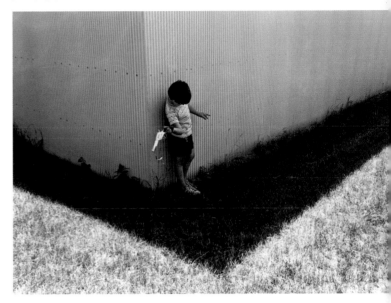

*www.fotolog.net/**colorstalker**/?pid=6999479*

The price of glory

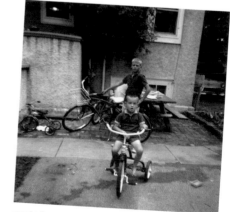

*www.fotolog.net/**old_ness**/?pid=7834354*

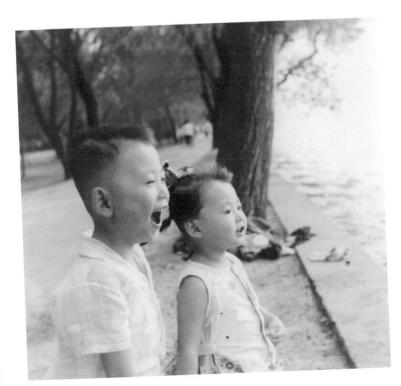

*www.fotolog.net/**airmemories**/?pid=7670378*

My brother and I looking upon the West Lake, the most beautiful lake in China. I was probably three years old and my brother, four. We were the best of playmates in the world during our childhood. There was not much I remember from those few years in Hangzhou, but I still remember what I said one day to my brother: 'Please don't die! If you die, who will marry me when I grow up?'

PUBLIC IMAGES UNLIMITED BY NICK CURRIE

'THERE ARE NO SUCH THINGS AS "JUST" IMAGES,' said Godard, 'there are just images.' But was that before or after he said that cinema was 'truth twenty-four times a second'? Did he change his mind? I suppose there's a meaning that fits both statements: images, photographic and filmed ones especially, have something irreducible about them. This makes images both less and more trustworthy than words: less because they're pinned to the literal, the circumstantial, the contingent, the trivial, and more because they make no claim to universal statements of truth. Images lack the authoritarian bluster of words; they just are what they are. And when we like them, it's because we know what we like.

I'm a word person, but I've never fully trusted words. Can words even semi-adequately describe a human face? Why do words tug me so, and try to take me to a place I can't help thinking of as dusty and conformist? Why does every thought, once it's framed in words, start to hunt for its place in Flaubert's *Dictionary of Received Ideas*? Only the best poetry escapes this staleness, and often at the price of intelligibility. That's why, if you make a blog, please make it a photoblog.

Images have become even more humble, amiable, accessible and intimate since people could start posting them casually on the Web. Since digital photography and photoblogging started getting popular in the late 1990s, you could say that photography has just become more like itself. But what about the Web? And what about me? As we move from text to image, do we become more or less like ourselves?

The Internet is going through a transitional phase, in which we're still relating to other people as text on a page, rather than as visual avatars or full three-dimensional representations. I sometimes think this has helped to distort my normal relational tendencies, in ways both good and bad. I've spent the last five years debating people on the Internet, responding to them as lines of text, abstractions and positions, and not as embodied people whom I might expect to think a certain way, based on how they look.

Now, this obviously brings up some major issues. Why does Justice wear a blindfold? Should we 'turn a blind eye' to or make allowances for someone's particularities? Should we treat everybody the same or as they individually deserve? Should we judge before we speak or after we hear the response? Should we judge a book by the cover, or a cover by the book? In a world where we talk to people based more on texture, feeling and emotion than on logic and argument, has talking become passé? What if first impressions, visual impressions, are mostly right? What if one of life's big lessons turns out to be 'trust your instincts, first impressions and emotions instead of trying to suspend judgment and come to some reasonable, reasoned assessment'? Malcolm 'Tipping Point' Gladwell's book, *Blink: The Power of Thinking Without Thinking*, argues exactly that.

Blink! Click! Nobody debates a photograph – it's a given. You can't disagree with it; you can only accept or reject it, get something from it, then move on. Perhaps that 'something' is a whiff of utter strangeness. This is not, after all, another string of familiar words – it's a particular moment you've never seen before. You can't immediately categorize it and file it away.

Two completely different languages run alongside each other: the rational–symbolic and the visual–associative. The first is a reason-based language of universals, where we think we all share the same terms and can defend our positions as we would in a game of chess. The second is an emotional language of specifics, of images and textures and the feelings they evoke. The Internet has so far favoured the first, but as bandwidth grows, it will increasingly privilege the second. That's why, if you have a word blog now, you might very soon have something more like a photoblog.

Word culture is left-brain culture; it's lawyers and politicians, not artists and dancers. The Web began as a word-net in hypertext, and not much has changed. Text can be searched, and the Internet – 'the index of all indexes' – is all about searching. Even images are searched for according to the text strings attached to them. Words and sentences

seem always to aspire to become part of the giant cumulative glob of human knowledge, whereas images aspire to...what, exactly?

Well, images could be ingredients in an enormous soup of human experience. Here's what you need to make a big bowl: one Internet, one camera (preferably digital), one website and one computer. Mentally, you'll probably need a combination of an exhibitionistic streak and a Puritan–Protestant 'diary-making and accountancy' mindset like the one Max Weber discusses in *The Protestant Ethic and the Spirit of Capitalism*. Or you may be a post-Protestant trying to escape your word-bound culture and fly towards the aesthetic and the sensual. You may be an avid collector keen to document all the Oskar Niemeyer buildings you can find, or the stereotypical Japanese tourist clicking the shutter to prove that you were there. You may want to show off your talent, or convince yourself, by convincing the world, that you have a life. You may be an artist, a designer or an amateur. In the great tureen of digital *pho*, those categories are all blurred anyway.

When you first encounter the photographs of professionals like Andreas Gursky or Doug Aitken, your initial reaction is, 'What's the fuss, what's this work about?' You resist, declare yourself mystified by and oblivious to the hype. Then you see some theme, and how it relates to something important in the world. Finally you realize, Gursky's photographs are that unphotographable thing, apparently literal images of the processes of globalization, while Aitken's are — well, you haven't yet put a name to what they're about, which is interesting in itself. This is how artists break us in, chip away at our resistance and create appetites for new types of ugliness that then become the new standard of what's beautiful. If you're not prepared to go with them, you're left behind with exhausted formulas of beauty.

It's the same with photobloggers. You get to know them. They train your eye. Dutchman Jip de Kort (www.kwark.org) likes coloured plastic, art galleries, fire extinguishers and trains. The plastic bottles in his bathroom are arranged according to colour, like a Tony Cragg installation. Jip clearly lives to photograph. He does it with an eclectic, sensual

abandon, and as a result I feel like, first, an initiate and, later, an intimate in his world. I understand his love of plastic, his affection for the future, his gentleness, and the harmonious, hedonistic pacifism of his life. Oh, the words are so much uglier than the images—'hedonistic pacifism', indeed! The photos train me to see as Jip sees, to recognize his holy holies, his habits, his fetishes, his wounds.

An important function of Jip's photoblog is to document his 'nieuw haar'. Look, that blond cut is the fourth radically different way he's had it this year! Mere language is unfit for the stern task of specifying hairstyles, especially Jip's. What do I call his knotted, braided toplock style? The 'hairnoodle'? The 'ring tin tin'? Or simply 'the Jip'? Could it work on my head? Why do I identify so readily with his quest for an interesting 'hair identity'? Why do I so implicitly trust his hair-restlessness?

Perhaps because, as Oscar Wilde said, 'It is only shallow people who do not judge by appearances.' History has borne out Wilde's judgment, to an extent. I mean, does anybody now say, 'Oh yeah, the Elephant Man, really lovely bloke, told a good joke, played a sharp game of chess...'?

FAMILIES: A WAY OF GROUPING THE BIG PEOPLE WITH THE LITTLE PEOPLE

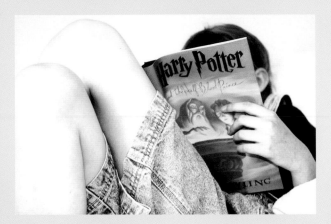

mr_walker @ 2005-07-20 05:18 said:
i was thinking of your photos from the
release of the last book, when i bought
my copy on the weekend. almost finished
down here. i think poor j.k. is starting
to suffer writer's fatigue.

ricosphotoz @ 2005-07-20 09:51 said:
lost in hogwartsland

WAIT, IS THIS YOUR LITTLE BROTHER OR IS THIS BATMAN? Your sister's like a miniature version of you! Happy birthday, was everybody there? I wish I could have made it. The baby sleeping in the grass, time must pass at a different speed for him. The cat ate the flower, I swear! We were drinking champagne out on the veranda. Your toddler is paddling in a Richard Serra installation! What is it about children, the cellphone camera just loves them! Don't forget where you came from, how long did it take you to get here? All that confetti would've gone to waste if you hadn't snapped it. Do you want to eat the leftovers? Gran, you don't look a day over seventy-eight in this one…I'm kidding! I like the pot of red soup, the black-and-white dress hanging between the mirrors. Who'd have thought sisters could have such different hairstyles! Is it time to go home already? But I'm home already! Families: they're a way of grouping the big people with the little people. And the old secretly have the same faces as the young.

bon appétit!

chanel @ 2004-01-07 18:59 said:
Oohhhh my god!!
Hhhhowww cute is that!!!??
:) I love it.

petitepoupee7 @ 2004-01-07 23:09 said:
Mmmmmmmmmmmmmm…
How delicious! ;)

angelissima @ 2004-01-08 00:19 said:
Hi KIDS!! Were you standing on the
table for this shot, Virginie?!

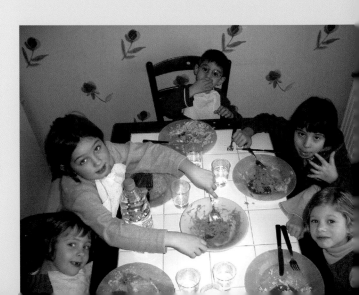

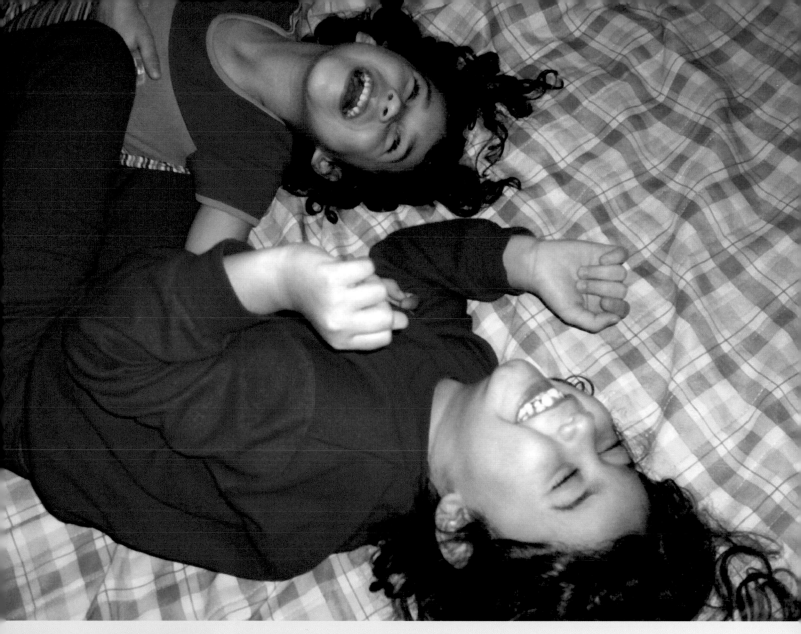

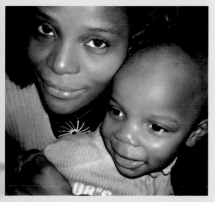

above: www.fotolog.net/mothern/?pid=8273812
girls just wanna have fun. foto do leo.

rosapomar @ 2004-07-06 09:28 said:
they just wanna
they just wannaaaa
oh girls just wanna have fun :)
(lindas!)

left: www.fotolog.net/cameron_1964/?pid=7759301
Moji and Bobo

WE ARE FAMILY

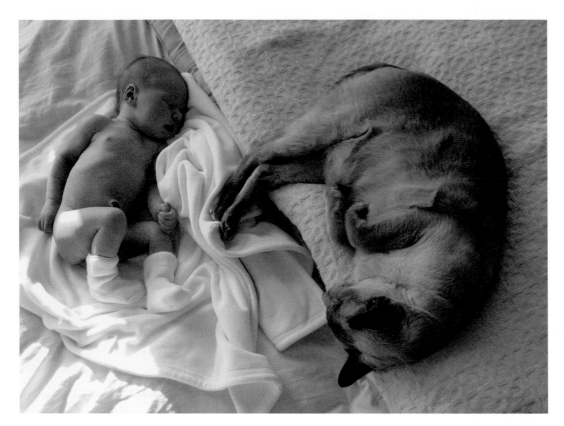

*left: www.fotolog.net/**jkh_22**/?pid=1008519*
...as lauratitian said, 'aren't you glad you didn't give birth to Pippen?!!'
uh, yeaaah...for numerous reasons!!

epmd @ 2003-09-12 15:04 said:
so cute. it's amazing to see the size differential.

setya @ 2003-09-12 15:04 said:
the socks, oh the socks, how sweet!!

aaannnaaa @ 2003-09-12 15:58 said:
Wow...you've got a huge cat...she's lovely as always...they're so cute together...aren't you afraid that the cat decides to play with her?

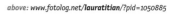

*above: www.fotolog.net/**lauratitian**/?pid=1050885*

eel_03 @ 2003-09-15 13:27 said:
tallulah's fingers are so fantastically long and perfect...

jandolin @ 2003-09-16 23:58 said:
These are great pictures...and tiny fingers

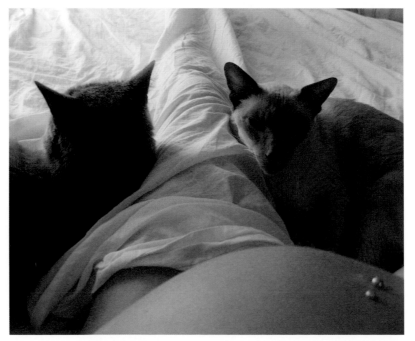

*www.fotolog.net/**jkh_22**/?pid=562923*
is there room for one more?
(5 weeks and counting...)

fgcwjh @ 2003-08-08 03:27 said:
Is there room for two more?

50mm @ 2003-04-20 12:57 *said:*
good lord! brilliance. do you do this
every day? shoot the world on polaroid?

koray @ 2003-04-20 21:17 *said:*
aliens bringing this child back to earth,
nice catch! :)

This solid five accent is a little bit scary!!!!!

jkh_22 @ 2003-12-03 18:27 *said:*
i think this is when you told her there
wasn't pumpkin pie in france.

fgcwjh @ 2003-12-03 18:38 *said:*
I think this is when YOU told her you love
(and eat) pumpkin pie so much.

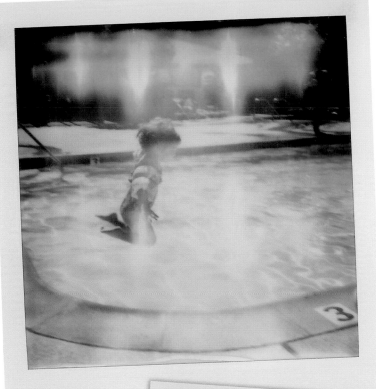

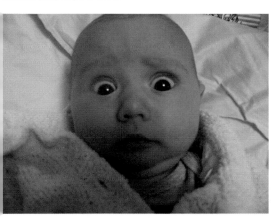

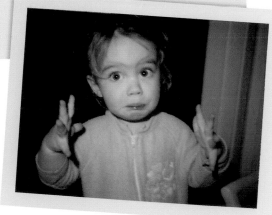

cypher @ 2003-03-17 17:53 *said:*
'You would not believe what's
in my Huggies...'

michale @ 2004-10-09 13:55 *said:*
gimme gimme.
really lovely shot.

ribena @ 2004-10-09 17:39 *said:*
this one's my favorite—the cake's so
huuuuuuge and yumyumyummy.
baby-perspective.

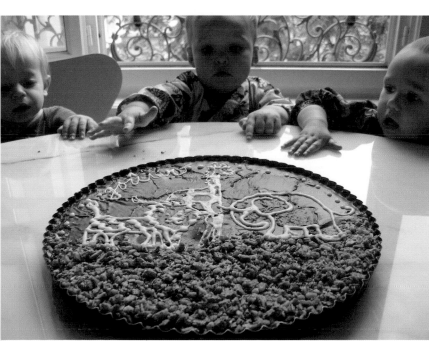

right: www.fotolog.net/**zenbomb**/?pid=7414493

Aunt Tanya @ 2004-03-12 07:07 said:
Birds of a feather! Two of a kind!
Great seeing ya'll! love!!

frenzy @ 2004-03-12 11:17 said:
the cheeks almost melt together. very sweet.

oldlace @ 2004-03-14 02:43 said:
yup. i'm a lucky girl.

right, centre: www.fotolog.net/**zenbomb**/?pid=7628465

anomalous @ 2004-04-29 12:33 said:
superb. very gentle

laurenpink @ 2004-05-02 15:03 said:
it's probably not so easy
to have a grumpo morning
when you've got such a precious
little face peeping back at you
heart-fluttery sweet

right, bottom: www.fotolog.net/**zenbomb**/?pid=7068322

goon @ 2004-03-02 01:47 said:
bizarre on many levels, one of the strangest
images i've come across here. excellent!

beatle @ 2004-03-02 18:40 said:
Three hands? This one is gonna play the piano
like nobody else does!

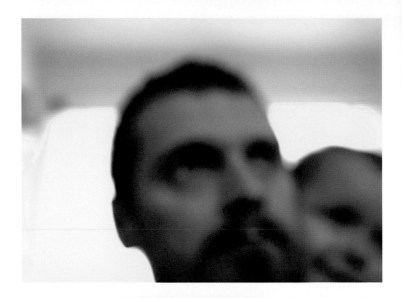

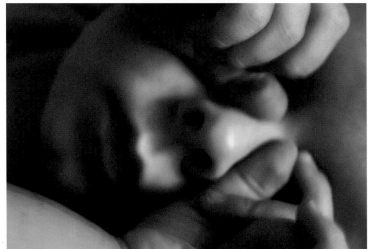

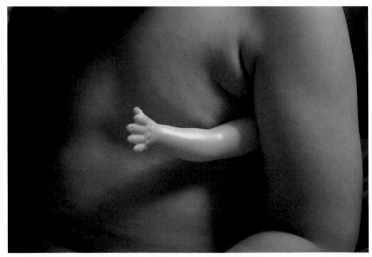

www.fotolog.net/**replace**/?pid=9955028

meshel @ 2005-07-08 17:06 said:
fruity petals temper tantrum

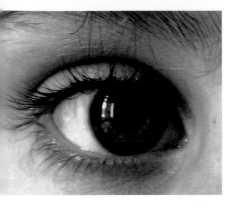

*left: www.fotolog.net/**virginie**/?pid=2273388*

Léonie's eye.

Is it too audacious or too pornographic? This is a question for all the fanatics: 'right thinking', mad and crazy people who want to re-educate the poor and calamitous mother that I am! I'm so furious and disappointed, because of some of the comments on my earlier pictures...

galamander @ 2003-11-13 18:29 said: Maybe those people with the critical comments are 'right' – maybe there ARE pedophiles looking at and downloading pictures of your daughters (and all of our cute children), but it's almost too complicated an issue to deal with like this...At least they will have some beautiful and artistic photos to look at! I don't think you are endangering or violating your children – I think you are celebrating them and sharing your point of view of two adorable, lovely daughters –

it's a joy and an inspiration to 'check in' with you and I hope you won't start censoring yourself more than necessary after yesterday's guestbook comments.

unter_geiern @ 2003-11-14 03:12 said: You should become upset, but also think about it. Your response makes it even worse in my opinion. The problem is not the pictures. The pictures are great, beautiful & completely innocent in a private context. But this is public & it is not the publisher who defines how the pictures are/can be viewed. I'm neither prudish nor hysteric, but my professional background teaches me to be sensitive. Just a few weeks ago disabled residents of the institution I work for were forced to do obscene things in front of a movie camera & filmed. That's the real world...

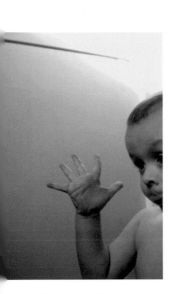

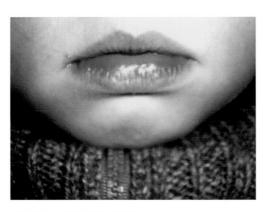

*www.fotolog.net/**virginie**/?pid=2678335*

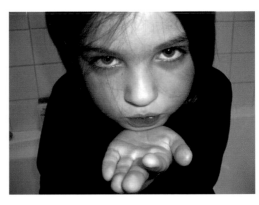

*www.fotolog.net/**virginie**/?pid=2303224*

Uncle Mayo, Zoé and Léonie send you a kiss for your birthday!

*www.fotolog.net/**replace**/?pid=9205523*

He's grown an inch in the past month!

zenbomb @ 2005-03-02 07:19 said: my little godzilla.

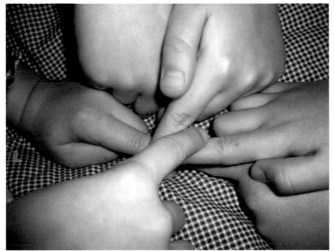

*www.fotolog.net/**virginie**/?pid=2950631*

tamino @ 2003-12-02 18:04 said: they're making a pact.

sharonwatt @ 2003-12-02 21:20 said: sweet pudginess

lauratitian @ 2003-12-03 00:00 said: all for one and one for all!

oooh_caro @ 2003-12-03 03:19 said: these small fingers are so cute!!!!

gagah's archive

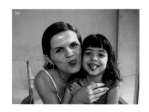

05/17/04

06/05/04

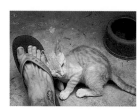

04/27/04

06/05/04

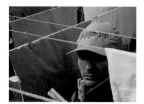

06/12/04

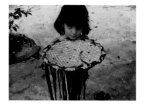

06/15/04

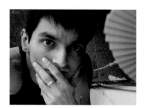

06/18/04

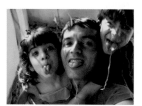

06/13/04

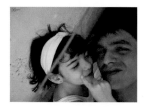

06/15/04

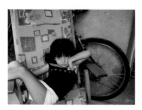

06/17/04

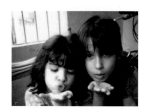

07/08/04

06/19/04

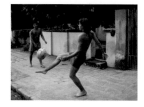

06/27/04

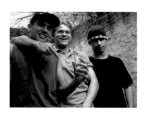

06/26/04

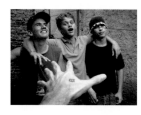

06/26/04

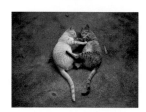

07/02/04

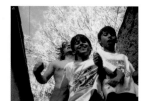

06/29/04

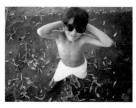

07/09/04

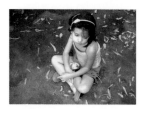

07/10/04

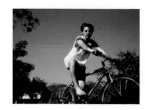

07/23/04

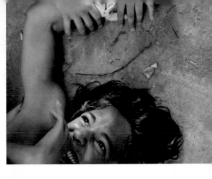

www.fotolog.net/**gagah**/?pid=7862714

lucyfloripasc @ 2004-06-24 09:08 said:
was he playing on his own?? 'cause each one of them has a different look on their faces... ;)

pekenah_ @ 2004-06-24 09:11 said:
owww when i was little (oops...i'm still little) re-start: when I was a child I used to love games with balls ;***

ahrlohimma @ 2004-06-24 09:15 said:
is it a filter that you use???? the colours are amazing!

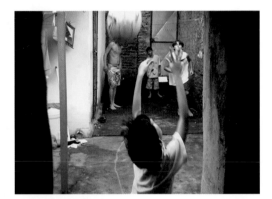

www.*fotolog.net*/**gagah**/?pid=9207836

jay33jay @ 2005-03-10 21:06 said:
There you are! Broke your doll... :(

hudlu @ 2005-03-10 21:27 said:
I like the pic, the blur contributed to her expression. A hug!

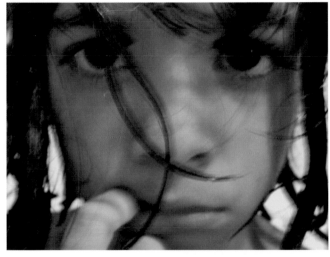

above:
www.fotolog.net/**gagah**/?pid=8460065
sunday doesn't deserve its name

jay33jay @ 2004-10-31 10:16 said:
It's always a joy to get here and keep looking at your photos. I learn with you! Nice weekend

pano_pra_manga @ 2004-11-01 01:07 said:
Wow it looked like the Sistine Chapel painting from the thumbnail... Are they torturing him with tickles?

lulalula @ 2004-11-01 04:00 said:
the colours and the light are sooo angelic. beautiful one gagah. beauteeee.

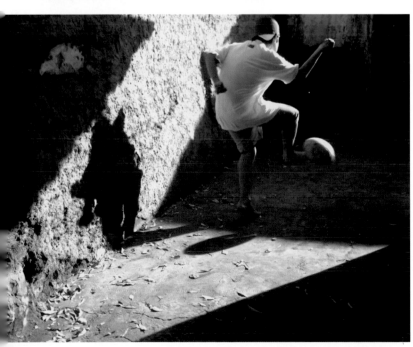

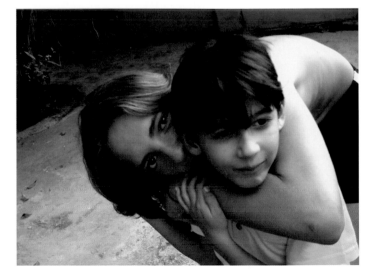

above: www.fotolog.net/**gagah**/?pid=7868030

meninaemo @ 2004-06-25 18:04 said:
I am absolutely CRAZY for your pics. Lucas and Gabriel look like two little angels! :p

cobrinha @ 2004-06-25 19:05 said:
Lucas is strangling Biel. Or could it be just a hug? haha :}

left: www.fotolog.net/**gagah**/?pid=7924396

michale @ 2004-07-12 17:11 said:
the dance

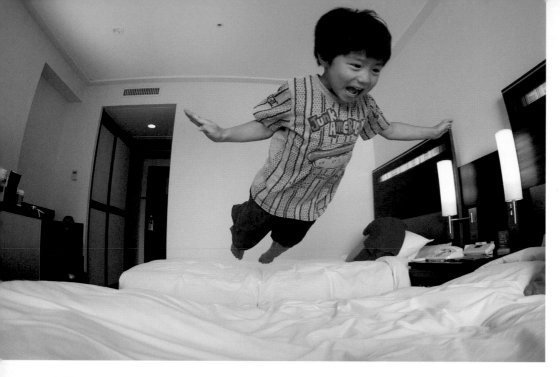

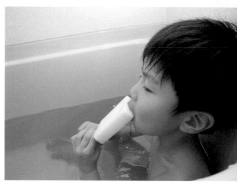

he loves having an ice candy while taking a hot bath.

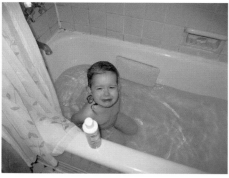

WAIT! Before you think me some kind of cruel mom who takes a photo instead of soothing her crying child, please know, as I'm sure most of you do, that besides the fact that babies and 2-year-olds cry an awful lot, sometimes they don't actually want your help or comfort, especially when they are two, and are stubborn, and really are just tired, because they woke up extra early at Grandma's and then got tired out by lots of playing and being spoiled with shoe shopping, ending in a sushi dinner out where she said, 'I want to go home.'

SO, ALTHOUGH she seemed to break into tears because Daddy washed her hair when she really didn't want that, she was really just tired and needed to be in bed. So when she refused to get out of the bath and be held or helped, I thought, well, I'll take a photo, 'cause really shouldn't there be some of this in the album, instead of just smiles?

Of course, I wasn't totally in my right photographic mind and the mommy-side of me must have interfered, because otherwise I would have moved that bottle of conditioner.

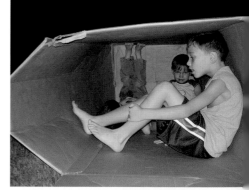

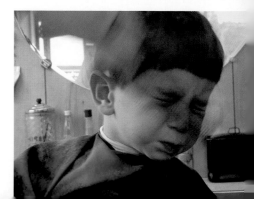

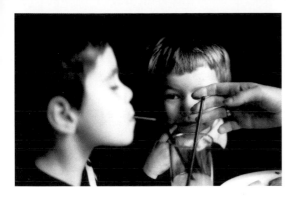

yesplease @ 2004-08-26 17:18 said:
we'll have another round of shirley
temples, please

carlos_noboro @ 2004-07-26 08:47 said:
this is your best shot yet!!!

bigmuff @ 2004-07-26 09:18 said:
this is super! so light!

sizeofguam @ 2004-07-26 10:11 said:
stripes on stripes. this rules!

ruby

suzannasugar @ 2004-03-24 13:25 said:
this is gorgeous!
We have ballet class tonight...

left: www.fotolog.net/**roeqie**/?pid=8057311

colorstalker @ 2004-08-07 18:52 said:
funny. like that game where you fold
a sheet of paper into threes &
everybody draws a part.

below: www.fotolog.net/**styleeliciousz**/?pid=10380846
my mom & my sis! foodloversssss

nannna @ 2005-05-17 11:16 said:
nice, u have a really nice family...
they all look very friendly...
where is your mama from?...
i'm always so curious, right?...
how ws ur weekend?...
can't help it, hihi ;)
kisses...

below: www.fotolog.net/**frisjes**/?pid=8257792
my sweet sweet sisters

aaannnaaa @ 2004-09-09 06:57 said:
you have so much fun together... ;)

tathy7m @ 2004-09-09 16:10 said:
'X'
Smile!
Click!

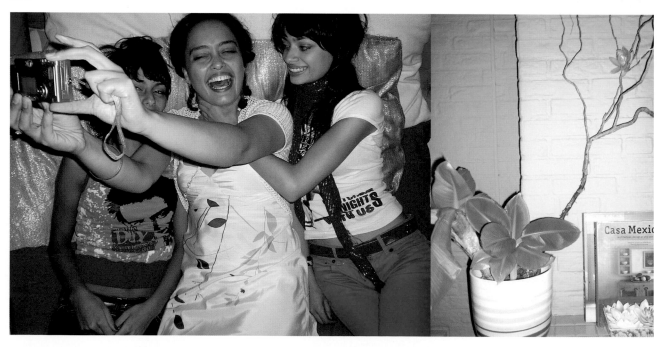

don't take a photo, mom!

beckbecky @ 2005-07-22 10:43 said:
a box boat! how fun to be a kid and
to have plenty of cardboard.

atomic flower

sk8rsherman @ 2003-04-17 16:01 said: cute

sharonwatt @ 2003-04-17 20:53 said: a beauty!

beeker @ 2003-04-18 08:04 said: swell shot.
a cotton candy mask? ;)

yolima @ 2005-03-29 12:34 said:
Back on the asphalt with her Snoopy
Dog cart, very purposeful!

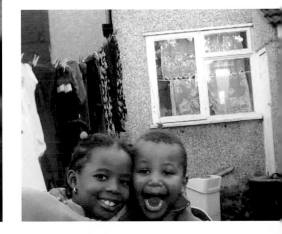

mr_walker @ 2003-07-05 23:48 said:
Aaahahahaha!
I wish there had been a Fotolog
when I was your age, none of my
friends would have been safe!

ljsky @ 2003-07-06 02:05 said:
Great shot speedy.
I wish I could get my son (10 years
old) interested in photography!

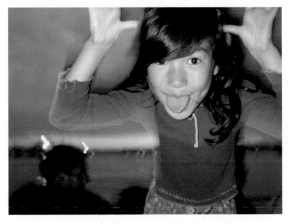

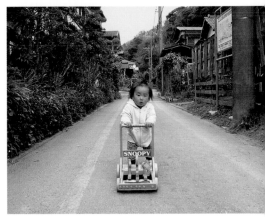

the parent becomes the child

gato_zeca @ 2005-01-24 14:18 said:
delicious chocorange cake!
congrats to her :**

stringbeanjean @ 2005-01-24 16:37 said:
bloody brilliant.
you know, this is actually bringing tears
to my eyes. that hardly ever happens.
it's so sweet and soft and she's gorgeous
and so are you.
oh you made me go all *funny*

placeinsun @ 2005-01-25 00:36 said:
i find this genuinely touching
i know exactly what you mean by the
caption and the photograph says so much
cue bee gees :-)

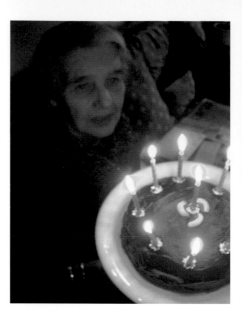

pavan soni @ 2003-02-03 11:02 said:
the pic is really touching...it reminds
me of my grandmom and my sisters...
i miss them all....

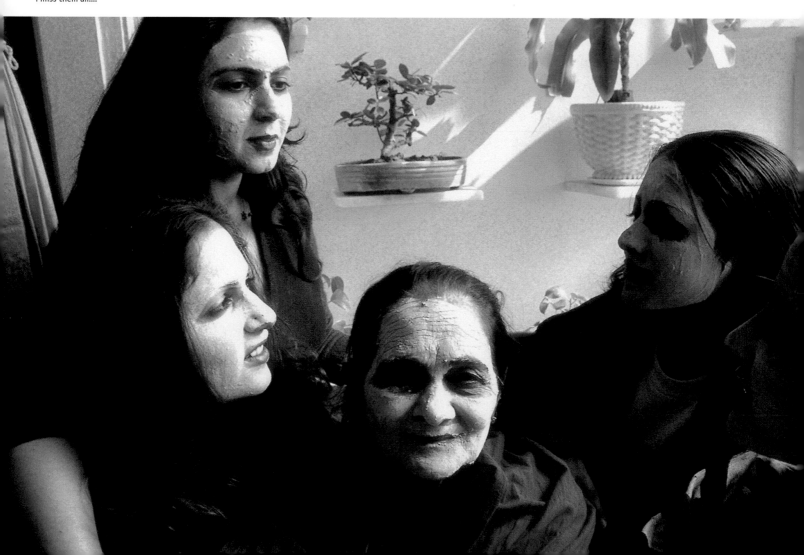

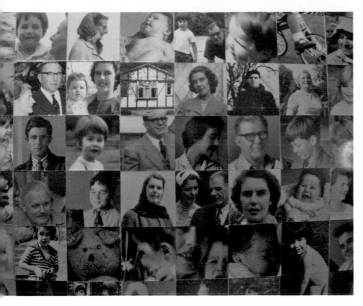

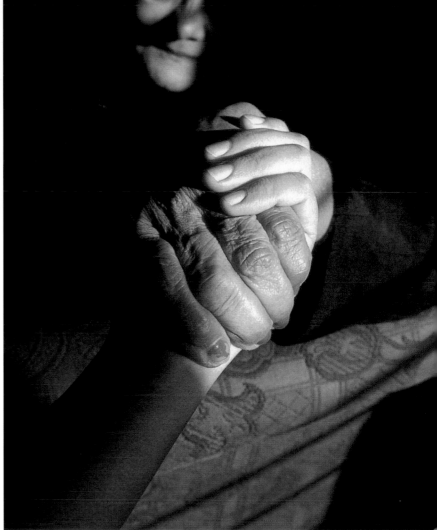

*above: www.fotolog.net/**virgorama**/?pid=8253403*
**how quickly the days pass
my mother is 79 tomorrow.
she can hardly believe it.
the birthday request was The Bee
Gees' Number 1 singles. I'm just about to
make a chocolate orange cake**

colorstalker @ 2005-01-22 12:06 said:
faster & faster. best to your mom.

gardengal @ 2005-01-22 12:12 said:
your mom is totally hip.
choc orange is a fave combo!

batut @ 2005-01-22 18:40 said:
if we concentrate, we can slow them down.
love this collage

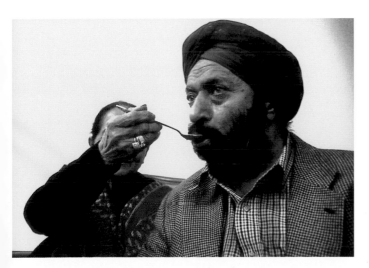

www.fotolog.net/**machlee**/?pid=4564609

machlee @ 2004-01-12 00:30 said: ;) that's my
grandparents...grandma sits next to me as i write
in: 'i like the pic, but why is my hand covering my
face?...my face should've been visible...at least a
bit...it would have been a better pic...'

thtstudios @ 2004-01-12 20:52 said: I kind of like
the mystery of the hand covering the face. you can
tell a lot by someone's hand. this shot is divine. I
am sure you can please your grandma by posting
a special portrait of her.

www.fotolog.net/**machlee**/?pid=4178023
grandma 'n...me

butterbiscuit @ 2004-04-13 10:25 said:
this is way too beautiful and intimate
for me to ruin with some trite remark
about the lighting or expression.
so i'll desist.

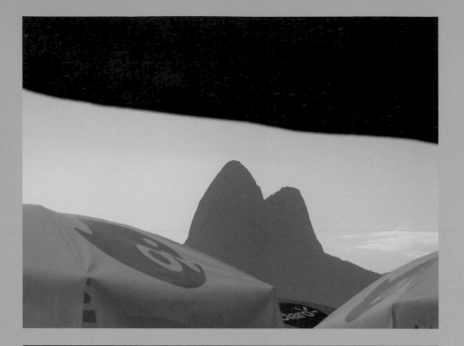

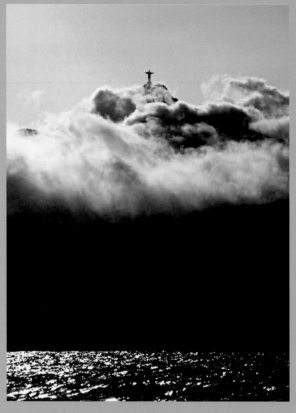

I'LL COME TO VISIT YOU
BY CABLE CAR

YOU SPEAK PORTUGUESE, DIONYSUS. I snooped you talking to a Barbie on Farme de Amoedo. It was you, Dionysus, grapes spilling from your hair, talking to a tight-butt hot bod, one ear open for the whistle that signals the beach patrol, ready to hide your stash! And wasn't that you beating your drum at the Sambodrome? Shake a feather, Dionysus, as you sweep by in drag, throwing shade!

Didn't I glimpse you in a trolley car one night, trundling up a hill in Santa Teresa? You clutched a sprig of ivy, and the Maenads sat nearby. You left Mount Nyssa, didn't you, Dionysus? Now you live on top of Sugarloaf Mountain. I'll come to visit you by cable car.

www.fotolog.net/meltoledo/?pid=1688811

mlpsaraiva @ 2003-10-21 20:58 said: Wow this is beautiful...your photo has brought last century's romanticism back to Santa Teresa!!! :)

top left: www.fotolog.net/gato_zeca/?pid=8825548
oi, claro!
:D

above: www.fotolog.net/jimsk/?pid=9330670

jvc @ 2005-04-11 23:36 said:
ahhhhhhh
what's this??
No way. It's not real! There isn't such a beauty!!!
It's Rio, though, isn't it? Hmmm...and with Jim behind the lens...yeah...it might be real.

aragarcas @ 2005-04-12 12:12 said:
Wow, Jim, what's this?
Besides your eye and your sensitivity, you must have had some 'divine' help!!!
Big kiss.

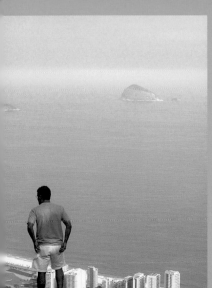

the trunk voyeur

g_s @ 2005-07-30 15:54 said:
Nice...trunk.

– Hey, come back here with my wallet!!!!
– If you want it back, empty, catch it on that
island...hahaha
– Son of a bitch!!! He stole my wallet and
flew away on a hang glider...

kath @ 2005-03-14 12:23 said:
for a short period of time, really short,
I believed the story...
hehehehehe
beautiful pic! :)

RIO DE JANEIRO

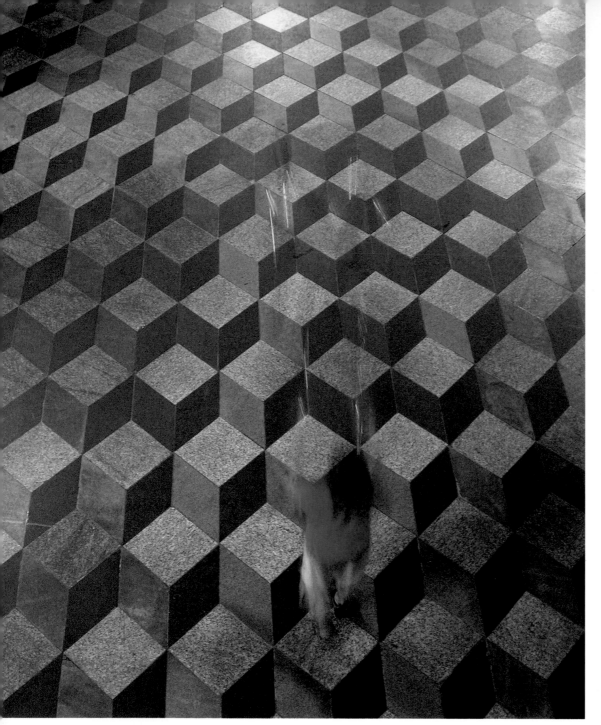

dasarteseafins @ 2005-04-12 16:04 said:
Wow JC! What a fantastic photo! And Escher deserves
it! Do u know what I like the most about your work?
The importance you give to the simplicity of moments
before you.
I love it. :*

deiaebia @ 2005-02-28 14:59 said:
The eye that sees all.

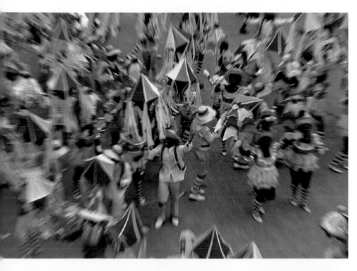

www.fotolog.net/**ze_lobato**/?pid=7828163

pmmc @ 2005-02-04 21:10 said:
Beautiful, wonderful, I feel like diving into it!

neloqua @ 2005-02-04 21:17 said:
Pure emotion, in motion!
Nice Carnival!
kisses

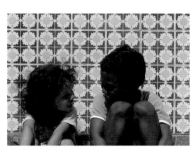

www.fotolog.net/**aeaflores**/?pid=10346284

pickle @ 2005-04-08 08:44 said:
friendship and sunshine.

*below: www.fotolog.net/**nelson369**/?pid=3862224*
**The Eye of the Streets wishes
you all a Merry Xmas**

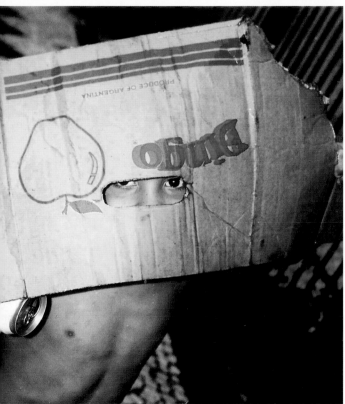

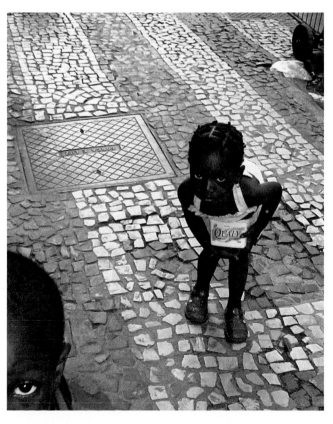

right: www.fotolog.net/**jucafii**/?pid=8905990

cunucks @ 2005-01-31 14:39 said:
Fantastic series! And for an 'expat' like me,
it really makes me homesick...! kisses

www.fotolog.net/**aeaflores**/?pid=9956018
Yellow chairs and red wood through our glass tile.

cariocando @ 2005-02-28 08:36 said:
Totally Miró, huh? Beautiful!

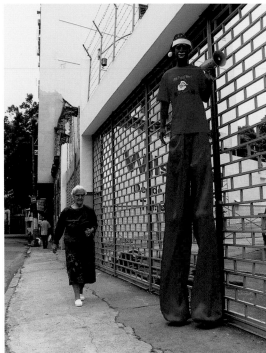

above right: www.fotolog.net/**dasarteseafins**/?pid=9288298

digitart @ 2004-12-20 15:54 said:
I cannot figure out if he will get down the chimney
easier this way...or not??

www.fotolog.net/**angar**/?pid=9553661
**Afroreggae
Video Clip**

circopicolino @ 2005-01-16 14:51 said:
Congrats on your Afroreggae work.
Very good...they also have a Circus School
with artists from the Cirque du Soleil,
just like we do.

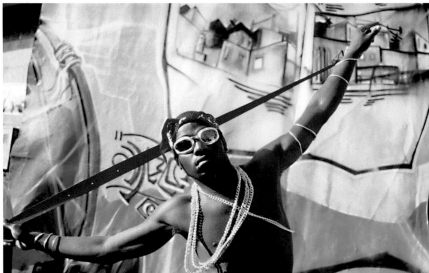

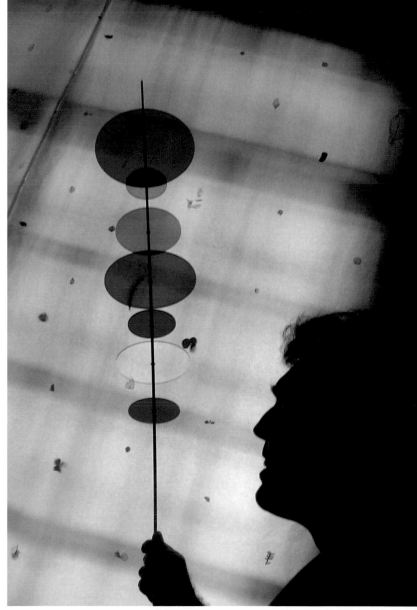

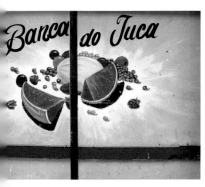

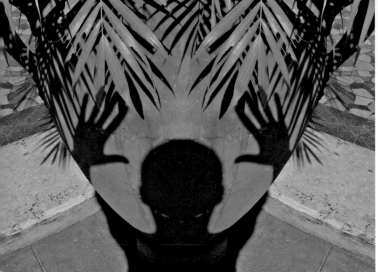

www.fotolog.net/*gato_xeca*/?pid=10485707

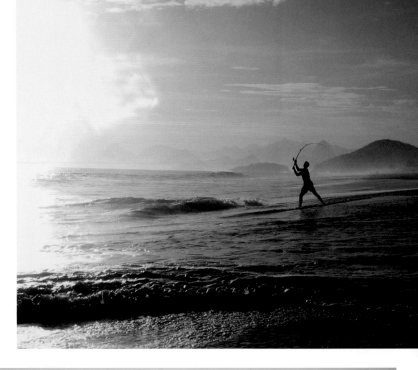

*right: www.fotolog.net/**rhpecanha**/?pid=10298326*

bruxama @ 2005-08-31 19:01 said:
Illustrated Poetry.
hugs

*right: www.fotolog.net/**nelson369**/?pid=9129342*
Botafogo Beach
Tuesday of Carnival, early in the morning.
Very early.

advogadissima @ 2005-02-08 16:53 said:
WOW!!!
One of the most beautiful pics I've ever seen of Rio!!!
:D
(look, taking good pictures of Rio is easy...
but you surpassed my expectations!)

Jason @ 2005-02-08 22:36 said:
A new way of photographing an obvious landscape!
And the second pigeon from the left reminds me of an
Egyptian figure...(never mind: I'm still drunk
from the last day of Carnival)

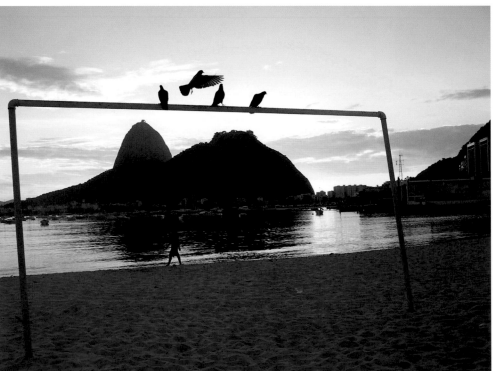

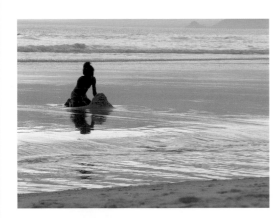

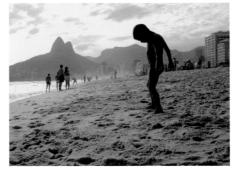

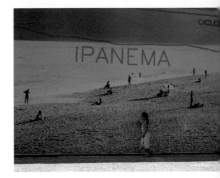

*above: www.fotolog/**interludio**/?pid=4591173*

fft. @ 2004-01-12 20:45 said:
Perfect, perfect! I've been following /interlúdio
since you were just a weblog. Fantastic.

*left: www.fotolog.net/**jcfilizola**/?pid=8797899*

vbenedetti @ 2005-01-12 06:17 said:
'playing in the fields of the Lord'...
It looks like the whole scene is in the sky!

*www.fotolog.net/**jcfilizola**/?pid=10284743*

acravo98 @ 2005-09-14 03:41 said:
a girl walking
with hope in the background
could it be the girl from Ipanema,
the eternal one?
Hugs from the waves

*above: www.fotolog.net/**rodperez**/?pid=8349322*

lucyo @ 2004-10-02 07:19 said:
i love the muscle man behind her!
this series is awesome.

*below: www.fotolog.net/**rodperez**/?pid=8380821*

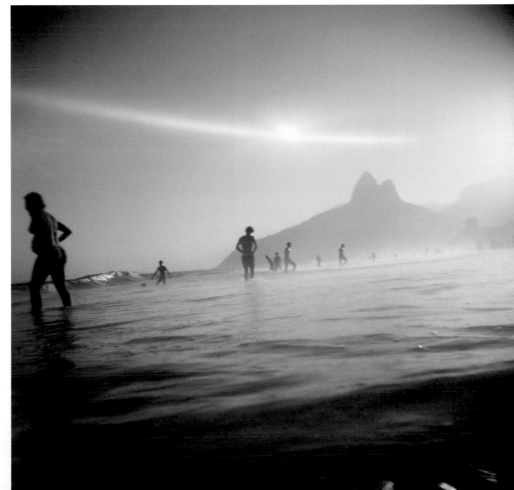

shake. Instead of making the medium as neutral and transparent as possible, both amateur and art photographers play around with the inherent qualities of film, lenses and light, transforming flaws and failures into pleasures, coaxing innovations out of errors. You could try telling the purist what happened when Picasso met a sceptic on a train. The man asked why the artist couldn't make his paintings more realistic. Picasso looked puzzled. 'But what would a realistic portrait look like?' he asked. The man produced a photograph of his wife. Picasso peered at it intently, then said, 'Is your wife really so small and flat?'

above: www.fotolog.net/dansemacabre/?pid=8665318
need a new wardrobe.

surimi @ 2004-10-06 12:36 said:
i need another too. kisses!

fotofogy @ 2004-10-06 12:42 said:
Great! Polaroid is my first love!

nadia @ 2004-10-06 18:05 said:
beyond sexy

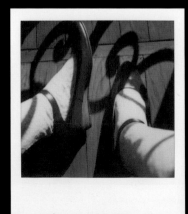

www.fotolog.net/dansemacabre/?pid=9720972
hello hello spring.

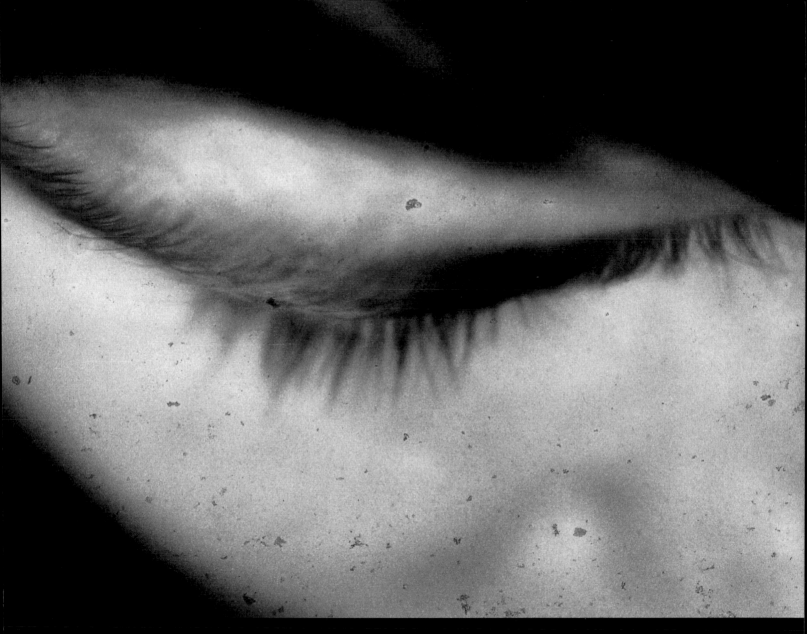

WORLDS ON FILM

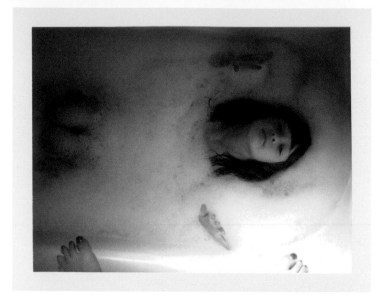

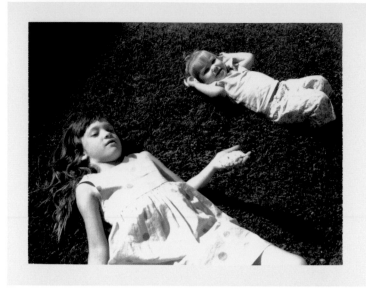

*top: www.fotolog.net/**suzannasugar**/?pid=7099193*

squaremeals @ 2004-03-02 13:03 said:
Her head and hands, your feet – nice.

juliyap @ 2004-03-02 21:23 said:
I love this!! Especially because I'm imagining
you balancing on the edge of the bathtub to
get the photo.

*above: www.fotolog.net/**polaroids_only**/?pid=7679270*
*from www.fotolog.net/**a_picture***

*top: www.fotolog.net/**suzannasugar**/?pid=7680153*
Madi and Lula on Easter Sunday

dontbecruel @ 2004-04-13 12:48 said:
look how the planet is bending under them,
two starchildren sitting on top of the earth

nadia @ 2004-04-14 10:50 said:
those names, this picture! i hope i take great
shots of my kids.

*above: www.fotolog.net/**polaroids_only**/?pid=7721417*
*from www.fotolog.net/**a_picture***

polaroid_billy @ 2004-04-24 01:32 said:
excellent

vampireblood @ 2004-04-24 13:27 said:
So haunting I love it!

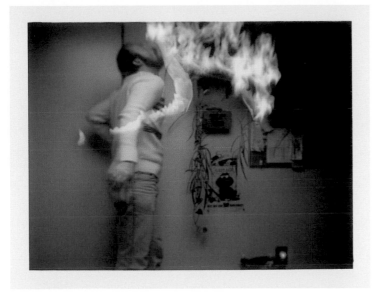

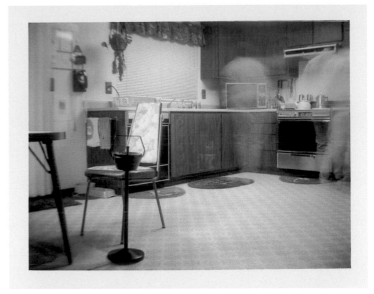

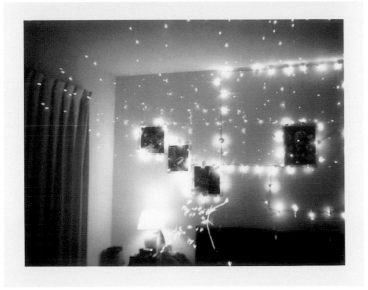

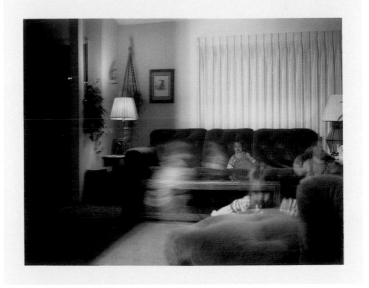

sk8rsherman @ 2003-02-13 19:40 said:
didn't mom teach you when you were young?
'no fireballs in the house kids,' is what mine
would always yell! this is crazy!

greddick @ 2003-02-13 20:03 said:
great color. the nightlight is a nice touch...
you have fire insurance on your house, right?

dogseat @ 2003-02-23 11:20 said:
man, what is going on in your house?!

llujan @ 2004-10-12 01:40 said:
I see dead people.

automatik @ 2004-10-12 14:26 said:
this is quite old stuff. are you still doing this?

staciemerrill @ 2003-02-21 11:25 said:
that is great

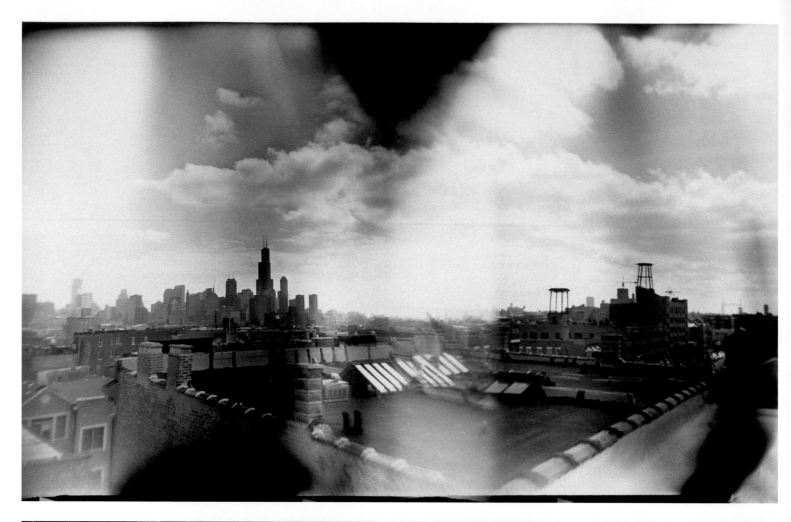

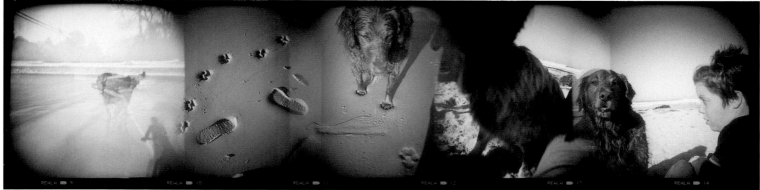

top: *www.fotolog.net/kalloosh/?pid=3604591*

View from my old apartment rooftop on Erie Street, Chicago (Holga)

hazelmotes @ 2003-12-18 22:34 said: Those Holgas turn the whole world into a vintage hallucination...! Thank you for your visit, and I have enjoyed visiting your log...lots of inspiration...me and the Holga have just met, still trying to figure it out, but hope to have more soon. Thanks again...

above: *www.fotolog.net/jonesgunn/?pid=48446*

masouth @ 2003-03-28 16:11 said: wow, this is bizarre... is this one long neg?

greddick @ 2003-03-28 16:35 said: excellent! love the rising and falling rhythm.

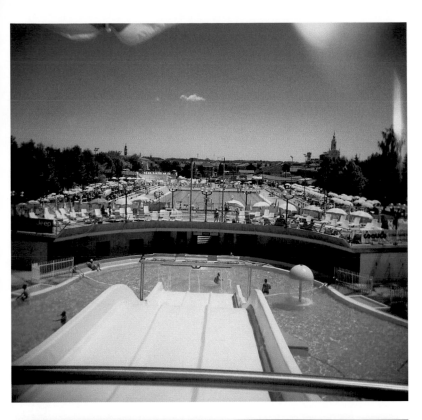

*left: www.fotolog.net/**brillo**/?pid=388295***
Cristian works at a local pool.

*below: www.fotolog.net/**puckles**/?pid=474538***
ahhhh...pooooooool paaaaaaarty... :)

ligfietser @ 2003-07-29 19:24 said:
Nice pool, but what part of the body do I see
on the right?

puckles @ 2003-07-29 22:23 said:
ligfietser: Random kid's elbow and toe. The joy of
the holga is: if you look through the view finder,
you won't get what you want, so I just hold it up
in front of my face :)

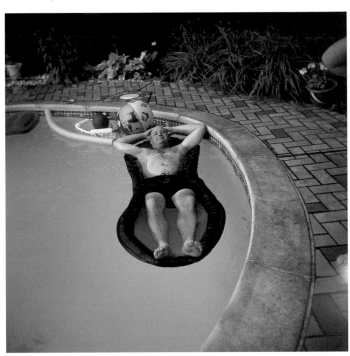

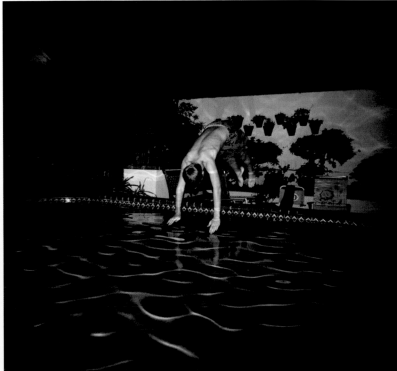

*left: www.fotolog.net/**courtneyutt**/?pid=23412***
more holga — swimming at night in my gran's pool

staciemerrill @ 2003-02-06 08:55 said:
Wow, this looks like it should be in the Holga-how-
to-shoot-an-awesome-shot-book. Really beautiful.

bunnyrivera @ 2003-02-06 13:14 said:
Disgustingly gorgeous. Makes me want to destroy
my camera.

johnnyraygun @ 2003-02-06 14:05 said:
Viva la holga!!! Brilliant use of Chinese technology.

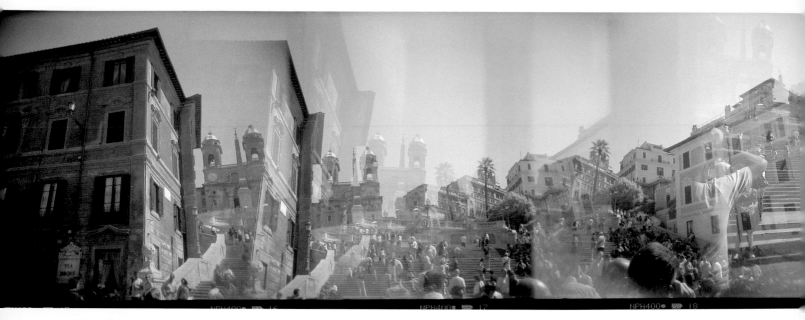

www.fotolog.net/**luluvision**/?pid=1257952

The Spanish Steps, Rome. Holga style.

im_a_nerd @ 2003-10-01 10:13 said:
this is so awesome. you can just see tons and
tons of picture-takers! great stuff girl!

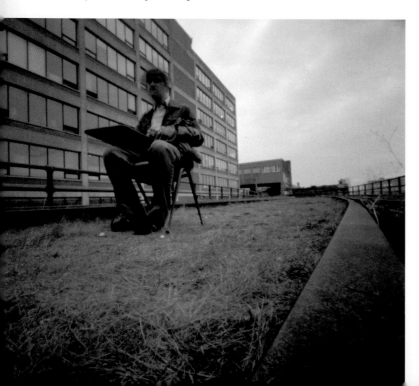

www.fotolog.net/**hominy**/?pid=7652643

squaremeals @ 2004-05-02 11:08 said:
A surreal world.

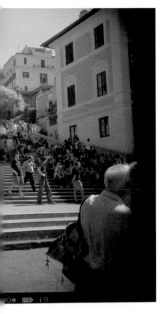

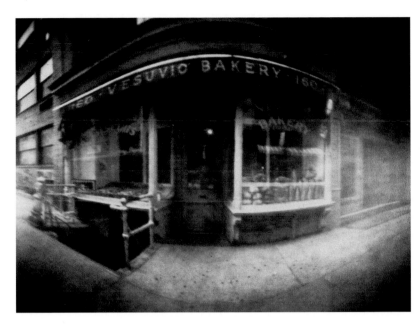

*www.fotolog.net/**mbayard**/?pid=375773*
pinhole photo done with film canister (paper neg.)

acosta @ 2003-07-15 19:34 said:
great!! I love pinhole pics! welcome to Fotolog ;-)

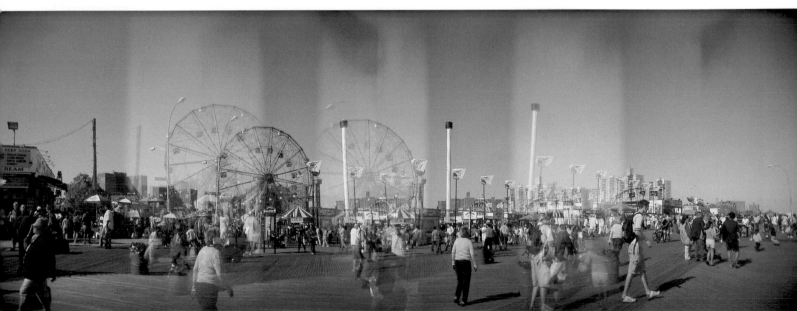

*www.fotolog.net/**luluvision**/?pid=7988671*

rinascita @ 2004-06-09 21:01 said:
I love that you turned the viewing tower into a parade of
red-tipped matches...excellent job!

www.fotolog.net/*eau*/?pid=7828102
It's what's revealed when what's hiding hides.

youzoid @ 2004-07-23 17:03 said:
like a strange supernatural optical illusion

stringbeanjean @ 2004-07-23 17:38 said:
great apparition apparatus

greeny @ 2004-07-23 17:59 said:
Run!...Don't walk!...from...LAMP THING!

opposite, clockwise from top left:

www.fotolog.net/*jinx*/?pid=71375

www.fotolog.net/*jinx*/?pid=121788

www.fotolog.net/*jinx*/?pid=222502

www.fotolog.net/*jinx*/?pid=134225

below centre and right:
www.fotolog.net/*brillo*/?pid=8933256
**Don't get us wrong,
Mickey Mouse made us do it...**

isthisyou @ 2004-11-03 16:41 said:
please...take the sweets...take them all...!

youngna @ 2004-11-29 22:31 said:
double the fun.

below:
www.fotolog.net/*dansemacabre*/?pid=8992695

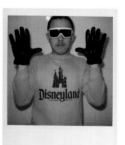

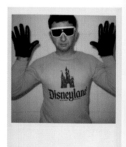

left: www.fotolog.net/*mattpaper*/?pid=1080552

lightpainter @ 2003-08-23 08:00 said: nicely wacky

buster @ 2003-08-23 14:20 said:
not quite radiohead, but close enough.

stringbeanjean @ 2003-08-23 19:35 said:
ohhh...bravissimo. genius...I'm having an 'I wish
I'd thought of that' moment. I love it.

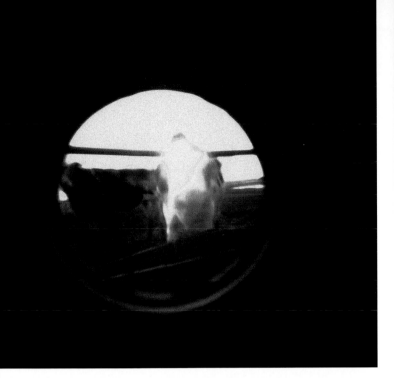
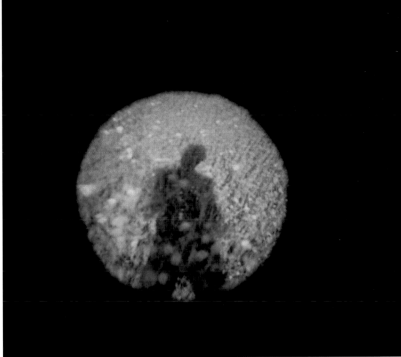
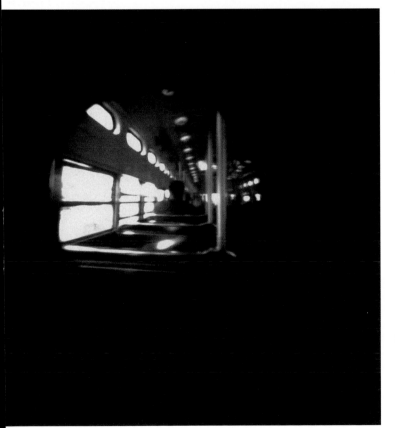
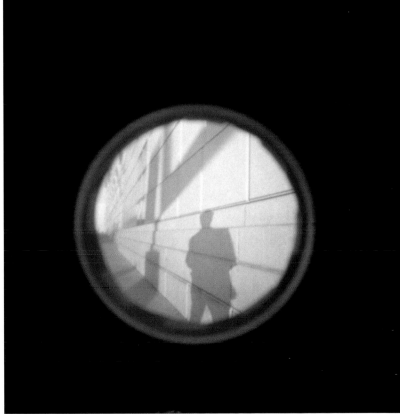

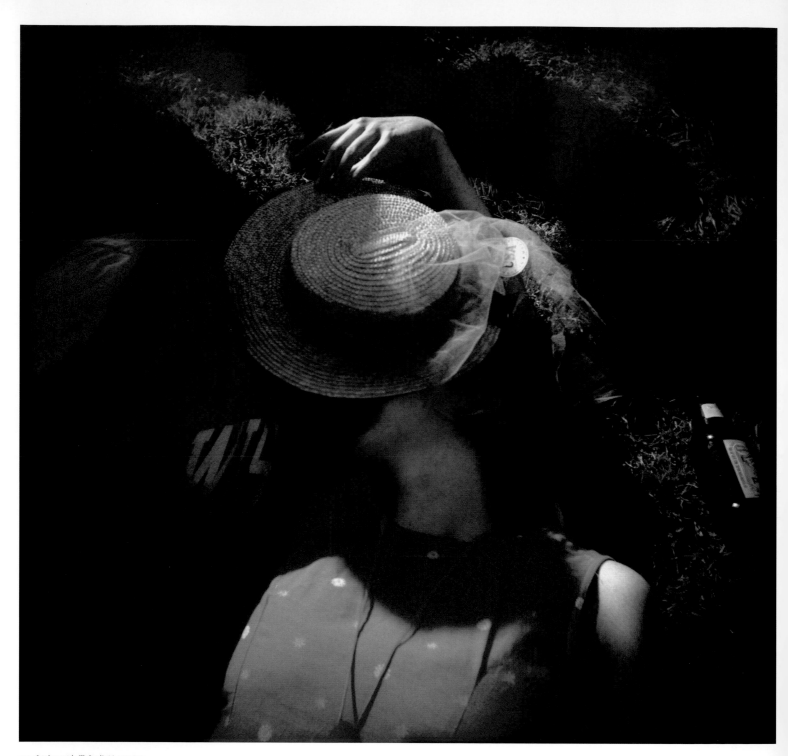

*www.fotolog.net/**willsfca**/?pid=3917624*
i'm digging up some of my favorite portraits from
the past. these are my friends lucy and art. i think this
was just before they got engaged. i love the empty beer
bottle next to their heads.

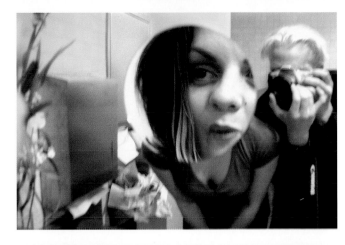

women's bathroom

machlee @ 2003-02-25 09:03 said:
this is awesome sherman. 'women's toilet'??
like in the old paintings...

d76 @ 2003-02-25 10:55 said:
Larger than life face, plants on the left, cleavage,
and the photographer working his photo voodoo
right in the frame. Excellent work. Plus everything
looks better in black and white.

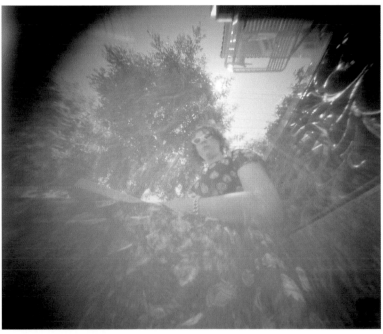

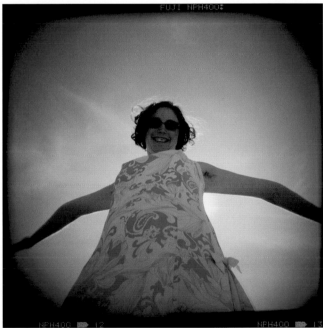

above: www.fotolog.net/**courtneyutt**/?pid=345720
me hangin' out at 12th and folsom on my lunch break

kingclovis @ 2003-07-10 15:27 said:
u got a small head Utt.

pashe @ 2003-07-10 17:20 said:
Nothing like a pinhole break. I like the look.

above right: www.fotolog.net/**willsfca**/?pid=2499131

meshel @ 2004-02-23 02:01 said:
great! just happiness galore!

www.fotolog.net/**machlee**/?pid=249687
**icanseewhaticanthearicantouchnotseemuch
to Rupam – my sis**

sk8rsherman @ 2003-06-21 00:58 said:
you are SO good at photography!!! just amazing!!

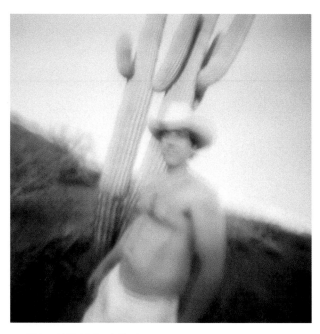

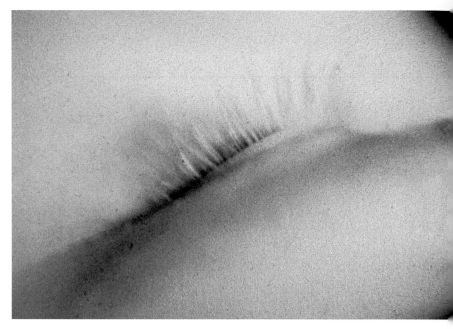

So fellow photobloggers...
I have a brilliant idea!!!!!!!
This morning when I was scanning this image,
I was thinking, 'Hmmm...What kind of caption will
I put with this image?' Obviously, I'm gonna write
photokitchen is the hottest photoblogger I know!
Look at him posing by this cactus!!!!!

AND then it hit me...I have met tons of good-looking
Fotolog men. We should auction them off and raise
money for Fotolog! So what do you guys think???

ANY BOYS WANNA BE BOUGHT?!?!?!?!?!?!?
IT WOULD BE SOOO MUCH FUN!!!!!!!!!!!!!

Oh, and this is the start of my vacation
to Arizona and Missouri...

suzannasugar @ 2003-09-08 15:53 said:
breathtaking...

squaremeals @ 2003-09-08 16:15 said:
So soft and gentle – the graininess is nice.

batut @ 2003-09-08 16:43 said:
luna lid landscape! very sensual...

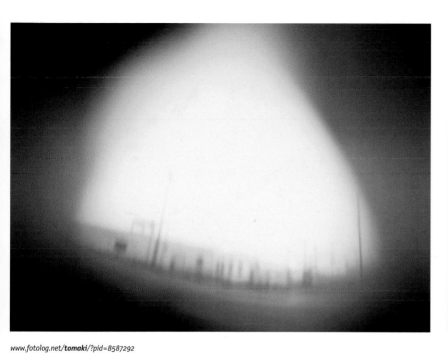

www.fotolog.net/*tomaki*/?pid=8587292
Film case pinhole camera.

abeltrana @ 2004-10-12 21:09 said:
Um UFO!!!

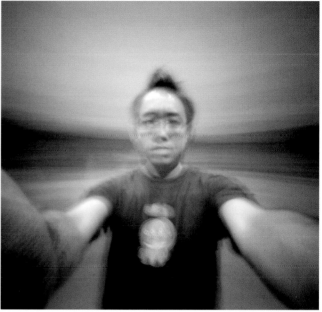

www.fotolog.net/*willsfca*/?pid=7620135
**I don't normally like to do self-portraits,
but I had an idea for this shot, so I had to
try it. People kinda looked at me funny.
But sometimes you just gotta go 'WHEEEEEEEE'!**

neuskool @ 2004-04-04 03:38 said:
i like the light -> dark in the background and
the wide angle. very graphic.

rachelweeks @ 2004-04-04 13:15 said:
this made me smile big!

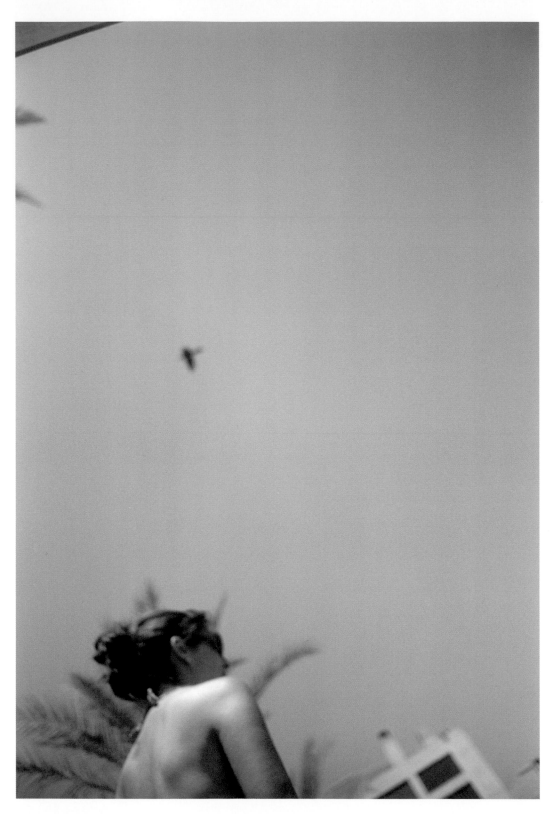

www.fotolog.net/**juliyap**/?pid=7978540
**Unidentified Flying Object.
Palm Springs Pool**

youzoid @ 2004-07-28 11:21 said:
lovely lovely framing

an_ge_la @ 2004-07-29 01:56 said:
has a lovely nuance like a Tina Modotti photo

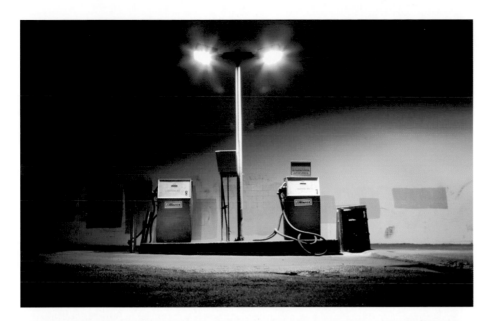

hoyumpavision @ 2003-04-28 20:54 said:
COOL colors...pretty colors...and so vacant.

plaintiger @ 2003-04-29 00:56 said:
wait — you mean this is a real, life-size gas station?! I thought it was a little tiny toy setup! absolutely amazing.

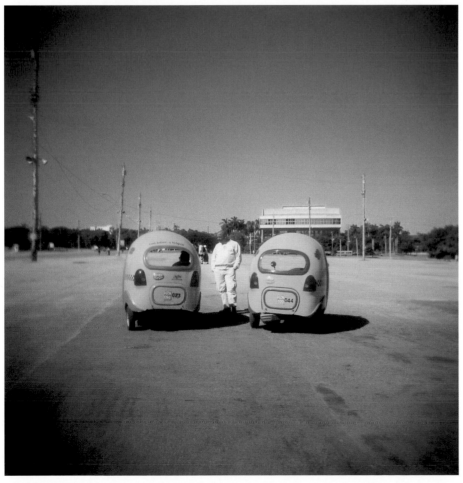

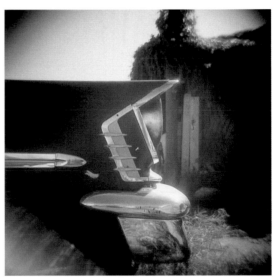

'2 Coco Taxis'
Coco Taxis are moped-powered tricycles with big yellow ball pods for seating. Unfortunately, I never rode one, but they were really cute. And the name 'Coco Taxi'? SOOOO awesome!
Shot taken at the Plaza de la Revolucion, Havana.

dansemacabre @ 2004-03-03 08:15 said:
oh my! now that i've seen what a coco taxi is i think it's wonderful! I wanna have one to go around milan!

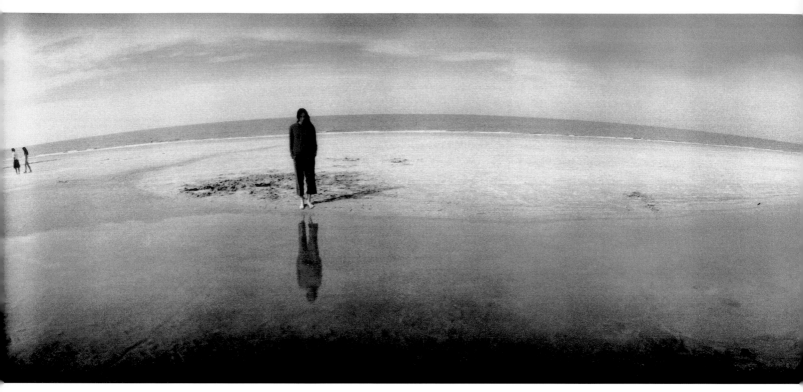

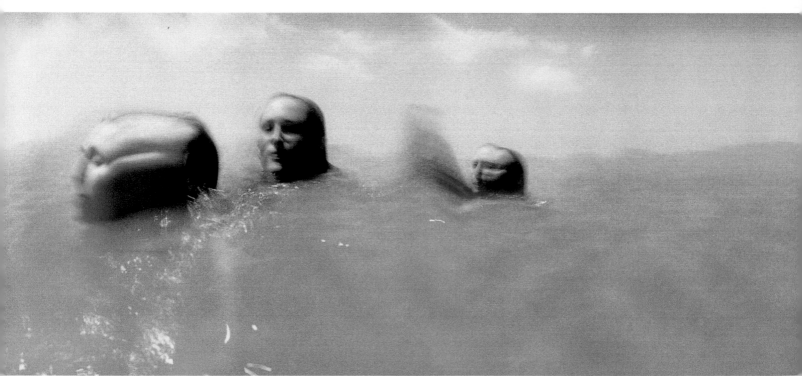

suzannasugar @ 2004-05-18 17:56 said:
oh, wow, that is so good. the colors are just SO
GOOD!!!

50mm @ 2004-05-19 07:51 said: perfect.
put it in a capsule for earth's posterity

suzannasugar @ 2004-05-19 17:22 said:
it just occurred to me – are you in the water
taking this?

paulbeagle @ 2004-08-20 23:36 said: love the effect
of these, you get some crazy good stuff from it

polaroid_billy @ 2004-08-21 00:52 said:
wowie zowie

zen @ 2004-08-22 13:20 said: wow, looks like our
return to an aquatic life has begun!!

kml @ 2004-08-24 23:49 said: still can't quite
figure out what yer doing but lllovvvvvvvvvvvvvvve
it!

squaremeals @ 2004-09-20 10:35 said:
Great, saturated color. Usually a tilting horizon
bugs me, but here it works.

suzannasugar @ 2004-08-04 14:56 said:
hot damn. how you do that?!

drugsintokyo @ 2004-08-04 18:40 said:
wow, a triple exposure? this is gorgeous!
the colour is spot on!

oz_lomo @ 2004-11-29 01:00 said:
Oh dear Mr Pelican...who has a
beak that can hold more than
his belly can!
;)

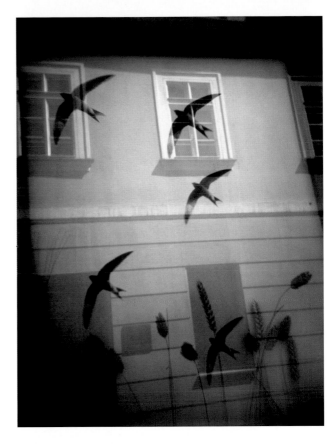

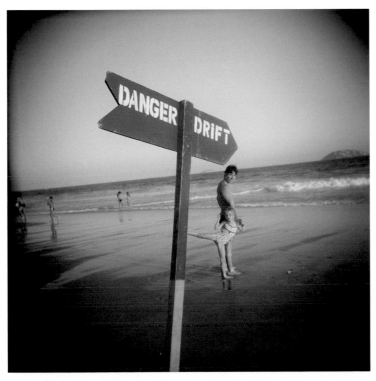

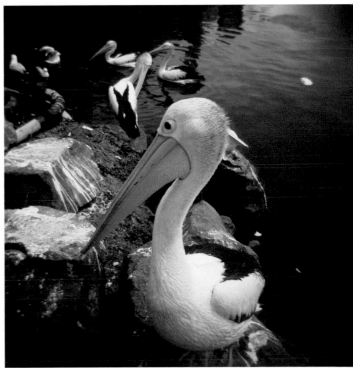

seeds inside waiting to grow

**Let me push this dark cloud from here
and give the sun shining to you.**

grantbw @ 2004-09-07 10:32 said:
seaweed cowlick
:DD

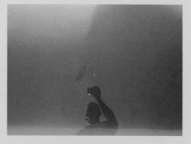

home

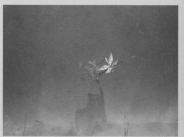

**had an absolutely difficult day today, if i hadn't
gotten to take pix i think i would have totally
(instead of only partially) lost it, so glad to be
back home!**

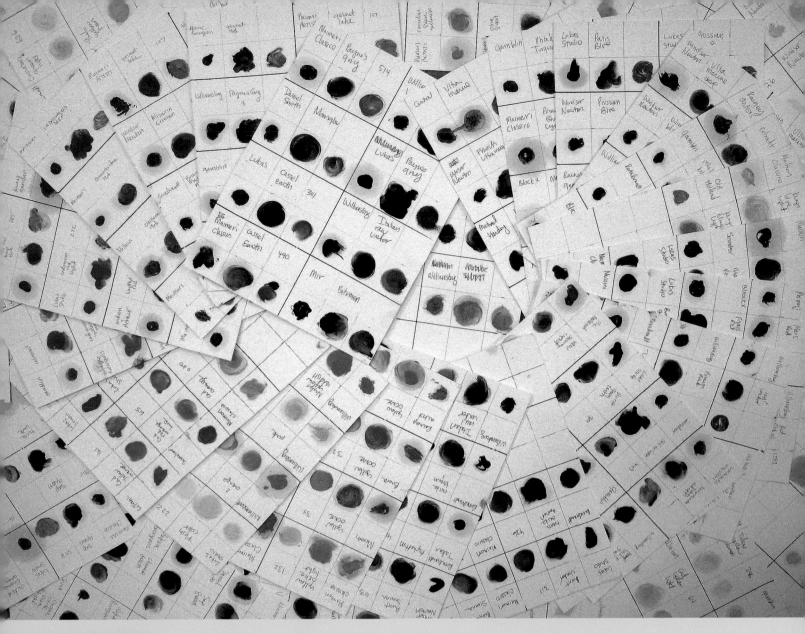

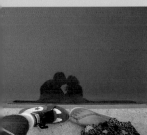

DIALOG

within | without
frustration (without)

jdiggle @ 2003-12-03 16:23 said:
Powerful in its simplicity, layers of texture and colour are
gentle on the eye and challenging for the imagination.

meditation
meditation

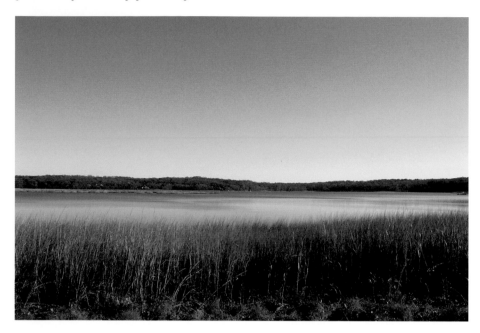

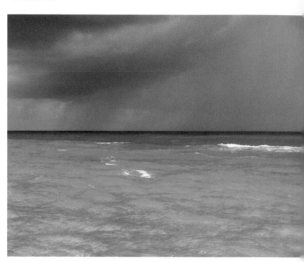

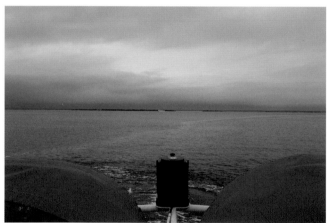

purple sky
green water

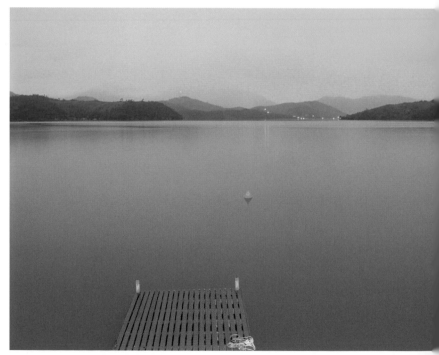

Eu posso.

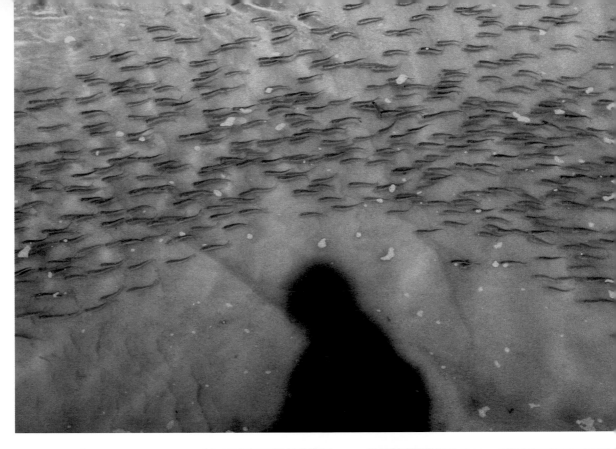

zenbomb @ 2003-11-11 03:31 said:
nice! I want to be where the leaves fall.
cactus looks the same all year. :(

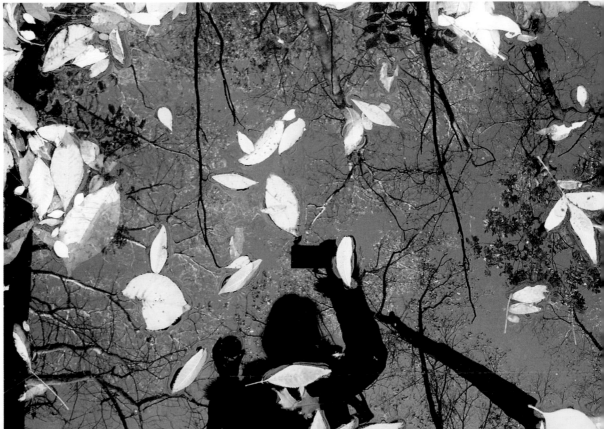

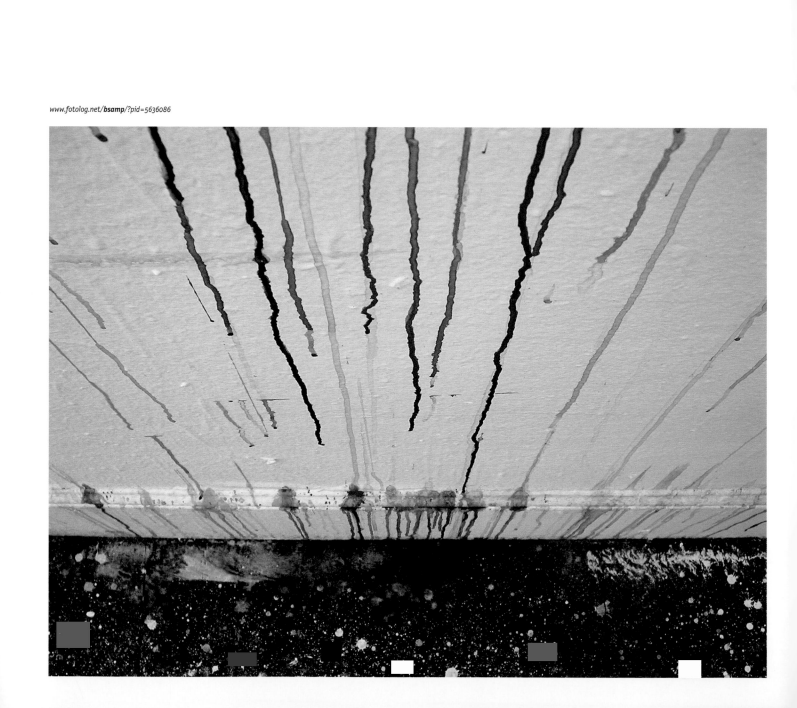

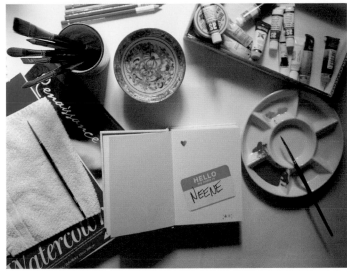

*above left: www.fotolog.net/**neene**/?pid–7634341*
light box

mashuga @ 2004-04-02 17:46 said:
Such negativity, but I'll let it slide. Just making light of it.

*above: www.fotolog.net/**bsamp**/?pid=8181229*
MISSING 19/26

*left: www.fotolog.net/**neene**/?pid=7540943*
oil on canvas, detail

tomswift46 @ 2004-03-15 18:17 said:
like frayed neurons...very interesting.

*below left: www.fotolog.net/**neene**/?pid=7622828*
**it's all about process
i am working my way back slowly**

*below: www.fotolog.net/**bsamp**/?pid=4549202*

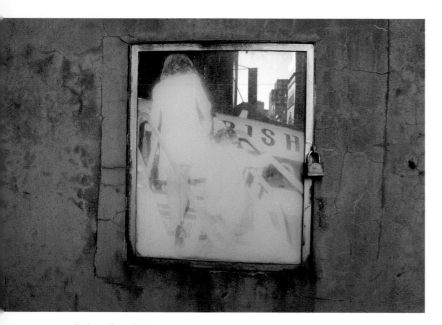

*www.fotolog.net/**neene**/?pid=7728716*
dirt, debris, decay... #6

gato_zeca @ 2004-05-09 19:55 said:
window to past beauty!

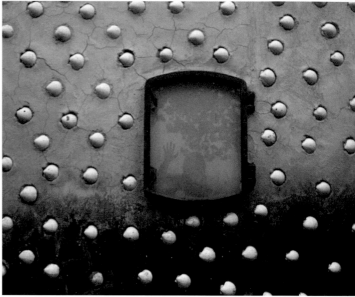

*www.fotolog.net/**bsamp**/?pid=8162645*
DUMMY 11/26

*www.fotolog.net/**neene**/?pid=8118803*
life

*www.fotolog.net/**bsamp**/?pid=8375079*
candy love

*above: www.fotolog.net/**bsamp**/?pid=3257383*

*below: www.fotolog.net/**neenna**/?pid=7857623*

luce @ 2004-06-19 15:31 said:
don't do it...it's not worth it...

selfmademug @ 2004-06-19 19:11 said:
aaaaaahhhhhhhhhh

www.fotolog.net/**bsamp**/?pid=2726746
abundance

www.fotolog.net/**bsamp**/?pid=8034223

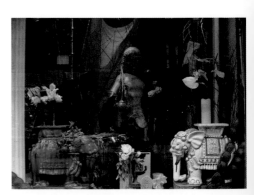

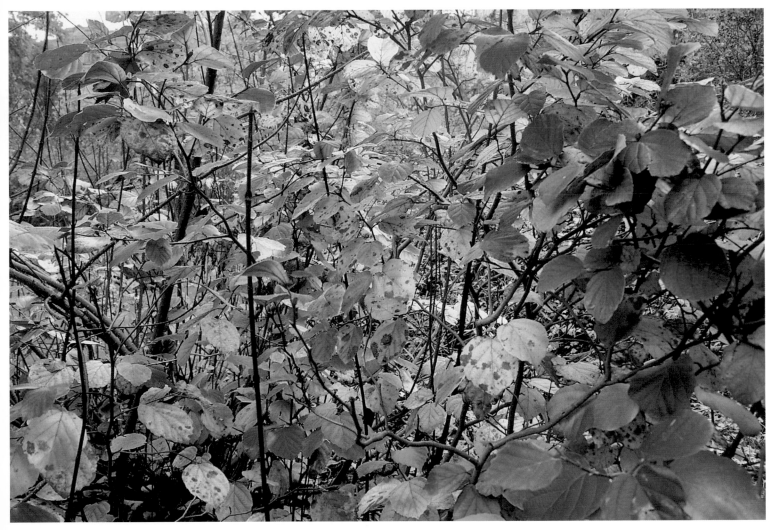

*above: www.fotolog.net/**neene**/?pid=2160299*

melancholy baby: (a rainy walk in the park) #1

stringbeanjean @ 2003-11-10 09:29 said:
ooh...i thought it was a fantastical splatter painting.
aren't they delish, those colours?

*below left: www.fotolog.net/**neenna**/?pid=7840973*

colorstalker @ 2004-06-14 22:51 said:
lord of the flies

*below: www.fotolog.net/**pavement_pix**/?pid=8113833*

*www.fotolog.net/**pavement_pix**/?pid=8996673*

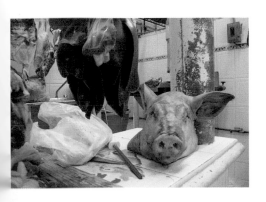

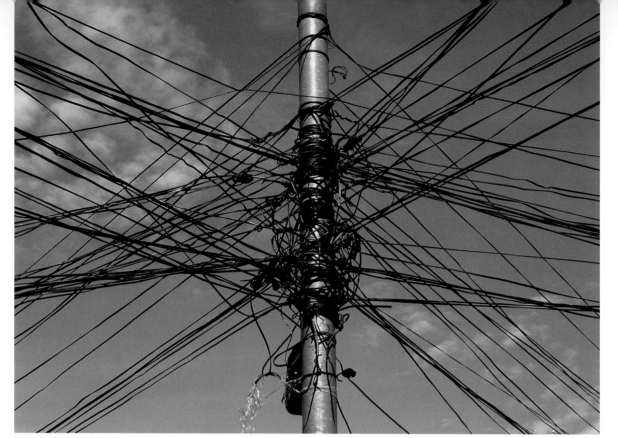

.uruguaiana

selfmademug @ 2004-02-20 17:54 said:
The pole seems superfluous!

lampiao @ 2004-02-20 17:51 said:
olha o gato.
experiencing network problems?

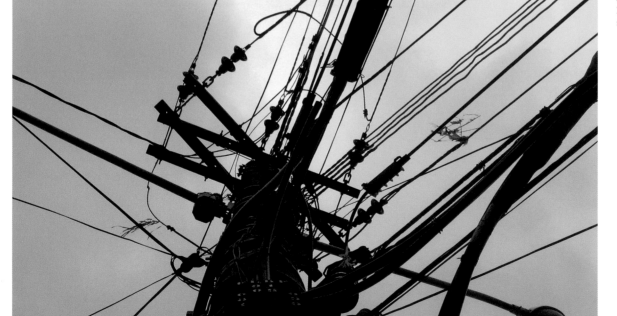

overpopulation (props to bsamp)

chineque @ 2004-09-30 17:32 said:
It's like the cover of a single of the Brazil
singer Chico Buarque.

LINES 01/26

www.fotolog.net/*petitepoupee7*/?pid=9431888
Copacabana, Rio de Janeiro, Brazil

marcelvangunst @ 2005-01-01 18:20 said:
Happy New Year PP7!

alinematias @ 2005-01-01 19:56 said:
feliz ano novo!!!

ernestone @ 2005-01-02 03:55 said:
Bonne année Poupée!!!

www.fotolog.net/*patisfaction*/?pid=8742715
Rawkin' Senna

mariaojr @ 2004-10-12 09:42 said:
Yeah baby!!!

svana_rauthkinn @ 2004-10-12 12:39 said:
So she wants to be a rock 'n' roll star (haha this
was just playin' on my computer! The Byrds).
What a demure little smile she has.
:-)

andy101 @ 2004-10-12 13:28 said:
Rock on, Senna. :)

u4eah @ 2004-10-13 02:44 said:
Hah…she's gonna be trouble!

'PARTY PEOPLE, ALL AROUND ME FEELIN' HOT HOT HOT'

I CAN GO CRAZY AND I CAN STAY SAFE AND SANE. I can be a fabulous super-being and still stay me. Tonight I can be an adult and play too, wear two faces, shave my pubes. I can crash the plane and walk away. I'm feeling pleasantly dislocated. I like your Dracula eyes. I liked you the moment I saw the fake blood. I'm sure I won't recognize you in your clothes. But right now I feel like this is the closest my life and my imagination are ever going to get to each other. So pour out the ice, vodka, cranberry, makeup. Hieronymus Bosch is shooting strobe flashes from a Sony Cybershot, but I'm too busy dancing. Tiny Toulouse-Lautrec snaps away with a silver Fujifilm. The room turns. Can I crash here tonight?

www.fotolog.net/*frank_bklyn*/?pid=1429878

familybmx @ 2003-10-09 11:42 said:
Bootsy

location_iceburg @ 2003-10-09 11:42 said:
beer goggles, 200 proof vision…

jw_arch @ 2003-10-09 11:43 said:
total bootsy! awesome.

digital_daisy @ 2003-10-09 11:45 said:
is eric okay?

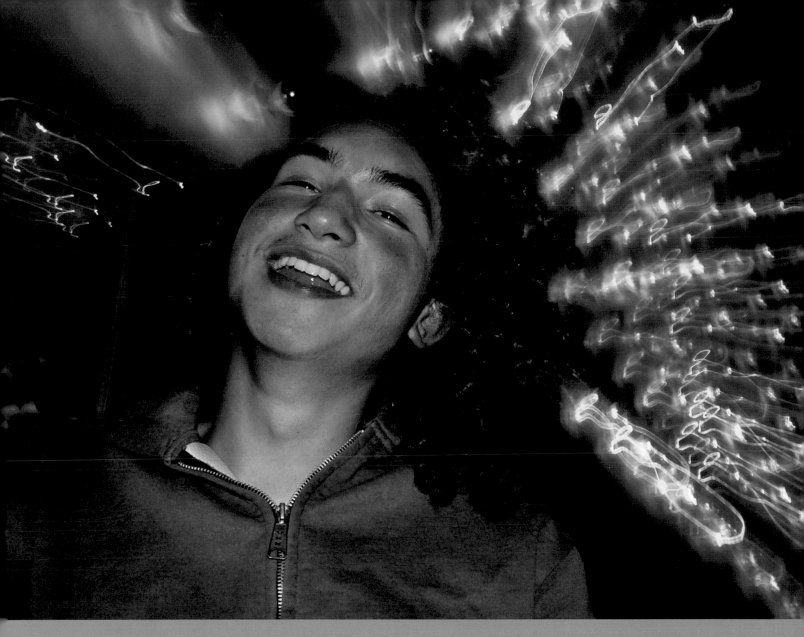

above: www.fotolog.net/**patisfaction**/?pid=10526841
This is my nephew Nathan [aka Nate Masta K]
@ de Kroon @ Queensday '05
gr8 hair huh?
:p

lucilia @ 2005-05-08 10:01 said:
...Shocking hair...yeahhhhhhhhhhhh ;)

*far right: www.fotolog.net/**victorcampos**/?pid=8457808*

PARTY ON

parsnip @ 2004-11-06 01:49 said:
sweet creepy shot

frankienose @ 2004-11-06 03:28 said:
four-eyes!

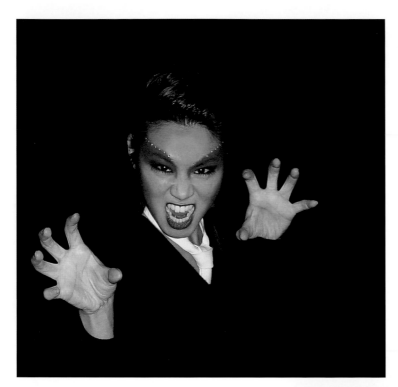

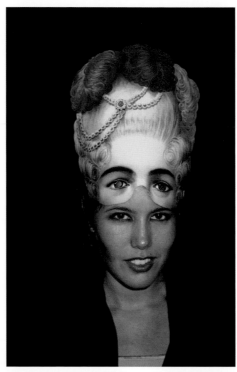

Hostess da mostess
Christy 1 of da luvly hostesses @ Must roaarrrrrrrrr!
@ Nighttown [Rotterdam nov. 22nd 2k3]

swampdiggity @ 2004-10-06 19:52 said:
Here kitty kitty!!!

janes @ 2004-10-06 22:37 said:
Awesome foto! She's beautiful...a little scary...
but beautiful! ;} I hope you're doing well...
(`·.,
 `·.,)Take
,.·)´care
(.·´Sweetie...
`*´¨)Kissesssssss
,.·´,.·*´¨) ,.·*´¨)
(,.·´(,.·` *Janie* xoxo

THE TWO HOTTEST 'IT GIRLS' IN NEW YORK
CITY RIGHT NOW! Miranda Moondust & Rainblo,
Disgraceland at CROBAR Oct. 21st NY

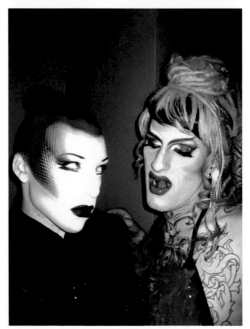

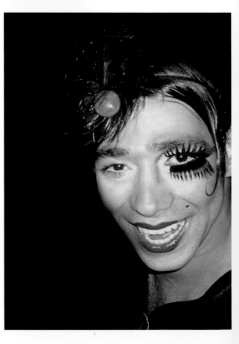

below: www.fotolog.net/**golden**/?pid=9387262

luce @ 2005-04-07 22:02 said:
tutti frutti

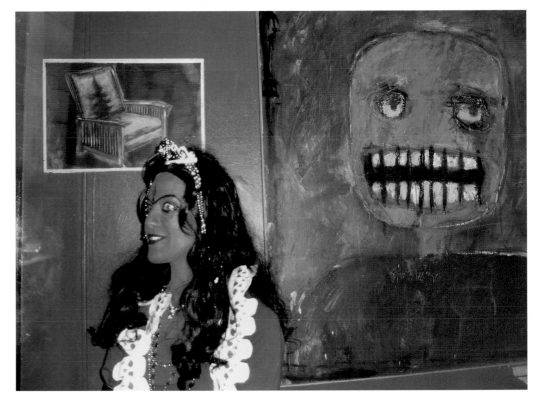

above: www.fotolog.net/**gardengal**/?pid=8459823
kirsten as kali.

jdiggle @ 2004-10-31 11:23 said:
waaaaaaaaaaah what have you done to
the delightful Kirsten??? Give her back now!

forrest @ 2004-10-31 13:06 said:
awesome costume idea, and totally sacrilicious!

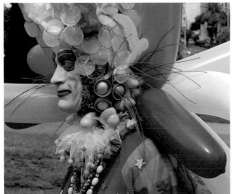

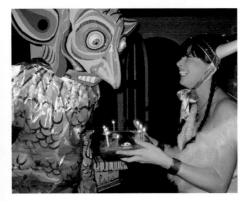

www.fotolog.net/**cookieb**/?pid=9088253
my man is a sea monster

reedster @ 2004-11-01 01:39 said:
...and his lady is a viking

anon_ms_b @ 2004-11-01 06:04 said:
you are the sweetest looking viking ever

opposite, bottom right: www.fotolog.net/**petitepoupee7**/?pid=10033898

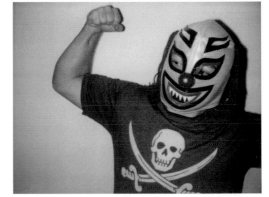

www.fotolog.net/**frank_bklyn**/?pid=8367673
i am sancho.
are you sancho?
i did not think so.

youzoid @ 2004-09-29 17:20 said:
there is only one sancho.
i am santo.

roycebannnon @ 2004-09-30 11:17 said:
never seen a luchadore pirate
named sancho. i think i can take him

elation @ 2004-10-02 16:22 said:
no one can be sancho but sancho.

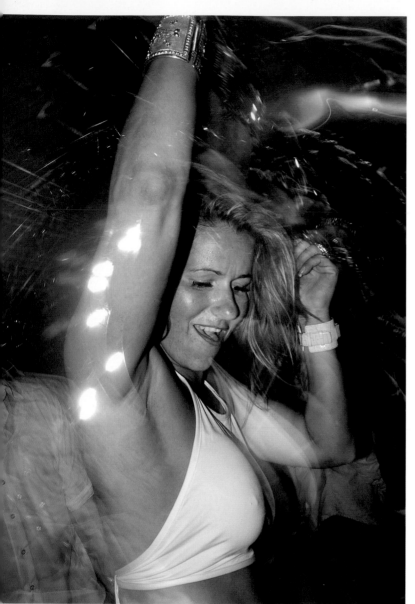

**Sexy phun on da floor @ Discotheque
@ the HAL building june 25 Rotterdam
literally damn hot, sweated my ass off!
:p**

jonathann @ 2005-10-13 00:24 said:
FABULOUS...............

Hairy phun

melbo @ 2004-05-29 20:41 said:
give me his shirt!!!!!!
hehehehe
no way, it's too cute

**Fab 5 Super Girl
Colorful Hot Dancer @ Betty Ford Clinic
@ Las Palmas [RiP] 27th of feb. Rotterdam**

lokithorn @ 2005-04-01 17:40 said:
Now that's a Wonder Woman!!! :D

'Parallax Inferno'
a couple of months ago i shot this when my sis
dj La Ona was spinnin' @ Rosso in Rotterdam
on this occasion i rarely had my tripod with m
it got quite warm in there btw :p

**hot cutie @ da Rotterdam Summer
Carnival 2k4**

macpherr @ 2005-02-04 15:44 said:
Such a happy face!! That is why I liked
it in here...always positive vibezzz!!
Have a nice weekend...Pat
XOXOXOXXO

**Sharp dressed [dj] Urvinson showin' sum
wicked skillz on da floor @ da Circle of Sole's
Live 'n Direct Session with DJ Jurgen
[Jazzanova] & da FlowRiders [live]
amongst others @ Nighttown
Rotterdam march 2k5**

fassbinder @ 2005-10-13 10:32 said:
long time honey!
how's life?
Kisses

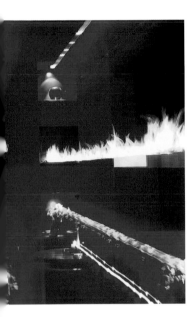

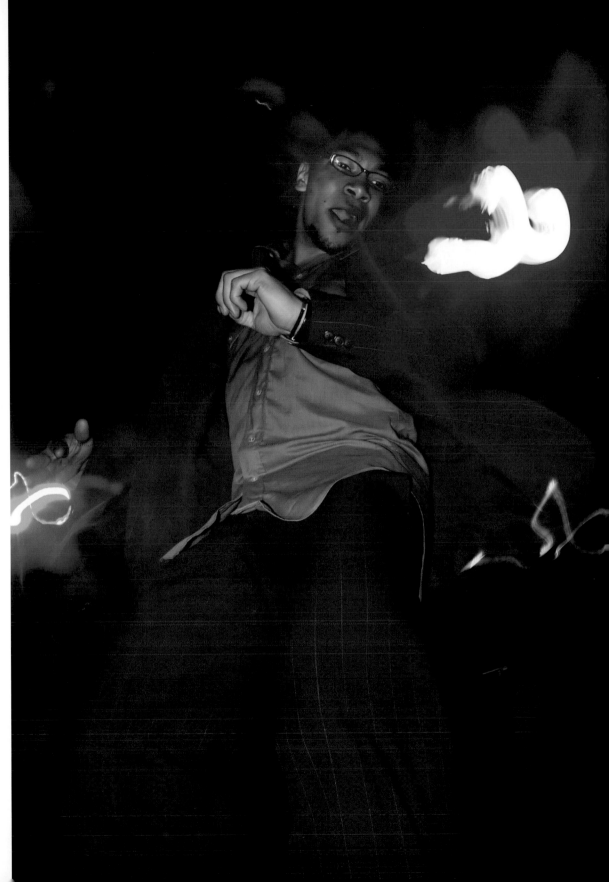

*above: www.fotolog.net/**cristi**/?pid=9648989*

*right: www.fotolog.net/**cristi**/?pid=9289246*

athomic @ 2004-11-22 09:58 said:
Like a dream...you and the photo!!! ;-)

*right, centre: www.fotolog.net/**cristi**/?pid=9302647*

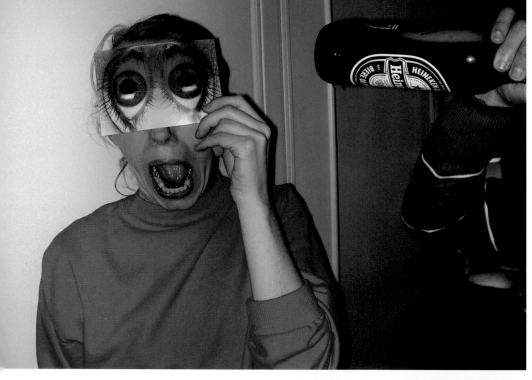

*above: www.fotolog.net/**davidgarchey**/?pid=8749181*

pro_keds @ 2004-10-17 11:37 said:
i think she likes you

petitepoupee7 @ 2004-10-17 13:41 said:
oooooh lalalla TERRIBLE!!
:P.

beebs @ 2004-10-19 21:56 said:
i know the feeling well

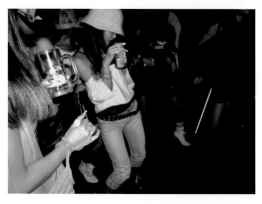

*www.fotolog.net/**cozy**/?pid=3527390*
girls girls girls...

patisfaction @ 2003-12-17 04:28 said:
thatz what we wanna C bro! ^_^

*top: www.fotolog.net/**frisjes**/?pid=7638219*

*above: www.fotolog.net/**frank_bklyn**/?pid=1151927*
Good Morning!

brillo @ 2003-09-22 09:24 said:
terry richardson party??

brainware3000 @ 2003-09-22 09:50 said:
3 boobs

goon @ 2003-09-22 10:25 said:
yow frank, eyes wide open

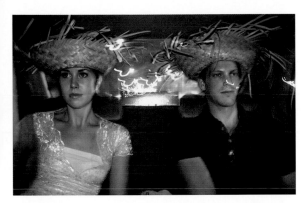

www.fotolog.net/**nadia**/?pid=8099514

d76 @ 2004-08-18 16:14 said:
There would be less problems in life if more people walked around in hats like that

siobhan (the girl in the hat) @ 2004-08-18 22:26 said:
this
makes
life
worth
living

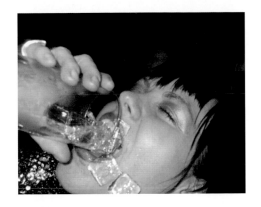

*top: www.fotolog.net/**cookieb**/?pid=9958220*
god i love my friends

moredogseat @ 2005-01-30 21:08 said:
don't we all

super8mm @ 2005-01-30 21:12 said:
remind me to cover the furniture before they come over.

sizeofguam @ 2005-01-30 21:25 said:
i hope she smacked her lips and said ahhhhh after that.

*above: www.fotolog.net/**cookieb**/?pid=12548244*

*below: www.fotolog.net/**cookieb**/?pid=11845765*

terrybrogan @ 2005-08-07 14:44 said:
foreplay?

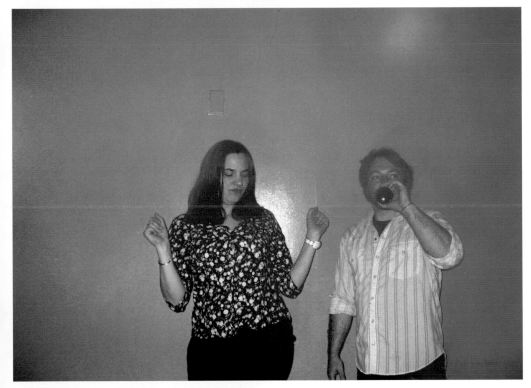

*above: www.fotolog.net/**pixietart**/?pid=9496300*

lugolounge @ 2005-01-10 14:03 said:
two words AWE SOME

world_o_randi @ 2005-01-10 14:39 said:
bw is too busy drinking to dance with his woman. this calls for an intervention.

www.fotolog.net/**frank_bklyn**/?pid=7634696
**I cleaned up my image.
April fools!**

staciemerrill @ 2004-04-01 09:35 said:
yup mm hmm

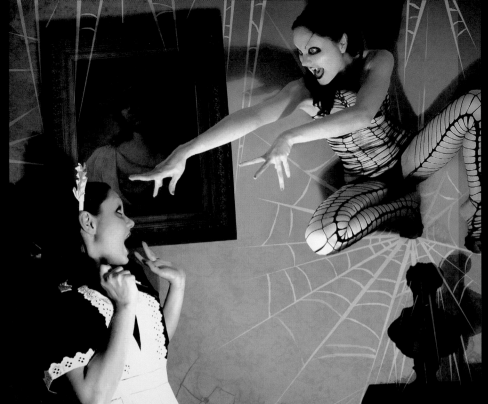

about sinistra:

Thank you for visiting my photoblog. My name is Singoalla Lagerblad, aka Sinistra, and I am a Brazilian artist and performer who is currently finishing an art therapy postgraduate course in Rio de Janeiro. Here are the answers to some frequently asked questions.

Q1. Who is the model?

A. Unless otherwise stated, I portray all of the characters seen in the stories.

Q2. Who does the artwork?

A. My partner Sean C. Graham, aka Lokithorn, creates all of the photography, illustrations, Photoshop and graphic designs.

Q3. Why do you do this?

A. 'Bloody Kisses' started out as a fun way for us to work out scenarios and artwork for our graphic novel *Fiend Fatale*. We have since started the 'Malicious Manor' series just for Fotolog which has gone further and reached more people than we ever expected.

Q4. Do you work in a professional studio?

A. No, we work out of our apartment with very basic tools. Our camera is a Sony Cybershot P-71. The lighting is created with common desk lamps or sunlight. The artwork is created with Photoshop 7 and Illustrator 10. I do all of my own makeup and hair and own or make all of the costumes.

Q5. Are you insane?

A. Are you talking to me? ;)

helenbar (left) and sinistra (right) posing for their photos. photo by galessa.

about helenbar:

Welcome to Wonderland!

These illustrations are inspired by the original story of *Alice in Wonderland* by Lewis Carroll.

I am the designer, photographer and model as well and make them by using a digital camera and Photoshop.

Thanks for visiting!

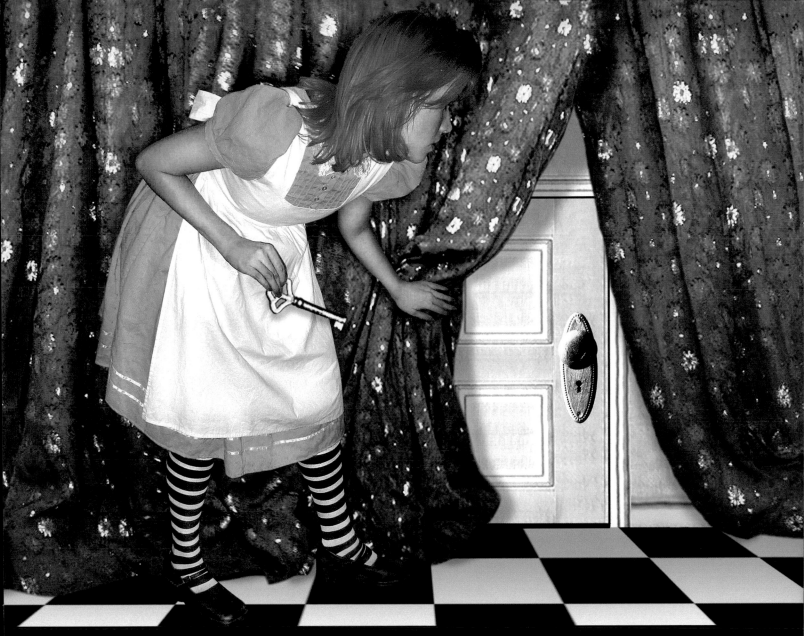

...she tried the little golden key in the lock,
and to her great delight it fitted...

TELLING TALES

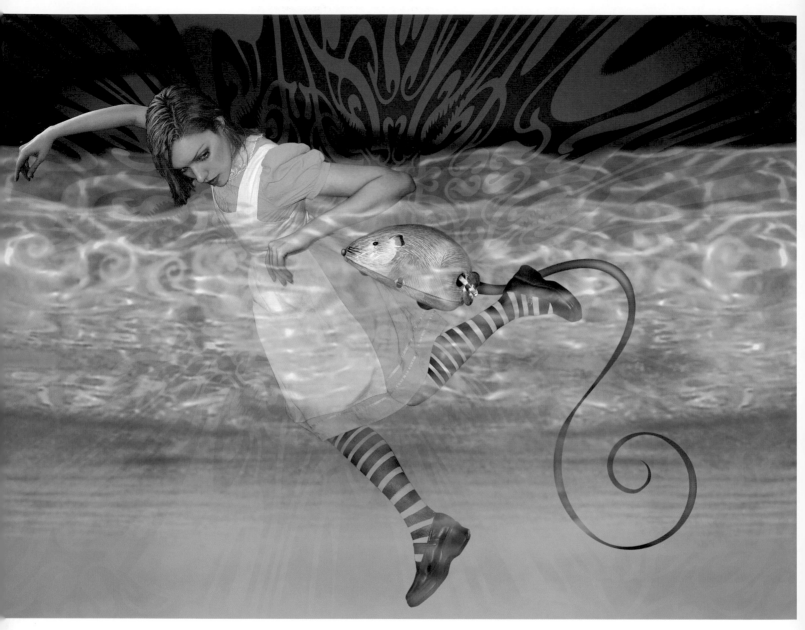

Would it be of any use now, to speak to this mouse?
Everything is so out of the way down here, that
I should think very likely it can talk. At any rate,
there's no harm in trying...

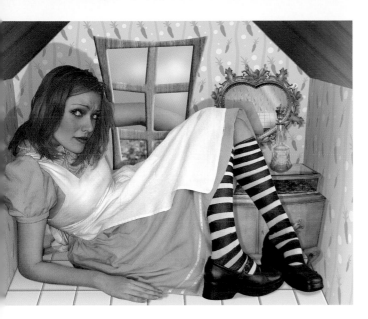

She had found her way into a tidy little room with a table by the window, and on it (as she hoped) a fan and two or three pairs of tiny white kid gloves. She picked up the fan and a pair of gloves, and was just going to leave the room when her eyes fell upon a little bottle that stood in front of the looking glass.

'I know something interesting is sure to happen whenever I eat or drink anything, so I'll just see what this little bottle does. I hope it'll make me grow large again, for really I'm quite tired of being such a tiny little thing!'

It did indeed, and much sooner than she had expected: before she had drunk half the bottle, she found her head pressing against the ceiling and had to stoop to keep her neck from being broken...

While she was peering about anxiously among the trees, a sharp little bark just over her head made her look up in a great hurry.

An enormous puppy was looking down at her with large round eyes and feebly stretching out one paw, trying to touch her. 'Poor little thing!' said Alice in a soothing tone. She tried hard to whistle to it, but she was terribly frightened as she thought it might be hungry and want to eat her up, in spite of all her coaxing.

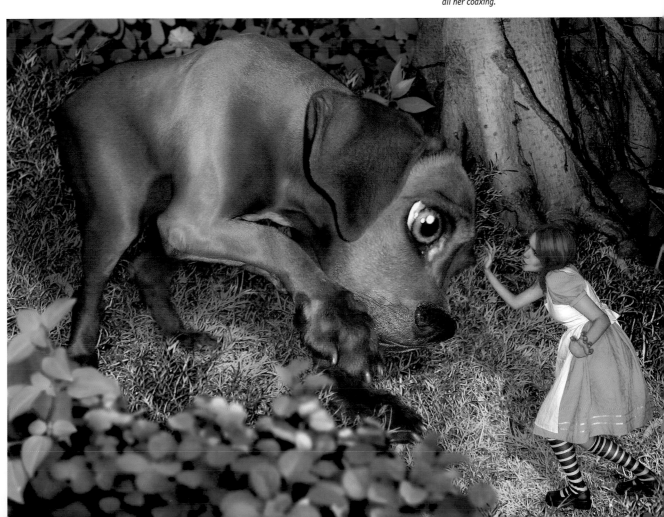

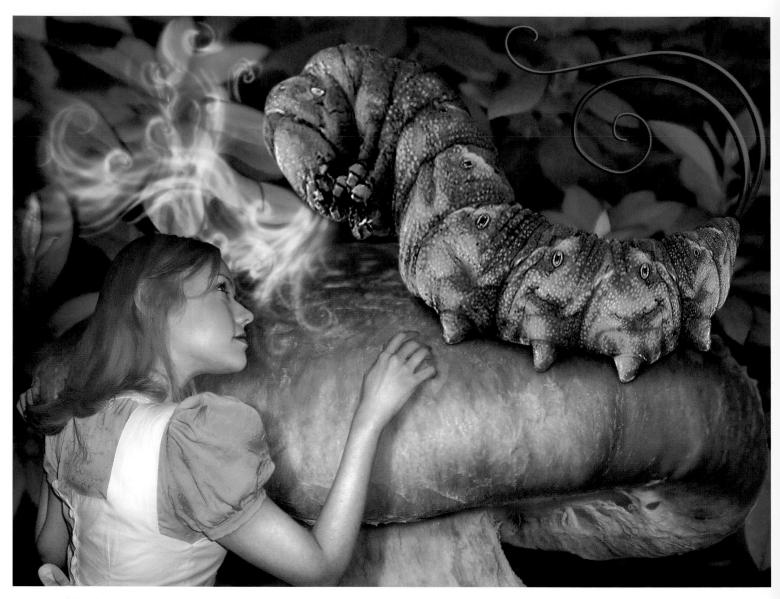

There was a large mushroom growing near her, about the same height as herself; and, when she had looked under it, and on both sides of it, and behind it, it occurred to her that she might as well see what was on the top of it.

She stretched herself up on tiptoe and peeped over the edge of the mushroom. Her eyes immediately met those of a large blue caterpillar that was sitting on the top with its arms folded, quietly smoking a long hookah. It took not the slightest notice of her or anything else.

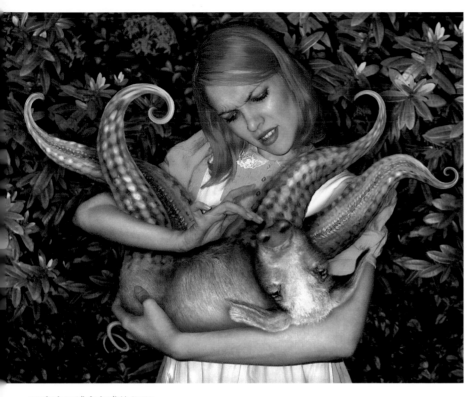

'Here! You may nurse it a bit, if you like!' the Duchess said to Alice, flinging the baby at her. Alice caught it with some difficulty; it was a queer-shaped little creature and held out its arms and legs in all directions – just like a starfish, Alice thought. The poor thing was snorting like a steam-engine when she caught it, and kept doubling itself up and straightening itself out again.

The baby grunted, and Alice looked anxiously into its face to see what was the matter with it. There could be no doubt that it had a very turned-up nose, much more like a snout than a real nose; also, its eyes were getting extremely small for a baby. It grunted again, so violently that she looked down into its face with alarm. This time there could be no mistake about it: it was none other than a pig.

'If it had grown up,' she said to herself, 'it would have made a dreadfully ugly child. But it makes rather a handsome pig, I think.' And she began thinking of other children she knew who might do very well as pigs...

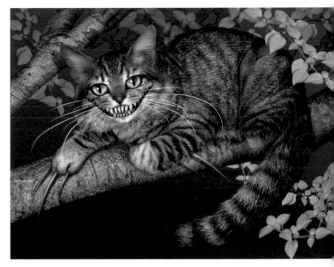

'Why does your cat grin like that?'

'It's a Cheshire Cat,' said the Duchess.

'I didn't know that Cheshire Cats grinned; in fact, I didn't know that cats could grin.'

'They all can,' said the Duchess, 'and most of 'em do.'

'I don't know of any that do,' Alice said.

'You don't know much,' said the Duchess, 'and that's a fact.'

The cat only grinned when it saw Alice. It looked good-natured, she thought. Still, it had very long claws and a great many teeth, so she felt that it ought to be treated with respect.

'Cheshire puss...would you tell me, please, which way I ought to go from here?' she asked.

'That depends a good deal on where you want to get to,' said the cat.

'I don't much care where,' said Alice.

'Then it doesn't matter which way you go,' replied the cat.

'So long as I get somewhere,' Alice added as an explanation.

'Oh, you're sure to do that,' said the cat, 'if you only walk long enough.'

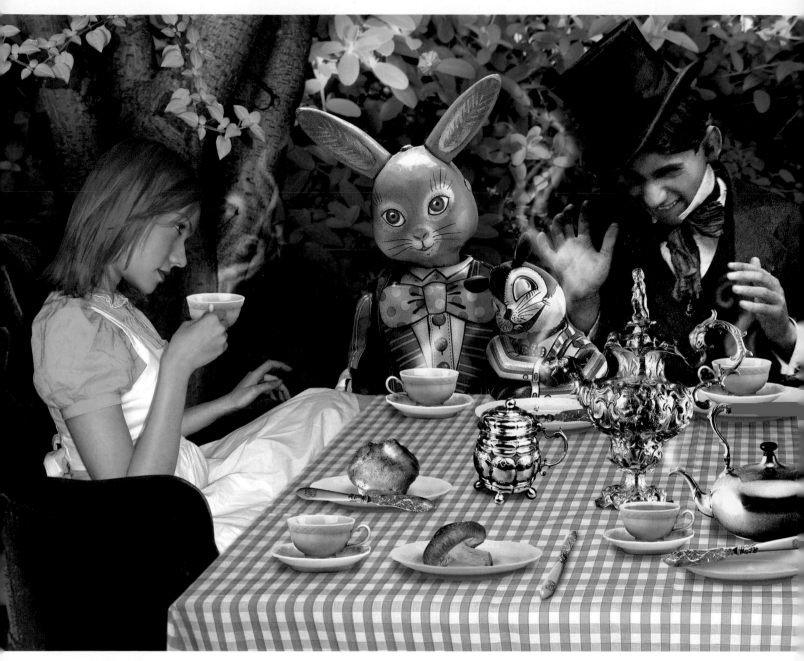

There was a table set out under a tree in front of the house, and the March Hare and the Hatter were having tea at it. A dormouse was sitting between them, fast asleep, while the other two talked over its head, using it as a cushion to rest their elbows on. The table was a large one, but the three of them were all crowded together at one corner.

'No room! No room!' they cried out when they saw Alice coming.

'There's plenty of room!' said Alice indignantly, and she sat down in a large armchair at the end of the table.

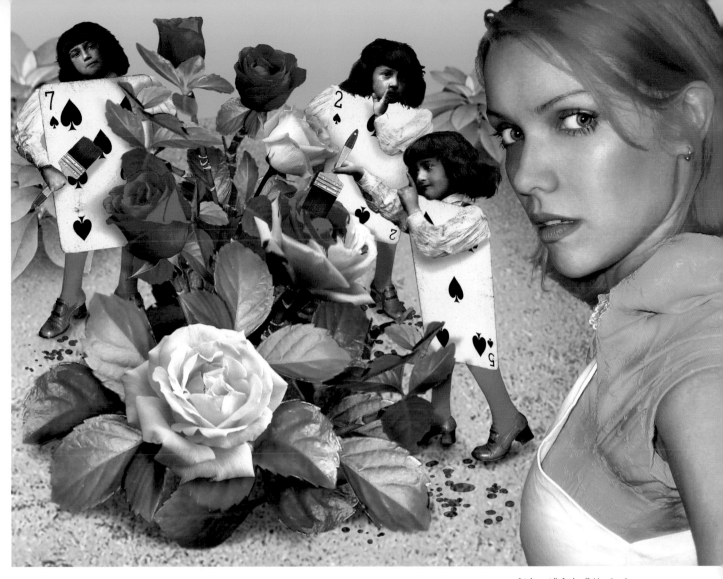

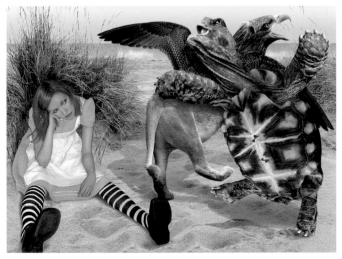

www.fotolog.net/**helenbar**/?pid=7365276
The Lobster Quadrille

At last the Mock Turtle recovered his voice, and with tears running down his cheeks, he went on:

'You may not have lived much under the sea –'

'I haven't,' said Alice.

'– and perhaps you were never even introduced to a lobster –'

Alice began to say, 'I once tasted…' but checked herself hastily and said, 'No, never.'

'– so you can have no idea what a delightful thing a Lobster Quadrille is!'

'No, indeed,' said Alice. 'What sort of a dance is it?'

www.fotolog.net/**helenbar**/?pid=1161436

A large rose tree stood near the entrance of the garden: the roses growing on it were white, but there were three gardeners busily painting them red. Alice thought this a very curious thing, and she went nearer to watch them.

'Would you tell me, please,' said Alice, a little timidly, 'why you are painting those roses?'

Five and Seven said nothing, but looked at Two. Two began, in a low voice, 'Why, the fact is, you see, miss, this here ought to have been a red rose tree, and we put a white one in by mistake; and, if the Queen was to find it out, we should all have our heads cut off, you know.'

helenbar's archive

08/26/04

08/21/04

08/16/04

08/15/04

08/03/04

07/30/04

07/27/04

07/18/04

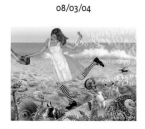

07/08/04

07/11/04

07/10/04

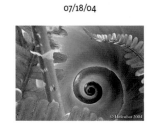

07/09/04

06/29/04

06/27/04

06/06/04

06/04/04

06/02/04

05/03/04

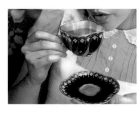

05/27/04

05/26/04

sinistra's archive

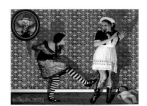

06/28/03 06/26/03 06/24/03 06/24/03

 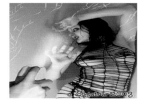 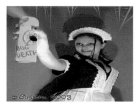 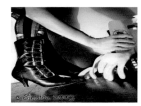

06/23/03 06/20/03 06/19/03 06/18/03

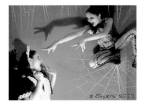 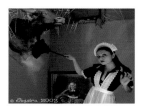 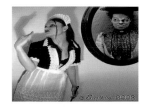

06/17/03 06/10/03 06/13/03 06/11/03

06/11/03 06/10/03 06/08/03 06/07/03

06/06/03 06/05/03 06/05/03 06/03/03

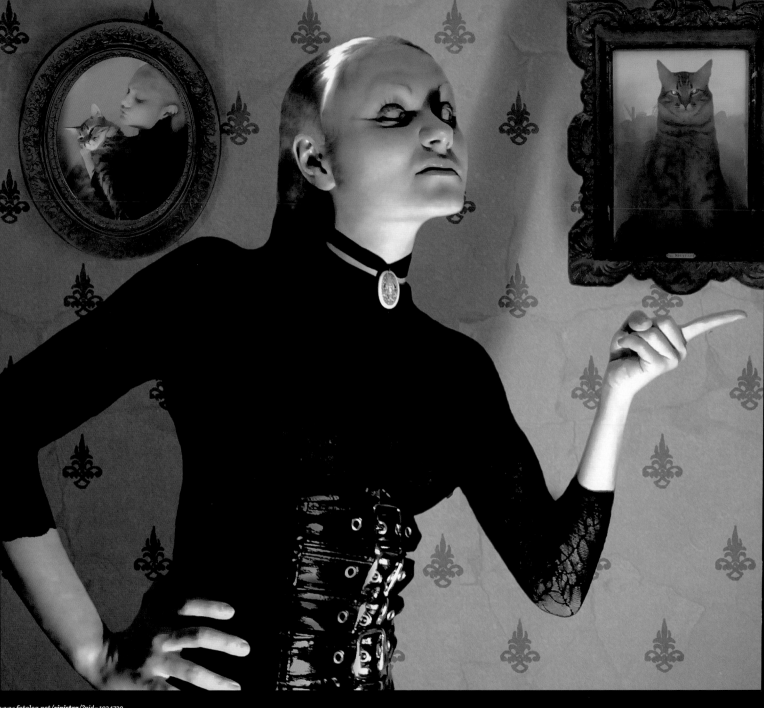

**The Malicious Manor • Scene 8 • Chapter 4 –
The Cat's Meow**

'One last thing, girl. My private library is off limits
to everyone, and I do mean everyone, do you
understand? The price for breaking this one simple
rule is your termination from our service. Now
get out front and help Lars with the luggage.
We don't have all day, you know!'

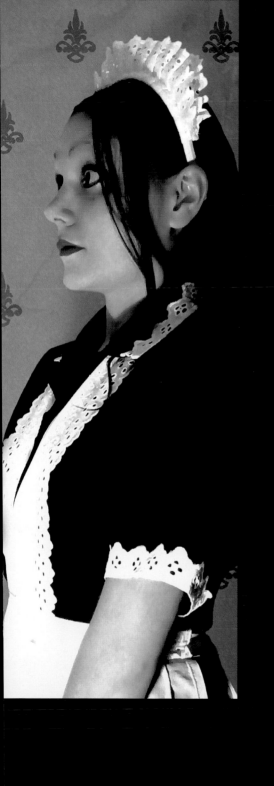

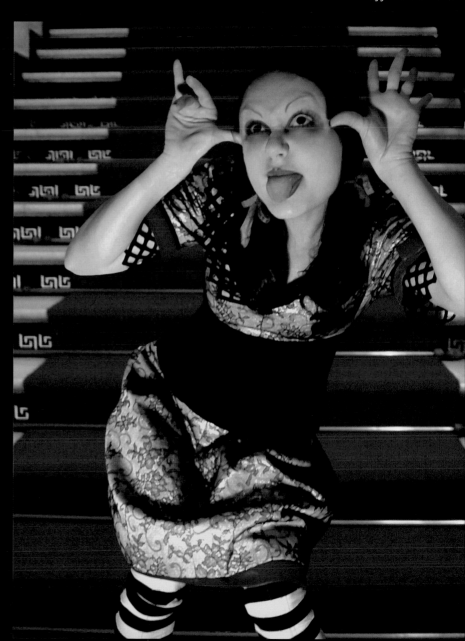

**The Malicious Manor • Scene 18 • Chapter 3 –
Petunia the Pest**

*'Ahhhh, help, it's a monster! Bwaaaaahahahaha.
Poor Sinistra, I'm sorry, I was just pulling your
leg, don't lose your head now, bwaahahahaha! Catch
me if you can thbbbbbbbb!!!!*

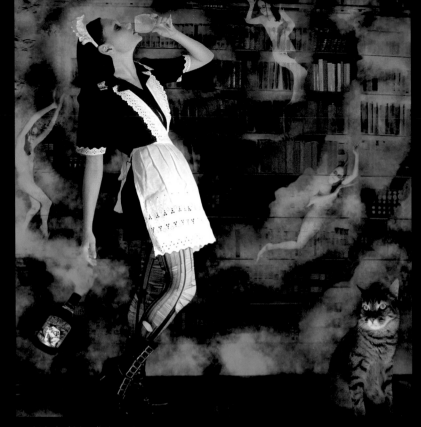

**The Malicious Manor • Scene 34 • Chapter 4 –
Petunia the Pest**

Sssssssssssssssssssssssssssssssssss!

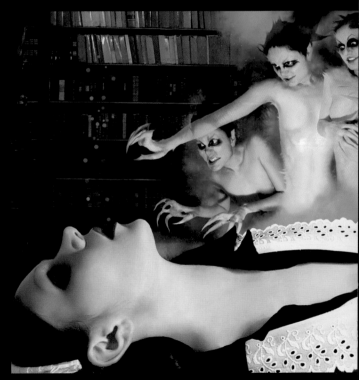

**The Malicious Manor • Scene 35 • Chapter 4 –
The Cat's Meow**

'What isssssss it?'
'It'sssssss a human!'
'Issssssss it tassssssssssty? Let'sssssssss find out!'

**The Malicious Manor • Scene 40 • Chapter 4 –
The Cat's Meow**

*'I might not be a "connoisseur of the grape",
but I think this wine is past its prime!'*

**The Malicious Manor • Scene 36 • Chapter 4 –
The Cat's Meow**

*'If anything is going to be eaten around here it will
be you, my fine little morsels! Get away from the
maid...NOW!'*

**The Malicious Manor • Scene 41 • Chapter 4 –
The Cat's Meow**

*'I should have read the label first. It says
right here, "Shake well before serving"!
Take that you little pests, heehee!'*

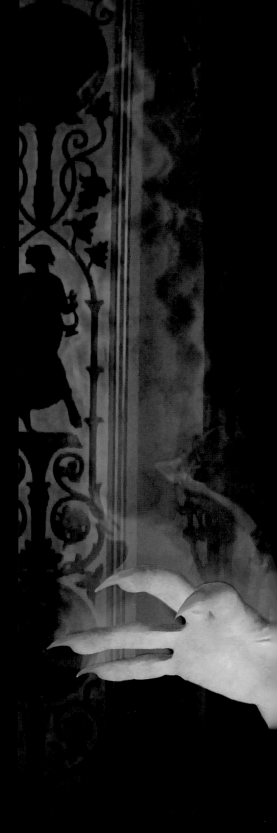

www.fotolog.net/*sinistra*/?pid=311365
**The Malicious Manor • Scene 5 • Chapter 3 –
Epilogue**

*'I took a black cat, a cave bat, and threw them
in a pot pot, pot pot, pot pot,
I took a blue snake, a green snake, and tied them
in a knot knot, knot knot, knot knot,
I took a hog jaw, a dog's paw, and hung them
on the line line, line line, line line,
I took a whore's hair, a green pear, and made
a crazy sign sign, sign sign, sign sign.*

*I'm castin' my spell on you, I'm castin' my spell on you,
I'm castin' my spell on you, you'll never never be untrue!'*

www.fotolog.net/*sinistra*/?pid=7850005
**The Malicious Manor • Scene 53 • Chapter 4 –
The Cat's Meow**

'Mrrrroooooooooooowwww!!'

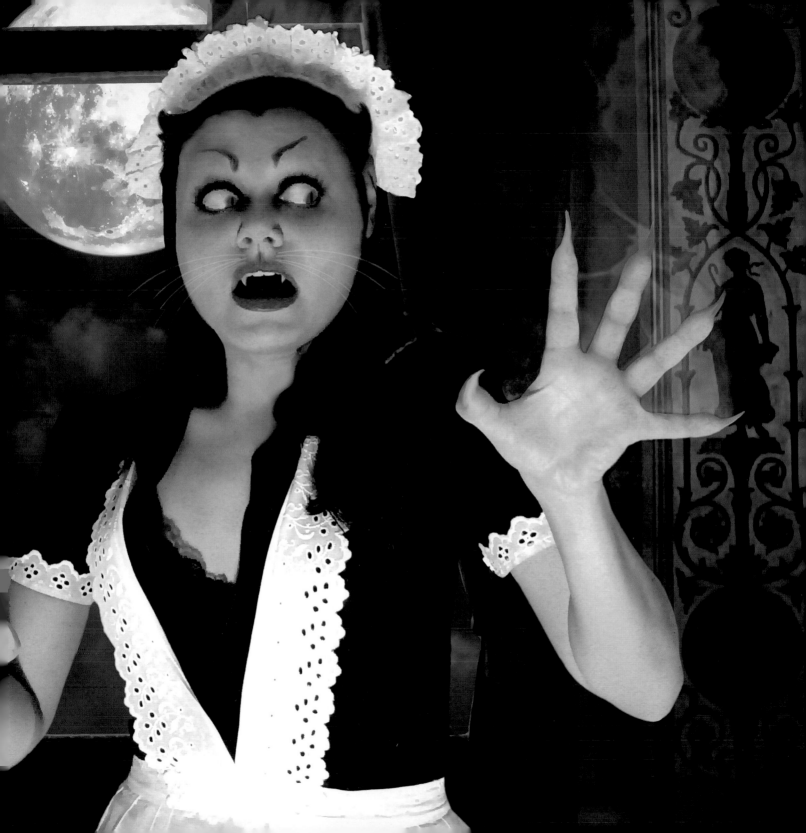

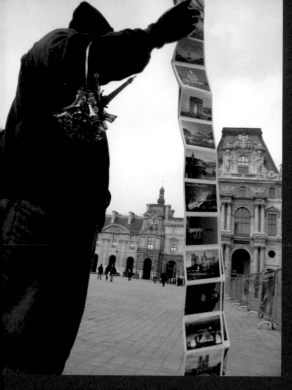

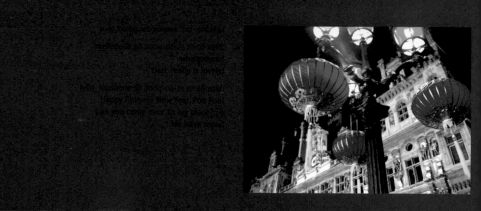

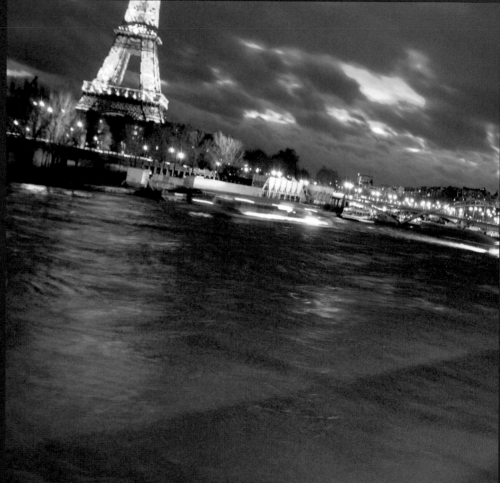

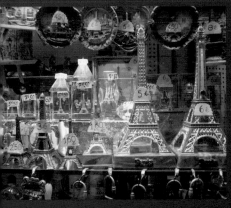

PARIS

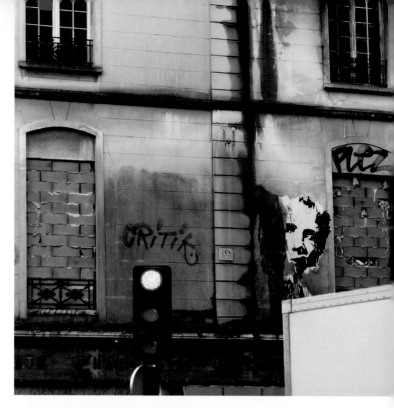

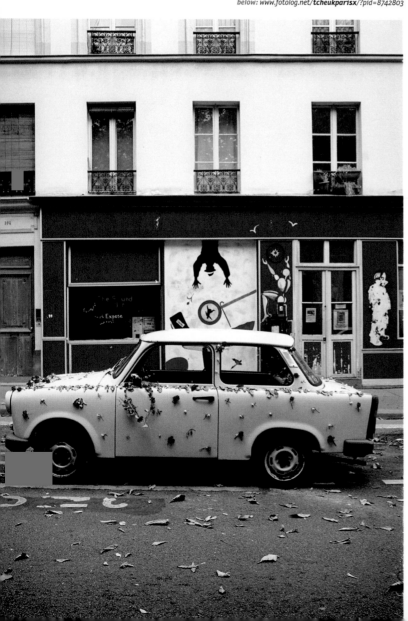

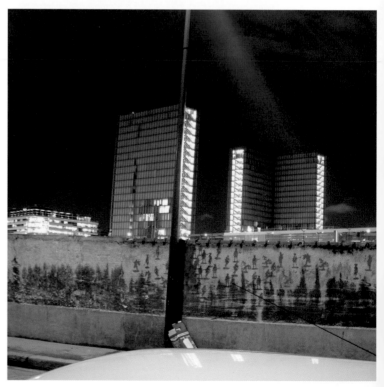

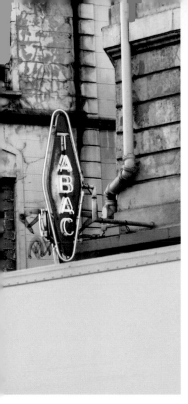

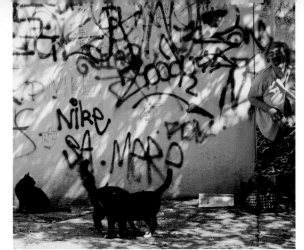

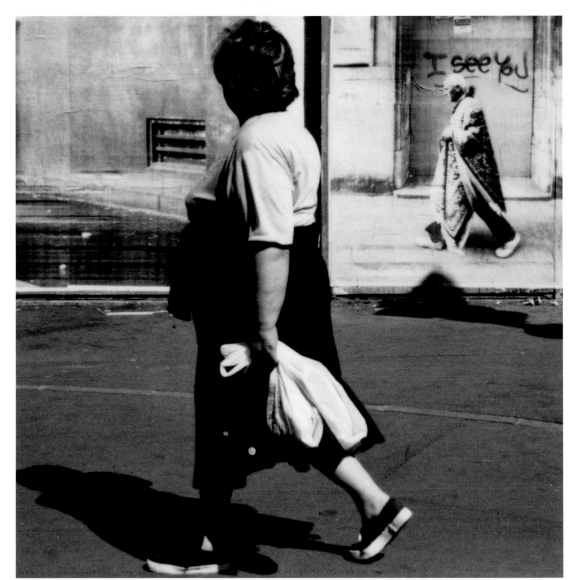

opposite:

anomalous @ 2004-02-10 13:56 said:
so weird...

virgorama @ 2004-02-10 15:18 said:
but seriously fantastic

madmaxnyc @ 2004-02-11 01:28 said:
Ah, awesome shot of La Tres Grande
Bibliothèque Stupide. ;p
God, Mitterrand did some ugly-ass things
to poor Paris...
You make it look good, as always.

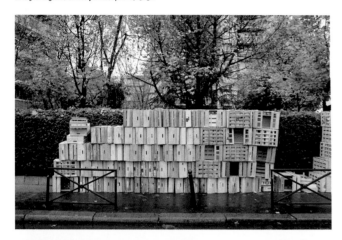

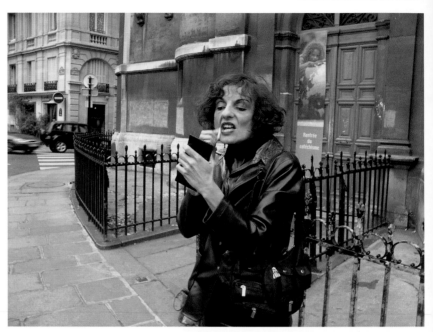

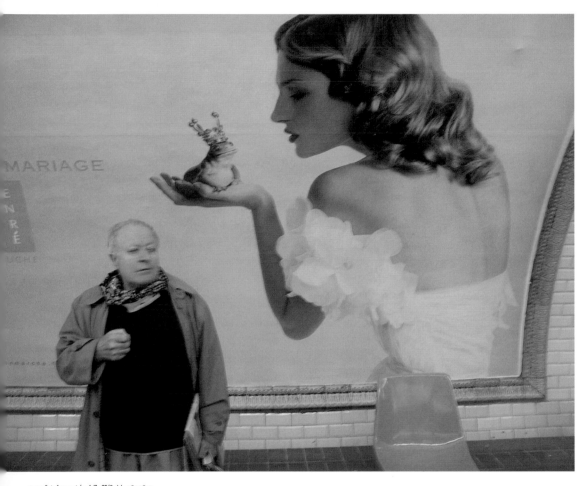

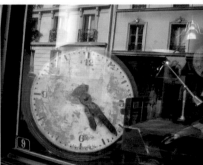

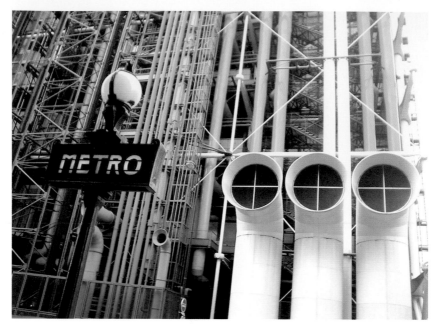

www.fotolog.net/**ponpon**/?pid=2843146

fabrys @ 2003-11-30 06:11 said: Pretty, this
viewpoint. The discrepancy between the art deco
style of the métro and the tubes of the Centre
Pompidou is funny.

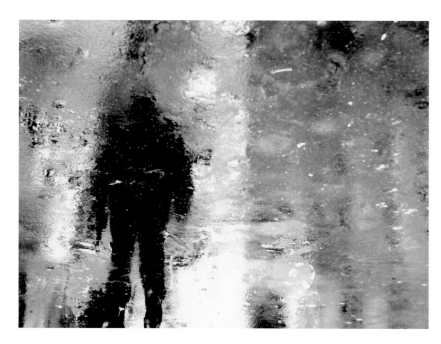

www.fotolog.net/**ponpon**/?pid=2232875

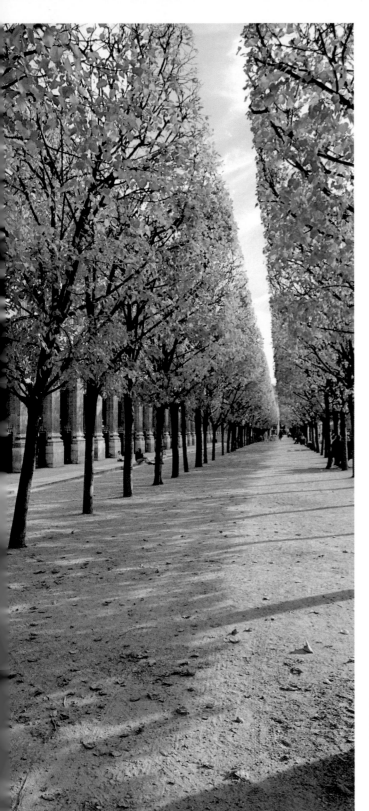

below: www.fotolog.net/**ponpon**/?pid=8025217

ricosphoto7 @ 2004-07-01 05:29 said:
nice framing.

hidude @ 2004-07-01 11:30 said:
so cool this man with his walkman!!!

bottom: www.fotolog.net/**ponpon**/?pid=8158926

undertow_63 @ 2004-07-24 16:17 said:
I love this photo...
The lady seems to be a Lilliputian in the middle
of this quasi-Promethean architecture...

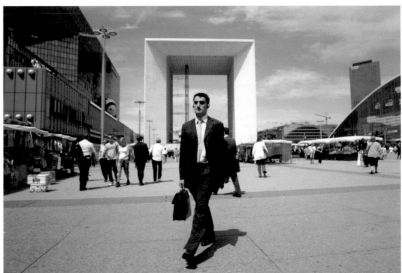

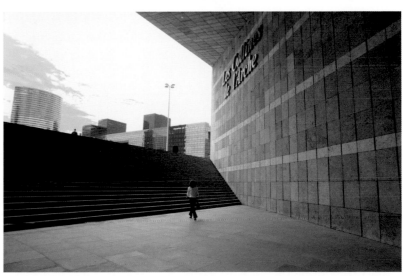

www.fotolog.net/**eshepard**/?pid=961101

staciemerrill @ 2003-09-09 11:28 said:
you two and your discotheques

eshepard @ 2003-09-09 11:31 said:
we just can't stay away!

kdunk @ 2003-09-09 14:11 said:
this also may be the only good photo we have
ever taken of us

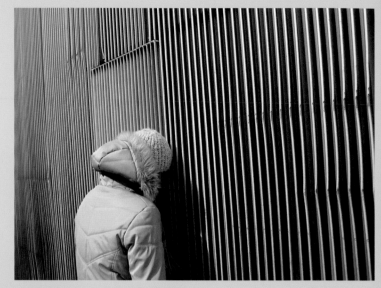

www.fotolog.net/**eshepard**/?pid=6501142

parsnip @ 2004-02-20 11:40 said:
sad i think, but great shot

kdunk @ 2004-02-20 11:55 said:
i call this one 'kdunk's rough,
rough day yesterday'

nosuchsoul @ 2004-02-20 13:06 said:
aah. so kdunk is the sound her
head makes. owie ow ow.

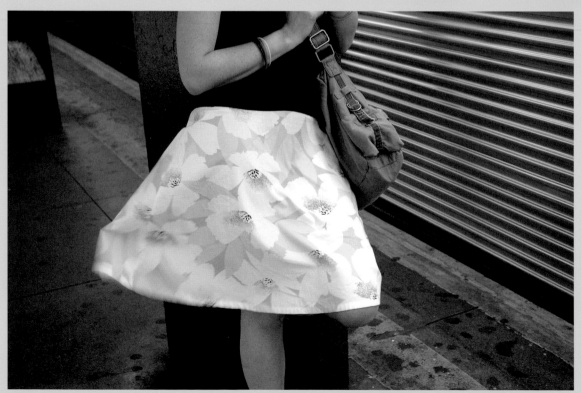

www.fotolog.net/**eshepard**/?pid=7743603

hanalita @ 2004-06-14 10:02 said:
a summer wind came blowin' in

yeah that skirt is lovely

pro_keds @ 2004-06-14 10:03 said:
happy

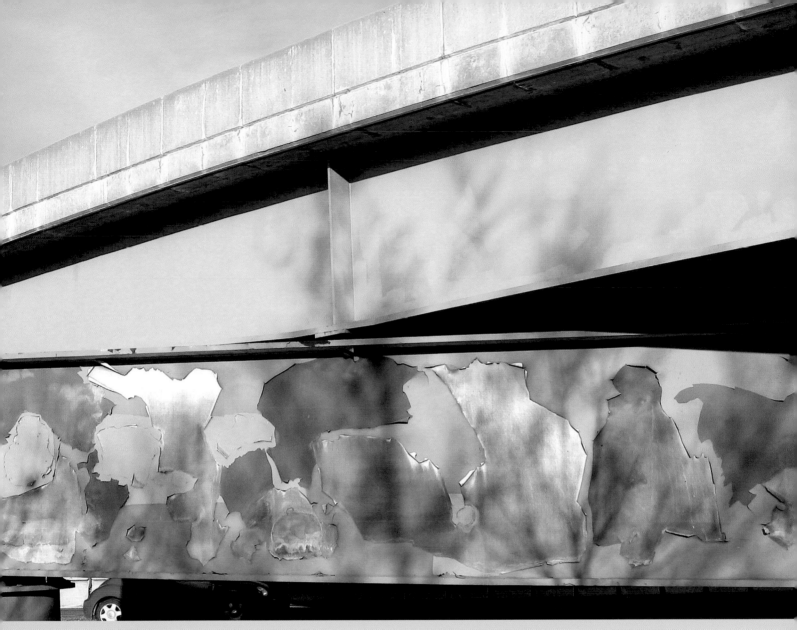

location_iceburg @ 2004-03-08 22:45 said:
the shapes lined up like a zoo display...
keen eye.

/eshepard

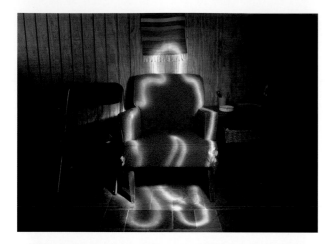

im_a_nerd @ 2003-06-26 12:06 said:
oooh. the mystery guest has arrived.

zenbomb @ 2003-06-23 13:41 said:
POW! great image...monolithic...

courtneyutt @ 2003-02-20 20:44 said:
a cake!!? that's some crazy
glow action contrasting with e's
standard yellow snow.

sk8rsherman @ 2003-02-20 20:54 said:
so, there is life on mars!!!

eshepard @ 2003-02-21 00:48 said:
my standard 'yellow snow' eh.
i'll get you for that utt

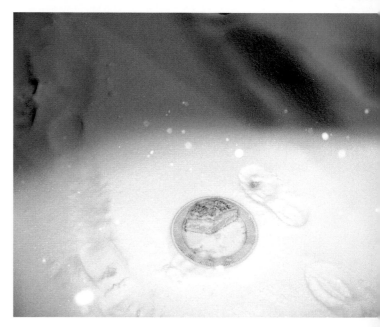

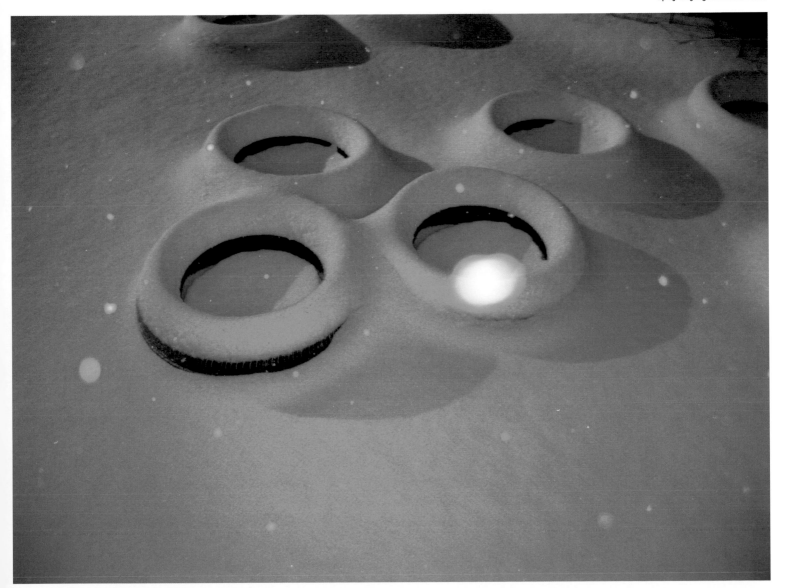

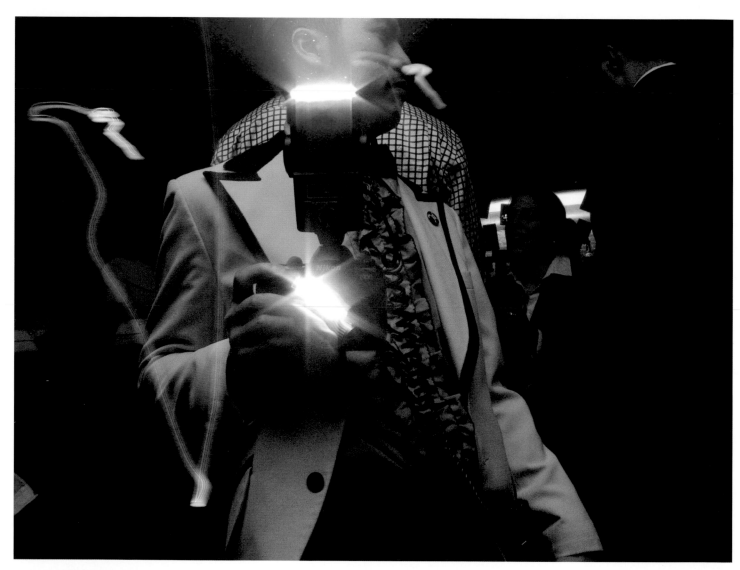

*www.fotolog.net/**eshepard**/?pid=7363169*

honeycut @ 2004-03-10 11:06 said:
suh-weet tux baby!

stringbeanjean @ 2004-05-14 09:24 said:
hehehe...i like his b-boy stance.

thechicken @ 2004-05-14 10:09 said:
Love the flarey flash on her hair. And Mr Hyde creeping up on them is killing me – or maybe the real Hyde is that hand on her hip. Or is she sinking her teeth into his neck? V. nice.

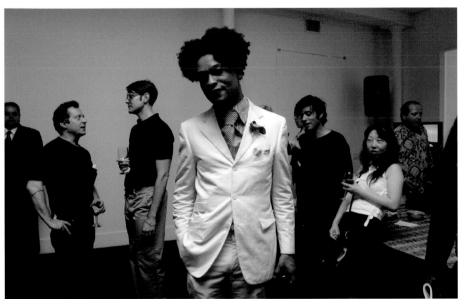

d76 @ 2004-07-29 15:28 said:
Didn't he used to hang out with Warhol?

everyday @ 2004-07-29 17:20 said:
I like that style.

youzoid @ 2004-07-29 19:28 said:
how come your life looks so clean and orderly?

golightly @ 2004-02-04 15:48 said:
cutie...and he knows it?

moredogscat @ 2004 02 04 16:12 said:
what office is he running for?

nadia @ 2004-02-04 22:37 said:
what a little big man!!! there's probably rum in that coke.

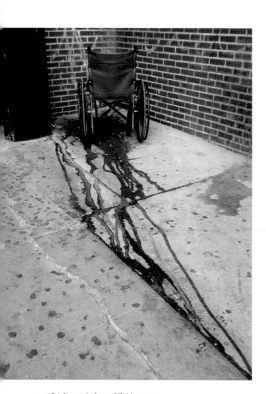

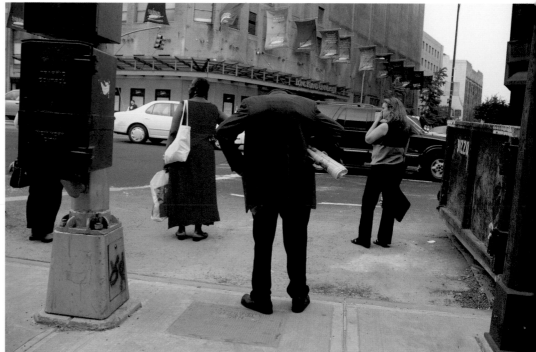

agatebay @ 2003-07-29 03:36 said:
Yikes. I haven't decided if it's funny or tragic.

beebs @ 2003-07-29 10:09 said:
such a strange find and so many options for an absurd narrative. nice.

kdunk @ 2003-07-29 12:47 said:
u scare me

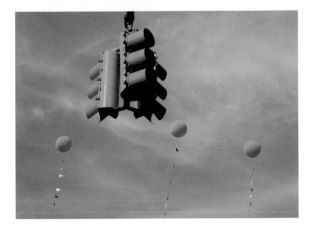

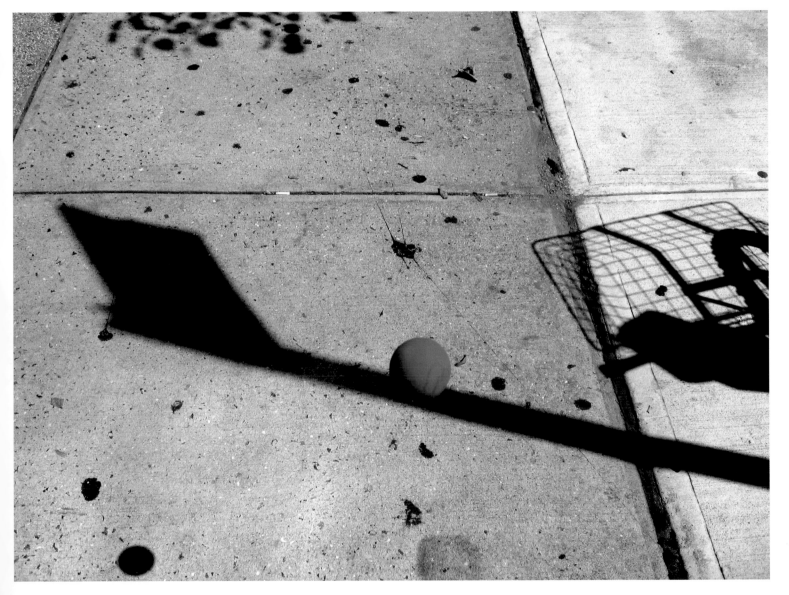

www.fotolog.net/**eshepard**/?pid=7752957

*below: www.fotolog.net/**eshepard**/?pid=3259443*

sylvia @ 2003-12-10 17:40 said:
The bird...is added in? Is a statue?
Is a really oversized bird coming to get us all?

eshepard @ 2003-12-10 17:44 said:
it is a statue

insurgente @ 2003-12-10 18:09 said:
this is surreal, great capture.

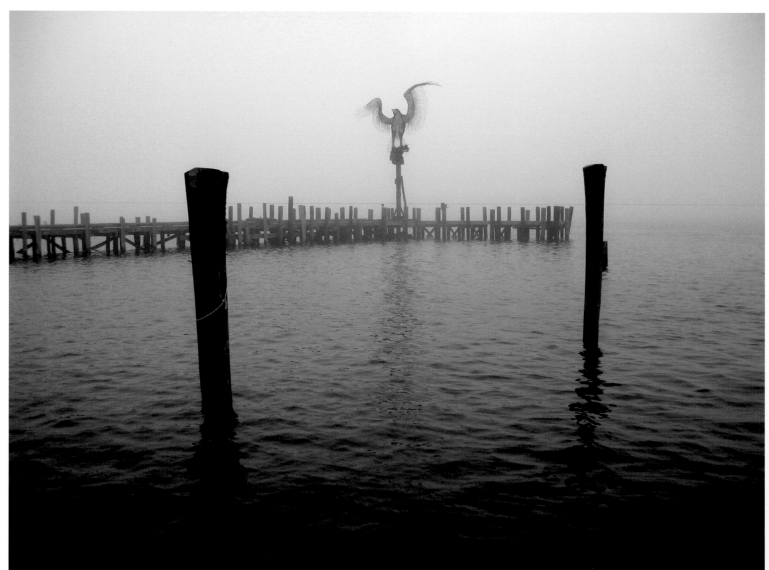

mashuga @ 2004-03-29 20:13 said:
Really nifty!! Spatial drawing

jopalane @ 2004-02-18 14:53 said:
like silver

u4eah @ 2004-02-18 15:08 said:
Like a thick, crinkly sheet of black plastic over a
dirt mound...or a huge chunk of shiny obsidian.
Makes me think of my swimming/breathing
underwater dreams...want to dive in,
it's not cold in dreams.
Love how the light dances about
the surface, this has such life.

kaleidoscop1k @ 2004-02-18 15:18 said:
liquid or solid?

tank_engine @ 2004-02-18 15:58 said:
water or steel?

mindyhertzon @ 2004-05-07 11:26 said:
Mystery pool player!

along @ 2004-05-07 11:29 said:
faceless eddie felsen

dirtdirt @ 2004-05-07 15:21 said:
it's better to burn out than to fade away...

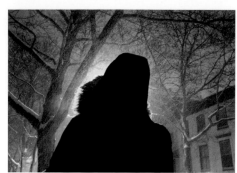

milfodd @ 2003-02-19 00:29 said:
Wow...

heif @ 2003-02-19 00:38 said:
dang

angelagarcia @ 2003-02-19 07:37 said:
splendorous!

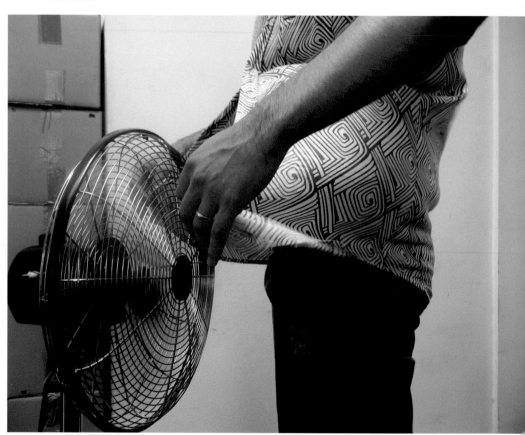

t_squared @ 2003-05-24 02:32 said:
cool! look at that hang time.

frisjes @ 2003-05-24 09:33 said:
i like this one. very happy

kdunk @ 2003-05-24 22:11 said:
i was happy.
when i'm happy i can jump very high.

yesterday @ 2003-09-07 18:01 said:
that's why they put guards on those things :)

5points @ 2003-09-07 20:42 said:
The fan, the shirt — neat!!

SONGS OF OURSELVES BY NICK CURRIE

IT'S 1996 AND I'M VISITING NEW YORK. My friend Eric Swenson is showing me around. He puts out a CD-ROM called *Blam!* It's pretty extreme; Eric and his partner Keith Seward believe that 'interactivity is a lie' and they program *Blam!* so that you can't quit it — you have to crash your machine to abort the Theatre of Cruelty-style sequences of aggressive black-and-white text flashing by in a HyperCard rush.

Eric takes me to St Mark's Place. There, in a cellar, is a 'zine store. I know it's a good one because alongside comics by underground 'zine scene regulars like Julie Doucet, there's the 'underground of the underground' — single-page xeroxed sheets with titles like *My Dick*. Seriously, there's some guy in a bedroom in Ohio writing a regular magazine about his own penis. 'Isn't this great?' asks Eric. I can't help agreeing. It's not so much that a 'zine about some guy's wang is exactly what was missing from my life, more that a specialist shop is made great by the obscurity, outrageousness and uselessness of the stock it carries. Surplus and variety justify the whole shebang, the whole souk. The really great record shops are the ones that can carry records you'll never buy...without going out of business. Capitalism may be at its most typical when it brings you Snickers, but it's at its most fabulous when it brings you *My Dick*.

It's 1977. I'm kneeling on the floor of the upstairs bathroom of the family house in Edinburgh. The tiny cramped space is filled with sulphurous odours and red light. I'm not in hell, but in my homemade darkroom. Learning to develop and print my own black-and-white photos has liberated me. It's not just that I can buy my Ilford FP4 film in bulk and print pearly 8 x 10s much more cheaply than if I used commercial services, but that I can take quite different kinds of photographs — private pictures, pictures just for me. Would I dare to hand in to Boots the Chemist a film containing multiple trembly shots of the pretty prostitute in Visconti's *Death In Venice*, sitting legs akimbo, wearing striped stockings, snapped from the screen of my miniature Sanyo TV when they showed the film on BBC2? No. These passionately private photos belong here on the bathroom floor. Lock the door and watch the reddish-grey images materialize slowly across the wet paper as

you tug and tong it back and forth through the pungent, amniotic developer. Home-developing and -printing: your first step towards independence.

In the late 1970s 'independence' is a buzzword in Britain. The place is suddenly full of new independent labels. They start with reggae and prog specialists like Island and Virgin, but before long the scene has diversified: there are labels fusing several genres, and labels like 4AD (the one I sign to) that are genres unto themselves. Of course, although we indie artists love the diversity of the indie label scene, we want there to be a big core, a strong mainstream that might one day notice us, welcome us in. We're not quite Freud's Primal Horde; we don't want to kill and eat Daddy. The outside doesn't destroy the inside; it balances and, ultimately, legitimates it. And in return, the inside legitimates the outside by choosing its future insider artists from its ranks. The big labels pick up the most promising acts from the indie labels, and popular daytime radio takes tips from obscure nighttime radio.

I won't name the most important gatekeeper to the world of my chosen profession. It doesn't really matter; he's dead now. I was surprisingly sad when he died; while he was alive I could never move forward in Britain because he didn't like my work. I might have remained an eternal jilted bridesmaid, a swan wrapped in cellophane, making records for the same two thousand people, if two things hadn't happened to make the terrible tragedy of exclusion less terribly tragic.

First, a thing called globalization started to take place: markets all over the world joined up, shops in one country began stocking products from other countries, and suddenly I could sell records in places as far away as Japan, where the powers that be don't necessarily agree with the ones back home. The person I dreaded (and ultimately missed) seemed to cast a long shadow as he barred the door, but it didn't cross national borders. Other doors appeared, with other people guarding them.

Second, doors started appearing with no guards at all. Digital media appeared, which not only made it possible to create records at home for almost no money, but also, with the help of the Internet, to publish and distribute work all over the world, instantly. The Web brought micropayment systems and 'disintermediation', allowing music artists to bypass labels, managers, agents, shopkeepers – in fact anyone who threatened to slice and share the tiny artist's tiny pie. My example here is music, but I could be talking about photography, writing or knitting patterns – anything that can be represented as a stream of digits.

As the costs of the digital production and distribution of cultural goods approach zero, another possibility arises. Instead of using micropayment systems like Paypal to charge for downloads, we start to consider the idea of chasing money out of the equation altogether. Why don't we all become amateurs, and just share our digital goods with each other in a kind of loose, generous barter system? Why don't we switch from a money economy to an attention economy? If you give me your attention (and God knows, lots of other people are after it) I'm already grateful for the mindshare. As for money – well, you know, I'll live. There's this phrase, 'ancillary revenue streams', which means that if I get your attention and give you something good for free, one day you might buy a T-shirt or something, and eventually some editor might notice what I do and commission me to do something for money. If that doesn't happen, there's always the day job. Yes, I'll do something else to make a living, but I'll do what I love to do for love, and you'll love me for sharing it with you – and that will give meaning to life for both of us. The word 'amateur' contains the Latin word for love, after all: *amo, amas, amat, amamus, amatis, amant*.

Karl Marx said a lot of sensible stuff about work: for instance, people should give according to their ability and take according to their need, labour shouldn't be divided, and the worker should enjoy the fruits of his labour while controlling the means of production. Did Marx envision type-workers setting their own thoughts in type, which is what happens every day with self-publishing systems like Moveable Type, Blogger and

LiveJournal? When I publish my blog, am I a diarist who happens to be publishing, a publisher who happens to be expressing myself, or just a person communicating with people? What would Marx make of Fotolog and Fotola and Flickr, systems that allow you to publish your photos to the entire world almost instantaneously? Don't they let us control the means of cultural production? Sure, someone owns these systems, but they're free to use.

Are these self-publication systems out of their 'beta' versions yet? What does 'beta' mean? It may be something like, 'For now this self-publishing system is free because we want lots of people to use it. The attention you're now giving these pages every day is the important thing; that's what gives them value. When millions of people are coming here every day, then we'll figure out a business plan that makes that value pay.' But what if everything stayed in beta forever? What if the idea that 'eventually it'll pay' were like the little message on British banknotes: 'I promise to pay the bearer on demand the sum of five pounds'? If you take this promissory note into a bank, and demand it, they must give you something 'real' – gold or silver – to the same value. But nobody takes a banknote in and asks for its equivalent in precious metal. That's not what's real; what's real is that we all work together, and the trust system of currency works in society. Money is fiction, but attention and community are real. Why not be an amateur? Why not write for love, photograph for love, sing for love, publish for love? It's more real than money.

Amo, amas, amat, amamus, amatis, amant.

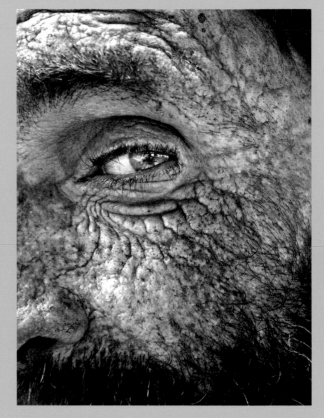

www.fotolog.net/*mashuga*/?pid=3923197

12/26/03

Homeless, fenced parking lot
under some freeway bridges passing
through downtown Miami.

'Sam's Eye'
I can see myself.
Sam is fifty-one years old and has
been on the street ten years.

dalbertazzig @ 2003-12-26 19:36 said:
No words, your photo says everything...
Nice shot, you open our eyes for the world.

lucycat @ 2003-12-26 19:46 said:
I feel so sad about Sam's condition. The photo of his
hands yesterday nearly brought me to tears, and
now, to see his face...He is so desperately in
need of a bath, a place to take care of his poor,
beleaguered skin. But for whatever reason,
he can't get it. It's just too sad for words.

tienna @ 2003-12-27 05:22 said:
The picture is a proof that what you really are is not
the outside but the inside. You can see it in his eye.

xpatriot @ 2003-12-27 13:13 said:
This is truly powerful. Your pictures often
haunt us, and this one is no exception.
Thanks for being our conscience.

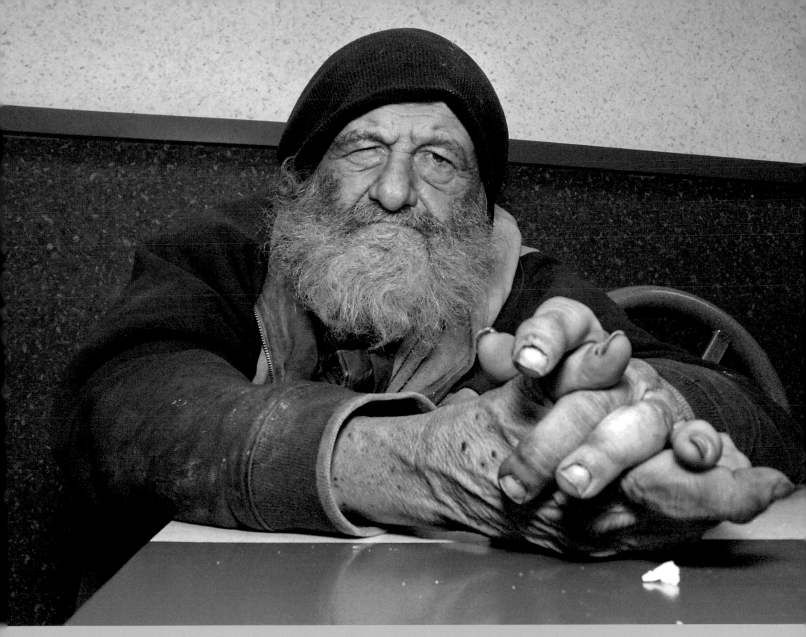

11/25/04
Homeless, McDonald's, 7th Ave. & 47th St.,
New York City.
'Wyatt Earp' He quoted Will Rogers:
'I never met a man I didn't like.'

thomas_simon @ 2004-11-25 14:12 said:
you help me to be thankful

andesfinito @ 2004-11-25 16:37 said:
why is it that seeing this image makes me forget (what
i consider) my problems and misery? it's like looking at
a cautionary tale that reminds us of the fragility of the
developed world we live in. even though i don't like
thanksgiving, i can give you thanks, not just today but

every day, for bringing these stories to my life,
through the sterilized screen of my computer. it's
much easier to examine the details of a story from
a distance. i can't help but point out the irony.
good work.

mr_worker @ 2004-11-26 23:33 said:
this is an outstanding portrait, in the context of this
photoblog as well as the whole genre of portraiture.
tight composition and playful perspective, and such
a strongly stoic expression on wyatt's face that the
heart almost leaps out to shake his hand.

very apt image for thanksgiving, though the same
could be said of most of your portraits.

/mashuga

www.fotolog.net/**mashuga**/?pid=9167892
09/29/04
**Homeless, Astor Place,
New York City.**

'Ian' When I saw Ian he had been in
New York for one week. He'd been on
the road for four or five years. He said
he was originally from Vermont and
had been kicked out of his home. The
fruit he is holding was just given to
him by a passerby. As I got up to leave,
two policemen told Ian to move on.
Ian had been panhandling. I turned
and snapped a couple of shots of the
policeman moving Ian along. When
they saw me taking pictures they
came over and asked me if I was with
the press. When I told them I wasn't,
they told me to delete my photos. I
said I thought it was a public street
and I had the right to take a photo if
I wasn't interfering with their actions.
They replied that I had to because it
was official business. I didn't want to
get run in or my head split open over
two crummy photos, so I deleted them
with one of the cops looking at my
LCD screen. Some free country.

*hopsmaltyeast @ 2004-09-29 21:59
said:* If you had not deleted the
photos the terrorists would have
won.

I applaud your selfless sacrifice.

(In these times I feel compelled to
point out that I am joking – unless
Mr Ashcroft reads this.)

kalabrax @ 2004-09-29 22:14 said:
THAT'S A DISTURBING PIC! Beautiful
Ian...his eyes, so full of peace. It
really touched me, this picture. I'm
not sorry for Ian...I kinda envy his
freedom, wherever he is.

suitablegirl @ 2004-09-30 08:05 said:
that SUCKS. it's even worse if you look
arab/pakistani and you are taking
pics in public. trust me. i know.

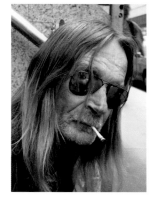

www.fotolog.net/**mashuga**/?pid=528765
08/04/03
**48th St. off 6th Ave.,
New York City.**

'Papa Rock' Originally from Houston,
Texas. I've been asked if I photograph
some of the same people over time.
This is an update to the photos I
posted of Papa Rock on 07/22/03.
He plays heavy metal guitar on the
street and likes groups like Guns and
Roses and Metallica. He came to New
York to make it as a photographer.
His F1 Canon camera is in a pawnshop.
I get the feeling he prefers music.
He wants me to come back and
photograph him with a new guitar
he dreams of.

kunja @ 2003-08-04 15:32 said:
Grizzled. Love that hand-rolled
cigarette. Papa Rock looks like Kid
Rock in 30 years. Always wonderful
photography.

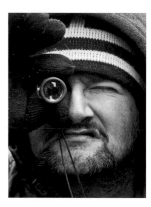

www.fotolog.net/**mashuga**/?pid=10451355
01/06/05
**Homeless, Near Union Square Park,
New York City.**

'Larry' Larry close up with a
monocular scope (a mini single lens
telescope for viewing distant objects).
I usually know where to find Larry
and spent some time with him and
some of his friends on the street.
Larry had this monocular which he
uses to scout the area and see what's
happening around him. I've been
posting pictures and updates on
Larry for quite a while.

buster @ 2005-01-06 15:12 said:
i love the way you see individuality
in all these people most of us walk
quickly away from not wanting to
notice anything. thank you, again,
friend, for encouraging us to look,
to see, to feel. hello, larry.

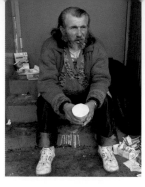

www.fotolog.net/**mashuga**/?pid=10296420
12/22/04
**Homeless, 8th Ave. & 41th St.,
New York City.**

'Steve' I've talked to Steve before,
though not for a long time. He is
very hard to understand as he has
a thick Italian accent. He said he's
been on the street 'a long time'
and that 'work comes and goes,
life comes and goes.'

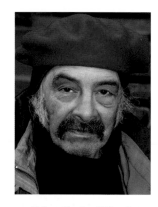

www.fotolog.net/**mashuga**/?pid=2567235
11/23/03
Homeless, New York City.

'Carlos' Carlos is seventy-one years
old, and says he's been on the street
longer than he wants to remember.
He participated in the Martin Luther
King civil rights campaign, and was
involved in the 1969 occupation of
Alcatraz. He turned down a university
teaching position. Carlos is on the
street after his brother cheated him
out of money to be used for purchasing
an apartment. He has no alcohol,
drug, or psychological problems.

djen @ 2003-11-23 00:31 said:
Hi Mashuga. I respect Carlos' desire
to live on the streets but just don't
understand it. It's as if it's payback to
his brother, yet it hurts Carlos more.

You have that understanding, which
is good. As many have told you, you're
doing a great service by making us
aware...not all homeless people were
cut from the same cookie cutter.

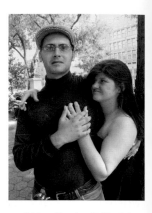

www.fotolog.net/**mashuga**/?pid=9280829
10/08/04
**Formerly homeless, Union Square
Park, New York City.**

'John and Eunice' I first introduced
you to John and Eunice on 12/01/03
(www.fotolog.net/**mashuga**/?pid=2912154).
They had been on the street for a long
time. I wrote: 'John and Eunice are a
couple who are engaged to be married.
"Time to be determined, maybe in the
spring." Eunice told me they've been
engaged about two months, and that
they first met on Avenue C. Eunice is
thirty years old and John is twenty-
eight. Eunice has been on the street
thirteen years and John two.'
I just recently met up with them and
they are now off the streets and living
in an apartment in NYC. They are
married and expecting a child, due
around Christmas time. They are both
clean and sober, and in a methadone
treatment program. I was really happy
to hear all this good news. While I was
talking to them a woman came up and
asked them if they were registered to
vote. They were signing up as I walked
away. Who would have thought?

*bubblesthebug @ 2004-10-08 21:20
said:* wow, that was actually a
touching story. I hadn't thought
I'd ever find something like this
on Fotolog. Thanks for putting it
out there.

tabula_rasa @ 2004-10-09 04:16 said:
I love it when there is good news
reported on your log...it happens
so rarely, but it is extra sweet when
it does.

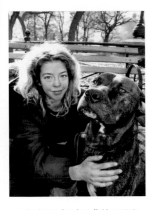

www.fotolog.net/**mashuga**/?pid=2798364
11/28/03
Homeless, Union Square Park, New York City.

'Rachael & Joey' Rachael is twenty-four years old, and has been on and off the streets since she was fourteen. She is originally from Manhattan. She is a heroin addict and has been shooting since she was fourteen. Rachael told me she had gone through a detox program and is down from twenty bags of heroin a day to three. I asked her what she was going to do for the winter and she told me she would spend it in Indiana with her husband. He is a chef and not on drugs. They have no children.

zyphichore @ 2003-11-28 23:28 said:
this is selfish, but what scares me is that this could happen to anyone. i notice this once in a while. if somehow you find yourself on 'the other side' you immediately become invisible. you can't do the things other people do...walk into a store, have a cup of coffee & watch the world go by, or even find someplace private/locked just to sleep...

mashuga @ 2003-11-28 23:49 said:
zyphichore: You have it exactly right. They are invisible. When I spend time with the people I photograph I become invisible too. I have known this and felt this since I started this work. Some of it has to do with the fact that they scare the hell out of most people. It is easier to walk by or ignore them out of fear or indifference or disgust than it is to engage. Most people don't know if they will be attacked or asked for something or have an unpleasant experience with them, for they are an unknown. Yes invisible. I have moved back and forth many many times...and you're right, it makes simple things so much harder for them.

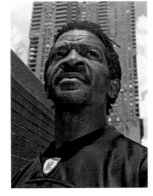

www.fotolog.net/**mashuga**/?pid=8129156
06/16/04
Homeless, 'Open Door' Drop-in Center, 9th Ave., New York City.

'Gerald' Gerald is forty-eight years old and originally from Michigan, and has been on the street for five years. He is a high school graduate. Gerald is a veteran who served in, and was wounded in, Vietnam. He recovered and then stayed in the military for a total of seven years, where he became a drug addict. He said, 'I learned that the U.S. government makes the most potent morphine in the world. That's how I became an addict.' Currently he receives no military benefits. He has gone through drug detox and is completely clean. I asked him what he would like to say here and he said, 'I wish this country loved us as much as we loved it.'

justmouse @ 2004-06-16 17:22 said:
a tired man refusing to look anything but proud.

hopsmaltycast @ 2004-06-19 17.43 said: One of your best shots (and that is saying a lot). Very dramatic. Fits Gerald's story very well.

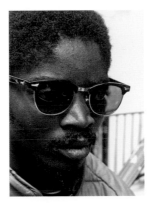

www.fotolog.net/**mashuga**/?pid=7719552
04/13/04
Homeless, St. Marks Place, New York City.

'Pape' Pape is twenty-four years old from upstate New York. He has been on the street for five years. Pape is from a family of eight children and is a high school graduate. He's just been moving around, sometimes staying with friends, and is on the street 'by choice...I like being outside.' I asked him if he wanted to say anything here on the log and he replied, 'If you have anything of value, keep it, hold on to it.' Pape said that he sees his family once in a while.

mr_walker @ 2004-04-14 08:29 said:
it may just be the glasses, more likely the gaze, but he looks like a poet. hang in there, pape, and stay cool.

kmv2 @ 2004-04-15 23:24 said:
You should have given him directions to McDonald's, so that he could fill out a job application. Or, even better, if he likes being outside, he could work on a construction site or maybe do landscaping?

If I was a detriment to society, it wouldn't be 'by choice.' He's obviously fooling himself.

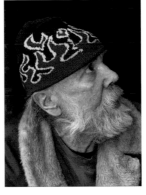

www.fotolog.net/**mashuga**/?pid=7058145
03/01/04
Homeless, 'Reach' Drop-in Center, Wilkes-Barre, PA.

'Steve' Steve is fifty-five years old and originally from Reading, Pennsylvania. He's been on the street since he lost his job driving semi-trailer trucks because of alcohol problems. He was married twice and divorced and has grown-up kids he doesn't see. Steve has an artificial leg he told me he lost when he was hit by a train. He quit drinking and doing drugs for about five years but started again six months ago. Steve and some other men were squatting in an old building until a building inspector condemned it and the police forced them out. I don't know where he's staying now.

fernandofiuza @ 2004-03-07 16:58 said: this sir, despite everything that has passed, seems a king

pamelaadam @ 2004-03-25 14:46 said: he really does remind me of king lear

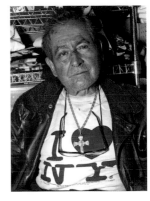

www.fotolog.net/**mashuga**/?pid=8145820
06/18/04
Homeless, 9th Ave., New York City.

'I Love New York' Albaro is seventy-three years old from Colombia, South America. He has been on the street for four years. I was taken to meet him by another homeless man who I had met the day before. Albaro was crouching on the floor in the corner of a Hispanic grocery store on 9th Avenue. The owner of the store and his wife have taken on the job of helping some of the homeless men in the neighborhood. This was the case with Albaro. They translated from Spanish for me, and I learned that Albaro had recently been beaten up on the street for his money. You can see some of the wounds on his face in this photo. The couple that runs the grocery now hold money for Albaro and some of the other men to give to them so they won't have it stolen, or so they don't drink it all away. I truly admire this couple for the help that they give these men. It's so rare. I asked them to ask Albaro if he wanted to say anything here and they translated, 'I love my country and the United States very much.'

neene @ 2004-06-18 21:27 said:
the humanity of this image and of the story match what you can see in this man's eyes

norax @ 2004-06-19 01:35 said:
It's amazing the optimism shown by some of your subjects – regardless of their situations. I'm sure it makes a lot of us appreciate our comfortable lives more. Well I hope it does.

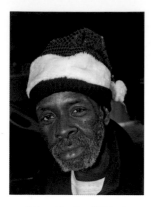

www.fotolog.net/*mashuga*/?pid=10309719
12/24/04 Homeless, 'Open Door' Drop-in Center, New York City.

'Laddie' Laddie is sixty years old and from Philadelphia. He has been on the street for about two months. He left home to get away from 'people selling drugs all around him.' When I asked him what he wanted to say here, he replied, 'Merry Christmas to all the people from September 11th and the homeless.'

smiling_da_vinci @ 2004-12-24 17:17 said: Merry Christmas, Laddie and all the other homeless people that we started to care about, thanks to you, Gary. I wish you and your loved ones a wonderful Christmas.

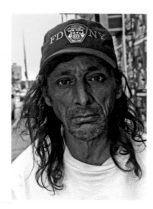

www.fotolog.net/*mashuga*/?pid=8220202
06/28/04 Homeless, 9th Ave., New York City.

'Emanuel' Emanuel is thirty years old and came to the United States in 1980 as one of the Cuban 'boat people.' He speaks no English and so I had to have another homeless man I know translate from Spanish to English. Emanuel was a cook in Cuba. He cannot find a job here and told me he was robbed of the papers that he did have. The translator said Emanuel is 'illegal.'

smiling_da_vinci @ 2004-06-28 13:00 said: He looks much older than thirty. He's got friendly eyes. Hopefully he will be able to find a job somehow. It sucks that his papers were stolen.

mashuga @ 2004-06-28 13:04 said: I'm relying on the translation that he is actually thirty. He looks older than that to me as well.

mr_walker @ 2004-06-28 22:16 said: unusual, if he is an 'illegal', that he let you take his photo. perhaps it's a measure of the trust he puts in you, perhaps he's beyond caring, perhaps he wonders what i wonder – would life be better or worse back in cuba?

beautiful portrait. inquisitive eyes.

below: www.fotolog.net/*mashuga*/?pid=389231
07/17/03 Homeless, St. Marks Place, New York City.

This series of photographs is titled 'Essential Humanity.' I almost never say this here, but I guess it must be obvious by now that many of the stories and images affect me greatly. I shot photos all day yesterday in NYC, and as usual it takes me days to shake it off, if one ever really can. Sometimes, certain stories and people really touch me in a special way, and I can't get over them.

'Emma' Emma is from France. She was recently released after eight months in jail. Before that, she was on the street for a year and a half. She is addicted to crack cocaine, and works as a prostitute to support her habit. When she was telling me her story, her eyes filled with tears and she wept. She told me, 'I had it all. I was married to a French fashion photographer and had a child.' Because of her addiction, she just left, walked out on them. She said, 'The only time I'm clean is in jail or in detox.' After she was released from jail, she had some money. She rented an apartment but never moved in. She just went back to the street.

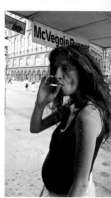

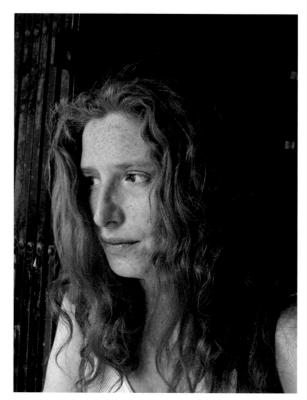

location_iceburg @ 2003-07-17 20:44 said:
great story...I can almost see her in her lucid, clean times through your photo...she is very beautiful.

neene @ 2003-07-17 20:53 said: 'There but for the grace of God...' One thing that this log (through both images and words) has done for me is to lessen that line between 'us' and 'them.' It has fed both my sense of compassion for the tribulations of others and my feelings of gratitude for what I have been given. These things in turn have enriched my life and hopefully increase what I have to give back. Thank you for this.

electrokate @ 2003-07-20 19:11 said:
It is said that an addict cares nothing for a job, a home, a family, they will steal and sell anything for a fix and feel not a whit of shame, they are oblivious to the pain they cause to those who love them and they can never get free. None of this is true. You feel everything and simultaneously have no strength to stop. I probably started because I wanted what I was told

the drugs would give me – no more ache of loss, no more loneliness, no more despair, just this warm oblivion and pursuit of MORE. Not true. How did I quit? I do not know. First I had to know it was possible to quit. Then I had to know nothing worked and the drugs wouldn't even kill me. Why am I free?

I didn't ultimately use doctors, they didn't think they could help me anyway. No detox or AA meetings. I don't know why. I feel for her all the more for this reason. I don't know if anyone can help her and I don't know when she will stop.

*opposite, top right: www.fotolog.net/**mashuga**/?pid=8255751*
07/03/04 Homeless, St. Marks Place, New York City.

Emma's story affected me quite a bit, and I have thought a lot about her and how she's doing. I hadn't seen her since last summer, although I did look for her. Nobody seemed to know anything about her until I ran into a young woman who said she'd been hanging out smoking crack cocaine with Emma. After she filled me in I left her, saddened. I ran into this same woman the next day and she told me that Emma was at the local McDonald's. I quickly went to the restaurant and found Emma sitting there. We talked a while and I took a few photos. Things are going very badly for her. She is five months pregnant and smoking crack cocaine very heavily. She really doesn't care what happens to her or the baby. I asked her what she was going to do. She just shrugged her shoulders and said, 'Maybe next time I see you it will all be over.'

Francaise @ 2005-02-04 10:12 said:
Thank you very much for your work...Is there any news about 'Emma'?

mashuga @ 2005-02-05 15:42 said:
Francaise, I have not seen her, but I'm told she is inside for the winter. Her baby died one week after being born, of a heart attack. I don't know for sure as it is street information. Thanks!

*opposite, below right: www.fotolog.net/**mashuga**/?pid=8262439*
07/04/04 Homeless, St. Marks Place, New York City.

'Emma' We stepped outside McDonald's and she posed for me. At one point she said, 'Do you want to take my profile?' I took that to mean her pregnancy. This was difficult for me. I took the photo, but was thinking all the while about how tragic her situation is.

eliahu @ 2004-07-04 19:04 said: this is one of the hardest to take, and that's saying something

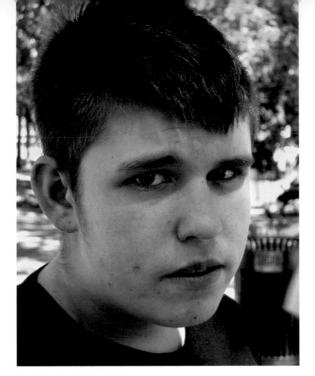

*www.fotolog.net/**mashuga**/?pid=980870*
09/10/03 Homeless, New York City, Union Square Park.

'Billy' Billy says he's seventeen years old. He's living in Union Square Park. He never knew his mother, and his father has thirty-seven years left to serve of a prison sentence. Billy was being raised by his grandparents. They died last year. He then went to live with a foster family, but disliked living there so just left. He told me he has a job as a mechanic waiting for him in Los Angeles. I asked him how he was going to get there and he said, 'Hop trains.'

smiling_da_vinci @ 2003-09-10 17:57 said:
I wish Billy all the luck he needs. He looks like a scared little boy. I wish I was there for him to guide him.

lizo @ 2003-09-11 16:53 said:
How is it you can walk away from all these people? One, you walked up in the first place, and then you talked to them and heard their stories. My heart just aches for this boy, and I wonder if he will make it to LA.

mashuga @ 2003-09-11 17:17 said:
In response to lizo, I always try to help. I don't just take a photo and leave. As to Billy I offered to help him. I also offered information about youth shelters and help agencies. He refused. I tried to talk reason with him. I ended up giving him some money, offering help again, and finally wishing him luck. There is nothing easy or satisfying about this. My instinct is to take him by the collar and force help on him but that doesn't work. I get very frustrated, emotional and exasperated when I can't do anything time after time. Every once in a while I can help. All I can do is keep going. I guess it's better to try to do something and fail, than do nothing. Argg. Moral dilemmas stink. I wish I had a magic wand to fix all the horror I encounter. I don't.

*below: www.fotolog.net/**mashuga**/?pid=4823100*
01/16/04 Still Homeless, Astor Place, New York City.

I've been looking for Billy on the street for months now, and finally ran into him hanging with a bunch of his friends on Astor Place. He recognized me, and said he had seen his photo on this log. He seemed happy to see me, and agreed to let me take some new photos. He told me he had moved around and had been staying with friends on and off. The rest of the time he has been on the street. Billy didn't say anything related to his plan to go to Los Angeles from last summer. This day, he said he had been drinking and was 'pretty drunk.' I usually don't make a whole lot of observations here on my log, but it's pretty obvious that the street has taken hold of this young man, and that somehow we've let him down. He is slipping through the cracks, or should I say caverns.

foxglove @ 2004-01-16 19:41 said:
in the earlier photo he looks like a frightened boy; now he looks like an angry young man. nobody should be surprised i suppose.

iamaspod @ 2004-01-17 07:50 said:
I lived on the streets off and on for years. I know what it's about. Putting on that facade. Trying to stay tough. You've only got yourself out there, even when you have friends. Take care, Billy! And don't let the streets take your soul.

*bottom: www.fotolog.net/**mashuga**/?pid=8722887*
08/23/04 St. Marks Place, New York City.

On my recent trip to NYC I saw Billy sitting on a staircase with a friend. We exchanged a few comments. The most important thing he told me was his plan to leave New York in a few days for California. He said he had a bus ticket but didn't know what he would do when he got there.

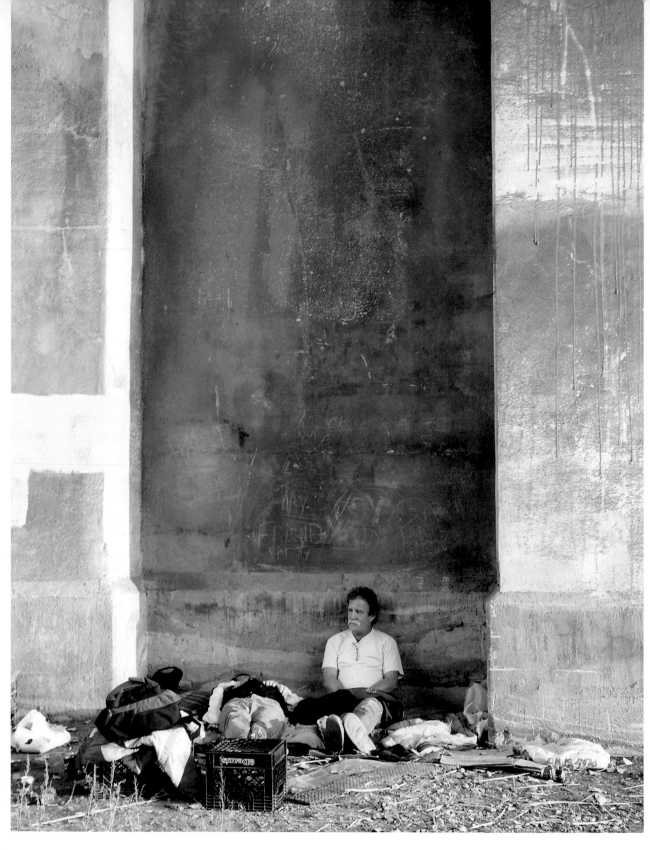

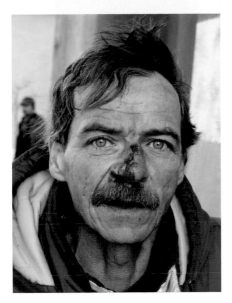

www.fotolog.net/*mashuga*/?pid=2147028
11/09/03
Homeless, Under the South Street Bridge,
Wilkes-Barre, PA.

*'Bobby' I was going to wait a while to share this picture
with you, but I decided to start this series off with
this one, because of the compelling nature of it. I have
spent three afternoons lately under the bridge sitting,
lulking and getting to know some of the residents who
call this place home, temporarily. Bobby is one of them.
Bobby is forty-four years old and has been in Wilkes-
Barre seven years. He has been on the street six years
and drinks a lot. His friend Paul lives there as well. I will
share some pictures and ideas from Bobby and Paul over
the next few days. Other people come and go. The guys
there have made me feel welcome and have told me
many things from their hearts. Bobby is a veteran of
the Navy. The bloody nose happened after he fell while
drinking. Paul wiped it with vodka because there was no
water to be had.*

crabber @ 2003-11-09 19:21 said:
ouch. some compelling eyes i cannot for some reason
stop looking into.

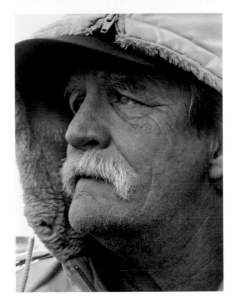

www.fotolog.net/*mashuga*/?pid=2239055
11/12/03
Homeless, Under the South Street Bridge,
Wilkes-Barre, PA.

*'Paul' I was taking notes in a little notebook. Paul asked
for my pen and the notebook. He wrote something in it,
handed it back and said, 'Look at it later.' It said,
'Somebody help us.'*

location_iceburg @ 2003-11-12 19:27 said:
it's hard to escape...dig deep, prayer, discipline, and
a helping hand...booze and drugs dig deep and don't
want to let go.

smiling_da_vinci @ 2003-11-12 20:15 said:
He looks like a lost sailor on an endless ocean.

below: www.fotolog.net/*mashuga*/?pid=6865527
02/27/04
*****Help! Please!*
*I've never asked anything of you before, but I'm
asking now. Some of you that have followed this
log may remember Paul.*

Homeless and ill, Wilkes-Barre, PA.

*Paul is very very ill, and in the interest of his privacy I
won't disclose the details here, but trust me it is very
serious. He has been in intensive care for a while, and
is now in a single room. Paul is alone except for a few
friends from the street. I would very much like to ask
you, the Fotolog community, to send him get-well cards.
Let him know that someone cares, and knows he's alive.
Please, let's make an effort to tell him that we care
about him and want him to get well. He is an intelligent
and truly nice person. Paul is also a veteran and served
us all in Vietnam. I don't know what the outcome of
his illness will be, but please could you send him a
message of hope. Thank you in advance. I truly
appreciate your help.*

eliahu @ 2004-02-27 20:40 said: mailed a card this pm

cronai @ 2004-02-28 01:15 said:
What a great idea, Gary! Card from Rio will be on the
way on Monday...Cheers!

opposite: www.fotolog.net/*mashuga*/?pid=2179679
11/10/03
Homeless, Under the South Street Bridge
(#1 of 2), Wilkes-Barre, PA.

*'Paul and Bobby' A few people asked to see a photo of
the view under the bridge. Here is a photo taken as I left
Bobby and Paul the first day I met them. Bobby is passed
out next to Paul.*

pandarine @ 2003-11-11 00:28 said:
Paul and Bobby, today is veterans' day. May someone at
least give you a hug and a decent meal. My heart goes
out to you.

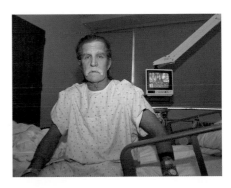

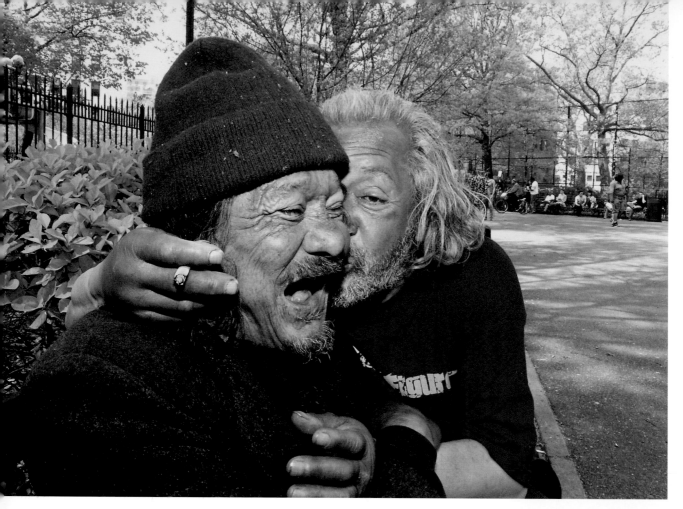

www.fotolog.net/*mashuga*/?pid=7835115
05/03/04
Homeless, Tompkins Square Park, New York City.

'Vinnie and Rabbit' I've introduced you to Vinnie and Rabbit
a number of times before. I just love to see them and spend time
with them. I have spent quite a few memorable afternoons with
one or both of them. They have been inseparable buddies for
many many years. They have a lot of stories to tell and I enjoy
sitting and listening to them. As we sat around talking, Rabbit
said to me that Vinnie and he are the old timers out here. 'Do
you know how many years we've been out here together? Over
twenty-five. I just love this old Indian, I think I'll give him a
kiss.' Vinnie laughed and scrunched up as Rabbit gave him a kiss
on the cheek. I'm so glad my camera was ready. These men take
care of one another, and watch out for each other. I know that
they are kind and good men. Yes, they have a drinking problem,
but as I've learned, that is but a piece of the total human being.
I am glad to know them and have enjoyed the time I spend with
them. I always wish them well and look forward to the next time
I see them.

justmouse @ 2004-05-03 16:35 said:
i wish everyone could see the real person behind the
face, the way you do. it's beautiful.

pamelaadam @ 2004-05-03 18:15 said:
glad the old boys have each other

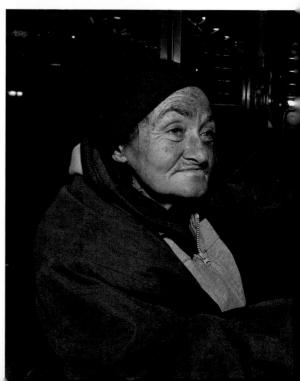

05/25/04
Homeless, 9th Ave., New York City.

*'Poppy, Tina, and Motown' We all just hung out on Ninth
Avenue talking, and after a while Motown got us singing.
We sang song after song: 'I Heard it through the Grape
Vine,' 'Last Train to Georgia,' 'Sitting on the Dock of
the Bay,' and many others. We sang and danced and
people on the street stopped and joined in. What a great
time we had. This is a picture of us singing 'Under the
Boardwalk.' It makes me smile and happy thinking
about it. Sometimes there is joy on the street.*

goon @ 2004-05-25 20:38 said:
wow that is beautiful, nice to see happy photos here!

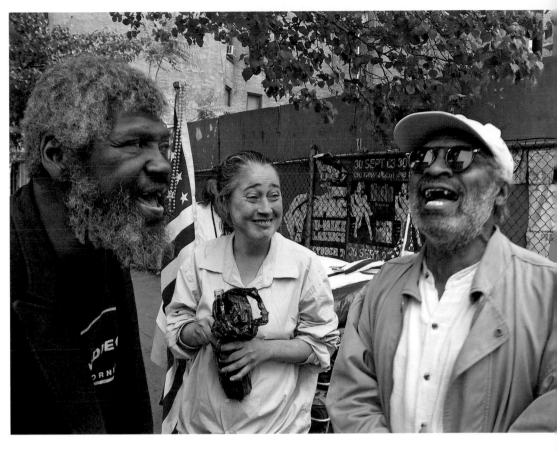

11/23/04
**Homeless, Port Authority Bus Terminal,
New York City.**

*'Monika' Monika's sixty years old and was born in
Germany, in the region that once was called East Prussia.
She said she has been on the street 'a long time' because
of political reasons, but didn't elaborate. We chatted
for quite a while. Monika is extremely intelligent and
articulate, and yes, quite opinionated. We talked politics;
she has an intense dislike of the present administration,
especially George Bush. Monika has lived all over the
world, including Paris and Rome. She speaks four
languages, and had gone to school at the Sorbonne in
Paris where she studied literature. One of the problems
that keeps her on the street is no identification. She said
it wasn't a problem about money, as her family would
send her what she needed. I asked her why she wasn't
in a shelter and she said she would not be confined by
their rules, and she did not want to associate with people
she didn't want to associate with. I really grew to like
her in the time we sat together talking. I was just
amazed at what a strong and independent person she is.
Her superior intelligence and feistiness are incredible.*

andreamurphy @ 2004-11-25 08:28 said:
her spirit is stronger than her flesh. amazing story.
her eyes are so bright. immigration should post signs
about amnesty programs for people like her so she can
show up, document herself and lead a more normal life.
i think right now they only do that for mexican folks
(no amnesty for any other cultures who just get
kicked out). all undocumented folks in the U.S. should
be treated like the valuable human beings they are.

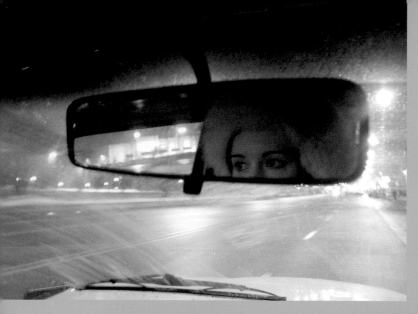

left: www.fotolog.net/**christyclaire**/?pid=9917024

julien @ 2005-01-27 10:04 said: be careful claire, with that warm comfortable hat she might fall asleep!

pro_keds @ 2005-01-27 16:34 said: scene from a forgotten movie

christyclaire @ 2005-01-27 18:49 said: julien, i'll take heed to your advice. no hats whilst driving.

left: www.fotolog.net/**nadia**/?pid=8209809

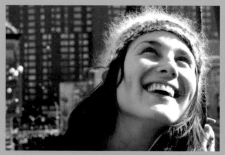

www.fotolog.net/**pixietart**/?pid=9794184

salmon @ 2005-02-14 09:38 said: fuzzy

sizeofguam @ 2005-02-14 09:44 said: dimples

dangerpaws @ 2005-02-14 17:28 said: so sweet. she is wicked cute.

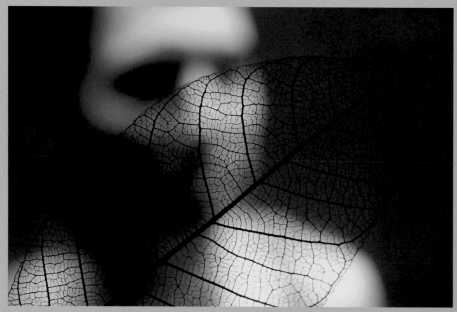

above: www.fotolog.net/**bekon**/?pid=9220000

hikaru @ 2004-12-07 18:39 said: hola como estas me gusto tu Fotolog bye bye

oz_lomo @ 2004-12-07 18:54 said: Pure art

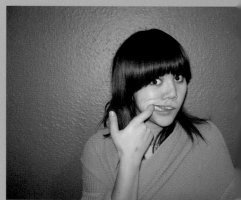

www.fotolog.net/**sucka_pants**/?pid=11345107

natamichels @ 2005-09-05 14:30 said: she's cool and fun huh. glad you got to hang out with her

natamichels @ 2005-09-05 14:30 said: DOH! that was me—sk8rsherman

beebs @ 2004-12-17 02:01 said:
LA'll do that to a guy. i like this. lots.

salmon @ 2004-12-17 09:38 said:
yer so moody

brainware3000 @ 2004-12-17 10:18 said:
phone home. wicked

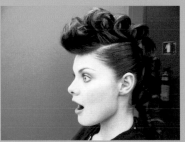

PORTRAITS

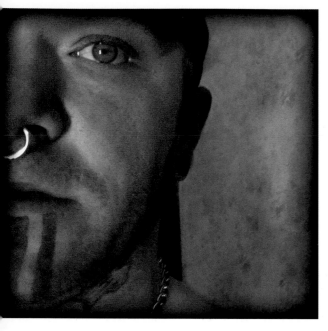

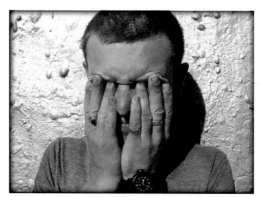

www.fotolog.net/**anomalous**/?pid=8959649
TODAY IN NEW YORK CITY
Josh is going to jail for nine months.

guyscoop @ 2004-11-06 01:28 said:
why? he voted Kerry?

anomalous @ 2004-11-06 01:38 said:
hahahaha – no, the punishment for that crime is life imprisonment, with the first 4 years in solitary confinement.

www.fotolog.net/**anomalous**/?pid=10485359

scopemedia @ 2005-04-21 23:20 said:
dude this photoblog is really nice. scoped.

paquetanto @ 2005-04-22 10:05 said: It's interesting that people always assume others are males when they don't know them. I've seen many people address you as a man in your guestbook. It happens to me as well in many internet circles...

bwd @ 2005-04-22 13:53 said: If you were a guy, I would think you were fascinated with dudes, 'cause there's so many fotos of them...Great photos, his eyes are pretty damn recessive...

anomalous @ 2005-04-22 14:24 said: I AM a guy, and I AM fascinated with dudes...

www.fotolog.net/**anomalous**/?pid=9983788

ninion @ 2005-03-02 20:11 said:
so much attitude! love it.

tangent @ 2005-03-02 20:14 said:
please tell me he was riding on the back of your motorcycle.

glitz @ 2005-03-02 20:45 said:
nice pic, you have beautiful friends... and i loved your 'about'...i'm so happy to find more intelligent people in your country :)

squishband @ 2005-03-02 21:15 said:
Wow, stunt models!

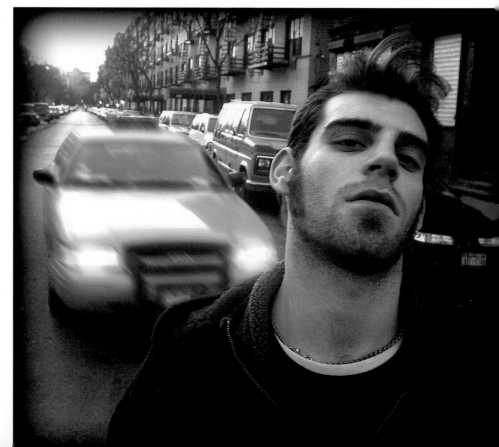

right: www.fotolog.net/**anomalous**/?pid=10943274

dansemacabre @ 2005-06-18 13:44 said:
oh beautiful.

trickybr @ 2005-06-18 14:42 said:
he looks like the coldplay guy

hiddenpendulum @ 2005-06-18 15:01 said:
...He looks like any bad boy from London really

hiddenpendulum @ 2005-06-18 15:03 said:
...hehe actually he looks exactly like
my friend...from Liverpool

cracker_cookies @ 2005-06-18 15:53 said:
Definitely looks like an english bloke.

felipezzz @ 2005-06-18 22:47 said:
TAKE A PIC OF ME

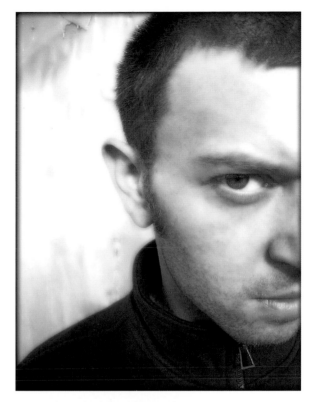

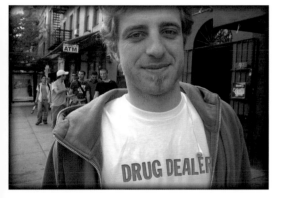

left: www.fotolog.net/**anomalous**/?pid=10676249

a43 @ 2005-05-20 19:08 said: he is the man!!!

street_fashion @ 2005-05-20 19:12 said: cool

paquetanto @ 2005-05-23 06:43 said:
I just love that t-shirt! I think I'm gonna make
one for me. You know, imitation is the purest
form of admiration.
;-)

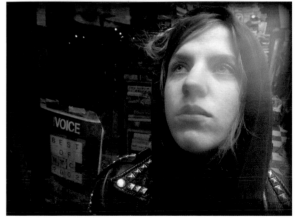

above: www.fotolog.net/**anomalous**/?pid=9652061

left: www.fotolog.net/**anomalous**/?pid=10845569
**Besides all his other virtues, he's also a great
photographer, and among the newest members of Fotolog.
Perhaps you could go welcome him? He's at:/shyspyrit**

housewifeonfire @ 2005-06-08 04:04 said: just cool!

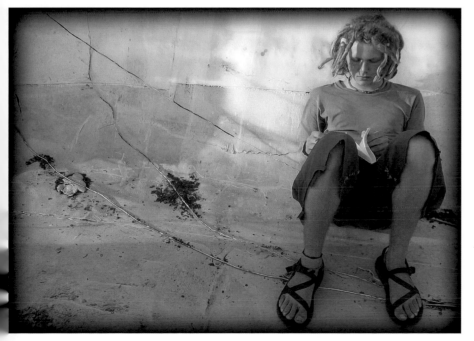

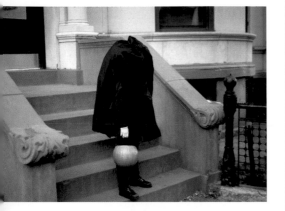

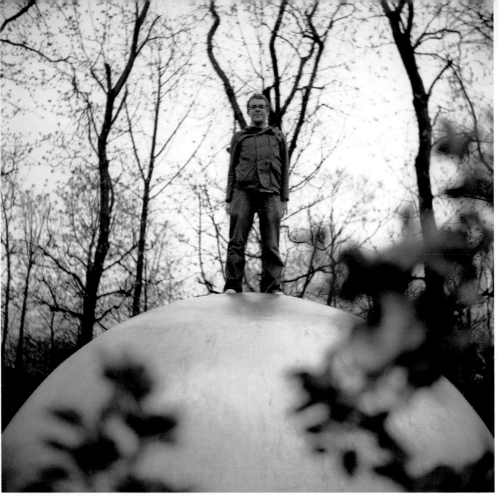

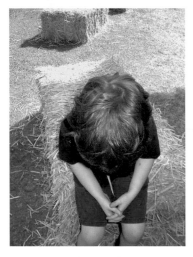

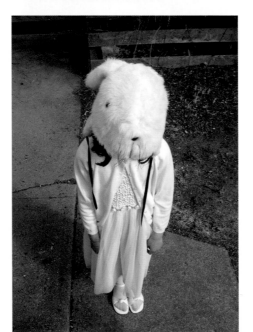

top: www.fotolog.net/**colorstalker**/?pid=1901611
Happy Halloween to all!

cbonney @ 2003-10-30 21:52 said: My mother, who usually didn't pay much mind to such occasions, once got it in her mind that I should be the headless horseman for Halloween. All I can remember is the coathanger that held the whole conceit in place constantly falling off my head and ending up wrapped around my neck. I'm happy to see the concept has evolved in a more pleasing, and less lethal, direction.

above: www.fotolog.net/**an_ge_la**/?pid=7839835

jkh_22 @ 2004-05-23 00:46 said: maybe it's a flash, but i love the pale pinkness of the skin—and of course, the red to the green...the hair to the straw. this is great.

above: www.fotolog.net/**pixietart**/?pid=12195401

quetzal @ 2005-10-29 08:25 said:
he looks wee.

paperheart @ 2005-10-29 09:22 said:
The aliens have landed

anon_ms_b @ 2005-10-29 14:00 said:
the boy on the top of the world

left: www.fotolog.net/**kandykorn**/?pid=7645287

absolutebeginner @ 2004-04-11 23:51 said:
Wonderful & adorable! I have never seen anything like it. Tell that bunny that she has a very pretty pink dress. I like it a lot.

debontekou @ 2004-04-12 14:17 said:
Wow. This could be a Diane Arbus.

omom @ 2004-04-12 22:43 said:
I once drank too much tequila and had a sight similar to this.

laurenpink @ 2004-04-15 15:36 said:
love her enthusiasm.
thank you for this one. never took the time to explain why i like it so much. and i don't think i can. bunched & bound in all those yucky, itchy-lacey easter church dresses over the years. what i would have done for that bunny head to hide.

ribena @ *2004-07-01 21:09 said:*
stellar, saucy, salty. what a portrait.

onez @ *2004-07-01 22:00 said:*
'Pippy Longstockings' gone mad – oh my!

maniabug @ *2004-07-02 17:46 said:*
awesome!! he just goes ALL the way up!

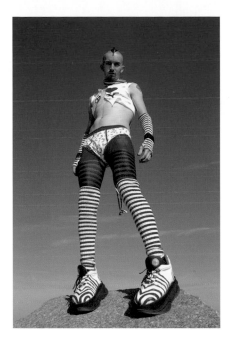

cookieb @ *2005-01-16 14:02 said:*
i can't say anything. she is too cute

jkh_22 @ *2005-01-16 14:23 said:*
the guy on the left can't either, it appears!

meadows @ *2005-01-16 16:52 said:*
great mural and an uncanny resemblance
to lulalula. must be why you posted it.

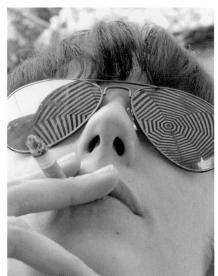

oneup @ *2004-04-22 06:20 said:*
ana stripes back! :)

oneup @ *2004-07-30 08:44 said:* i don't want to mess with her...

gardengal @ *2004-07-30 08:46 said:*
lock 'n load, sweetheart. lock 'n load.

honeycut @ *2004-07-30 09:44 said:*
the next cover of *soldier of fortune*!

world_o_randi @ *2004-07-30 10:02 said:*
that pose is *far* too natural.

sixeight @ *2004-07-30 10:18 said:* it fit like a glove...
i never knew what that emptiness was in my life until last night.

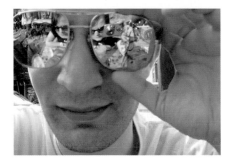

...on a mini vacation...see ya'll soon.

angelissima @ *2003-08-22 07:34 said:*
frankie boy!!!!! Have fun, hon.

frank_bklyn @ *2003-08-22 08:38 said:*
later

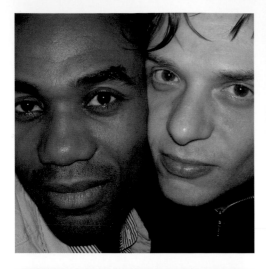

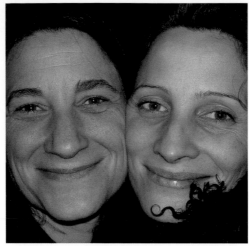

far left, from top to bottom:

www.fotolog.net/**luce**/?pid=9957645
**asia and david – thanksgiving at paige
– williamsburg, brooklyn – 25 november 2004**

www.fotolog.net/**luce**/?pid=10541537
umang and rekha – soho, nyc – 09 january 2005

www.fotolog.net/**luce**/?pid=10670266
**dustin and kevin – chinese new year at franklin station
café, tribeca – 20 february 2005**

left, from top to bottom:

www.fotolog.net/**luce**/?pid=10635403
anne and céline – geneva, switzerland – 07 february 2005

www.fotolog.net/**luce**/?pid=7963957
**shauna and hillary – cooper union students' party,
brooklyn, ny – 29 may 2004**

www.fotolog.net/**luce**/?pid=8788810
**christina and heather – bread, tribeca,
nyc – 14 august 2004**

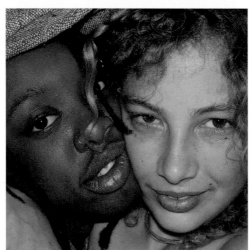

opposite, left column from top to bottom:

www.fotolog.net/**luce**/?pid=9073966
**matthias und linda – phoenix halle,
dortmund hoerde, germany – 03 october 2004**

www.fotolog.net/**luce**/?pid=10383731
**brent and britney – rubulad, williamsburg,
brooklyn – 18 december 2004**

www.fotolog.net/**luce**/?pid=7930330
**jennifer and love – 169 bar,
lower east side, nyc – 21 may 2004**

opposite, middle column from top to bottom:

www.fotolog.net/**luce**/?pid=10441588
**jeremiah and lizzy – adam dugas' chaos and candy,
deitch williamsburg, brooklyn – 21 december 2004**

www.fotolog.net/**luce**/?pid=10449938
**angela and yorgo – adam dugas' chaos and candy,
deitch williamsburg, brooklyn – 21 december 2004**

www.fotolog.net/**luce**/?pid=8102807
**jesse and paige – rubulad,
lower east side, nyc – 20 june 2004**

opposite, right column from top to bottom:

www.fotolog.net/**luce**/?pid=10482664
**bill and vanessa – adam dugas' chaos and candy,
deitch williamsburg, brooklyn – 21 december 2004**

www.fotolog.net/**luce**/?pid=9008885
**joe und hauke – phoenix halle,
dortmund hoerde, germany – 29 september 2004**

www.fotolog.net/**luce**/?pid=9181169
**katrin und christian – phoenix halle,
dortmund hoerde, germany – 09 october 2004**

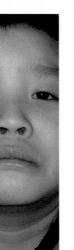

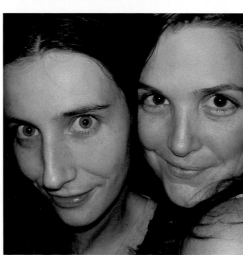

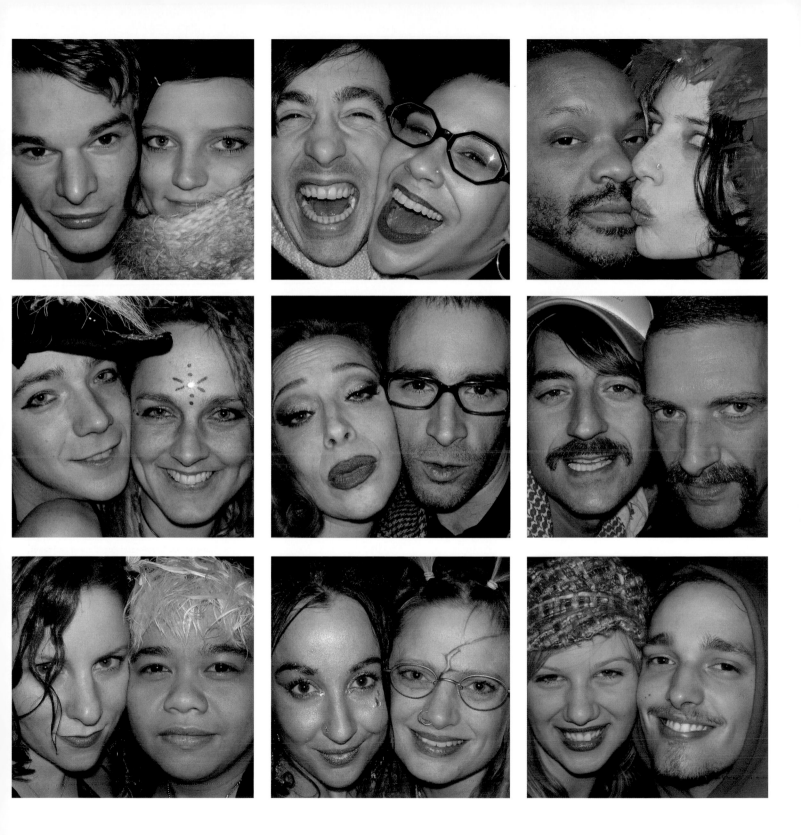

*www.fotolog.net/**quetzal**/?pid=7714556*

*www.fotolog.net/**emmy**/?pid=7775945*

digitart @ 2004-06-30 12:09 said:
beautiful are you

zoliman @ 2004-06-30 13:05 said:
perfect pastel. love the lipstick color
as a counterpoint — and in general

*www.fotolog.net/**frisjes**/?pid=7654265*

embleton @ 2004-04-08 16:03 said:
I don't think her mind is on her book!

sharonwatt @ 2004-04-08 16:50 said:
you must be a lip liner expert

*above: www.fotolog.net/**fabrys**/?pid=10265666*

ziggy19 @ 2005-08-07 17:30 said:
by the way
you're lovely
i add you
kisses from chile

below: www.fotolog.net/**snowpony**/?pid=9517956

beebs @ 2005-01-25 09:38 said:
Beautiful, e. So *A Bout de Souffle*.

www.fotolog.net/**bronko**/?pid=8360798

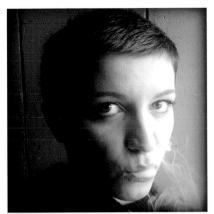

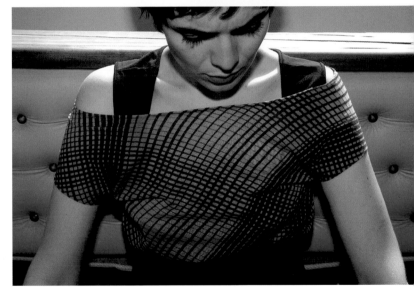

above: www.fotolog.net/**ninajacobi**/?pid=9353708

ricardo_d @ 2005-03-14 11:01 said:
What a beautiful picture, very cold.

alexandroauler @ 2005-03-14 09:53 said:
Just like in the movies! Fantastic. Kisses!

left: www.fotolog.net/**ninajacobi**/?pid=10826408

1_paralelo @ 2005-10-14 01:29 said:
You look really great with glasses!!

joaosal @ 2005-10-14 12:15 said:
With glasses...like a trendy little teacher
And is that the way you should hold a camera?
or you thought it was a cigarette?

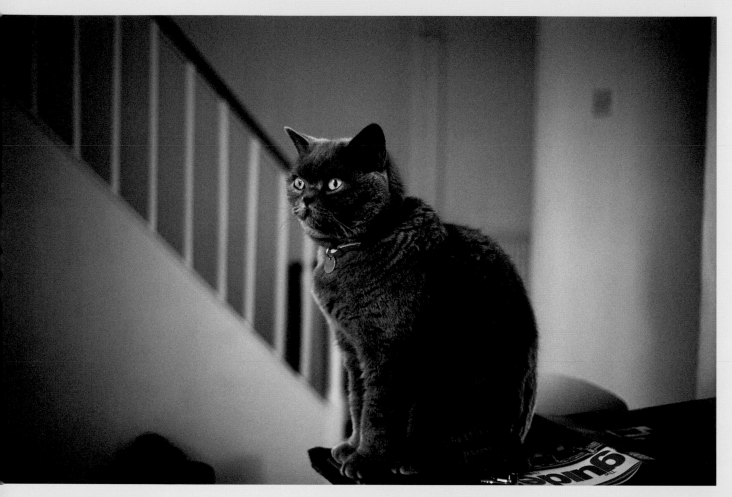

jdiggle @ 2004-10-31 05:05 said:
Will you stop mincing around and get that broomstick round the front so we can leave?!

yammy_yakkt @ 2004-10-31 20:29 said:
Perfect light, perfect cat!
>^..^>

Stand-off with a cow.

She was in the way. And she wasn't going to move, that much was certain. She was big and heavy. I looked her in the eye, and she looked right back at me. Then she began to smile. At least I think it was a smile. How can you really tell if a cow is smiling? But she saw something. She seemed to recognise me. She relaxed. At least I think that's what she did. Then she let me pass. I wonder what happened. What did the cow see in me?

auntiebs @ 2004-06-13 02:02 said:
Obviously, the cow was admiring your colors and thinking how much your wonderful black and white markings resembled one of her relatives.

flint @ 2004-06-13 13:17 said:
Joop, I think you and the cow both handled the situation very well. And you do look quite fetching together!

**She licks her tail and is absentminded...
(She is KUPPY)**

mayumlx @ 2004-09-06 02:45 said:
You work so hard for her, I am thinking
what she would dream about you.

THE ANIMAL KINGDOM

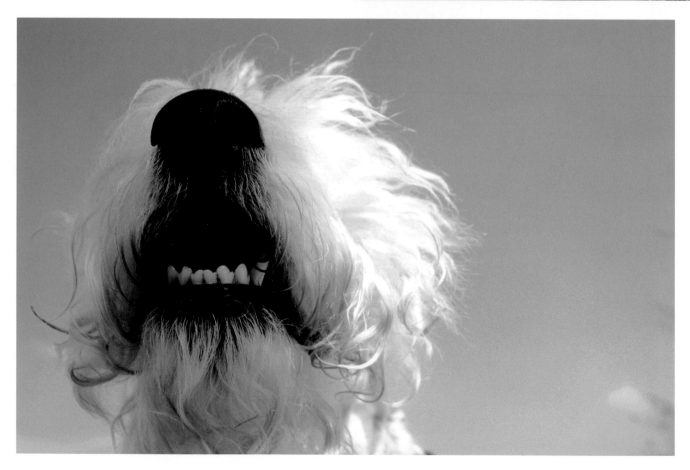

www.fotolog.net/**prunella**/?pid=78088
prunella in yella

prunella @ 2003-04-24 22:33 said:
taken in the scary guest bedroom

jef @ 2003-04-24 22:35 said:
Prunella: Dog of Mystery

kikks @ 2003-04-25 12:12 said:
my favorite dogstar!!!

www.fotolog.net/**mercyzee**/?pid=11600158
Czarma – our arab mare... :)

www.fotolog.net/**jvoves**/?pid=833339
This little guy showed up on our porch last night. Having only one way out of the house, he made it a little difficult to leave. A scared, cornered possum isn't the best thing to try and take on. He is cute though.

www.fotolog.net/**jvoves**/?pid=390981
that's my hunny

Believe it or not, this cat saved my bacon at work today

einstein2 @ 2004-10-22 21:57 said:
it looks like it ate your bacon

staciemerrill @ 2004-10-23 12:16 said:
agent 0207

along @ 2004-11-01 00:23 said:
fluffy and the fluffer?

sharonwatt @ 2004-11-02 16:17 said:
i need to take a cold shower

Rrrrrrrrrrr

keiko_v @ 2004-11-15 09:11 said:
hypnotic eyes!

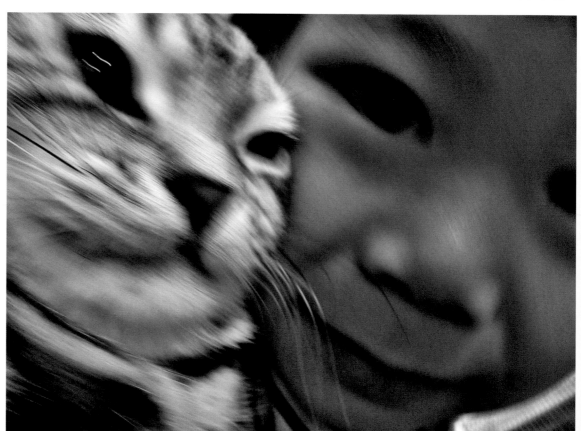

lauratitian @ 2003-03-28 12:46 said:
my mop, you've grown!

kandykorn @ 2003-11-17 07:21 said:
Mop! you're back! yippeeeee! =^.^=
super sweet photo!

joas_diary @ 2003-11-17 13:38 said:
oh, you are back! I love this series with your lovely baby
and this beautiful cat... =D

www.fotolog.net/fotocats/?pid=9069396
from www.fotolog.net/aponi

www.fotolog.net/staciemerrill/?pid=7856228
should i put him in the big apple circus?

luluvision @ 2004-05-27 08:35 said:
hahaha!! freakin' adorable! our cat is boring.
I'm worried about that light fixture falling
off tho!

www.fotolog.net/pro_keds/?pid=618716
**me and Link had a few Buds last night then hit
the streets of Williamsburg looking for some...
well, you know. we didn't have much luck but he's
hoping that the meet-up will go prrrfectly.**

www.fotolog.net/nishimuratsutomu/?pid=8670319

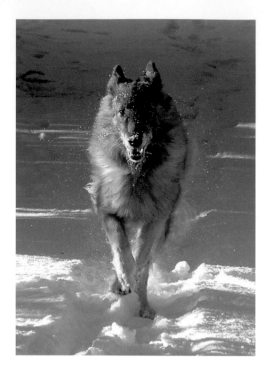

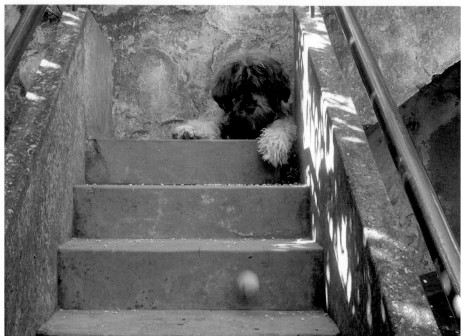

*above: www.fotolog.net/**mercyzee**/?pid=9812064*

*above right: www.fotolog.net/**johannaneurath**/?pid=8014157*

*www.fotolog.net/**joop**/?pid=7665224*
Hey everybody, listen up.

*Don't want to scare you but this is important.
In my country there's a lot of concern among dogs and
their humans about fatal cases of tick bite fever we're
suddenly having. I'm talking about Dog Malaria or 'Canine
Babesiosis' or Biliary Fever or Piroplasmosis. This week two
Dutch dogs died, in The Hague and Arnhem. Several others
are dangerously ill. There are cases in Germany too.*

*This is an infectious disease we weren't supposed to have in
the Netherlands. It's common in the Mediterranean countries,
Africa and South America, but now it's come to the North. The
disease is caused by a tiny parasite that gets in our blood
through a tick on our body. In the worst case it can kill a
dog within hours! But more often dogs get very sick first.
They lose all energy, don't eat, get a fever, their urine
turns red and they get nosebleeds.*

*There is no vaccine. The only way to prevent
this is by staying free of ticks.*

*So let's be careful. No ticks! If we remove ticks within
20 hours there's usually – in most cases –
not much danger, says my vet. Please be alert!*

*Thanks for your attention.
Have a nice day!*

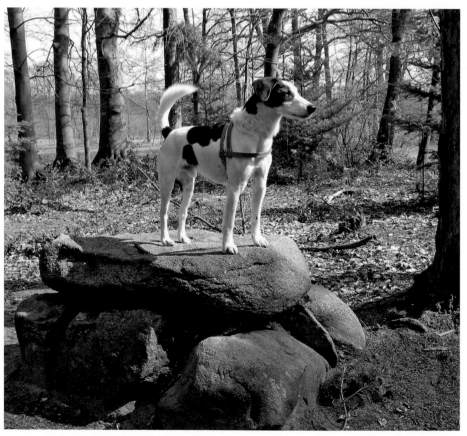

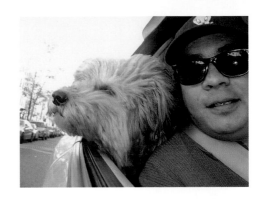

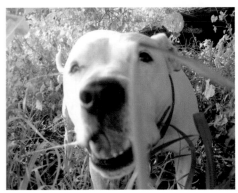

bub says: 'happy birthday dangerpaws!'

kandykorn @ 2005-03-11 20:40 said:
awww, indeed. what a sweet little birthday card this makes.

dangerpaws @ 2005-03-12 10:59 said:
BUUUUUB! thank you cookie and doggie.
you're both so sweet!

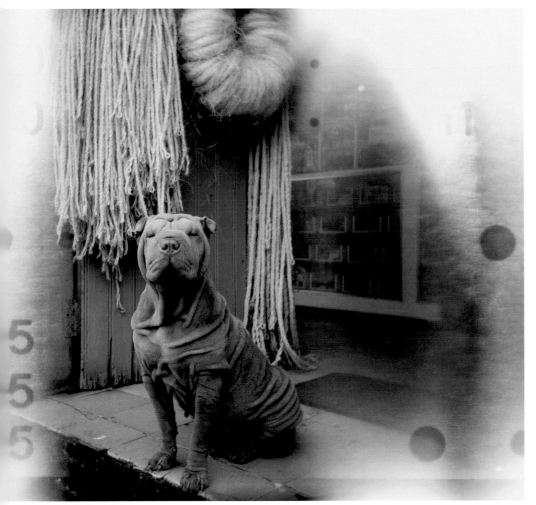

myfoodlog @ 2003-05-24 16:32 said:
Could use a good ironing.

fotodogs @ 2003-05-24 16:34 said:
yeah, it's like you could fit 2 dogs in there!

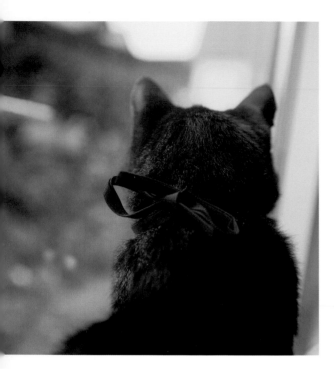

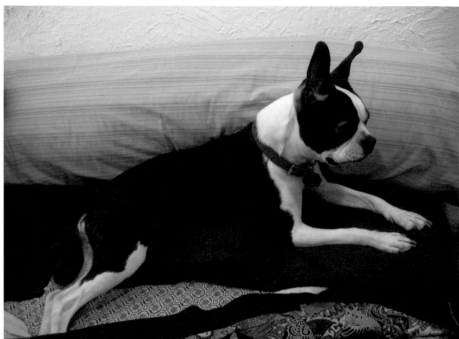

www.fotolog.net/mi4ko/?pid=9410427
my cat 'TETSU'

mayumlx @ 2004-10-20 02:16 said:
Pretty ribbon! She's all dolled up as if waiting for someone...!

www.fotolog.net/honeycut/?pid=8561005

zonepress @ 2005-02-11 09:47 said:
ahaha, Good Night Buddy.

lauratitian @ 2005-02-11 18:59 said:
no less than 3 pillows will do!

creme_brulee @ 2005-02-11 19:56 said:
SO not ready to face the day

placeinsun @ 2004-08-14 19:58 said:
let sleeping (or just very still, cooperative) dogs lie
great dog and dog foto, but that's not all...
those colors (the collar!), that composition

tinymark @ 2004-04-04 21:38 said:
I believe this is one of the signs of
the apocalypse.

stringbeanjean @ 2004-04-04 22:28 said:
i am as enamoured as i am repelled.
certainly a sight.

marellenmac @ 2004-04-05 04:44 said:
It's a wonder this little dog can stand under
the weight of all of those accessories!

youzoid @ 2004-04-05 06:15 said:
Time has not been kind to Cyndi Lauper

epmd @ 2004-04-05 07:20 said:
ok that's pretty scary.

odhusky @ 2004-04-05 21:18 said:
a real party animal, cute

momofreaksout @ 2004-04-06 00:50 said:
Jeepers. He looks like one of the Golden Girls.

marellenmac @ 2004-04-06 10:12 said:
Oh my god! I just read youzoid's comment!
That is so funny!

super8mm @ 2004-04-06 11:34 said:
that seems wrong

jkh_22 @ 2004-04-14 06:09 said:
accessorize, accessorize...

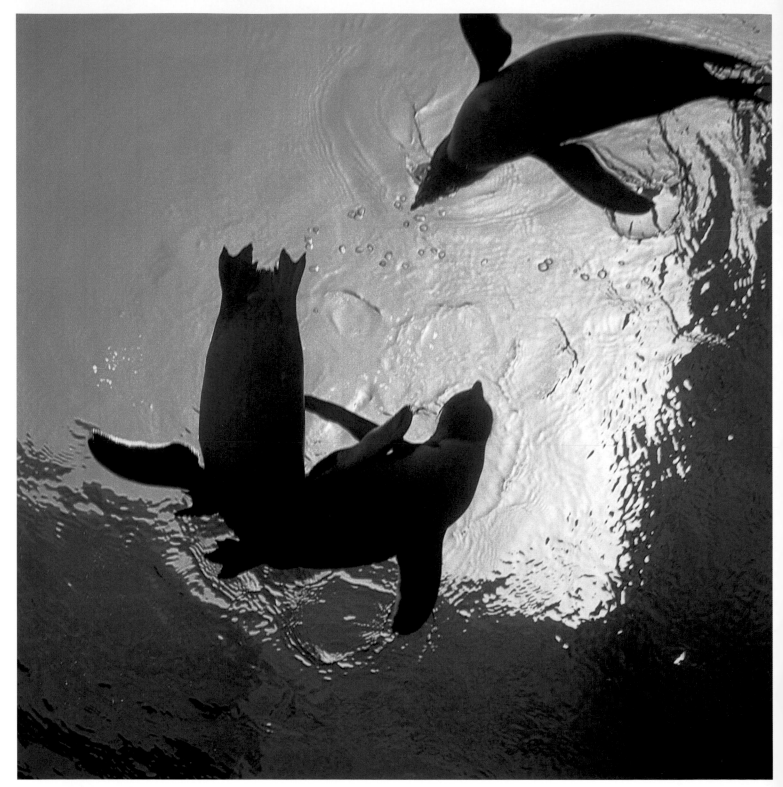

Great Grey Treefrog sitting on my teapot.

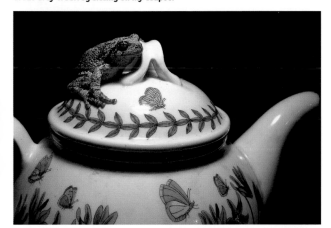

lauratitian @ 2004-10-04 12:57 said:
k'mova here, komodo

along @ 2004-10-04 13:02 said:
he works for scale

frank_bklyn @ 2004-10-04 13:29 said:
and here i thought the dragon was the only
chinese astrological animal that
doesn't actually exist.

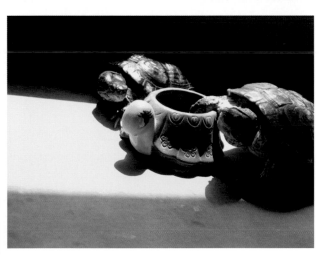

turtle series #3:
'i saw her first! back off buddy!' says the local tough guy.

arnoo @ 2003-07-14 20:52 said:
Putting a leg over...

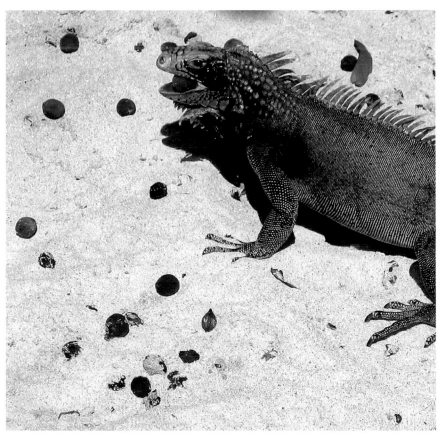

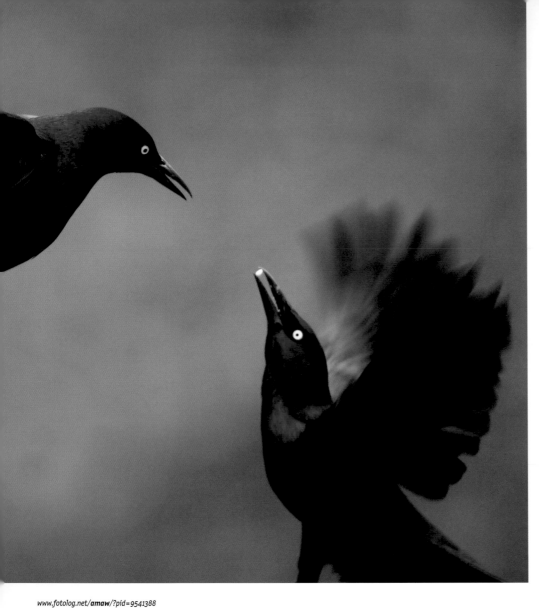

eulinarego @ 2005-01-12 22:32 said:
Clap! Clap! Clap!
What a great capture!!!!

carolgodoi @ 2005-01-12 22:34 said:
Woa...no words for that pic...amazin'
Kisses

clorofilaboy @ 2005-01-12 22:37 said:
man...UR PICS ARE TOTALLY AMAZING!!!! AWESOME!!!
IT'S INCREDIBLE THE POWER U HAVE WITH A CAMERA
IN UR HAND...MAN...CONGRATULATIONS...
cya

earlo1 @ 2005-01-12 23:30 said: Enjoying your images
is a wonderful experience...seeing (reading) how much
others enjoy them brings the experience to a quite
different level...keep sharing!!

**A bit late for Valentine's Day but finally got that
heart shape made by their necks when this male
and female mute swan flirted with each other
as I had waited patiently for them to do!**

lindader @ 2005-02-21 12:02 said:
they look a beautiful couple

mercyzee @ 2005-02-21 13:00 said:
What a shot. Wonderful...! :)

pamelaadam @ 2005-02-21 13:48 said:
ah, all you need is love love

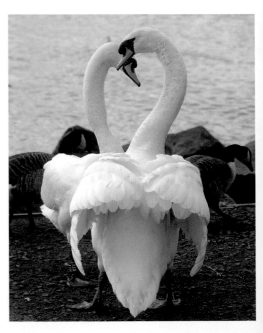

angles and wings [so i like gulls, unlike john hersey – who in some ways was an idiot – oh well*]

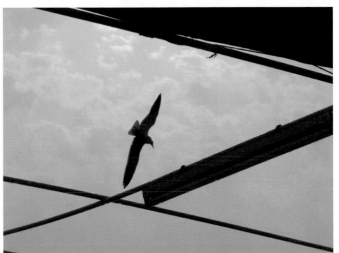

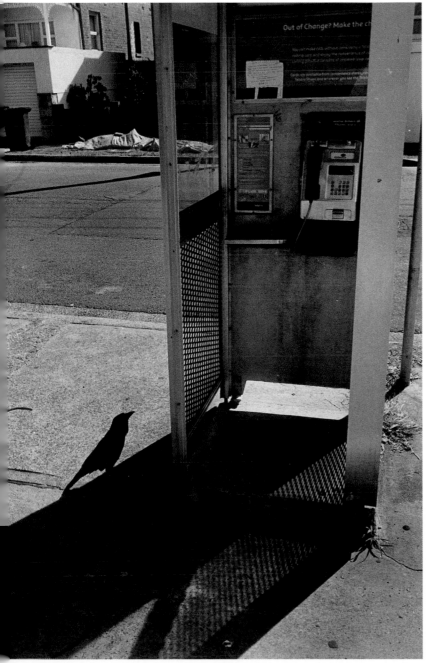

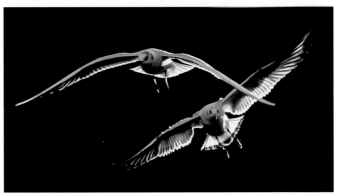

call...caaaaaaaall

50mm @ 2004-05-13 03:07 said:
:))))))))
i know the feeling

vimanaboy @ 2004-05-13 03:15 said:
beautiful brilliant capture and caption...
love this one :)

mr_magoo @ 2004-05-13 05:54 said:
beautiful! you and that bird are inseparable!...
i think the onomatopoeic joke of the caption is for
ozzies alone...

billy_1 @ 2004-05-13 13:51 said:
Has a Hitchcock element to it! Cool pic

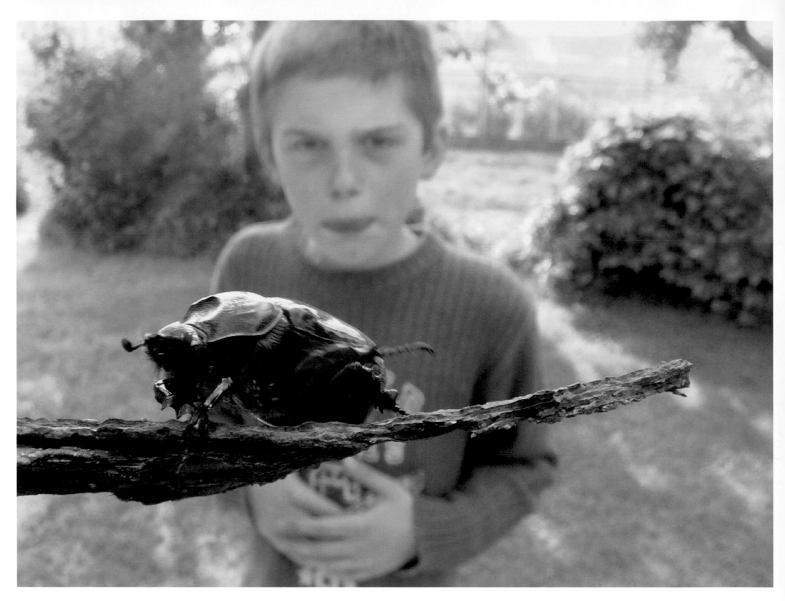

www.fotolog.net/**bugsncritters**/?pid=8536391
from www.fotolog.net/**e3000**
Rendezvous with a giant rhinoceros beetle

bugsncritters @ 2004-09-13 11:21 said:
this is a damn fine shot. love his expression of curiosity.
– mr_walker

patisfaction @ 2004-09-13 16:43 said:
haaa
huge bug!
nice!

**Alpha male Sulawesi Crested Macaque.
Posted by Chester Zoo's newest employee!!
I got the job!!!**

ajs @ 2005-02-22 07:24 said:
WELL DONE!!
Will you look at those teeth! Great shot!

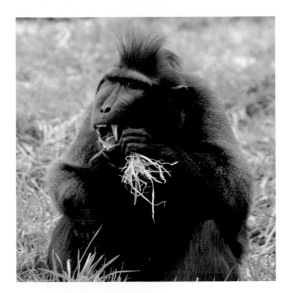

passing the buck

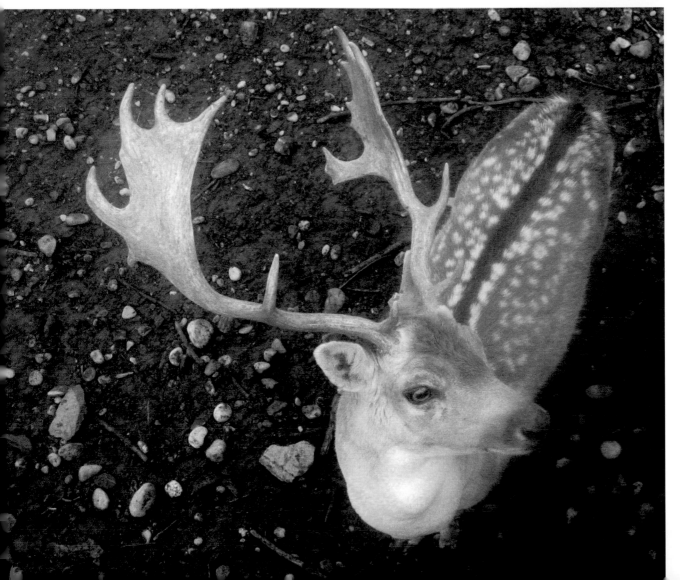

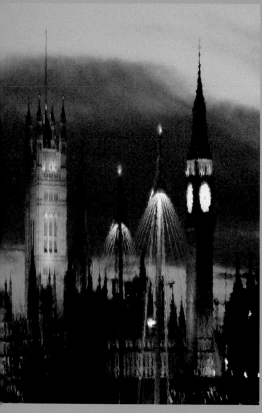

www.fotolog.net/eliahu/?pid=5176944
The view from Waterloo Bridge, London

forrest @ 2004-01-22 19:20 said: Distortorama!
The vertical stretching makes Westminster look
even more medieval than usual.

EVERY PHOTOGRAPH
MAKES A DIFFERENT LONDON

LONDON WEARS NEW EDGES IMPOSED BY YOU, four to a picture. It isn't bounded by the M25 or the Circle Line, but by two sets of parallel lines imposed by your camera. Negotiations are continuous between your personal sense of beauty and the city's utter indifference to it. Pictures document the struggle. Some hard new form of beauty might arrive that way, the way it did in Corinne Day's pictures. London fancies itself framed like this, but this only looks like London; in fact it's an arrangement of planes and spaces and characters made by you. When you take it out of context, it looks a bit more mysterious: the old trollop puckering up, the beautiful women in ugly flats with carpets and radiators and takeaway menus spilling through the letterbox.

Every photograph makes a different London: the couple on the tube; the actress on Regent Street; mannequins and masks; a torn pink poster; a blank brick wall. Plaster all the pictures together and make a 1:1 scale model, a picture of London the size of London, that complex agglomeration of bricks and window putty and garbage flies and junk mail. But fresh green still comes onto the trees despite everything. And, golly, isn't that a pantomime horse?

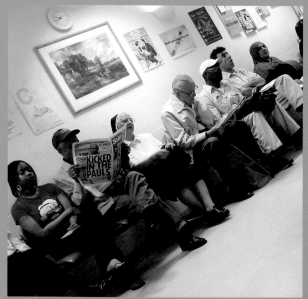

www.fotolog.net/virgorama/?pid=7840083
one thing's for sure...we all have blood

dubmill @ 2004-08-16 14:05 said:
very affecting, powerful image

palmea @ 2004-08-16 17:17 said:
a very well represented group —
nicely done (does it hurt very
much to be kicked in the pauls?)

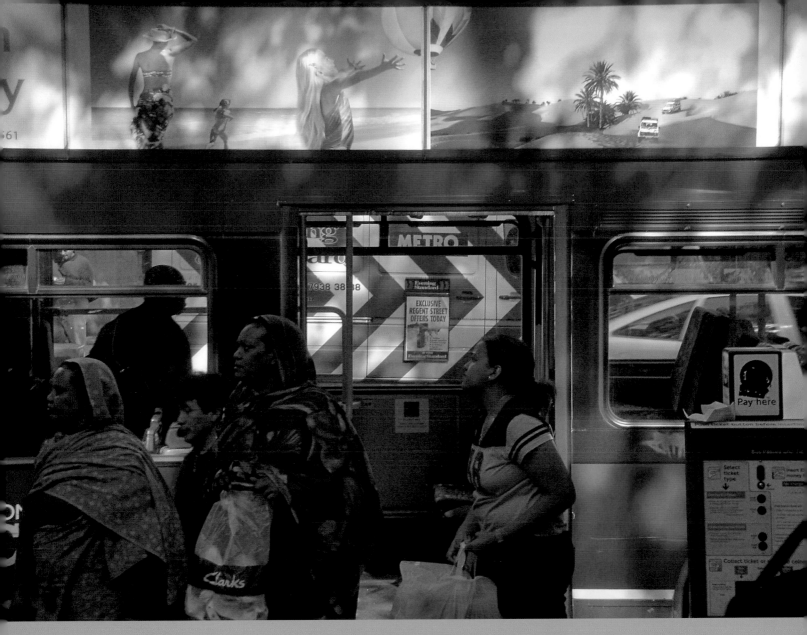

above: www.fotolog.net/*johannaneurath*/?pid=8178408
Kingsway, London WC1

left: www.fotolog.net/*eliahu*/?pid=2246103
The railway tracks near Finchley Road. London.

colorstalker @ 2003-11-12 23:22 said:
This yelled 'open me' as a thumbnail. It's so graphic
& then yields so much detail. The shoddy building
with its blank windows, the industrial fencing &
signs & then — Baby Blue.
Life becomes a brilliant collage in this one.

LONDON

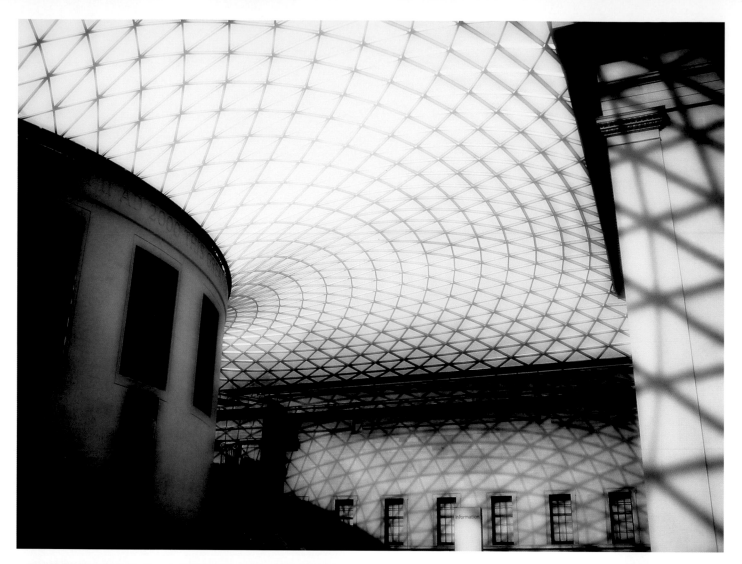

*above: www.fotolog.net/**timbattersby**/?pid=479164*

atcy7 @ 2003-07-30 10:31 said:
The shape of the shadow is so cool.
Great work!

juliyap @ 2003-08-04 14:41 said:
This is beautiful — looks like lace.

*www.fotolog.net/**koray**/?pid=7620975*

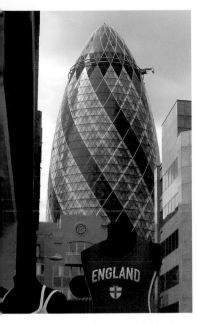

www.fotolog.net/**johannaneurath**/?pid=7821589
**The Gherkin a.k.a. 'The Towering Innuendo'
with a few items in the foreground to make it
extra topical this weekend...(football – yawn...)**

geogblog @ 2004-06-12 09:14 said:
What a monstrous carbuncle. Still it's great
that London has some absurd architecture. I was
beginning to think this was being monopolised by
Dublin (floozie in jacuzzi, spire in the mire etc.).
Now London has a Towering Innuendo.

*below: www.fotolog.net/**kojioppata**/?pid=2363393*

im_a_nerd @ 2003-11-22 17:14 said:
beautiful layered reflections! that's st paul's
in there, right? looks like it's been imprisoned!

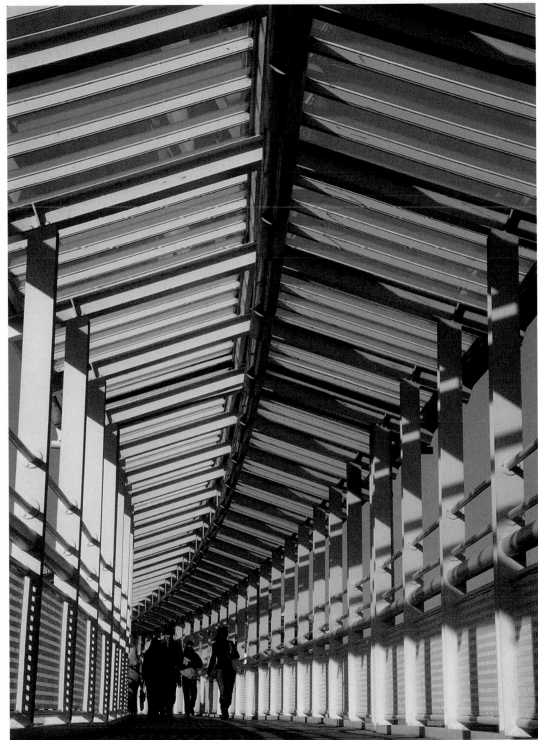

*above: www.fotolog.net/**jdiggle**/?pid=9098569*

eye2eye @ 2005-03-06 08:05 said: Brilliantly composed image,
James. Your framing is absurdly perfect. Unbelievable impact
here. PLEASE post it on Flickr so I can fave it!!!

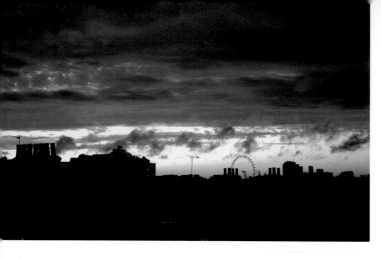

alinelapin @ 2005-08-25 02:11 said:
ouch! it's so beautiful, it hurts! :o)

lilfluffyclouds @ 2005-08-25 20:27 said:
Thanks for your kind comment. I've added
you to my FFs, if you don't mind.

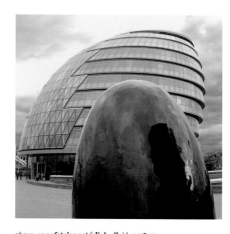

yuki @ 2003-10-10 03:55 said:
love the cloudy colours

broccoli @ 2003-10-10 21:39 said:
nice combination of shapes —
it is a curious-looking building

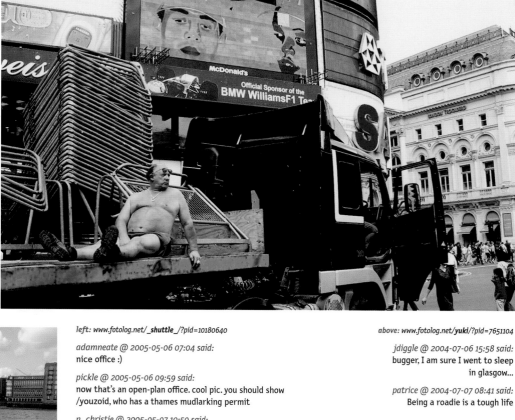

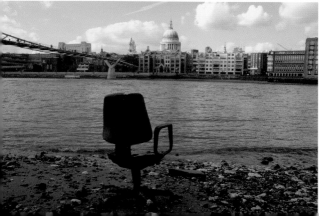

adamneate @ 2005-05-06 07:04 said:
nice office :)

pickle @ 2005-05-06 09:59 said:
now that's an open-plan office. cool pic. you should show
/youzoid, who has a thames mudlarking permit

n_christie @ 2005-05-07 10:50 said:
Just wanted to say cheers for telling me about Fotolog
(in a tottenham court road camera shop four weeks
ago ish). I've just uploaded my first photo...

jdiggle @ 2004-07-06 15:58 said:
bugger, I am sure I went to sleep
in glasgow...

patrice @ 2004-07-07 08:41 said:
Being a roadie is a tough life

www.fotolog.net/**youzoid**/?pid=7701022

sharonwatt @ 2004-09-27 15:06 said: slashtastic

*right, centre: www.fotolog.net/**dontbecruel**/?photo_id=7889354*
**now they'll always be together
in that happy hunting ground**

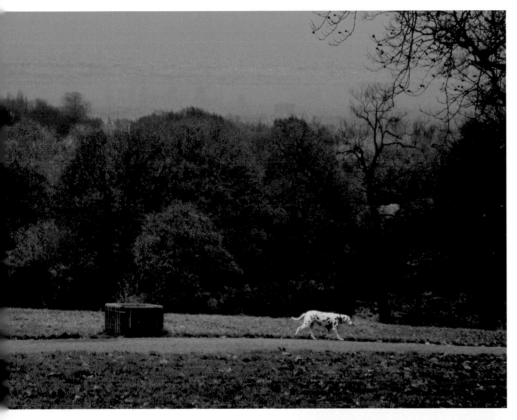

*above: www.fotolog.net/**eliahu**/?pid=8269730*

curioush @ 2004-12-09 16:05 said:
this is the most EXCELLENT shot!!!!!!
i'm in love with it. do you think it would
accept my hand in marriage?

irllinux @ 2004-12-09 16:11 said:
Beautiful Pic
I would like to know London someday... :o)

www.fotolog.net/**karolinka**/?pid=9222628

www.fotolog.net/**yuki**/?pid=6306609

50mm @ 2004-02-17 01:30 said:
gorgeous. such crispness, such blur, how very
very rich...sachertorte!! i love the stillness in
still life in black & white. it's..*right, somehow

Carnival coppers, Notting Hill Carnival, today

zimnoch @ 2004-08-30 06:04 said:
a right set of bobby dazzlers...

**'ello 'ello 'ello
Hammersmith Road, London.**

jerome_v @ 2004-05-27 07:44 said:
smiley people are good for u!

petitesoeur @ 2004-05-27 11:37 said:
changin' of the guard

Swiss Cottage, London.

geogblog @ 2004-04-20 12:25 said:
Can't think of a humorous comment for this.
Too busy admiring it.

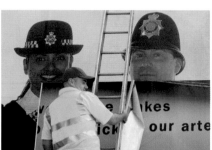

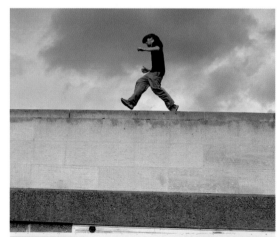

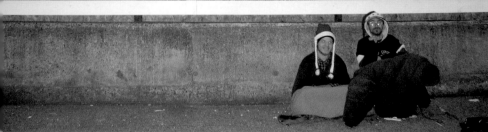

**Newman St. London
This is not a montage.**

celie @ 2004-01-15 21:05 said:
Oh, this is a beautiful juxtaposition!
The cig is almost life-size on my monitor.

Waterloo Bridge, London

ajs @ 2004-08-26 17:30 said:
So he didn't break his neck then?

Drury Lane, London WC1

theyoush @ 2004-04-26 15:42 said:
do you know the muffin man?

jkh_22 @ 2004-04-26 15:45 said:
fingers crossed!!

daisyjellybean @ 2004-04-26 16:01 said:
looks like those guys are ready to play!

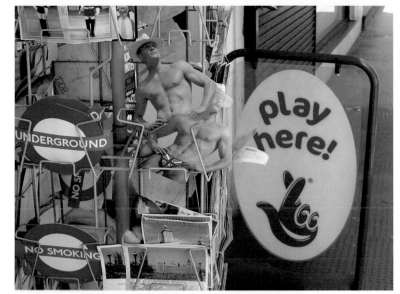

London somewhere.

onmywaytowork @ 2005-01-10 09:14 said:
It's how the world will end.
Fighting for kebabs............

isthisyou @ 2005-01-10 11:26 said:
you made that up.
didn't you?

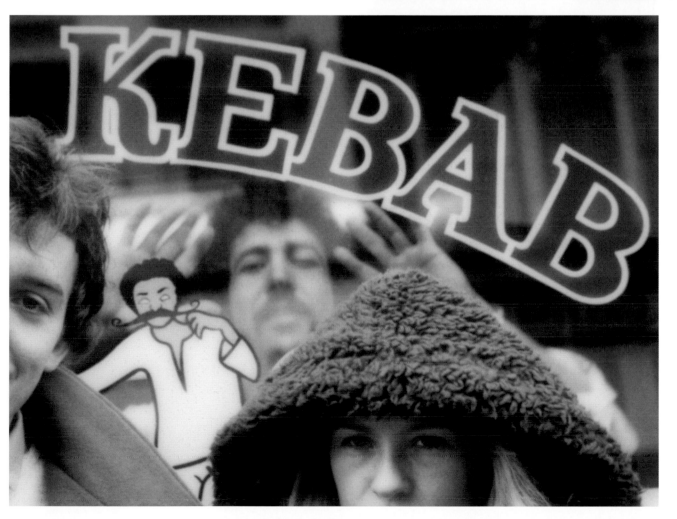

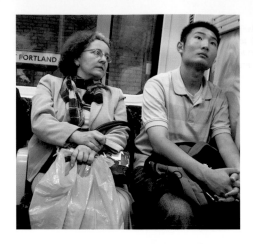

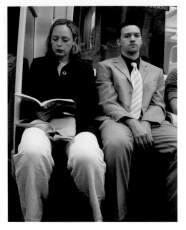

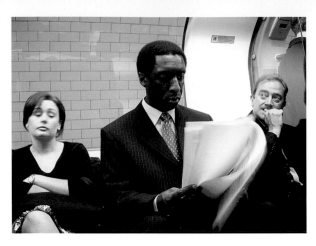

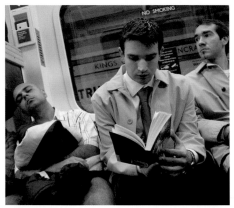

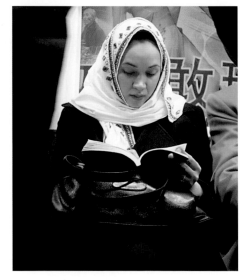

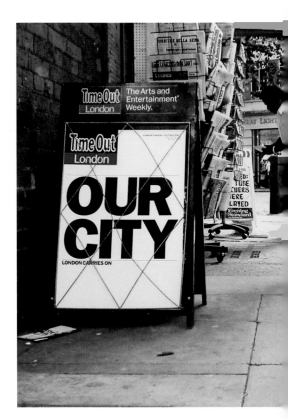

www.fotolog.net/*virgorama*/?pid=8718586

youzoid @ 2005-07-06 16:40 said:
more willing victims.

onmywaytowork @ 2005-07-07 02:36 said:
Sweet Gene Vincent. There's one in every town...

www.fotolog.net/*virgorama*/?pid=8721209
**It's a black day in London, several
explosions, confusion...
It's all taken place on my exact route to
work...if I'd been any earlier, well who
knows. There are fatalities and the general
opinion is that it's al-Qaeda
Some people's lives have been irreversibly
shattered, that's definite**

kikij @ 2005-07-07 07:24 said:
Good to know you're OK.
We are as well. I just can't believe it.
We're all in total shock. And after such
a happy day yesterday.
:(

youzoid @ 2005-07-07 16:50 said:
glad you weren't on the tube today. makes
me see yesterday's photo in a different light,
and my comment seems oddly appropriate.

sharonwatt @ 2005-07-07 22:50 said:
In a weird way I was hoping to see a black
frame on your page so that we know you
posted and are ok. Thinking about the cause
of the black frame a lot.

above, from top to bottom:
www.fotolog.net/*virgorama*/?pid=7860943
www.fotolog.net/*virgorama*/?pid=7960381
www.fotolog.net/*virgorama*/?pid=8366892

www.fotolog.net/*virgorama*/?pid=8763152

the_dead_kids @ 2005-07-20 19:18 said:
that's a good 'un

www.fotolog.net/*yuki*/?pid=7966340
London carries on

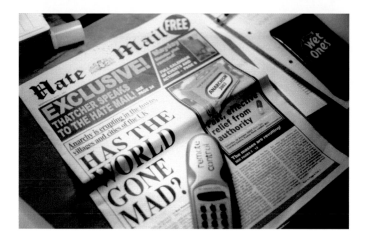

left: www.fotolog.net/**koray**/?pid=7120062

Like an unchecked cancer, hate corrodes the personality and eats away its vital unity. *Hate destroys a man's sense of values and his objectivity. It causes him to describe the beautiful as ugly and the ugly as beautiful, and to confuse the true with the false and the false with the true. Power at its best is love implementing the demands of justice. Justice at its best is love correcting everything that stands against love.* – Dr. Martin Luther King Jr.

andrewstevens @ 2004-03-03 05:54 said: That is quite funny. I hate that paper and everyone who reads it (except my parents, of course). What's wrong with giving lottery money to gay asylum-seeking heroin addicts?

pro_keds @ 2004-03-03 10:03 said: Anarchy...will it EVER go away?

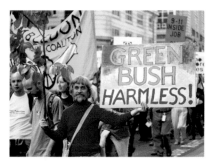

www.fotolog.net/**koray**/?pid=1407531

'Art is lies that tell the truth.' Picasso 27/09/03 London Rally

brillo @ 2003-10-08 10:13 said: shave him and he's the guy from star wars!! ahahah!!!...

galamander @ 2003-11-14 14:54 said: i LOVE that. so good. what a face. what a quote.

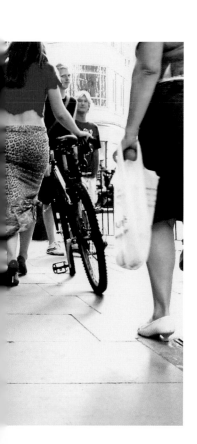

right: www.fotolog.net/**koray**/?pid=8356688

It's him again. A great guy.

hanalita @ 2004-11-21 12:24 said: nice. weird that you saw him again! and that shot on my page totally does look like brillo, doesn't it? you should interrogate your housemate about his extracurricular modelling activities...

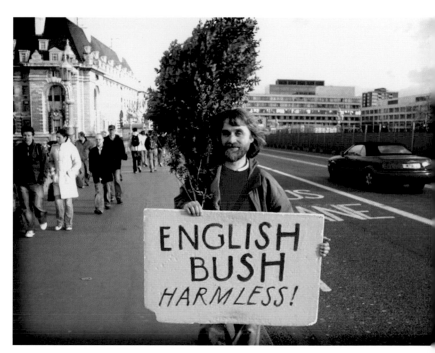

right: www.fotolog.net/**dubmill**/?pid=8812810

bevophoto @ 2004-10-25 06:54 said:
that blotch turned red...
what does it mean darling?

pickle @ 2004-10-25 09:24 said:
wow. cool shot. like a brushstroke, but
probably a windscreen wiper sleeve.
was this yesterday? it sure rained.

lulalula @ 2004-10-25 11:13 said:
rain rain go away
come again another day
cameras can get damaged this way

eliahu @ 2004-10-25 15:54 said:
this is one of your best ever. oh, and yes,
it was naked men walking by.

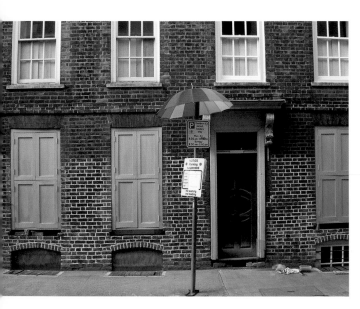

www.fotolog.net/**johannaneurath**/?pid=7749331
Fournier Street, London E1

jdiggle @ 2004-05-18 14:54 said: Ken Livingstone has finally
found a way to make bus shelters more cost-effective I see!

sarai @ 2004-05-18 15:18 said: poetic! whimsical!

youzoid @ 2004-05-18 16:13 said: they're so arty over in east london

www.fotolog.net/**eliahu**/?photo_id=7671099
**More from last week's torrential storm.
Holborn, London.**

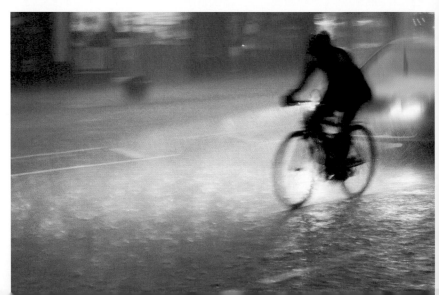

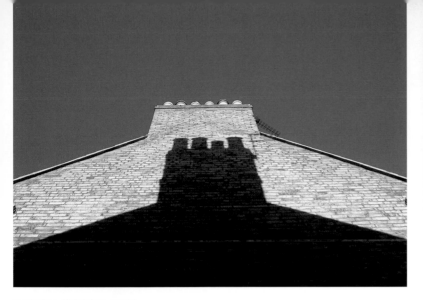

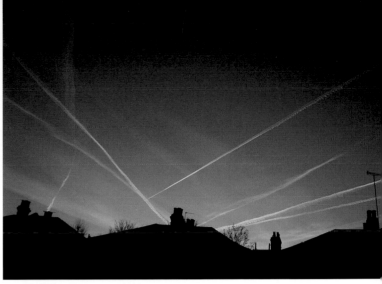

*www.fotolog.net/**jdiggle**/?pid=2351348*
Don't you just love Sundays?!

raceystacey @ 2003-11-17 03:49 said:
Ahhhh, Sundays – is THAT what they look like?
Must get up and try and catch one, one of these days.

*www.fotolog.net/**johannaneurath**/?pid=3588803*
Evering Road, London E5 | This morning.
Bye for now...I'll be away for a couple of days

onmywaytowork @ 2003-12-18 11:23 said:
Fantastic. Looks like everyone's flying off everywhere.
Enjoy your break......

*www.fotolog.nct/**yuki**/?pid=7643528*

tommasik @ 2004-06-18 07:12 said:
information overload leads to
a grinding halt

claud @ 2004-06-18 09:36 said:
right...right
look...look
information...information
why every sign twice?

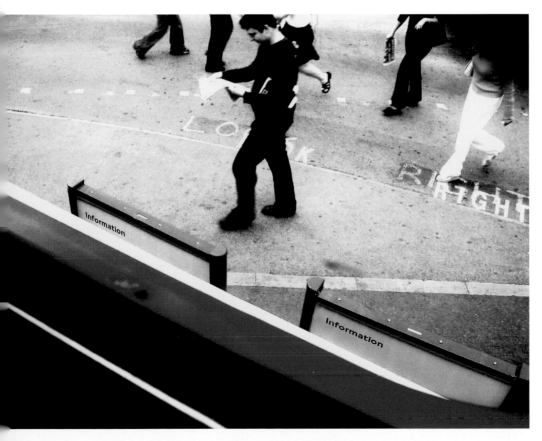

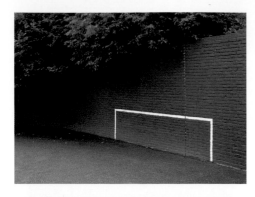

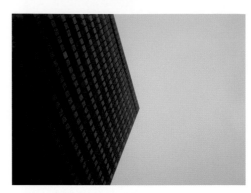

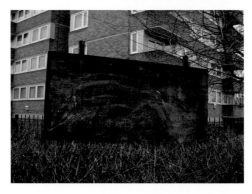

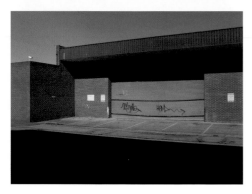
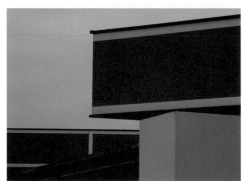
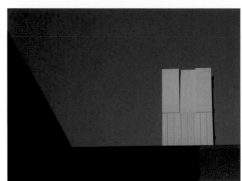

above, top row from left to right:

www.fotolog.net/**dubmill**/?pid=11932833

www.fotolog.net/**dubmill**/?pid=11917221

www.fotolog.net/**dubmill**/?pid=11932679

above, middle row from left to right:

www.fotolog.net/**dubmill**/?pid=11922331

www.fotolog.net/**dubmill**/?pid=9725290

www.fotolog.net/**dubmill**/?pid=11917192

above, bottom row from left to right:

www.fotolog.net/**dubmill**/?pid=11890559

snapdragon79 @ 2005-10-29 23:39 said:
fabulously bleak shot!! the lone cctv camera
is the cherry on the cake :) great work!

www.fotolog.net/**dubmill**/?pid=10047439

qinghuayuan @ 2005-03-29 06:03 said: precision.

brumes @ 2005-03-29 06:50 said: I love these flicks.
I love to come here.

www.fotolog.net/**dubmill**/?pid=11936730

www.fotolog.net/**dubmill**/?pid=11936735

*right: www.fotolog.net/**dubmill**/?pid=11917065*
Their word is Mybond

*below: www.fotolog.net/**dubmill**/?pid=9356691*

palmea @ 2005-01-01 10:30 said: this is magical...
wishing you the best for 2005, /dubmill

youzoid @ 2005-01-01 15:30 said:
ooh this is great. lots going on.
happy new year dub

av_producer @ 2005-01-01 17:16 said:
Love the way her feet move
but the heels stay sharp

MYBOND
PAWNBROKERS

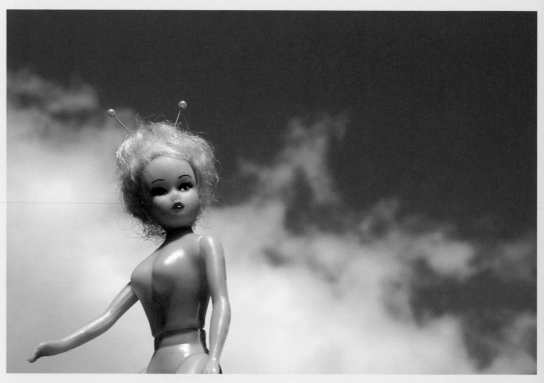

*www.fotolog.net/**stringbeanjean**/?pid=8522110*
**the girls wear gold
enough to sink the loveboat**

youzoid @ 2004-09-20 16:00 said:
i love her little antennae. radarrrrr.

nadia @ 2004-09-20 17:42 said:
she's a martian

gardengal @ 2004-09-20 17:58 said:
she's certainly MY favorite martian.

colorstalker @ 2004-09-20 23:46 said:
disappointed in earth men.

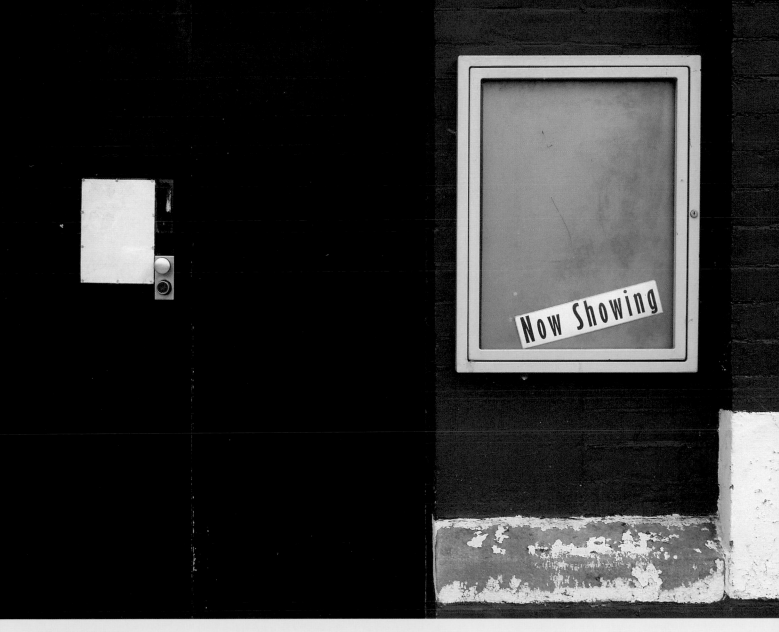

stringbeanjean @ 2003-08-07 20:45 said:
Very representative of our town. I love this shot.

tangent @ 2003-08-07 21:21 said:
The cinema sucks these days anyway. It's been
declining ever since *Star Wars Episode I*, probably
even before then. Nice shot.

/stringbeanjean + /batut

tangent @ 2003-10-09 14:26 said:
What the?!!
I'm completely awed by this shot.
This can't be real...

batut @ 2003-10-09 14:29 said:
cracked window – chinese takeaway.

mattpaper @ 2003-10-09 15:11 said:
The lamppost looks like a triffid.
Nice low-tech pixels.

squaremeals @ 2003-10-09 14:59 said:
Mixed up depth, mixed up seasons –
what a complex image.
The broken glass adds lots, too.

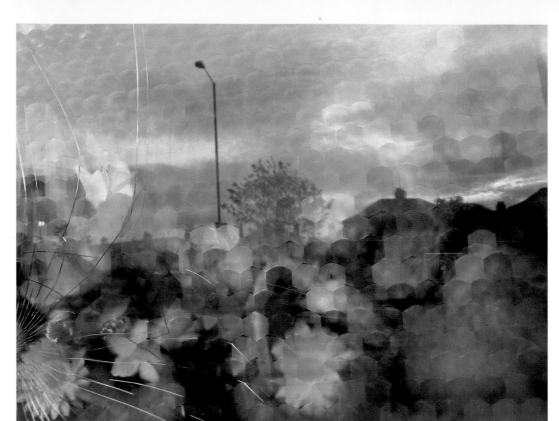

andrewstevens @ 2004-02-28 10:18 said:
Cool tail action there, fishy.

meshel @ 2004-02-28 10:52 said:
this is heavenly. my brothers have these
goldfish here in dallas that were in this huge
barrel outdoors where they'd lived for over
seven years and grown to be big, bigger than
my hands! and they were friendly, seriously –
you'd put your hand in the water and they'd
come up and rub against you! well, they're
not here anymore. they were attacked by
either a cat or probably a raccoon. the baby
was left. one of the large ones was lying next
to its home, gutted; the other was nowhere
to be found. so sad! this picture reminds me
of them. they were so angelic.
i'll post a pic (if i can find it) in their
memory...may yours live forever!

oslopaul @ 2004-02-28 11:25 said:
yes lovely image...er yes lovely image...
errr yes lovely image...err...yess lovely
image...er yessss lovely image...
(I've got a goldfish memory of two seconds)

:)

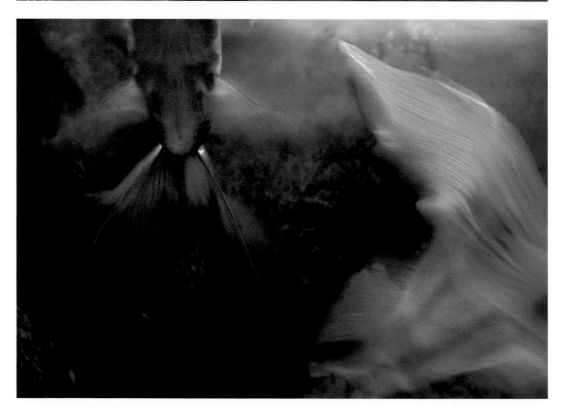

stringbeanjean @ 2004-05-13 11:22 said:
ARGH! this is gorgeous!!! i'm jealous! i came here to knack
you about taking the camera to work...but seeing as how
you're making exxxxcellent use of it, i might (only might,
mind) let you off. slippery nowt.

billy_1 @ 2004-05-13 13:13 said:
Nature vs technical stuff...Nature wins every time!

midnight72 @ 2004-09-04 11:05 said: hooo yeah i love it.

bdawg @ 2004-09-04 11:08 said: before or after?
either way, fabulous!

jdiggle @ 2004-09-04 11:09 said: it's getting hot in here...

stringbeanjean @ 2004-09-04 12:18 said:
i'm only doing up a button for goodness' sake!!

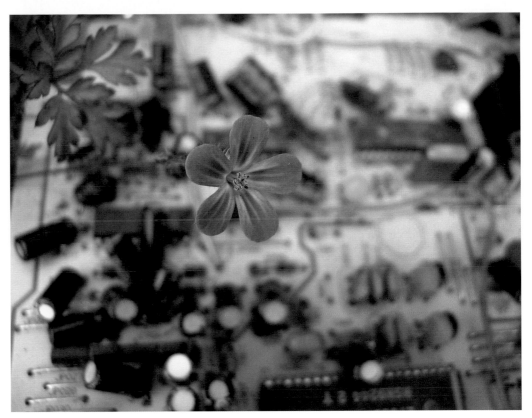

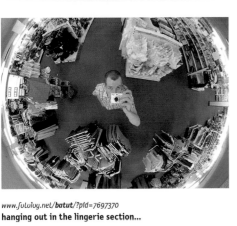

hanging out in the lingerie section...

lands_annex @ 2004-04-15 18:29 said:
Dude, how much longer are we gonna be in this
chick store anyway? So good it makes me giddy!

youzoid @ 2004-05-01 12:58 said:
Sweet. You on a special diet?

werankh @ 2004-05-01 15:18 said: lovely. but why in a dish?
is it going to be eaten or is it just a metaphor?

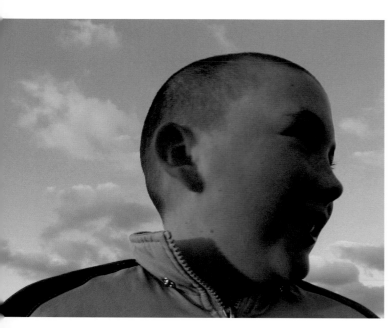

*above: www.fotolog.net/**batut**/?pid=6520607*

**i met some kids whilst photographing
the sunset this evening...**

pro_keds @ 2004-02-20 18:18 said:
and a rosy-cheeked one he is

*above right: www.fotolog.net/**stringbeanjean**/?pid=8100630*

bialamego @ 2004-07-16 18:14 said:
Here in Brazil when we know a secret
we say that 'a bluebird told me'.
Are your bluebirds telling you many secrets?
Have a nice weekend SBJ!

daisyjellybean @ 2004-07-16 22:55 said:
wow!!! I LOVE THIS!!! the contrast between
reality and everything else is wonderful.

zenbomb @ 2004-07-17 01:10 said:
what a wonderful tweet.

*www.fotolog.net/**stringbeanjean**/?pid=8160120*

youzoid @ 2004-07-27 08:08 said:
What a strange and interesting photo.
Even the sky looks unreal.

onmywaytowork @ 2004-06-28 08:09 said:
They'd charge you for it if they could...

the big if

d_saygoodbye @ 2004-04-02 15:10 said:
'If' is the largest word in the dictionary.
Sweet shot!

sixeight @ 2004-04-02 15:35 said:
i think about siestas under my desk...
i have a large amount of space...
but...IF i do it, i will get fired!!

pro_keds @ 2004-04-02 16:40 said:
must be heavy...three axles worth of IF.

youzoid @ 2004-04-02 17:56 said:
if...only cheap could fly.

trickhips @ 2004-04-02 18:33 said:
IF...i had about four more of those containers,
i'd have a house.

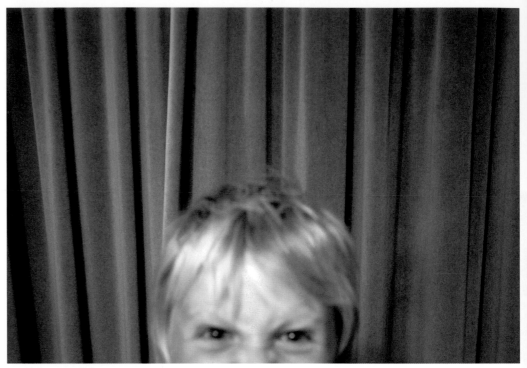

left-hand column, from top to bottom:
*www.fotolog.net/**batut**/?pid=5017482*

stringbeanjean @ 2004-01-20 10:19 said:
ooohhh...i LOVE it. it's wicked.
it's a work of fine art...
I'LL BUY IT!! can i have a lovey-dovey discount?
(make a big print for to go in the kitchenette!)
we'll give kate moss the old heave-ho.

*www.fotolog.net/**stringbeanjean**/?pid=7614715*
*www.fotolog.net/**stringbeanjean**/?pid=6665510*
*www.fotolog.net/**stringbeanjean**/?pid=7813814*

*left: www.fotolog.net/**stringbeanjean**/?pid=5525201*
*below left: www.fotolog.net/**stringbeanjean**/?pid=7911952*
*below: www.fotolog.net/**stringbeanjean**/?pid=4738396*

a night and day to be afraid of

cespenar @ 2004-09-02 06:24 said:
hair like curtain like hair like...

superchouette @ 2004-09-02 07:41 said:
so...one day i'll be a millionaire and stuff...
and i'll want you to take all of my portraits.

placeinsun @ 2004-09-02 10:20 said:
this is how i felt on the first day of school,
always.
that predominant greenish-yellow hue does
have a most fearful quality

awwww...

suzannasugar @ 2004-02-18 16:19 said:
awww indeed. great shot!

meadows @ 2004-02-18 17:33 said: brilliant shot but
also upsetting. i hope nothing too bad happened?

batut @ 2004-02-18 18:26 said: both she and
her sister were crying. they were with their dad,
lagging behind, and i shot from the hip.

stringbeanjean @ 2004-02-19 16:28 said:
she's hysterical 'cos she didn't get the matching
hat. the brat.

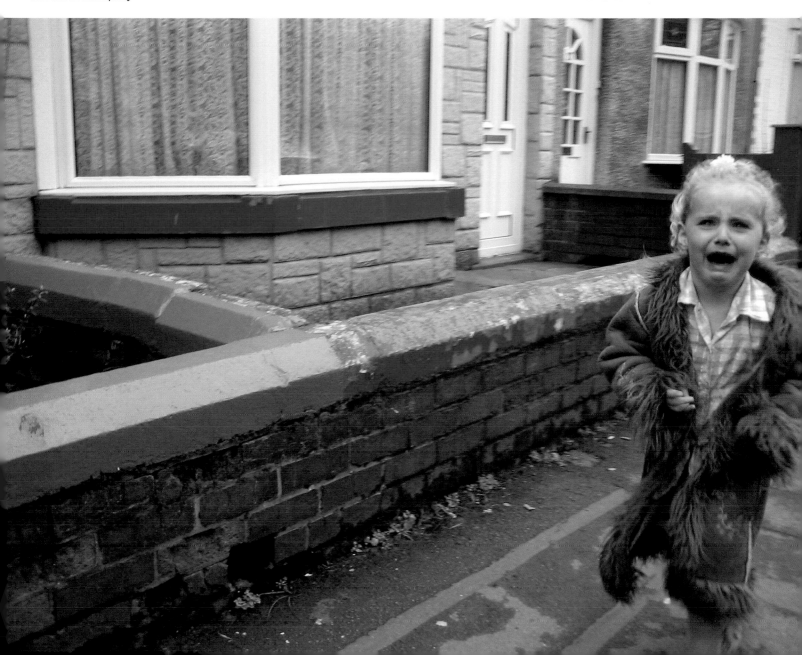

onmywaytowork @ 2003-11-07 09:49 said:
Sometimes you worry in case that's the
last thing you'll ever see...

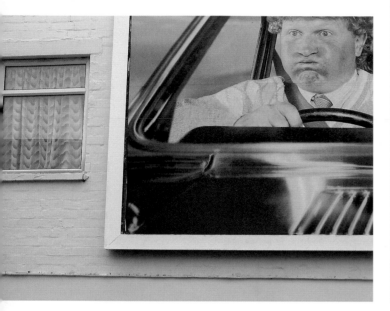

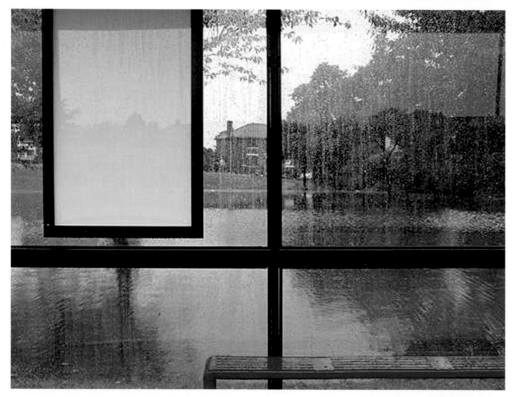

*left: www.fotolog.net/**batut**/?pid=2993775*

puckles @ 2003-12-03 20:10 said:
i like the juxtaposition between the clean/sharp lines of
the building on the left and the distorted/blurry image
reflected off the phone box.

wow. that's like the most coherent idea i've gotten out in the
past 4 hours

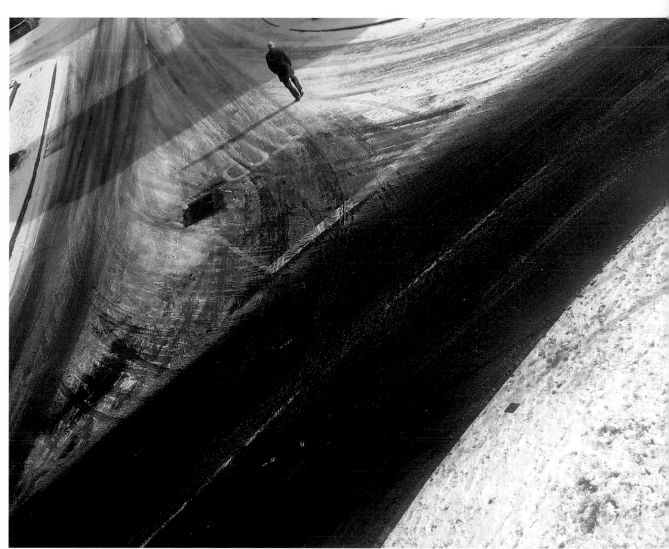

*www.fotolog.net/**batut**/?pid=6840337*

jewels_jungle @ 2004-06-30 18:30 said:
A portrait with no face in sight!

rebekkah @ 2004-06-30 19:56 said:
Tell her to get a dog.

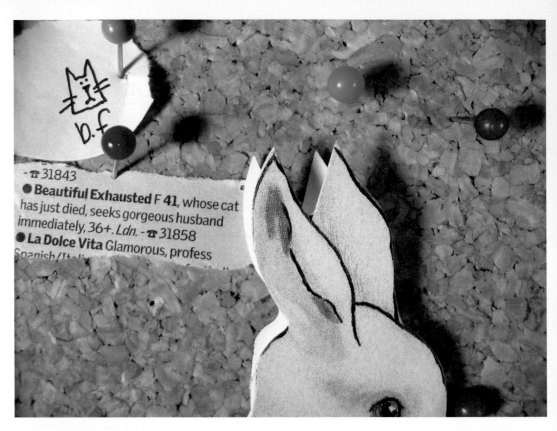

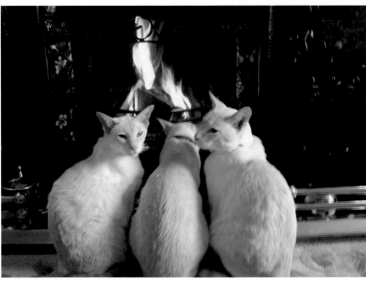

no one expects the spanish inquisition...

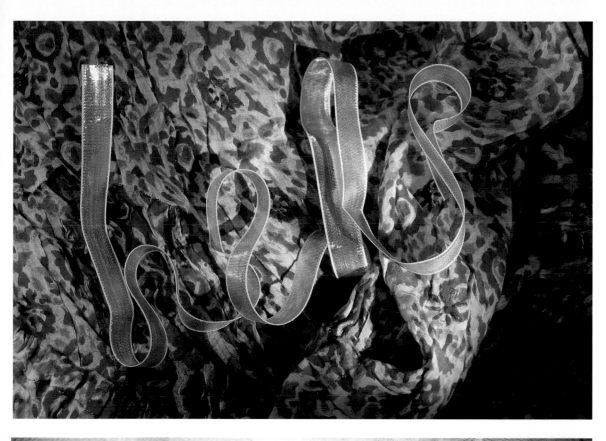

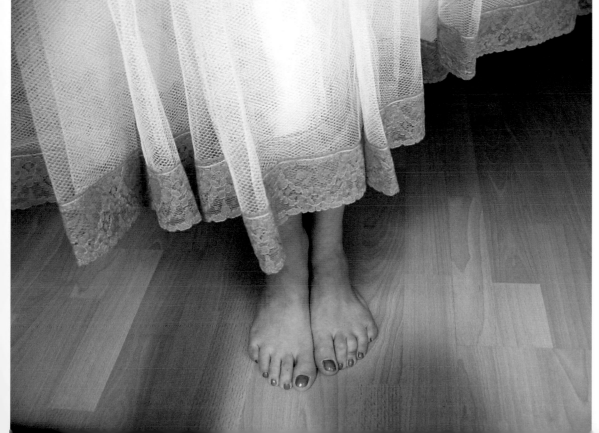

ATTENTION TO SMALL, FRIENDLY THINGS

'DOMESTICA' WAS BJÖRK'S WORKING TITLE for *Vespertine*, wasn't it? I remember her talking about it back in 2000. She was preparing the album at home on her laptop, paying serious attention to small, friendly things — ice tinkling in a glass, a cat purring, bubbling cookery. Domestica is a palette, a vocabulary. It's warm, laid-back, small-scaled, modest, organic. It's more orangey-green than bluey-grey.

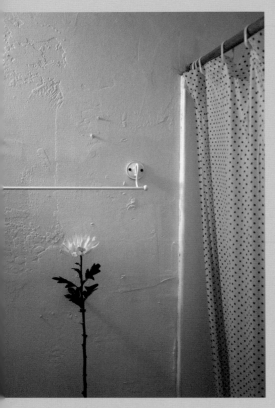

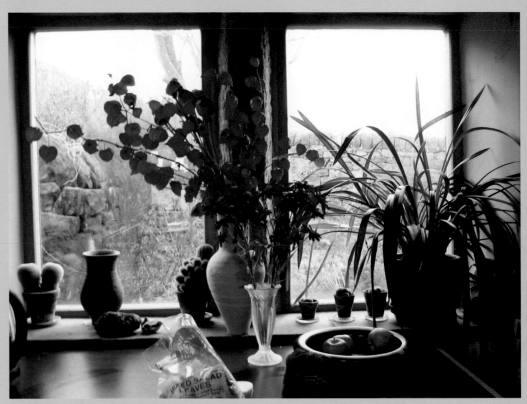

It's lyrical rather than heroic, feminine rather than masculine. But let's not make it gender-specific, shall we? Anyone can get tired of hype, tired of impact, tired of big sharky car ads, wars, Hollywood noir atmospheres, all menace and blue light. Domestica restores what really matters, acknowledges what actually surrounds us. It's wholesome. It's a life-support system. It's plants, toys, rooms, details, food, childishness, friendliness. I see it in Anders Edstrom's understated fashion portraits for *Purple* magazine in Paris, and I see it in the breezy style of *Relax* magazine in Tokyo. The editor of *Relax* once told me something great. He said, 'We try not to use stylists for our photos because the Shinto religion teaches us there's a spirit that lives in everything, no matter how small. To use a stylist would be to disrespect that spirit.' Of course, unstyled is a style too.

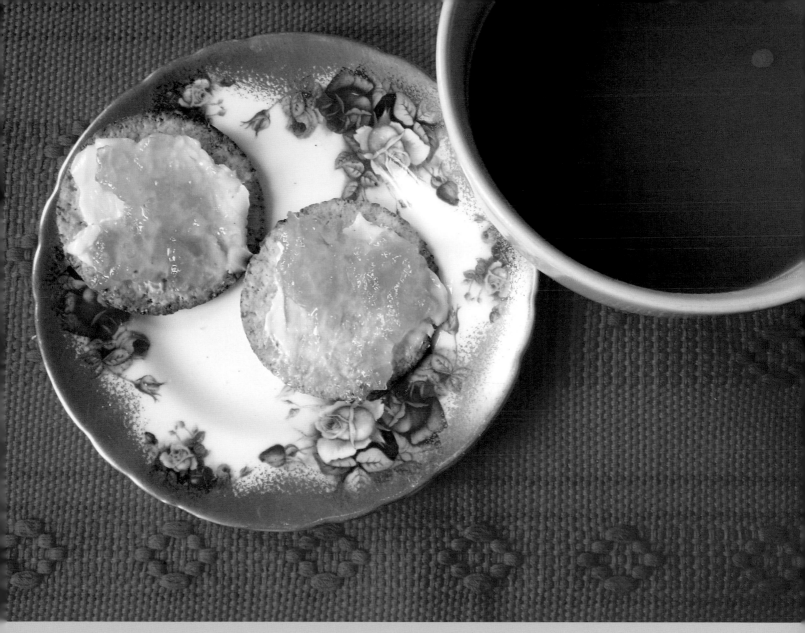

morning – a bright one

goon @ 2004-08-15 05:26 said:
an eye-opener, as they say.

spychic @ 2004-08-15 10:19 said:
looks so English! lovely.

eshepard @ 2004-08-15 12:31 said:
the tea to cracker ratio is high

DOMESTICA

www.fotolog.net/**ezra**/?pid=8490188

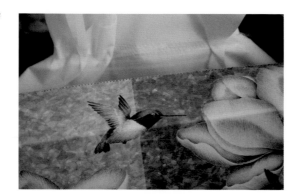

above: www.fotolog.net/**brainware3000**/?pid=8085103
gold sounds

youzoid @ 2004-07-07 08:52 said:
like a Rich Tea biscuit

meshel @ 2004-07-07 09:22 said:
wow. i thought it was shower tiles with soap scum in
the thumb. you have a mattress thing, don't you? i love
this picture. now it reminds me of donuts. yum.

left: www.fotolog.net/**clarsen**/?pid=597747

buster @ 2003-08-11 12:38 said: a very great shot.
william eggleston would keep this one.

clarsen @ 2003-08-11 12:45 said: Buster, Eggleston-
related comments will get you far.

clarsen @ 2003-05-25 17:28 said:
dang that's sweet!

Katharine @ 2003-05-26 09:45 said:
Sideways. It's sideways.

right: www.fotolog.net/_clr_/?pid=1494032
**these guys drive around my neighborhood
periodically, picking up abandoned mattresses
and strapping them to the top of their truck**

johannaneurath @ 2003-10-12 17:10 said:
Bingo! Jackpot! Full house!
There'll be a legion of
jealous photobloggers out
there when they see this!

0x99 @ 2003-10-12 17:29 said:
awesome.
is there a wide shot?

flicka_fotos @ 2003-10-14 17:57 said:
Now you just need a princess and a pea.

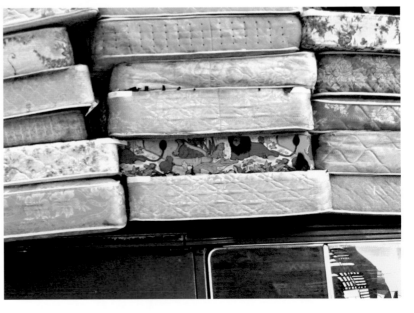

laundry's archive

04/24/04

04/22/04

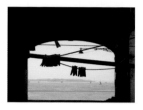

04/22/04

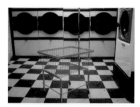

04/20/04

10/30/04

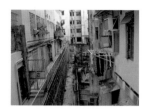

04/18/04

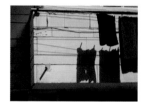

10/17/04

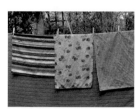

04/18/04

04/15/04

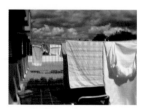

04/15/04

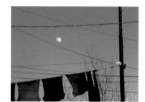

04/15/04

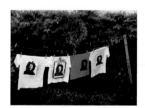

11/15/04

11/24/04

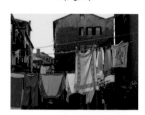

04/12/04

04/10/04

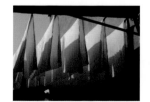

04/09/04

04/09/04

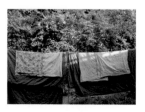

04/08/04

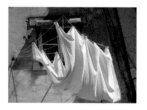

04/08/04

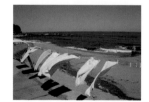

05/30/04

laundry jackpot!

laundry @ 2003-06-18 10:17 said:
okay I'm begging for one of your great shots...

along @ 2003-06-18 10:18 said:
excellent, so criss-crossy

im_a_nerd @ 2003-06-18 10:31 said:
oh yeah, that's the $$$ shot!

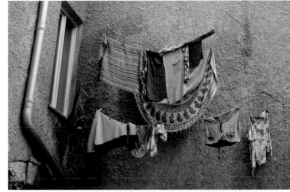

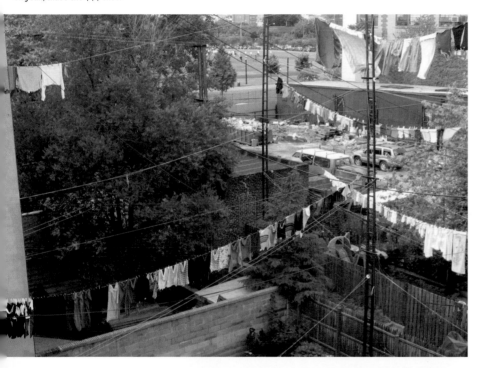

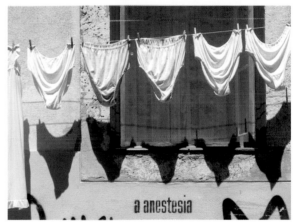

grantbw @ 2004-10-03 08:01 said:
what a wonderful sight to wake up to
bom dia

ale @ 2004-10-05 17:28 said:
Uau, perfeita!

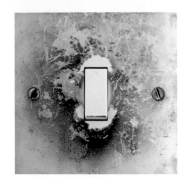

light switch

batut @ 2003-06-26 08:38 said:
It has certainly seen some action! Love it.

johannaneurath @ 2003-06-26 09:08 said:
Yuck! I think my home must have some of these...

illturner @ 2003-06-27 18:17 said:
man this is killer!

michale @ 2003-07-07 09:32 said:
compelling.

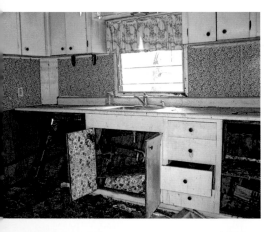

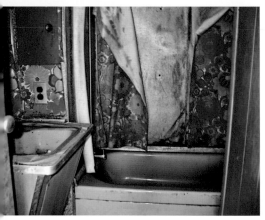

cypher @ 2004-04-10 13:02 said:
Incredible pattern inside those cabinets!

stitcher @ 2004-04-10 13:02 said:
The interior designers for these trailers
certainly had a flair for color.

squaremeals @ 2004-02-19 10:51 said:
So gross and yet so beautiful!

www.fotolog.net/**zenbomb**/?pid=4455698
little things in the back room.

anamorphosis @ 2004-01-09 03:25 said:
it's like a 3D sculpture color collage...except it's a
flat digital photo. er, well...it's very cool whatever
it is. are the brown thingies cookies nestled next
to bits of lobster? or is that chewing gum?

jkh_22 @ 2004-01-09 03:31 said:
hmmmmmm. not to be confused with
yummmmmm.

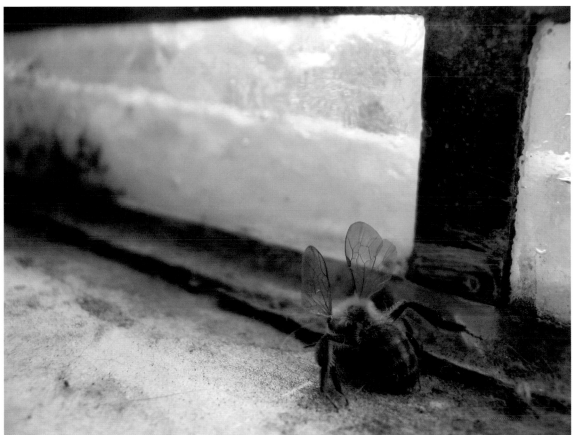

*above: www.fotolog.net/**lauratitian**/?pid=1297489*

beebs @ 2003-10-02 10:31 said:
slow seep. damn, laura, you always seem
to see the extraordinary in the ordinary.
i love your images.

golightly @ 2003-10-02 11:34 said:
just had to see what it was from the
thumbnail...chamomile?

www.fotolog.net/**stringbeanjean**/?pid=7996705

rebekkah @ 2004-06-26 13:34 said:
This is fantastic; reminds me of that filmmaker,
animation — he was Czech I think? Do you know
who I'm talking about?? Dang, now I'll have
to go searching...

www.fotolog.net/**meadows**/?pid=2522988

along @ 2003-11-21 17:21 said:
huzza bam! nice wallpaper. what the
freak is that...

www.fotolog.net/**celie**/?pid=524154

earlec @ 2003-08-04 19:48 said: is it for rent?

above: www.fotolog.net/**zenbomb**/?pid=7696476
you filthy, happy corner...

mashuga @ 2004-08-27 20:07 said:
Aftermath of one heck of a party.
Balloons I hope?

kazman @ 2004-08-28 04:37 said:
great! happy! garbage!!!!

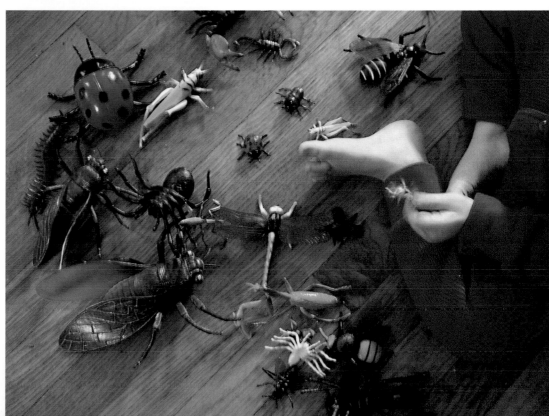

www.fotolog.net/**zenbomb**/?pid=3913327

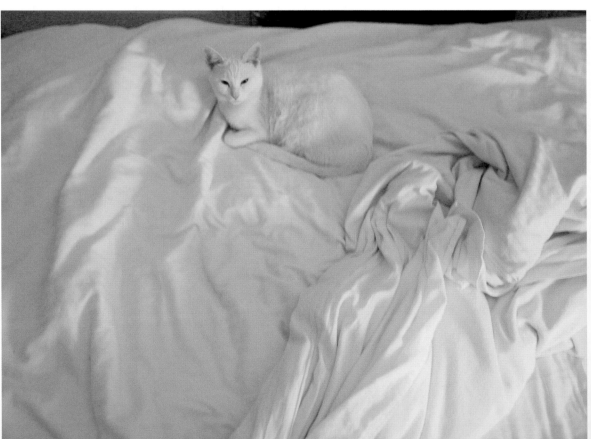

*www.fotolog.net/**lauratitian**/?pid=1407262*

frank_bklyn @ 2003-10-08 09:41 said:
you're nuts. see you at the meetup.

beebs @ 2003-10-08 09:41 said:
creme brulee! yah.

frank_bklyn @ 2003-10-08 09:41 said:
maybe the animal should have worn the shirt.
or is that matching too much?

habbit @ 2003-10-08 10:48 said:
white hot cat shot!

williambernthal @ 2003-10-08 11:02 said:
nice shirt, nice coat, nice photo!

im_a_nerd @ 2003-10-08 13:18 said:
very matchy matchy!

jenbekman @ 2003-10-08 13:27 said:
so cozy! (did you get my email?)

*www.fotolog.net/**stringbeanjean**/?pid=965236*
The King's new hat.

buster @ 2003-09-09 16:17 said:
Evvahbody, I mean, *evvahbody*
love the Kang. Wholly diggable image,
and I dig it.

colorstalker @ 2003-09-09 16:23 said:
Funny! What a winner of a pic.
Just great.

sinistra @ 2003-09-09 16:54 said:
LOL, that's great! I didn't know
Elvis wore a toupee! ;)

broccoli @ 2003-09-09 17:00 said:
'three to get ready now go cat go'
:) love this pic

mashuga @ 2003-09-09 20:49 said:
Yessssssssssss!!!!!
I love this picture. FAB!!!!!
Elvis with a large hairball.
So cool. Hey...baby.

location_iceburg @ 2003-09-09 21:19 said:
smiling now :)

amberwing @ 2003-09-09 22:05 said:
OMG! this is soo funny!
thanks for brightening my day!
and what a beautiful cat!

beebs @ 2003-09-09 22:58 said:
stringbeanjean, i so, so, so love
your log.

sharonwatt @ 2003-09-10 01:48 said:
I kiss my fingertips to you, girl

petbunny @ 2003-09-10 08:38 said:
that's the funniest thing i've seen
in a long, long time.

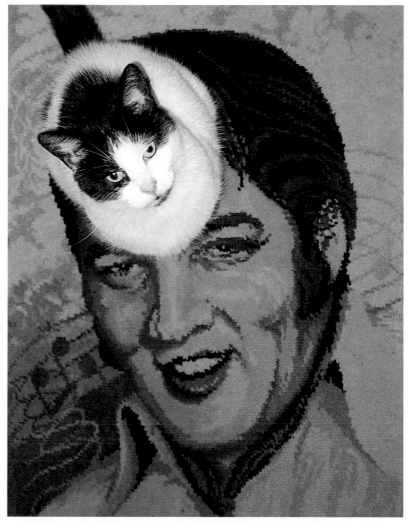

www.fotolog.net/**finalshot**/?pid=7836486
what a colorful place!

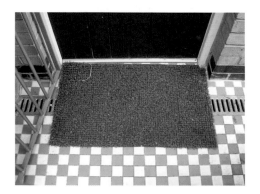

far left: www.fotolog.net/**johannaneurath**/?pid=6049211
A colourful welcome | Stoke Newington, London N16

left: www.fotolog.net/**luisacortesao**/?pid=7259597
**more squares and carpets
that's all for today!**

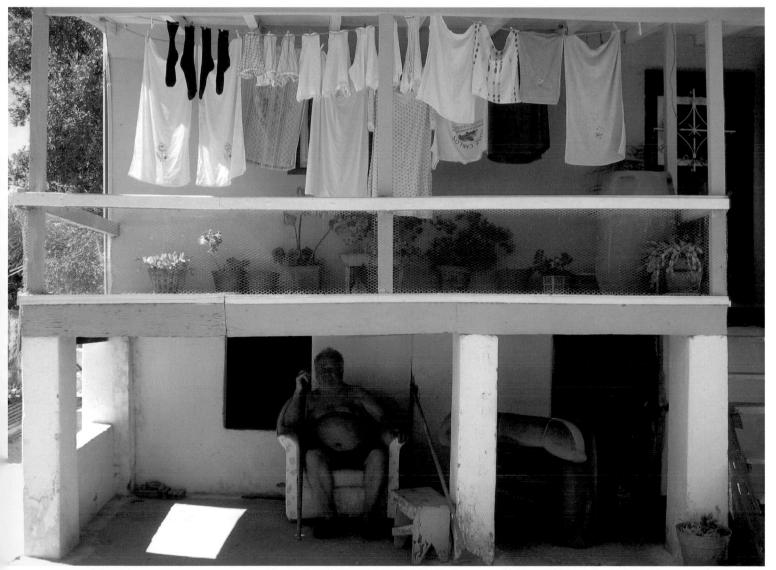

swab on the wall
+++shanghai old lane+++

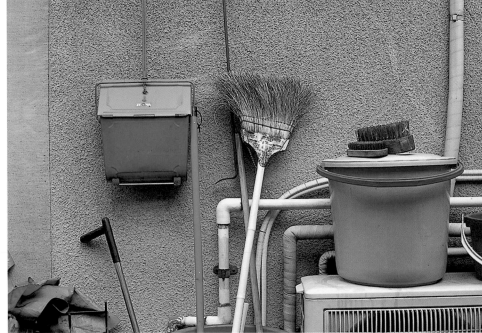

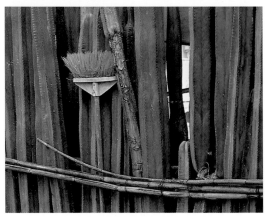

mitla, oaxaca

mashuga @ 2004-02-26 22:57 said:
Just a sweepy little Mexican town.

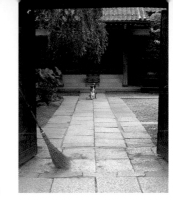

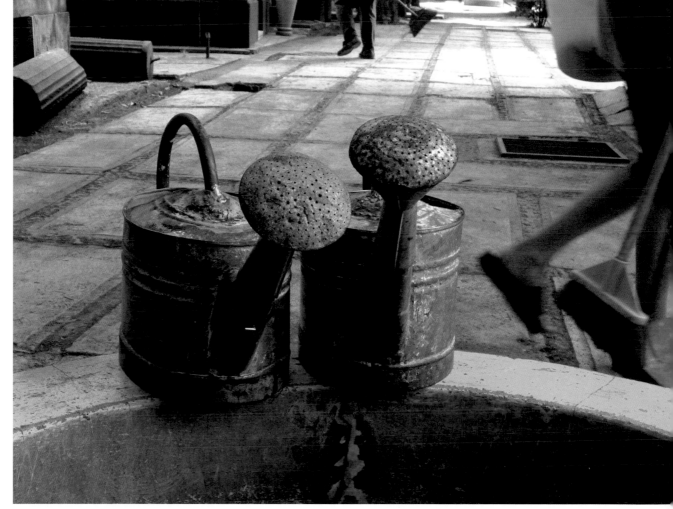

pro_keds @ 2004-11-04 12:47 said:
red sweeps

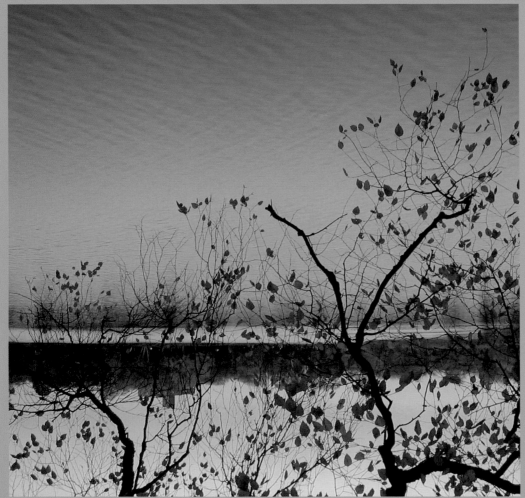

spychic @ 2004-11-17 10:54 said:
wow. this looks like a japanese print.
I can just imagine it printed on sheer silk.
lovely.

pirondelle @ 2004-11-17 12:48 said:
as natural as nature can be
complete with all her surprises

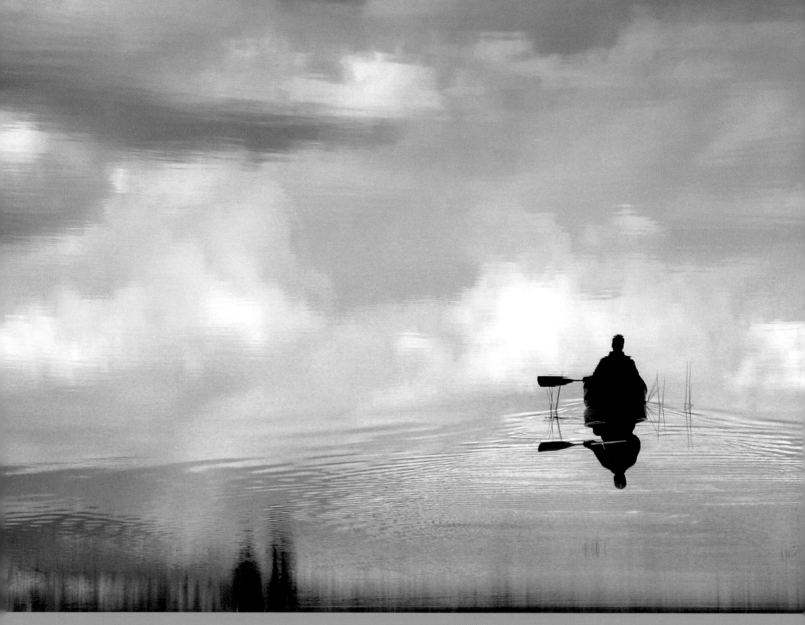

holakeelay @ 2005-06-29 01:27 said:
that's a really beautiful picture!
he looks as though he's about to
row off the end of the world...
speaking of the end of the world,
greetings from chile! :)

LENS AT THE END OF THE WORLD

lotusgreen @ 2003-07-12 22:10 said:
Oh my – it's stunning.
It really is true that the Chinese landscape
looks so different from, well, the ones I know
in the States, and it helps you to better
understand Chinese art.

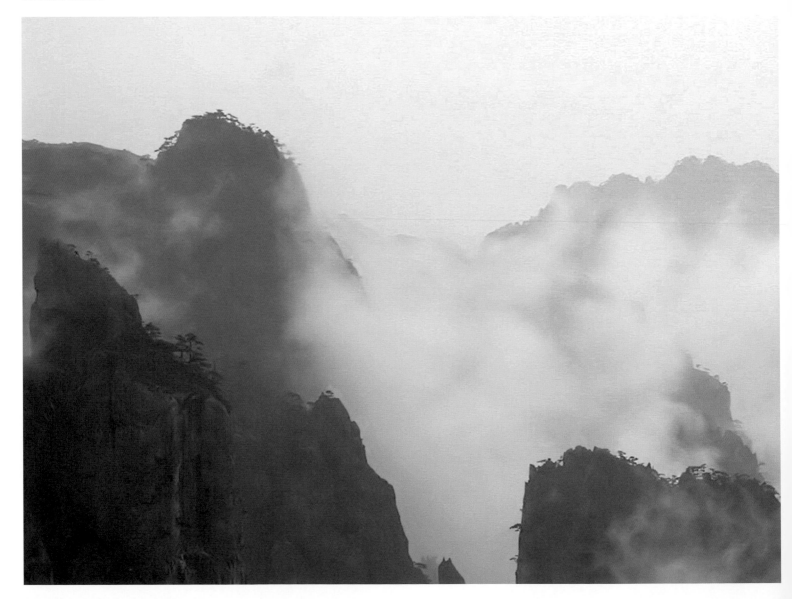

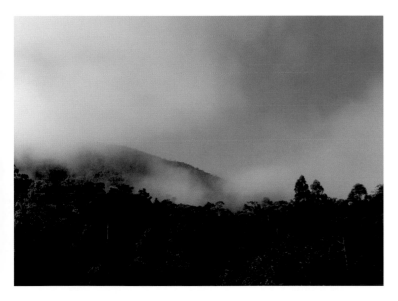

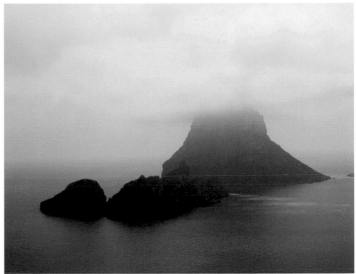

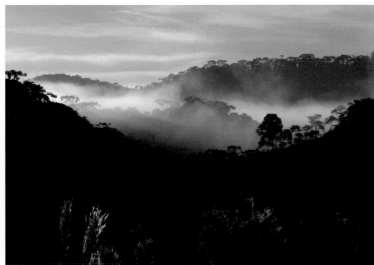

*top: www.fotolog.net/**zenog**/?pid=7260768*

oliby @ 2004-03-07 18:43 said:
Beautiful, Zé, it looks like a
Japanese painting.

silvia @ 2004-03-07 20:30 said:
Spring: even
hills without names dress up
with morning veils. (Basho)

*above: www.fotolog.net/**ecosites**/?pid=6486222*

run_to_the_hills @ 2004-02-20 07:26 said:
The combination of valleys and clouds
always ends up in a beautiful pic! This one's
no exception. Hugs dude!

thico @ 2004-02-20 10:23 said:
wonderful
simple words can't describe how
perfect this photo is...

*top: www.fotolog.net/**hihihi**/?pid=7683146*

ajs @ 2004-05-28 14:11 said:
Now you're not telling me that's Liverpool!
Wherever it is, it looks magnificent! Great shot!

kossaqui @ 2004-05-29 15:44 said:
Sometimes you just can't stop thinking that
it's a shame you're not a bird

*above: www.fotolog.net/**zenbomb**/?pid=7682347*

e_caskey @ 2004-08-08 18:35 said:
pearly dew drops

ezra @ 2004-08-08 21:17 said:
amazing...the power to see an ordinary
thing and change it into a levitating,
magical object.

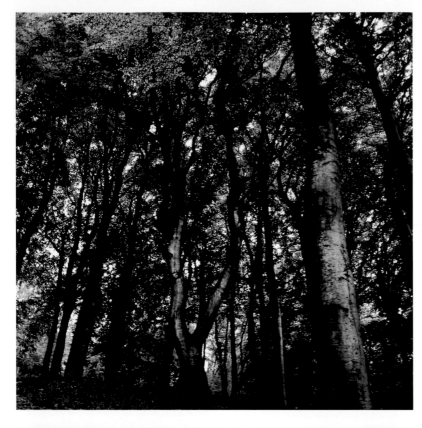

www.fotolog.net/muckel/?pid=9529254

eelend @ 2004-10-28 03:30 said:
those trees look like old and
surreal spiderwebs

www.fotolog.net/meadows/?pid=9781076

sizeofguam @ 2004-11-16 10:22 said:
this could be a lot of things

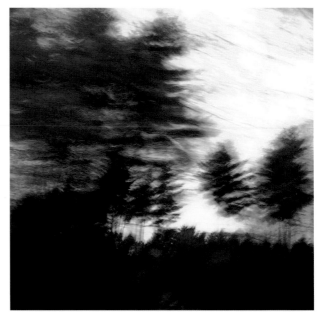

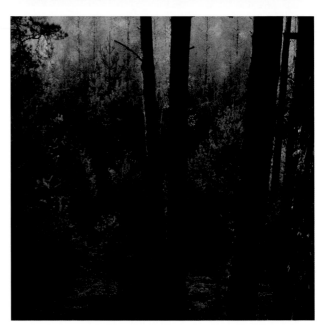

www.fotolog.net/inthegan/?pid=7945843

www.fotolog.net/muckel/?pid=10018558

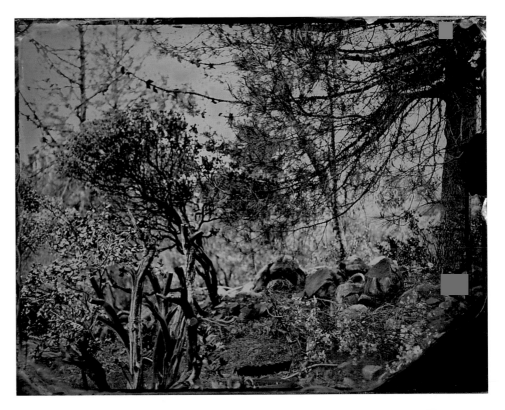

So much detail, but the light
values are all so strange that
the results are kind of surreal.
If you ever need to find a good
home for any of your plates,
you know who to talk to...

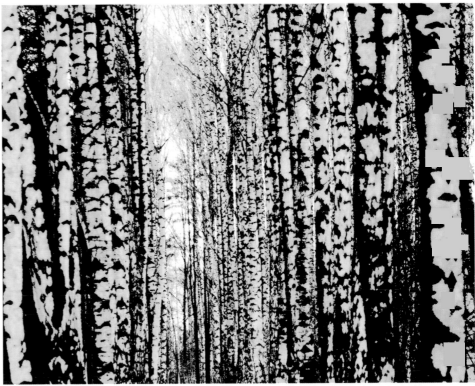

below, from top to bottom:

www.fotolog.net/**na_areia**/?pid=8620593

neene @ 2004-11-18 03:05 said:
oh luisa, this might be the most beautiful
image in this log

johannaneurath @ 2004-11-18 03:13 said:
ohhh...it's a map of a dream...and it's beautiful.

www.fotolog.net/**luisacortesao**/?pid=9185642

www.fotolog.net/**johannaneurath**/?pid=8334540

sito @ 2004-10-12 09:25 said:
strange, how could they drive this way? A miracle.

eliahu @ 2004-10-13 11:55 said:
this made me faint

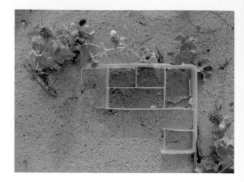

www.fotolog.net/**na_areia**/?pid=1017792
**neene asked me why didn't i put them in a series.
so...here they are.
a picture a day. hope neene will upload hers too.
luisacortesao**

verasayao @ 2003-09-13 09:04 said:
poética...

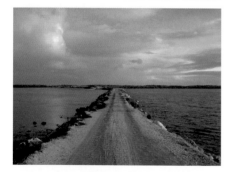

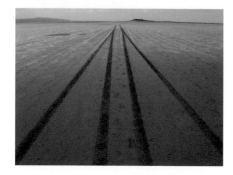

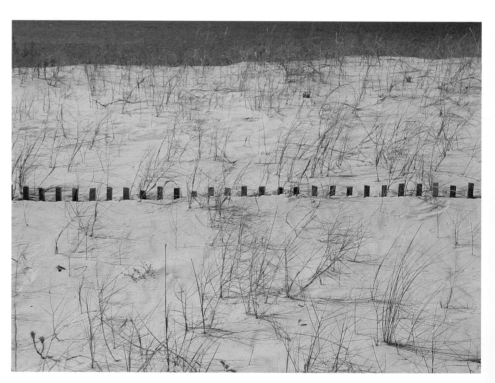

www.fotolog.net/**na_areia**/?pid=1867321
*from www.fotolog.net/**luisacortesao***

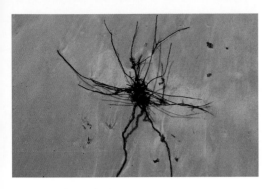

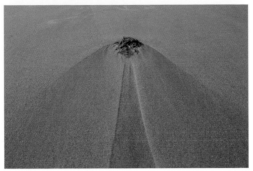

*www.fotolog.net/**na_areia**/?pid=7885011*
*from www.fotolog.net/**neene***

pandarine @ 2004-06-27 09:48 said:
Spiderman? ;-)

*www.fotolog.net/**na_areia**/?pid=8050290*
*from www.fotolog.net/**neene***

*www.fotolog.net/**luisacortesao**/?pid=9190059*

leo59 @ 2004-10-31 10:53 said:
kiddo, where did you say you left your ice cream?

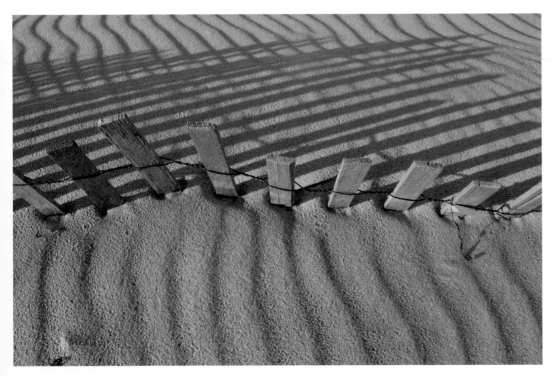

*www.fotolog.net/**na_areia**/?pid=1868561*
*from www.fotolog.net/**neene***

pandarine @ 2003-10-29 13:48 said:
Lots of stripes. :-) Sorry my pic was a bit out of
'the lines'. I was thinking 'ripples'. ;-)

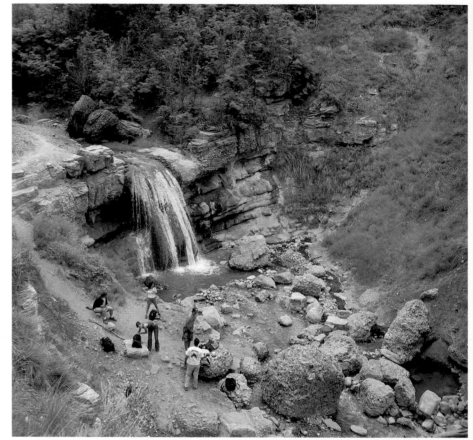

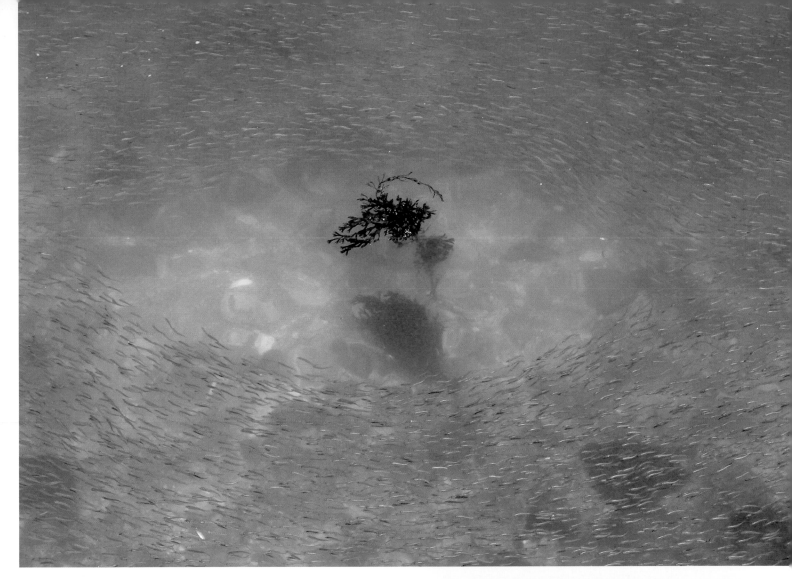

correia @ 2004-09-29 10:18 said:
My God, is it a shoal?
A path?
It's Life!

toinho @ 2004-09-29 10:19 said:
Beautiful pic, Zé.
It's a small aquatic celebration of the world.

Pudding Lane River, Bow, London E3
(Should be called Pea Soup River)

gardengal @ 2004-08-29 14:27 said:
cream of spinach
is this toxic?

sharonwatt @ 2004-08-30 19:39 said:
custardy moss pud

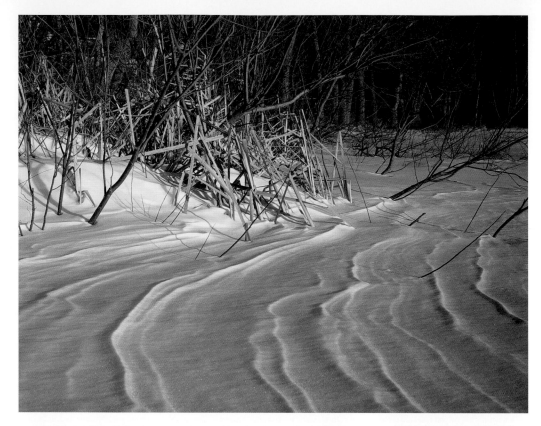

*left: www.fotolog.net/**along**/?pid=6568146*

colorstalker @ 2004-02-21 21:42 said:
is this with flash? the way the light picks
out the ridges & then falls off fast
is what makes this. quite beautiful.

kandykorn @ 2004-02-22 01:34 said:
snowdrift delight.

*below: www.fotolog.net/**clarsen**/?pid=6885850*

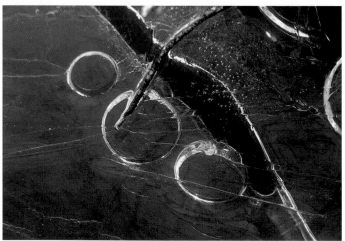

*www.fotolog.net/**zsaj9**/?pid=4063171*

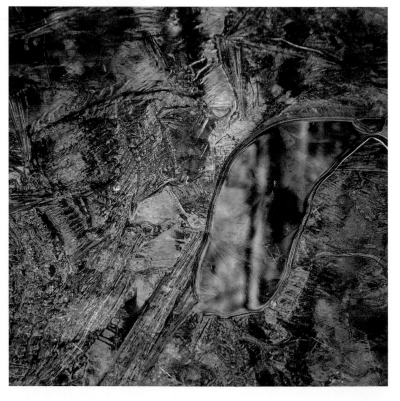

www.fotolog.net/**zsaj9**/?pid=1870911

Troubled leaves

bean @ 2003-10-29 14:15 said:
oh, poor leaves.
funny that it's still beautiful...

ndouvid @ 2003-10-29 14:25 said:
is it pearls strewn before swine...
or simply insect galls on the
underside of oak leaves?

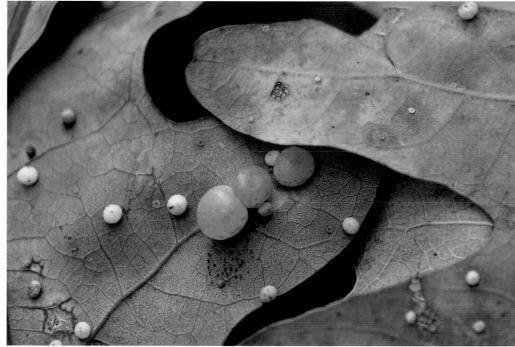

www.fotolog.net/**contrail_artist**/?pid=1043611

www.fotolog.net/**contrail_artist**/?pid=86946

contrail_artist @ 2003-05-09 13:17 said:
I just realized it reminds me of a seahorse. Henceforth,
I shall refer to this as the 'Seahorse Finger' of Soda Lake.
In one of the wider views showing this formation in context,
it appears to have outstretched front and hind legs, in an
abstract way, of course...

www.fotolog.net/**zsaj9**/?pid=4469943

andy101 @ 2004-01-09 10:51 said:
Wow—I was thinking this was going to be a
Photoshop creation. Wonderful catch.

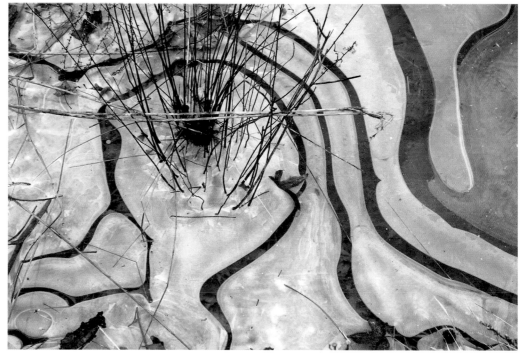

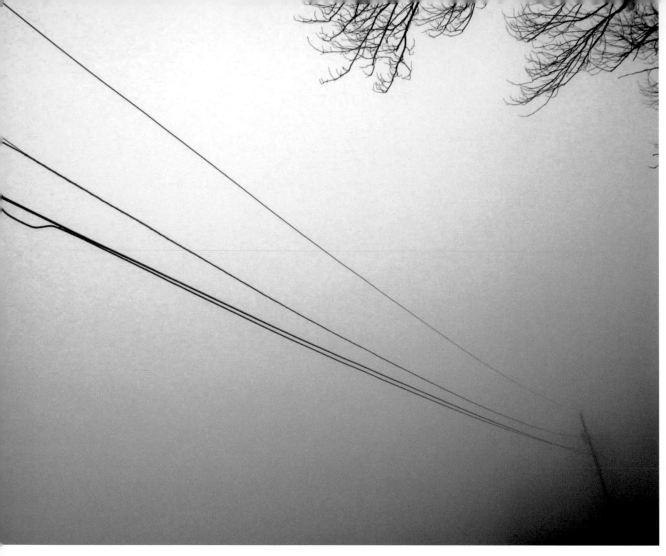

*www.fotolog.net/**kandykorn**/?pid=8404235*

andy101 @ 2004-11-23 18:43 said:
Just looked through this fog series and the only thing I can say is, 'You are getting too good for this place.'

sharonwatt @ 2004-11-24 02:34 said:
i love that imperfection on the line and the branches reaching out as if to hook it

*www.fotolog.net/**kandykorn**/?pid=8404161*

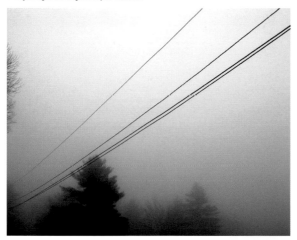

*above: www.fotolog.net/**kandykorn**/?pid=8404275*

placeinsun @ 2004-11-23 20:02 said:
i love this page, truly
gorgeously forlorn
it shows what is possible

brainware3000 @ 2004-11-24 13:12 said:
hound of the baskervilles

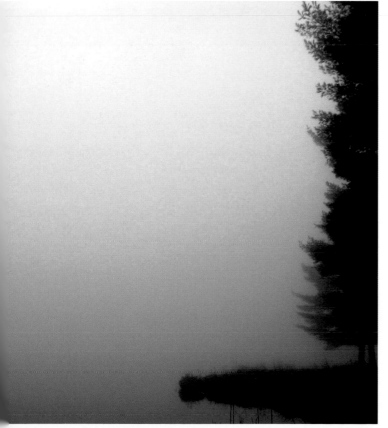

*left: www.fotolog.net/**kandykorn**/?pid=8404259*

ribena @ 2004-11-23 20:16 said:
my immediate, emotion-meets-intellect response
is, I hope death looks and feels like this. which is
entirely weird and personal and true.

*below: www.fotolog.net/**kandykorn**/?pid=8404102*

pro_keds @ 2004-11-23 18:28 said:
hello perfect dream

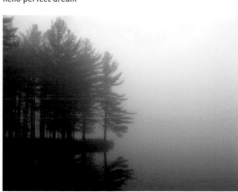

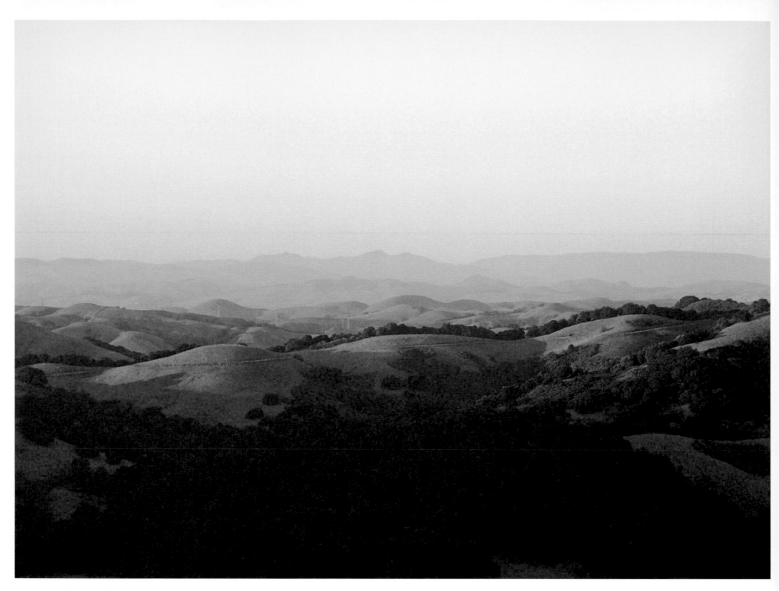

www.fotolog.net/*lotusgreen*/?pid=7328365
last evening, the berkeley hills

pahuljica @ 2004-03-09 10:54 said:
The panorama is gorgeous.
Are you telling me that this is
what you see all the time?

clockwise from top left:

www.fotolog.net/5points/?pid=1637069

www.fotolog.net/jopalane/?pid=6889034
'Iluminada' Serra do Mendro, Portugal

www.fotolog.net/clarsen/?pid=272498

www.fotolog.net/meadows/?pid=9717318

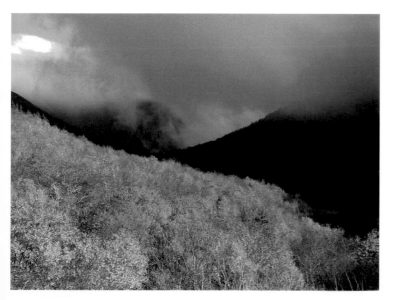

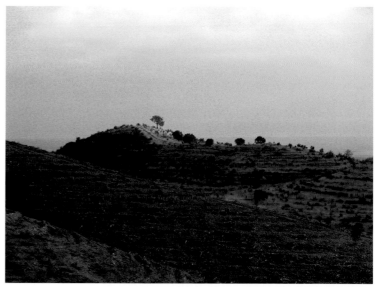

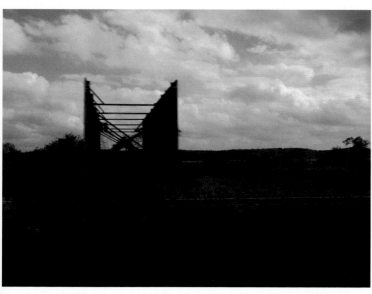

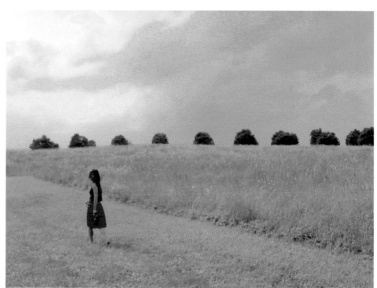

mariajohanna's archive

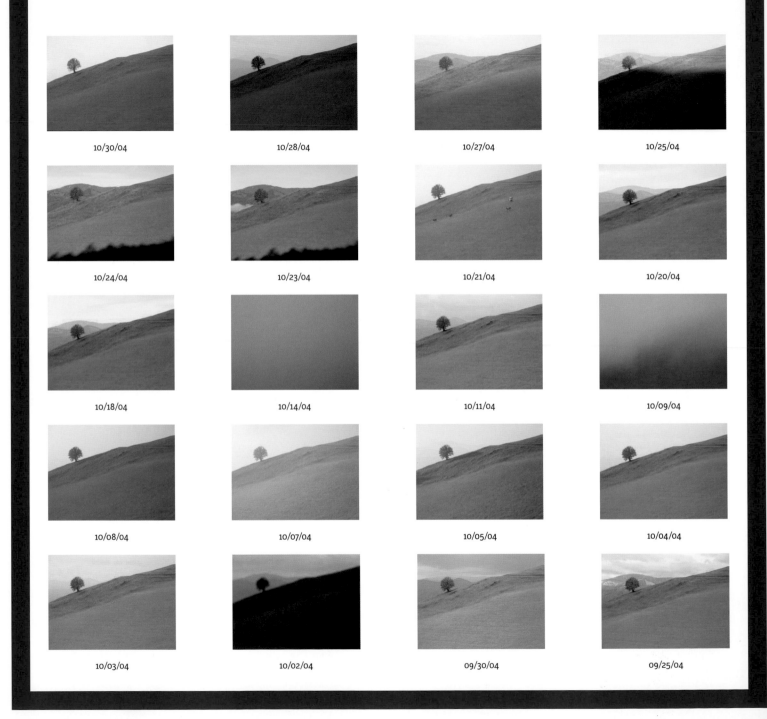

10/30/04

10/28/04

10/27/04

10/25/04

10/24/04

10/23/04

10/21/04

10/20/04

10/18/04

10/14/04

10/11/04

10/09/04

10/08/04

10/07/04

10/05/04

10/04/04

10/03/04

10/02/04

09/30/04

09/25/04

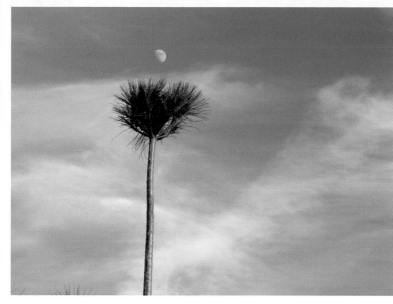

along @ 2004-01-01 22:24 said:
woooweee. moondusting.

amymm @ 2004-01-01 23:03 said:
wooooooooooow
beautiful!!!!!!!!!

ojo_blanco @ 2004-01-17 22:09 said:
i must say it's sublime!

Valley Forge

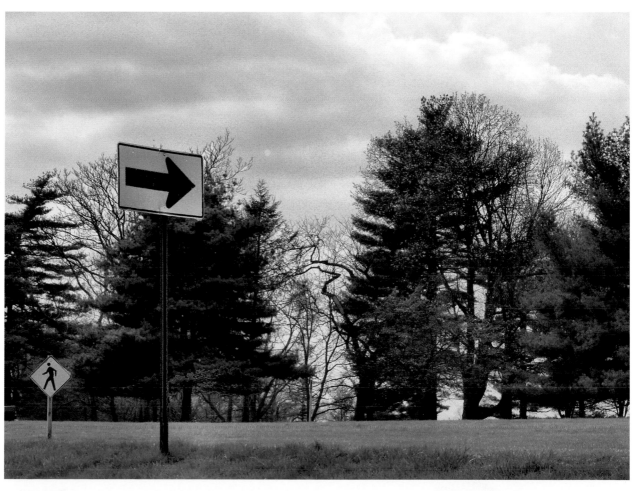

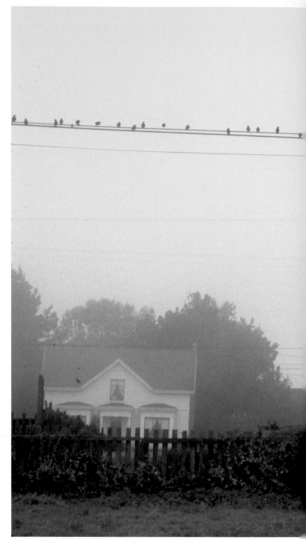

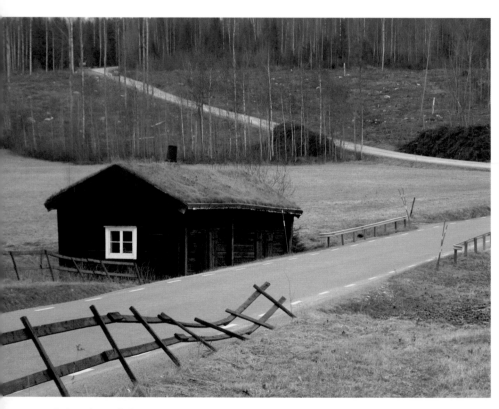

*www.fotolog.net/**paysage**/?pid=7697976*

momofreaksout @ 2004-04-18 00:56 said:
Looks like something out of a fairy tale!

juulia @ 2004-04-18 01:00 said:
after a twister maybe...

*www.fotolog.net/**colorstalker**/?pid=7988054*
Like a bird on the wire
Like a drunk in a midnight choir
I have tried in my way
To be free – Leonard Cohen
(thinking about California)

michale @ 2004-06-13 13:19 said:
nice to see you back. this is a beautiful shot.
all the birds and the california reference take me
right to hitchcock in bodega bay...
and poor poor suzanne pleshette...
;)

roomwithaview @ 2004-06-13 21:18 said:
Good grief!!
My heart is breaking with nostalgia and homesickness!!
It was after you left the place, Tim, but I lived in the top
two floors of that house on the left for a year.
Sniffling in my tissues here in China right now...
Beautiful photo.

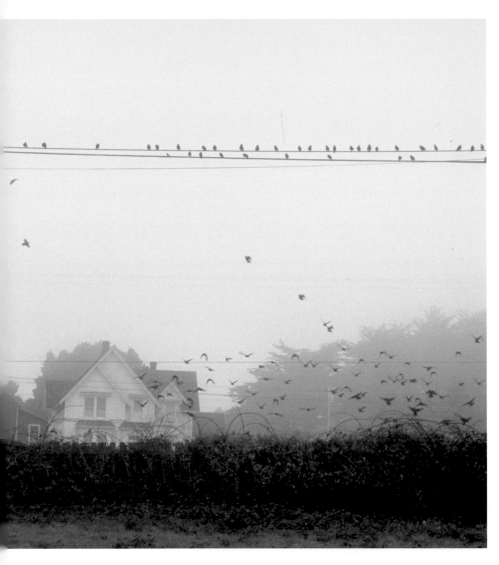

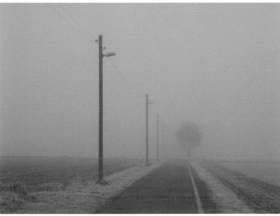

below: www.fotolog.net/**glblanchard**/?pid=742748
Tuscan Morning

lotusgreen @ 2003-08-23 23:15 said:
oh unbelievable – I can hear a string quartet

colorstalker @ 2003-08-23 23:18 said:
just the way I dreamed it

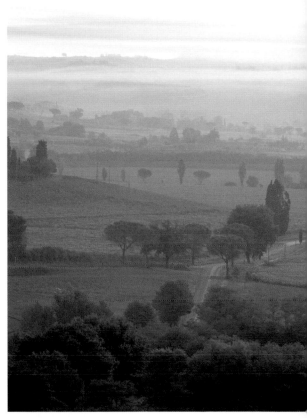

DIGITAL COMMUNITIES BY NICK CURRIE

'PEOPLE EXIST WHO FEEL THE WAY I FEEL. Perhaps not here, but somewhere. Somewhere out there is someone who thinks the way I think, and sees the way I see – if not identically, at least enough to be interested in, and interesting to, me. People exist who might desire me. People exist who might want to talk to me. People exist who wouldn't glaze over when they look at my photos, the ones I take just for me. They're just for me, but I would be happy to share them.'

Yearnings like these are universal, and throughout my life institutions and technologies dedicated to them have come and gone. I'm sure my experiences are fairly typical. I could go through them one by one, knowing that all the specifics here can probably be mapped to specifics in your life. Perhaps they'll trigger memories of your own attempts at community.

1976: I'm listening to Radio Luxembourg one evening when I hear that Japanese women are looking for pen pals in Europe. I start corresponding with a girl called Yumiko. I send her letters, drawings, photographs. She responds in kind.

1977: I'm a member of the school photography club. It's good, because you can use the darkrooms. I learn to do my own developing and printing. My initiation trial comes in the form of a nasty electric shock from a cheap Russian enlarger, but I'm rewarded when I win a small photography prize with a photo of my sister. Later I join the town photography society, but it's a bit grim; a big building full of middle-aged men talking about filters and S-bend curves, photographing fruit and pretty girls. I stop going to their meetings and start going to post-punk gigs instead.

1978: There's a spate of hit songs about Citizens Band radio. But apparently it's for truckers in America, and they use odd slang while cruising down highways, full of coffee and amphetamines. You can't send photographs over CB radio. In fact, if you're a trucker you can't take your hands off the wheel to take photographs in the first place.

1980s: I spend almost the entire 1980s without a telephone line of my own. For some reason I've never liked the telephone much. But towards the close of the decade I get my first personal phone line...and my first fax machine. The fax is exciting because it gives the

telephone eyes. Primitive, sooty black-and-white eyes, but eyes nevertheless. The most interesting fax I receive is from Pierre et Gilles in Paris. They're going to take my picture, and they fax me their idea (me dressed in a suit of rubber armour, cutting some fruit). I fax their drawing back with a single tear added. They agree to the tear and we take the photo.

I hear an interesting thought about the concept of networks. Value is added to networks exponentially as they increase in size. If you're the first person in the world with a car, you can use it; if you're the first person in the world with a fax machine, it's just the world's biggest paperweight. You need other people with fax machines to make yours useful, and of course you need the network that connects them. The more fax machines there are on the network, the more valuable your fax machine becomes, but this doesn't mean they're more expensive. Economies of scale mean that your fax machine gets cheaper to buy if lots of other people are buying them, as well as more useful. Sounds good to me!

1991: I write an essay called 'Pop stars? Nein danke!', which argues that digital culture will destroy the star system and create a more level field for communication. 'In the future,' I declare, 'everyone will be famous for fifteen people.' Sometimes I'm given the credit for this phrase, sometimes Larry-Bob of *Holy Titclamps* 'zine is — the main difference is that Larry-Bob said it in 1998. Later a very smart network theorist called Clay Shirky demolishes my theory by saying that Power Laws will always apply to any media system: a few big fish will get really big, while all the little fish stay small.

1993: I'm sitting with my friend Don Watson in my flat on Cleveland Street in London. There's Andy Warhol cow wallpaper on the wall and a rabbitskin rug on the floor. In addition to my fax machine, I now have a computer and a modem. I've signed up to Compuserve, and I'm showing Don a gay chatroom — we aren't gay, but this is the only forum we can find with anyone in it. We say hello to someone with a 'handle' then run away, scared but impressed. Those thin lines of text appearing on the screen, responding to us, really do feel like a faint human presence: 'Hey guys, are you feeling horny?'

1994: My friend Regina works at an advertising agency in New York. She and I email each other. In fact, she's the only person I email. In one message I ask her: 'What is this language called http?' She writes back: 'It's called html, actually, and it allows you to make pages on the World Wide Web.' I download a thing called Mosaic – my first Web browser. Within a year I have my own website. I use it to talk about the music I make, and put up pictures. Sometimes people email me about it.

1996: I go to a digital-media conference held inside a huge gas tank in Amsterdam. Louis Rosetto, founder of *Wired* magazine, is there, and so is Douglas Rushkoff, a very interesting writer on digital culture. Rosetto cites nineteenth-century biologist Ernst Haeckel. Haeckel's phrase 'ontogeny recapitulates phylogeny' (the idea that the foetus in the womb goes through all the evolutionary stages its species went through, including gills, a prehensile tail and so on) may have been discredited in biology, but it's a great metaphor for the Web, which is mimicking all the media that existed before it, one by one. I'm not sure I fully buy it. But it's cool.

1998: I buy my first digital camera, on Times Square in New York. For twenty years photography has been too expensive for me, but now I can take as many photographs as I like, and it costs nothing. I store them on my computer and show them to friends using a freeware slideshow program called Quickshow.

1999–2000: Turns out Rosetto is right about that ontogeny and phylogeny stuff. As broadband boosts bandwidth and digital entrepreneurs brainstorm, the Web successively mimics radio, television, jukeboxes, snapshot albums, social clubs, secret societies, pizza-delivery firms, department stores, auction houses, peep-show booths, libraries, your love life and your job. Do you telecommute? Do you have cybersex? Is there ever a moment in the day when you're offline? Did you meet your wife here? Has your life become a digital rush and does it revolve almost entirely around the Internet? Are you addicted? What alias are you using today? What's your user icon?

2001: The dot-com bubble bursts, but digital life goes on. I start participating on an online discussion board called 'I Love Everything' where we debate stuff. Opinions fly and things get pretty nasty. There are 'flame wars' but the challenges steel me. I feel like I'm training in a sort of intellectual gym. After a couple of years, people stop calling me a 'troll'.

I like jousting on the board, but when people start posting photos on the threads, I begin to see why we disagree so often. It's their aesthetic sense: their rooms look different from the rooms I know; their clothes look different from the clothes I wear. If I'd known this in advance, perhaps I wouldn't have debated with them. Language gives you the illusion of universality, but pictures are much more specific. Pictures are situated; they situate things.

2003: I join Friendster. You don't debate people on Friendster, but you can see pictures of them and read about their tastes. It's the opposite of 'I Love Everything': there's no strife, no conflict, just networking. The machinery of Friendster works behind the scenes to make sure that you meet people who think and feel like you do. I find I end up using Friendster mostly as a free global hotel network. Wherever I travel, there's a Friendster friend.

2004: I join Mixi, the Japanese Friendster. And I start my own blog, a LiveJournal called Click Opera. It revolutionizes my life. I spend several hours a day making my own blog and reading other people's. It's different from my website because people can comment here. It's like holding a fun seminar every day on a subject of my own choosing. It's a community, like a club or a university.

2005–6: I get a Skype account and start using free Internet voice telephony, chatting into my laptop with my girlfriend in Berlin while sitting in a freezing wooden house in Hokkaido. And I sign up for a free account and start posting my digital photos on Fotolog. See page…well, see all the other pages, really!

A MILLION VILLAGES
SQUEEZED NEXT TO EACH OTHER

TOKYO IS MY 'IT' CITY. BUT WHAT IS 'IT'? So many things. Perhaps above all it's a way of being: crows, super-fluorescent convenience stores, public bathhouses, the Yamanote Line; the electronic chime sounding at a train crossing as you return home laden with shopping; a room like a space capsule; a million villages squeezed next to each other; a river hidden by concrete banks and cherry trees; a little girl looking at the wooden figure of a raccoon dog with giant testicles. If one thing matters, everything matters: that particular mixture of the medieval and the postmodern, Shinto and capitalism; smoothness and safety, and the closest a gigantic city can come to tender-mindedness; riding a bicycle, feeling good in your body, sinking into a vibro-massage chair, sipping cool green tea; the surprising, compulsive sexiness, the togetherness, the attention to the seasons; sizzling yakitori underneath the railway tracks; endless TV variety specials; musicians carrying guitar cases through the intricate warren of streets at Nishi Ogikubo; a wedding at the Meiji shrine; fire flowers in Kichijioji Park; the train to Kamakura out on the coast; the moon over the Aoyama Dori. Enchantment. 'It'.

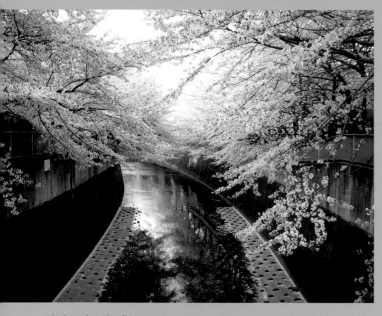

*www.fotolog.net/**moondrop**/?pid=11760884*
Sakura Tokyo

hana2003 @ 2005-04-09 09:19 said:
This year's cherry blossoms are the best
of the best! I wish it not to rain for a week.

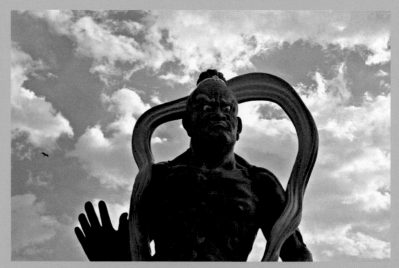

*www.fotolog.net/**emmy**/?pid=8578270*

hansolo @ 2005-03-07 20:45 said:
Very devilish!!! It seems like one
of Kurosawa's demons ;-)

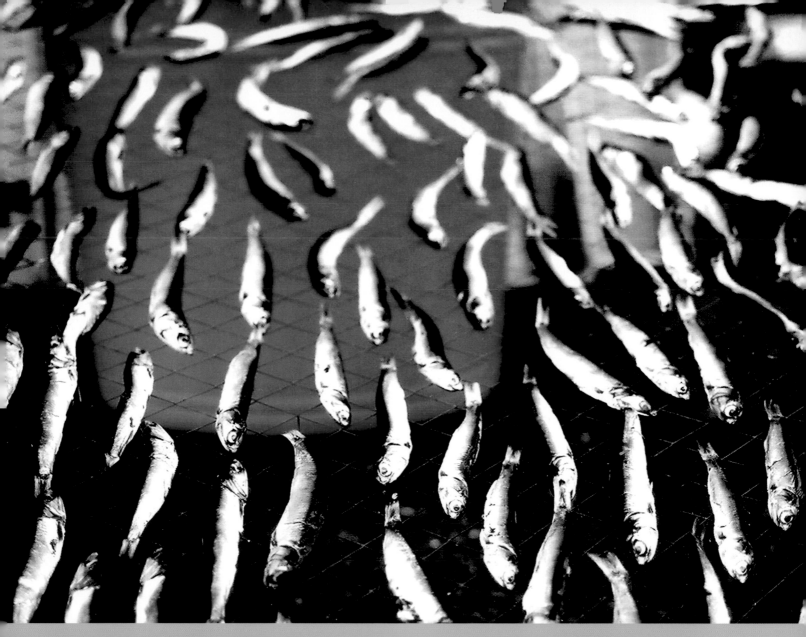

misaki harbor #4 'dry fish!'
location: misaki, kanagawa

shibainu @ 2004-03-04 08:11 said:
Fishes fly!!
The blue background is beautiful.

tok-yo

TOKYO

searocket @ 2004-05-08 16:17 said:
some wild urban shot!

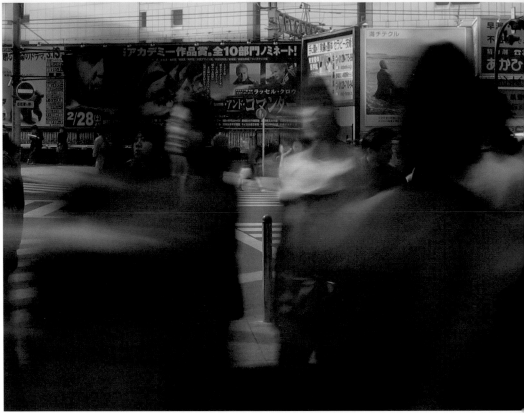

pechuga @ 2005-04-14 07:06 said:
tokyo station?

nysama @ 2005-04-14 08:16 said:
Zansu zansu zansu, take a zansu!

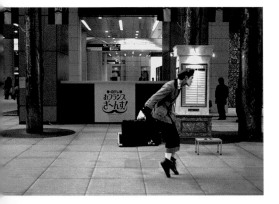

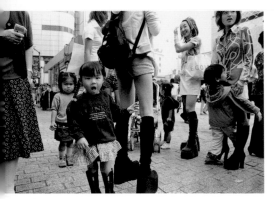

Shibuya, Tokyo. 1999.

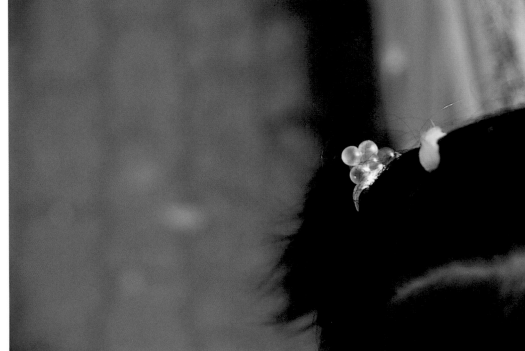

offshore @ 2004-09-16 05:03 said:
Suuuper – I like your eye for detail!

kulu82 @ 2004-09-16 03:49 said:
shiny little coloured bubbles!

gabrielita @ 2005-03-23 12:15 said:
!!!!!!!!!!!!!!!!

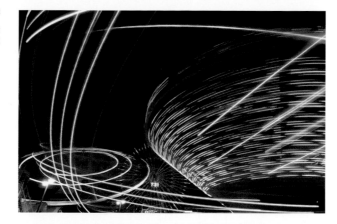

Ginza

koh @ 2004-07-22 08:36 said:
I met him last week.

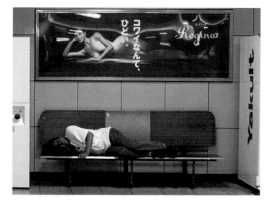

Tokyo Yoidore Report (Drunkenness)

dippy_redhead @ 2004-07-14 12:31 said:
This is really great! Almost appears as though
the guy is dreaming about her! hehehe

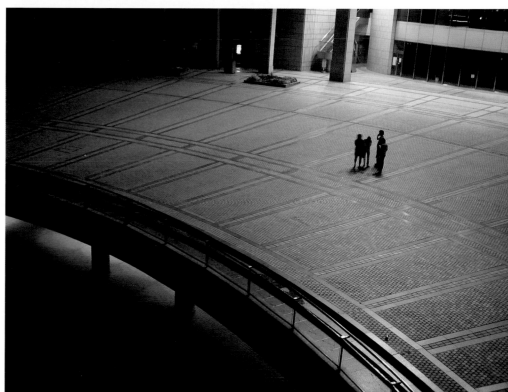

Shinjuku Tokyo Japan

everjoy @ 2004-08-16 10:33 said:
beautiful perspective!

quizz69 @ 2004-08-16 10:40 said:
you are phenomenal...tell me just one thing
though, why you ain't sleeping at night? lol

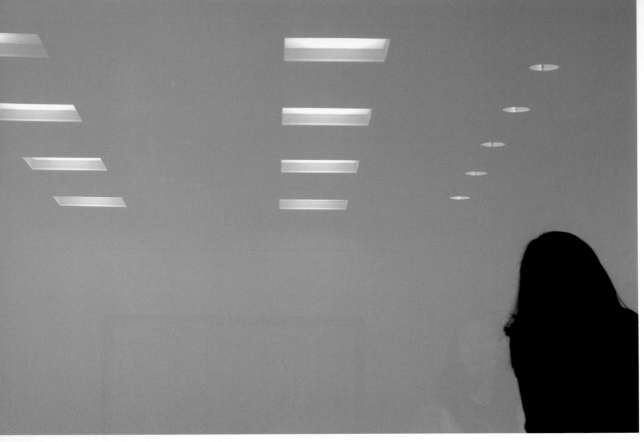

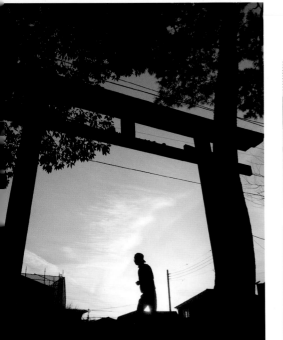

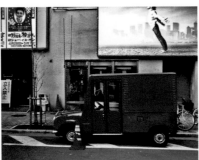

tokyo lookout

el_ @ 2005-04-10 13:27 said:
funny how little is seen and it does
make sense that it's Tokyo.

**Light & Shade...
Roppongi Hills @ Roppongi, Tokyo**

Akasaka #1 (Today, 13:59)

aeaflores @ 2004-02-18 07:34 said:
seems an urban puzzle – amazing
colors!

1fotobear @ 2005-01-11 09:15 said:
in future, please handwash your car in
lukewarm water only. or try ironing it
back into shape!

*left: www.fotolog.net/**moondrop**/?pid=7680308*
Clouds like a balloon

filecomfritas @ 2004-04-06 11:16 said:
Beautiful sky and city!!! What a weird cloud! :)

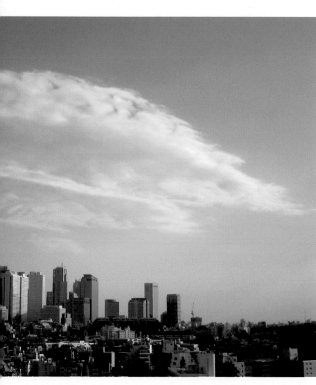

*above: www.fotolog.net/**chillhiro**/?pid=2679218*
Fortunately, my camera wasn't bombed.

nou @ 2003-11-25 19:45 said:
Great. *The Birds*.
A little bit Hitchcockian, no? :-)

markal @ 2003-11-27 23:37 said:
Angular beauty; the sky ruled by
lines (and birds).

*left: www.fotolog.net/**ysk**/?pid=3745857*
look up at the sky

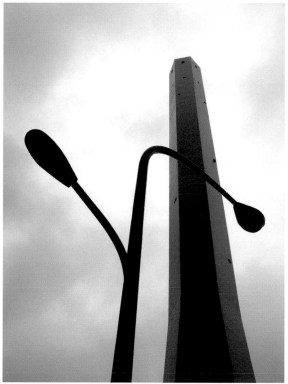

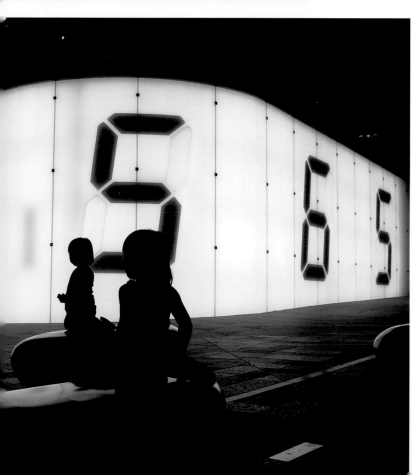

*above: www.fotolog.net/**tioseijinn**/?pid=447405*
210M: The highest chimney in Japan.

hukes @ 2003-07-25 23:10 said:
Jack's beans sprouted!!

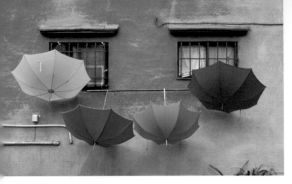

stelling @ 2004-09-27 20:28 said:
Why did an artist hang these umbrellas? Just
to let another artist capture the moment!

tinhart @ 2004-09-28 05:54 said:
the windows are crying teardrops of colored
umbrellas...beautiful.

17:49 Today
Shinagawa, Tokyo

spy_glass @ 2004-09-30 21:25 said:
wonderful diffusion of light

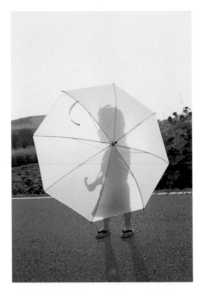

japes @ 2004-05-11 06:57 said:
It's like an old Hiroshige!

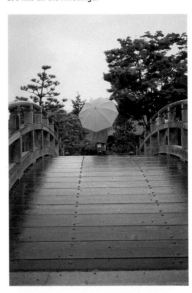

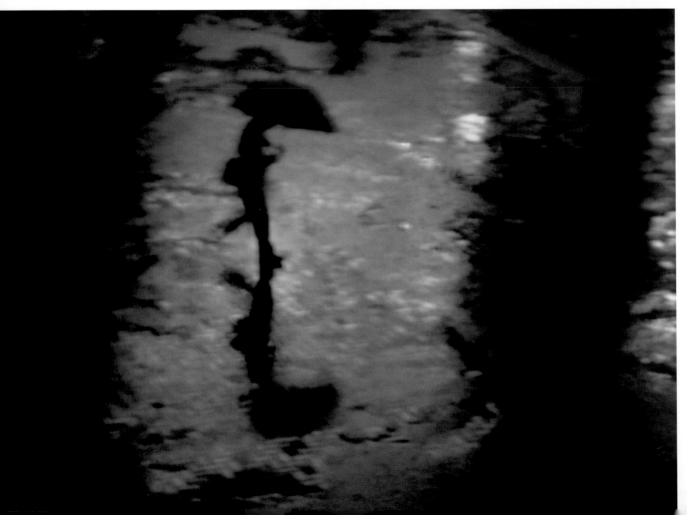

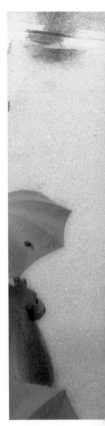

atcy7 @ 2003-10-15 08:50 said:
Matrix shot!!!

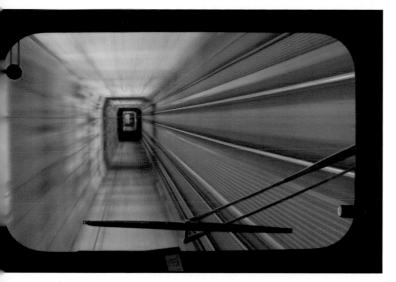

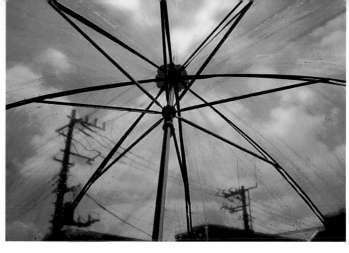

lenzeye @ 2004-06-22 01:27 said:
The sky as our shelter! Amazing.

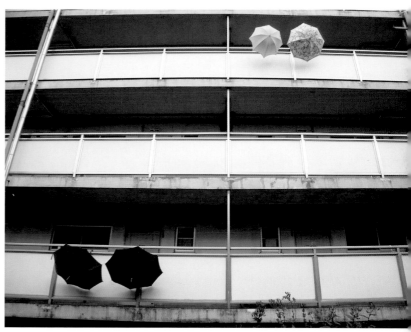

after the rainy day.

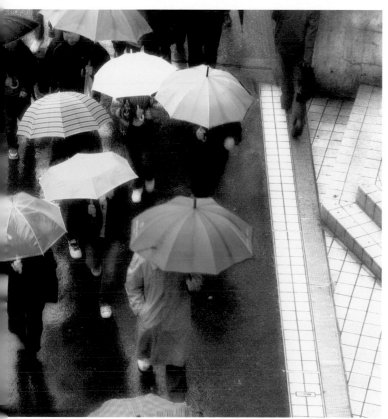

buster @ 2003-12-11 01:16 said:
muted loveliness, really fine.

searocket @ 2003-12-12 09:10 said:
candy for the eye!

iansummers @ 2003-12-12 09:59 said:
These colorful umbrellas resemble dancing ice cream cones. Great shot. Is it true that there are no two umbrellas alike in Japan?

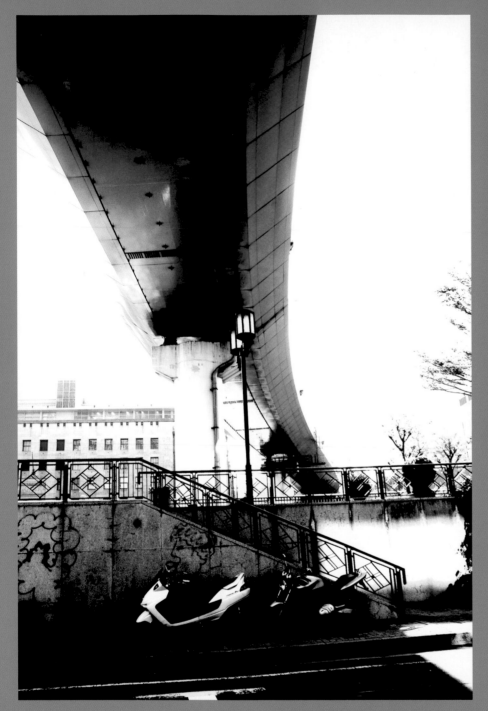

bekon @ 2005-01-24 04:38 said:
Cool!!

tar_lomo @ 2005-01-24 11:21 said:
Cool? Wow!
It is much more than just cool.
This shot is AMAZING, BRILLIANT!

mired_in_inertia @ 2004-11-15 19:46 said:
Gritty and beautiful.

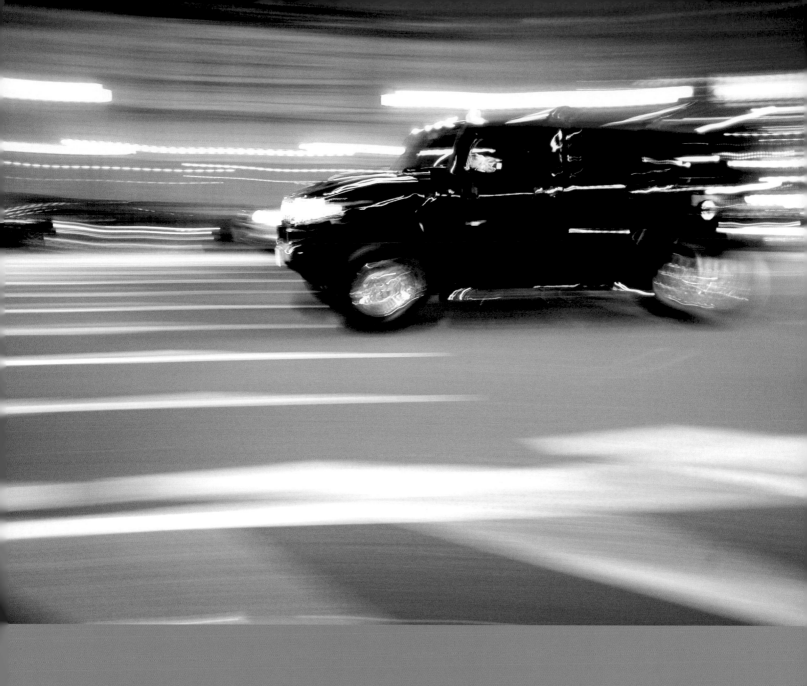

/palla

Sannomiya, Kobe.

williambernthal @ 2003-07-05 00:39 said:
Really cool. Paint conscientiously applied
and paint accidentally splattered.

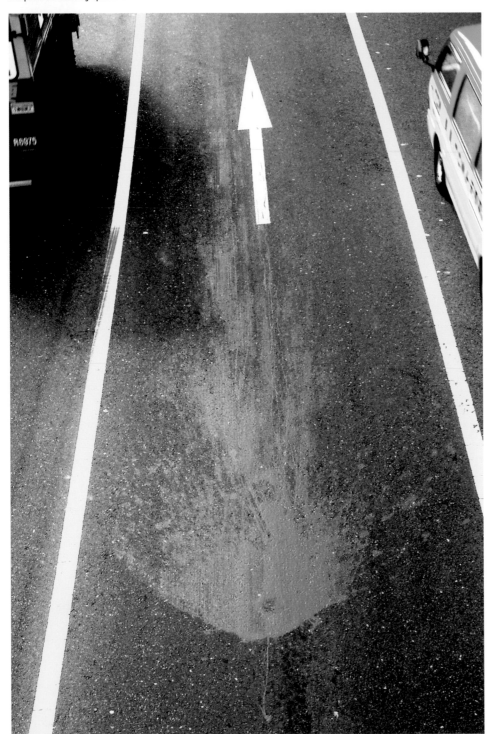

anti-symmetry

along @ 2003-10-16 11:37 said:
oh my god they just keep getting better!
I love this picture.

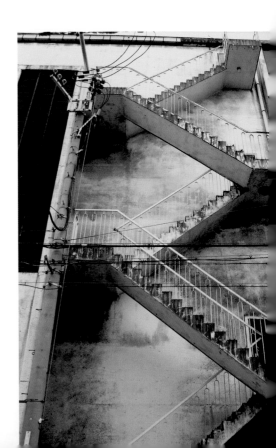

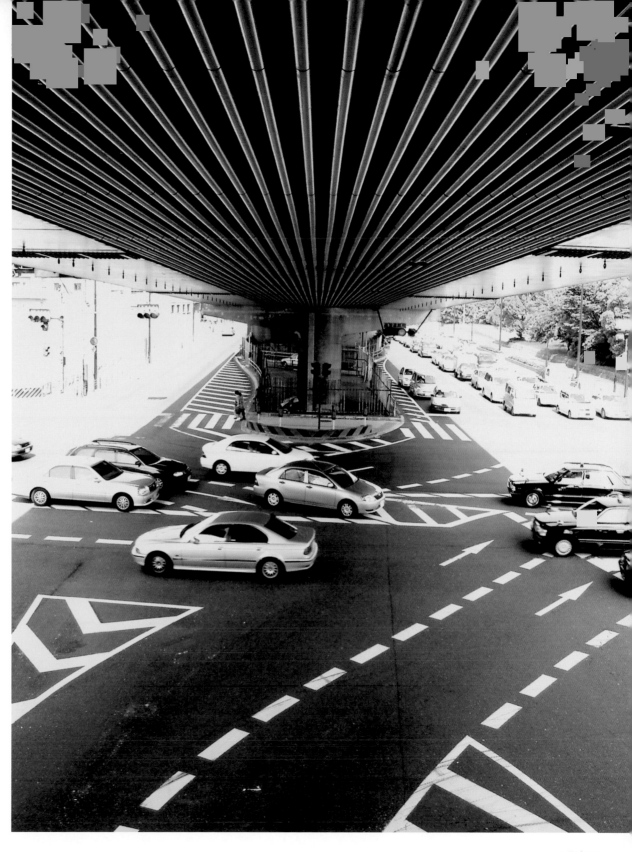

www.fotolog.net/**palla**/?pid=279780
Tanimachi, Osaka.

0x99 @ 2003-06-28 01:56 said:
palla, you're rockin' it

palla @ 2003-06-28 03:06 said:
^_^

t_squared @ 2003-06-30 04:57 said:
incredible! how'd you get up there?

keauxgeigh @ 2003-06-30 05:15 said:
ooh, that's an eye-catcher!

opposite, bottom right:
www.fotolog.net/**palla**/?pid=333253
Daikokucho, Osaka.

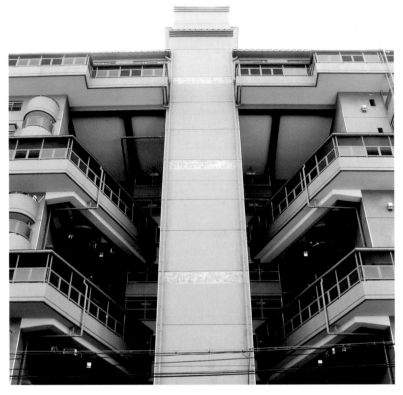

*above: www.fotolog.net/**palla**/?pid=315552*
Sannomiya, Kobe.

*right: www.fotolog.net/**palla**/?pid=12206479*

juspix @ 2005-10-30 12:14 said: nice pattern

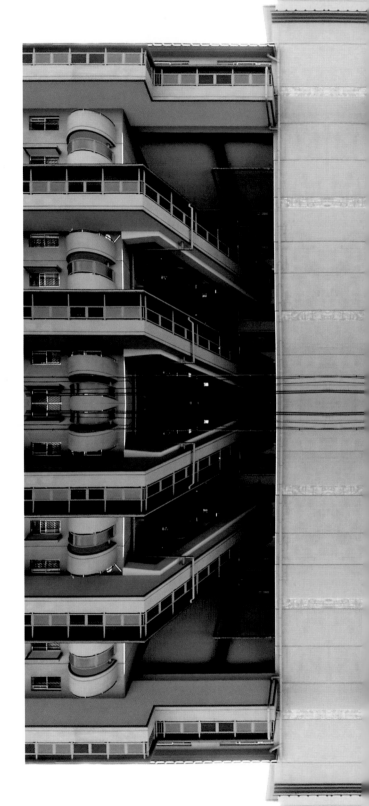

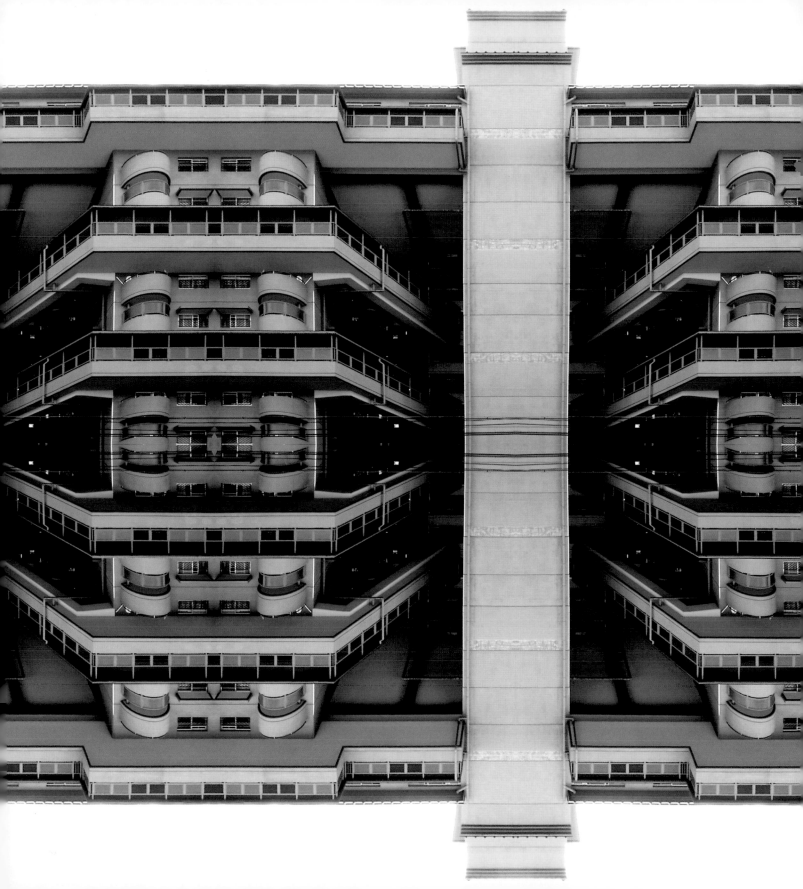

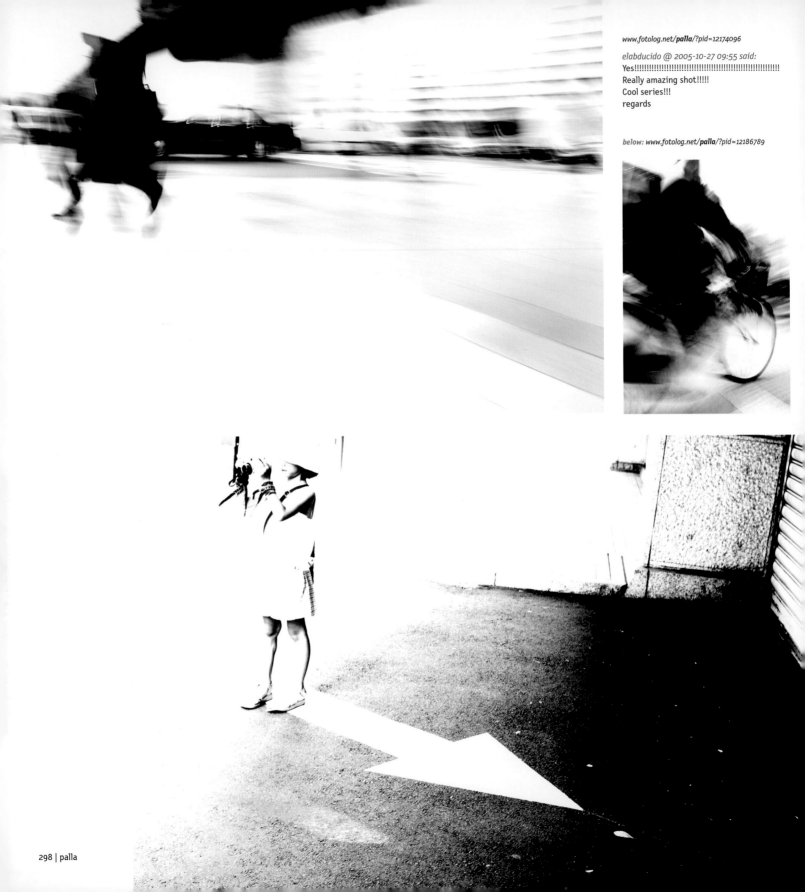

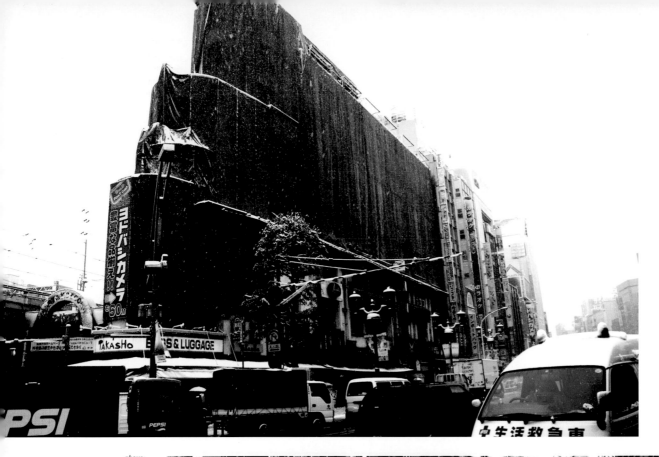

above:
www.fotolog.net/**palla**/?pid=12196588

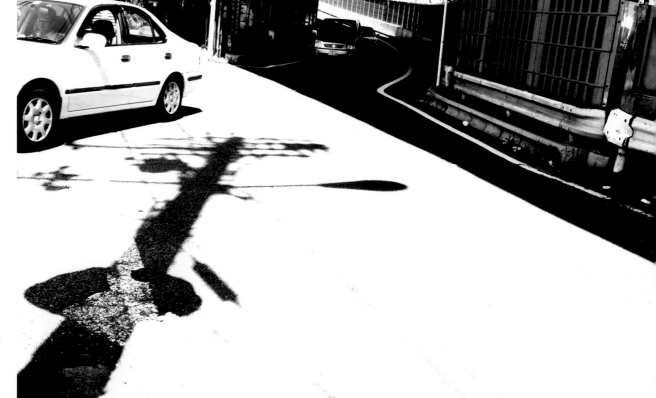

right:
www.fotolog.net/**palla**/?pid=7688288

goon @ 2004-04-16 00:36 said:
now this is a photo.
this is damn good and wow
you are taking more of them.
must visit more often.

opposite:
www.fotolog.net/**palla**/?pid=8392942
her log:
www.fotolog.net/**theta**

*www.fotolog.net/**arto**/?pid=5249361*

On The Embarcadero, yesterday afternoon

ojo_blanco @ 2004-01-23 23:00 said:
great composition. those silhouettes are wonderful.

lubbies @ 2004-01-24 11:34 said:
So much rhythm and spatial sense in your shots.
Love'm.

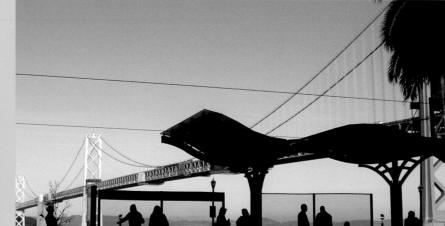

*www.fotolog.net/**pico**/?pid=7697625*

prunella @ 2004-04-23 02:54 said:
THE DOG THAT ATE THE GOLDEN GATE

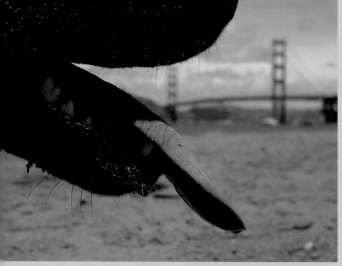

*right: www.fotolog.net/**michale**/?pid=9359476*

tgif
fly away

hermaj @ 2004-10-15 11:49 said:
Beautiful

johannaneurath @ 2004-10-15 13:16 said:
great...love it (& I'm kind of allergic to
cat photos so that's saying something)

planetjamey @ 2004-10-15 15:38 said:
Cool Furry Friday shot!
Took me a sec to notice the cat! :o)

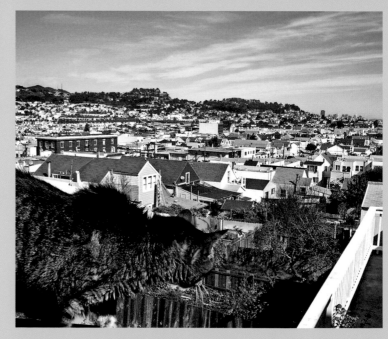

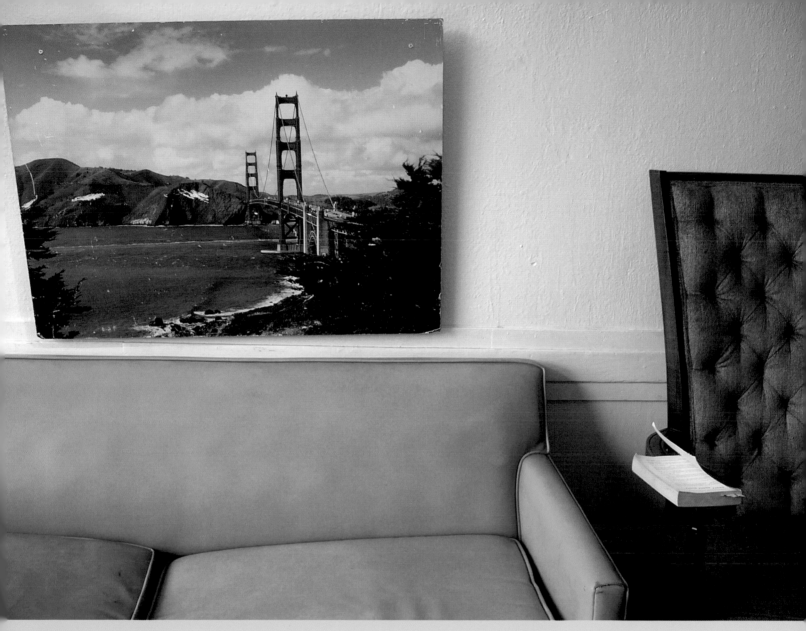

mama buzz cafe
oakland california

gabrielbarbi @ 2005-01-01 23:36 said:
Very good photo.

rafa_gato @ 2005-01-02 00:26 said:
Congratulations!
Happy 2005.
:)

SAN FRANCISCO

www.fotolog.net/**grantbw**/?pid=10062390

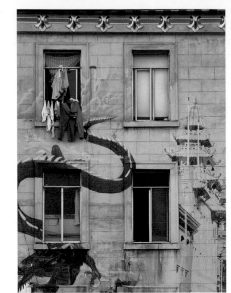

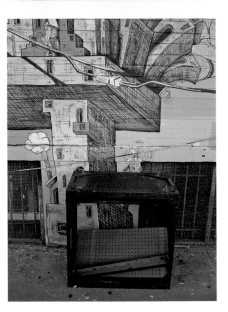

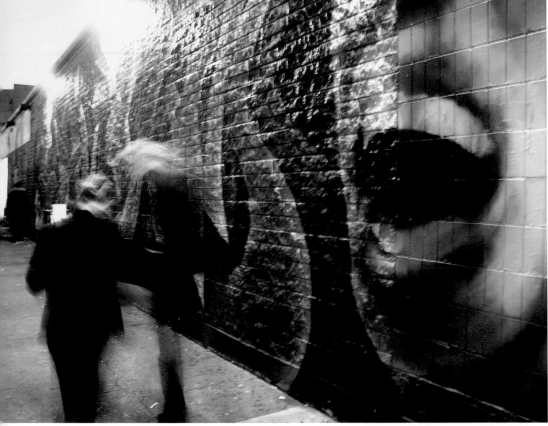

www.fotolog.net/**arto**/?pid=9074915
Geary and Fillmore, last night.

above: www.fotolog.net/**michale**/?pid=9887939
lexington st./mission district
for half a million bucks, you can pick up a nice little
1 BR apt. right across from this mural this week...

the mural is by andrew schoultz and aaron noble

left: www.fotolog.net/**michale**/?pid=10174263
persia ave., excelsior district

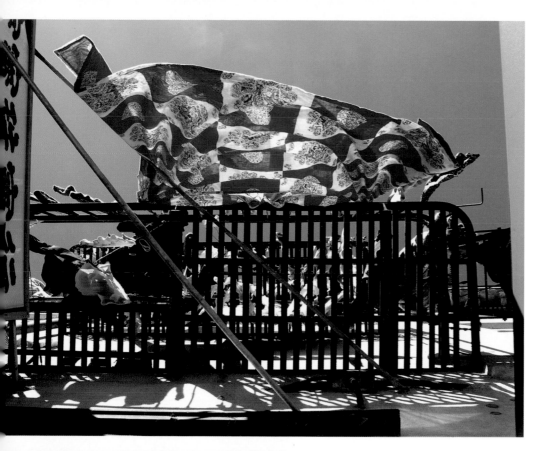

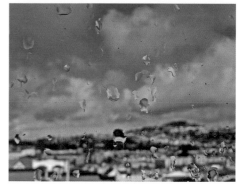

above: www.fotolog.net/*michale*/?pid=7755079
threatened rain for days producing only infrequent droplets

petalum @ 2004-04-20 01:05 said: this is so linda!
my linda!! a whole room full of lindas...

left: www.fotolog.net/*arto*/?pid=9728450
looking up, Chinatown, this afternoon

below: www.fotolog.net/*michale*/?pid=10716547
details, details...

anomalous @ 2005-01-27 23:03 said: miraculous
the desire of human beings to make the world
beautiful is so inexhaustible — I love it!

pop_stimuli @ 2005-01-27 23:18 said:
sooo...SF! a painted vw bus says it all.
love the composition

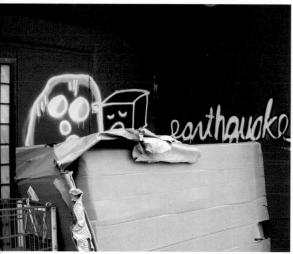

www.fotolog.net/*muta*/?pid=4351517

petalum @ 2004-01-07 03:47 said:
shelter

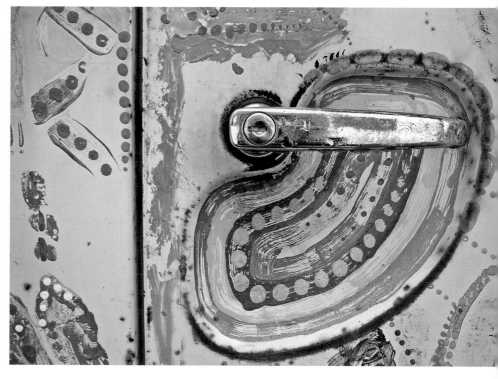

*www.fotolog.net/**adject**/?pid=5552306*

*www.fotolog.net/**willsfca**/?pid=7825143*

forrest @ 2004-11-10 21:12 said:
tiny fat smelly torpedoes!

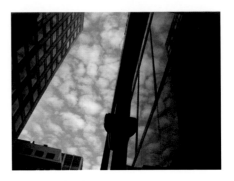

*www.fotolog.net/**arto**/?pid=9052729*

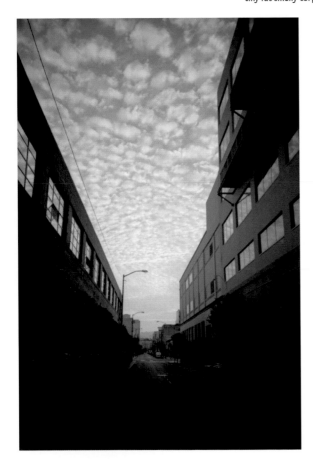

*www.fotolog.net/**willsfca**/?pid=7819169*

eau @ 2004-11-05 14:00 said:
very complicated emotional tenor...hopeful
above, ghostly mood below...communicates
so much about these times...

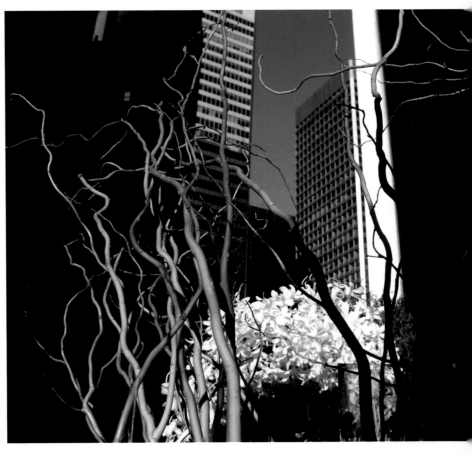

*www.fotolog.net/**arto**/?pid=8464440*

eel_03 @ 2004-12-20 22:10 said:
this reminds me of *the matrix*
for some reason

a_picture @ 2004-12-23 03:02 said:
nice one. i like the little imperfections
– the unlit bulbs...

**At the Southern Exposure Monster
Drawing Rally, hour 1, 2004/06/18.**

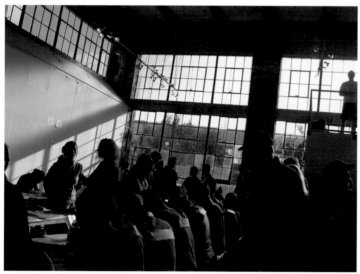

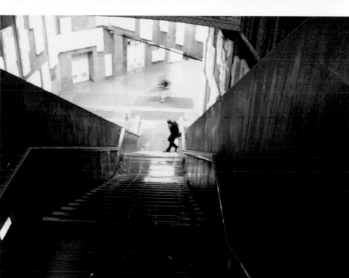

ana_rita @ 2004-03-02 13:20 said:
Nice picture...
No words...Beautiful...
kisses

eel_03 @ 2004-03-02 13:22 said:
showoff :)

thetigerduck @ 2004-03-04 00:56 said:
love the grittiness of this

from the dyke march – at the chevron station on market & castro.

'The brides of March'...

pleather

arto @ 2003-10-08 11:44 said: pneumatic!

earlier today at the castro street fair, #2

curioush @ 2004-10-05 00:56 said: Gail, this is the greatest photo!!!!! That's hilarious. It (and this guy) need a much wider audience than will see it at Fotolog. That should be published. Bravo!!!!!!!! You're my hero!

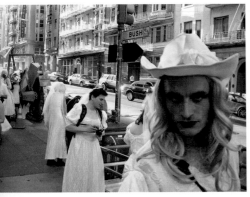

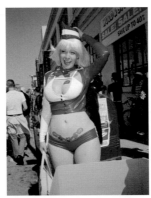

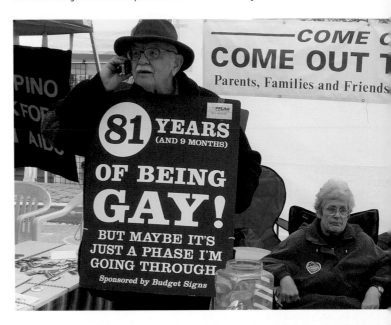

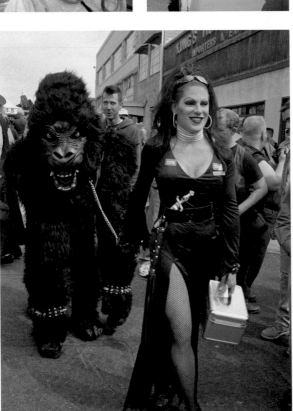

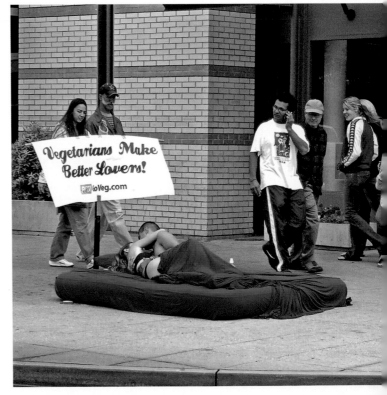

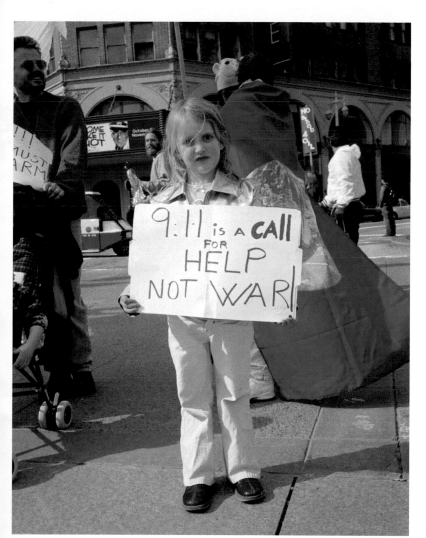

*left: www.fotolog.net/**courtneyutt**/?pid=45816*

davidfmendes @ 2003-03-24 22:50 said:
It's very good to see your pictures in a moment like this. We all know that most people are not supporting war, but at the same time you simply have to see it. You show it in beautiful pictures.

angelissima @ 2003-03-25 07:37 said: WOW

brendan @ 2003-03-25 14:26 said:
cute girl. she'd hold up a sign that read 'lamb tastes great with mint jelly' if her daddy asked her to. i'm unmoved. i'm against using children to promote positions on issues that they cannot comprehend.

christiane @ 2003-03-25 14:37 said: Bravo!

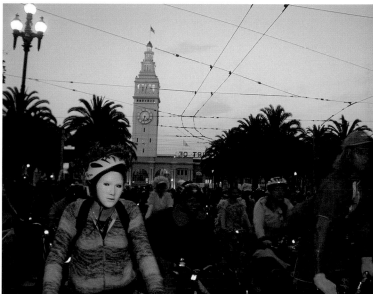

*above right: www.fotolog.net/**lleite**/?pid=9186148*
Halloween Critical Mass is always fun!

*right: www.fotolog.net/**golden**/?pid=602142*

teragram @ 2003-08-11 19:51 said:
Oooo naked baby butts! Pinch 'em!
Play baby butt bongos!

curlierthanthou @ 2003-08-13 02:12 said:
really lovely image!

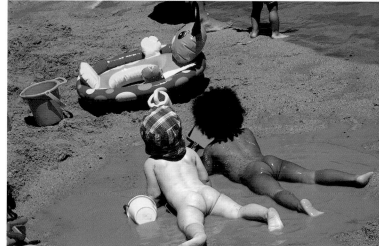

*opposite, bottom left: www.fotolog.net/**courtneyutt**/?pid=1317701*

*opposite, bottom right: www.fotolog.net/**michale**/?pid=8522978*

quite a sunrise this morning.
they say a storm's coming...

khardy @ 2004-02-13 18:06 said:
That light woke me up this morning!
Yellow light coming through the shade,
like the world was on fire.

andreamurphy @ 2004-02-13 18:41 said:
that's gorgeous, looks spectacular and
urgent with the wires cutting through it.

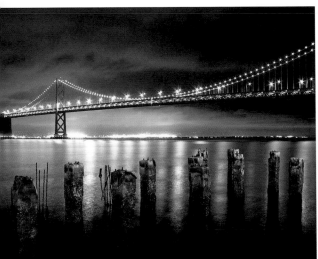

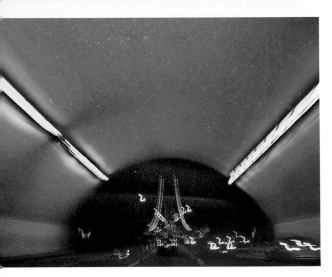

driving back over the bay bridge sunday night...

right: www.fotolog.net/michale/?pid=6727155

arto @ 2004-02-25 11:57 said: you're making the excelsior look glamorous! that's something only a good photographer can accomplish.

ojo_blanco @ 2004-02-25 20:39 said: great color in this. the kissing figures in the poster look like they're about to spontaneously combust. the motion blur works well.

far right: www.fotolog.net/arto/?pid=8844331

oslopaul @ 2004-10-24 11:12 said: wow — you don't see too many images like this of the golden gate bridge! really good image.

below: www.fotolog.net/cassiopeia/?pid=9117319
oakland sunset from the macarthur maze

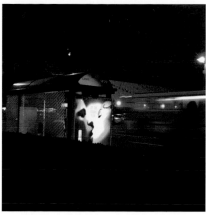

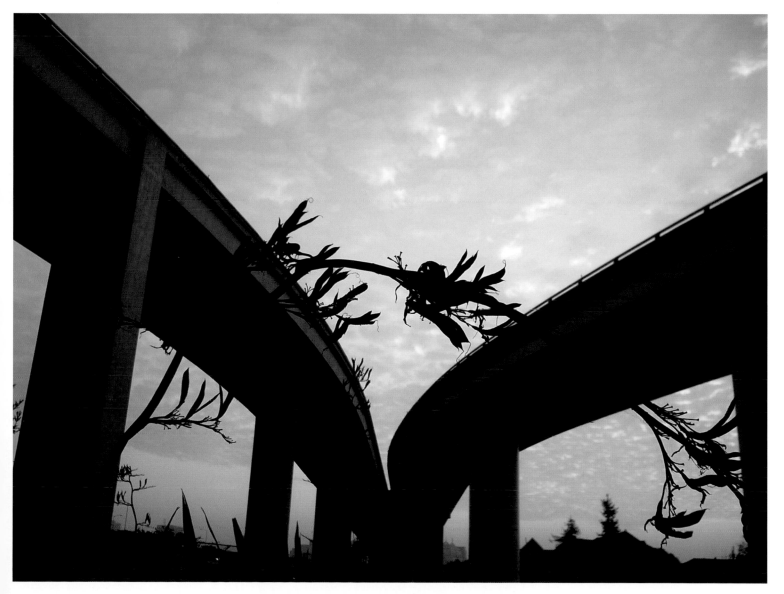

colorstalker @ 2004-04-29 23:43 said:
so fine. suggests massive crazy violence to me.
but i think another time i could be soothed by its
many felicities, i.e.: it's also really lovely.

buster @ 2004-04-29 23:48 said:
writing on the wall, the glass wall, okay, spidery,
with that red eye – and a slice of illumination.
crazily spiritual or visionary. something out of
flannery o'connor. edgy, wiry beauty.

goon @ 2004-04-30 00:12 said:
oppenheimer...'shatterer of worlds'...
what i feel from this image right now.

below, from left to right:

o'hare airport, january 1 [#6]

forrest @ 2004-01-06 23:23 said:
O'Hare has to try harder, or else you might remember
you're stuck in the Midwest, thousands upon thousands
of miles from civilization (I lived three hours south of
Chicago – a.k.a. 'the middle of nowhere' – for two years,
so I know what I'm talking about).

I really dig these video-wall captures.

o'hare airport, january 1 [#10]

o'hare airport, january 1 [#12]

/ojo_blanco

www.fotolog.net/*ojo_blanco*/?pid=7655645

uvalde43 @ 2004-05-26 11:33 said:
That's how Godzilla got started!

www.fotolog.net/*ojo_blanco*/?pid=7935357

johnnieutah @ 2005-01-10 01:57 said:
kind of mindblowing.

willsfca @ 2005-01-10 12:21 said:
this is so rich! are you trying to tell us you
have something to do with beer nuts?

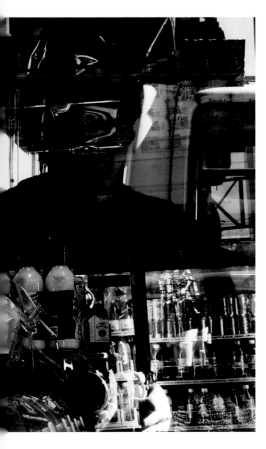

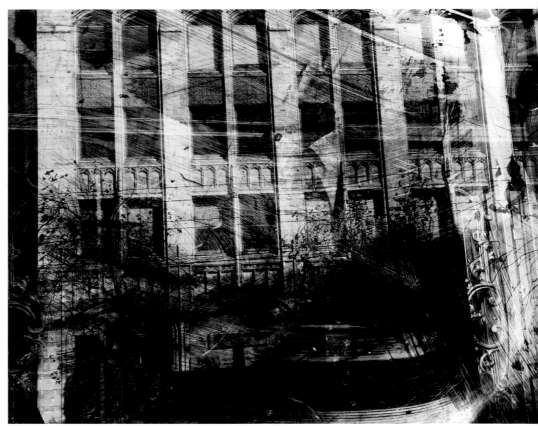

www.fotolog.net/**ojo_blanco**/?pid=7909287

carloserra @ 2004-12-18 18:13 said:
man, I always travel a lot on your images...
wow!

*www.fotolog.net/**ojo_blanco**/?pid=7677418*

[on revisionism in the historical process]

ysk @ 2004-06-22 09:35 said:
I like this image. How tone and edge stand is
very beautiful.
By the way, what is this?

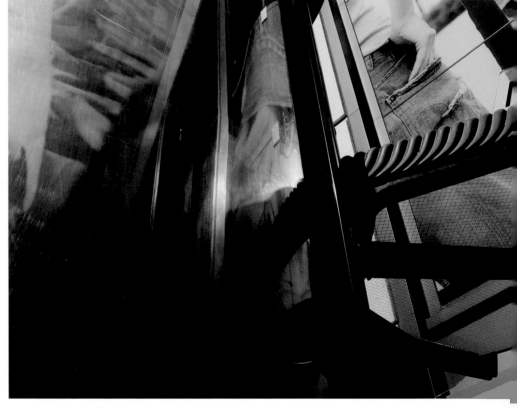

*www.fotolog.net/**ojo_blanco**/?pid=7228003*

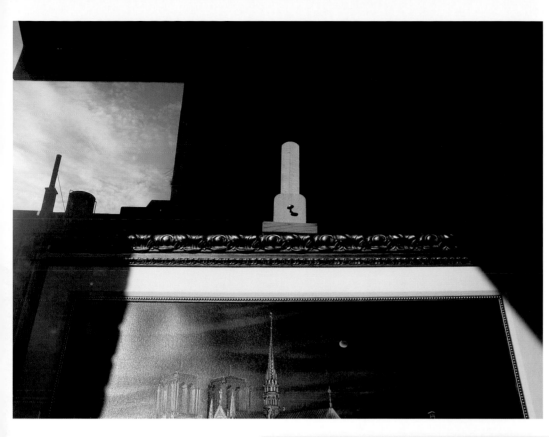

www.fotolog.net/**ojo_blanco**/?pid=5708509

zero8 @ 2004-01-31 11:50 said:
Great...it seems a Magritte...

colorstalker @ 2004-01-31 13:08 said:
Great how the vertical keeps repeating
& I love the blues & purples.

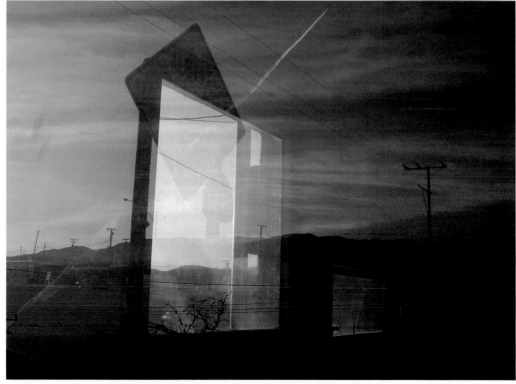

www.fotolog.net/**ojo_blanco**/?pid=7646022

stringbeanjean @ 2004-05-13 22:16 said:
this is a sight for my tired eyes.
i'm off to bed and this is the dream
i'm about to have.
it's nail-bitingly good.

watchthis @ 2004-05-13 22:53 said:
sometimes your photos make me
want to cry

opposite: *www.fotolog.net/**ojo_blanco**/?pid=7630237*

superlulu_1 @ 2004-04-20 23:46 said:
you didn't use Photoshop did you?

ojo_blanco @ 2004-04-21 00:13 said:
i didn't use Photoshop to composite the
image, superlulu. it's a single image,
not a collage.

i did use Photoshop for color
and to sharpen the image.

*www.fotolog.net/**ojo_blanco**/?pid=1508270*

*www.fotolog.net/**ojo_blanco**/?pid=192717*

eye2eye @ 2003-06-02 18:24 said:
Looks like that face is intentional...it's EXCELLENT...
is it a composite? Would make a phenomenal poster.

ojo_blanco @ 2003-06-02 18:40 said:
not a composite. just a 'found object'

along @ 2003-06-02 19:58 said:
Wow! I'm haunted

ojo_blanco @ 2003-06-02 20:20 said:
me too

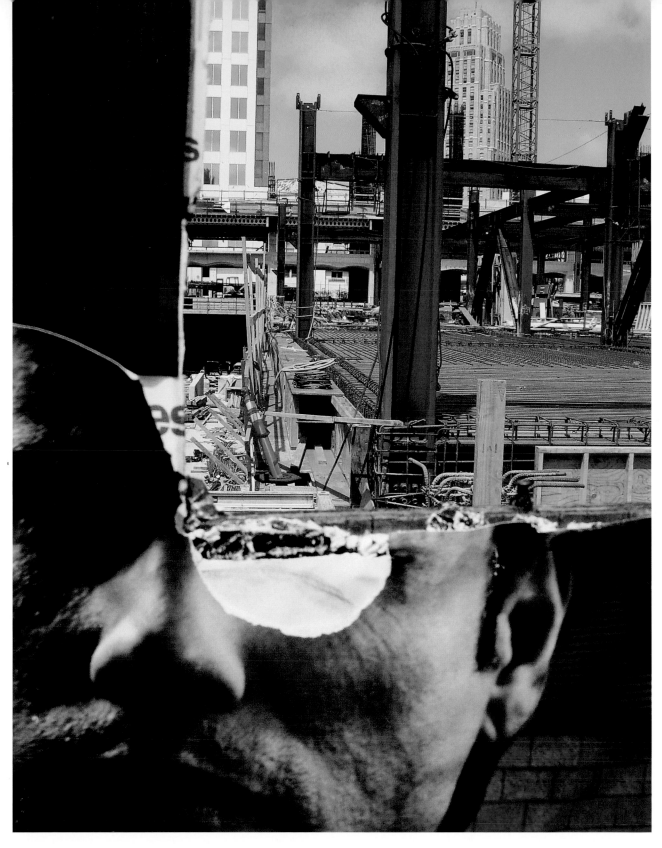

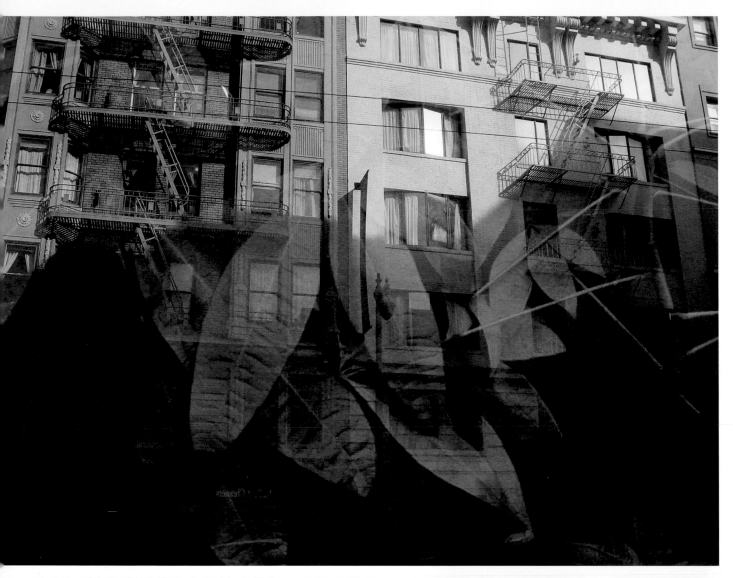

www.fotolog.net/*ojo_blanco*/?pid=6131868

uvalde43 @ 2004-02-12 00:54 said:
The fire escape landings look like decks on a ship.
Green life overlaying concrete: yin/yang, wang-dang-
doodle...

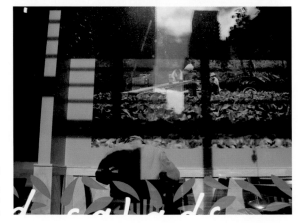

www.fotolog.net/*ojo_blanco*/?pid=7161044

tomswift46 @ 2004-03-04 11:12 said:
Complicated and interesting...like a
mural... Guernica Moderne...

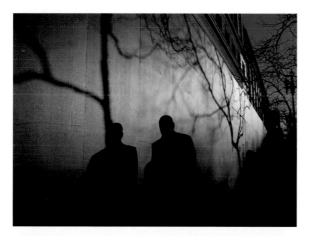

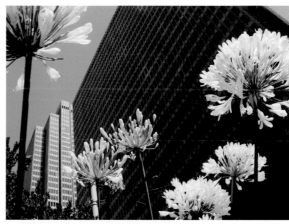

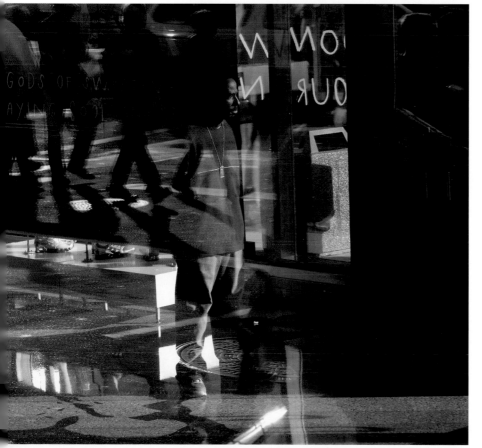

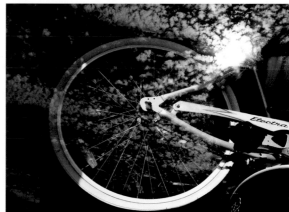

*top left: www.fotolog.net/**ojo_blanco**/?pid=7470238*

colorstalker @ 2004-03-13 15:24 said:
nosferatu timel this is incredibly graphic & has a chilling
emotional charge. i don't feel anything ironic here.

*top right: www.fotolog.net/**ojo_blanco**/?pid=1215481*

forrest @ 2003-09-26 18:25 said:
Hey, what you doing in my neighborhood? As always, the
gracefully impersonal Embarcadero Towers can use the lovin'
these flowers give them. Great composition!

*above: www.fotolog.net/**ojo_blanco**/?pid=416859*

muta @ 2003-07-22 03:52 said:
Great texture in the clouds. Made me think of Elliott in *E.T.*

*left: www.fotolog.net/**ojo_blanco**/?pid=7929411*

**is there an agency we can call for the prevention of
cruelty to these poor posters? and sometimes, even,
the abuse is actually made at the time of installation.
[is this an unconscious critique of capitalism
by disgruntled poster installers?]**

im_a_nerd @ 2003-12-19 11:40 said:
piercing! powerful! masterful! brilliant!
one of my all-time favorites!

miu @ 2003-12-19 11:43 said:
oh I love your eyes which can find this
kind of cool stuff :-))

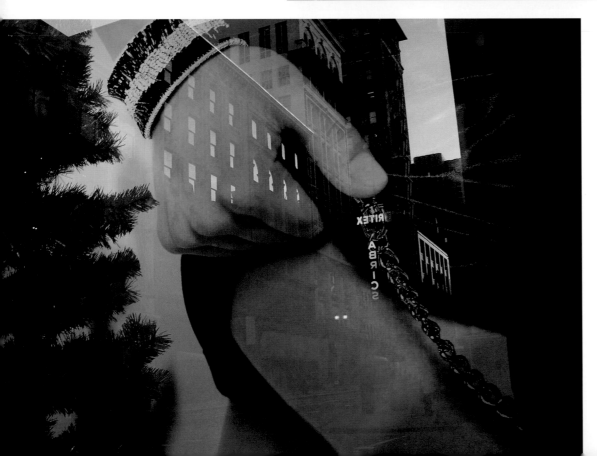

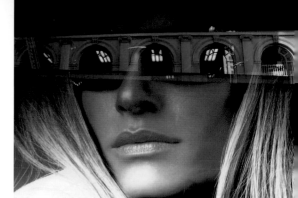

www.fotolog.net/**ojo_blanco**/?pid=2559394

mercurial @ 2003-11-22 18:13 said:
Handsome woman, handsome archways, handsome shot! I love the lights in the strip, the natural light of the sun, the odd-looking, possibly buzzing, perhaps fluorescent buzbuzlighting and some yellow lights seemingly at random that remind me of cars DRIVING much too fast upon the landscape of this amazing face.

thetigerduck @ 2003-11-22 22:08 said:
Elton John wants his sunglasses back. Sweet shot ojo—what a gorgeous yellow light on her face.

below: www.fotolog.net/**ojo_blanco**/?pid=5282693

bea_trix @ 2004-01-24 13:58 said:
HELP!

kunja @ 2004-01-24 19:21 said:
really cool. so many things going on here, all converging in the center. the yellow line really adds something too. well seen.

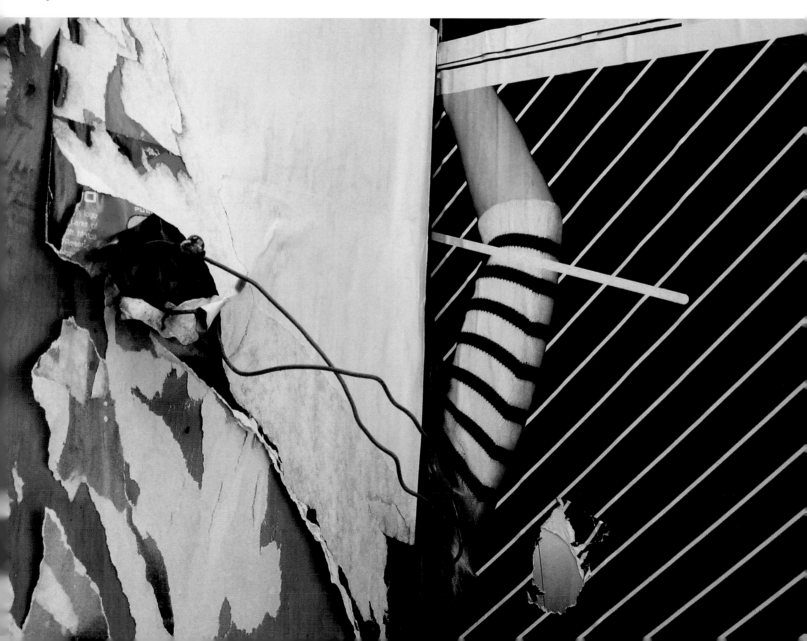

www.fotolog.net/**kool_skatkat**/?pid=9743877

far right:
www.fotolog.net/**bonchan**/?pid=8196685

shibainu @ 2004-07-25 09:17 said:
Summer has come!

www.fotolog.net/**jkh_22**/?pid=15452
...homage to cypher

cypher @ 2003-01-11 11:01 said:
Gee thanks. You must be very tall.

jkh_22 @ 2003-01-11 11:42 said:
no...i just have a very long neck.

www.fotolog.net/**cypher**/?pid=7738668
**Breakfast: It was a beautiful day so Carrie and
I got bagels and walked down the river.**

nandoinorlando @ 2004-04-23 20:32 said:
Hey Cypher, the other day I was watching
MYTH BUSTERS on Discovery Channel and they
were doing this thing about poppy-seed bagels.
They ate a whole bunch of them and then they
went to take a drug test, and guess what?
It was positive for marijuana!!!!!

nersitos @ 2004-04-23 21:39 said:
I LOVE BAGELS!! Unfortunately, i don't know where
to find those here in Brazil :ō(
nice photoblog :o)

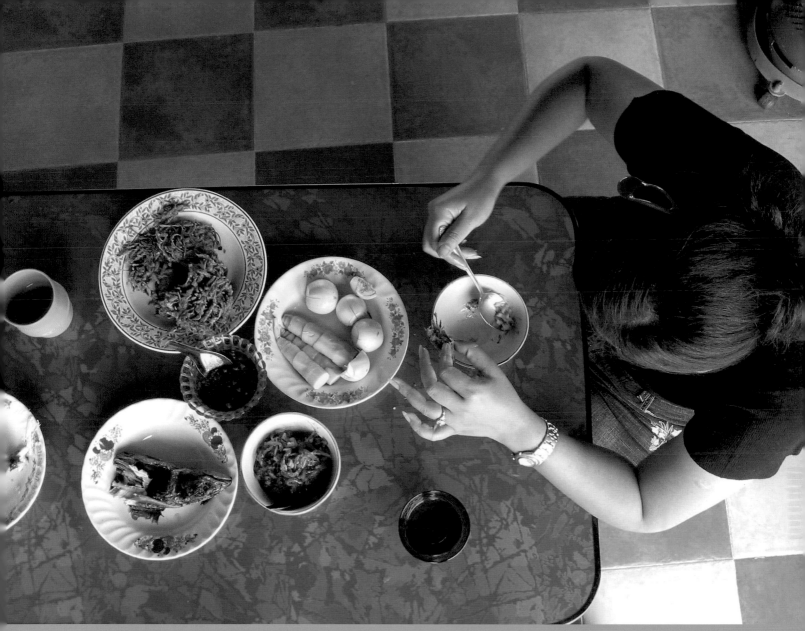

breakfast.

helene @ 2004-09-12 04:41 said:
I'm sorry to say that I never could stand thai
breakfast ;) But the picture sure looks good :)

**Breakfast: Fruit for dinner the night before.
Froot for breakfast.**

A VIEWABLE FEAST

below: www.fotolog.net/**nosuchsoul**/?pid=55256

nosuchsoul @ 2003-04-06 11:25 said:
I'm all about strawberries this morning.
Is anyone else going to see West Bank Brooklyn at
Gen Art's thing-thing-film-festival tonight? After-party
at Coral Room...even though I think I'll be on straight
Cranberry juice tonight. The constant open bars are
corroding my liver. It's rough!

yuki @ 2003-04-06 13:18 said: soooo sweeeeeeet!

virginie @ 2003-04-06 14:34 said: are you pregnant?

nosuchsoul @ 2003-04-06 14:39 said: Nope. Just fat!

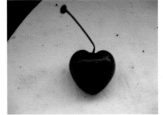

above:
www.fotolog.net/**davidgarchey**/?pid=214324

lauratitian @ 2003-06-10 09:31 said:
endearing

beebs @ 2003-06-10 09:51 said: i bet it
tastes sweet, too

hoyumpavision @ 2003-06-11 12:18 said:
Aw...cherry heart, or is it a heart
cherry?

lovefoxxx @ 2003-06-11 15:12 said:
oh no...! is this real?!?! Photoshop?!
I don't care...it's wonderful

www.fotolog.net/**ccarriconde**/?pid=3993756

*left: www.fotolog.net/**ccarriconde**/?pid=6071616*

koray @ 2004-02-09 11:18 said:
I love apples!

*right: www.fotolog.net/**beebs**/?pid=10729783*

frank_bklyn @ 2005-06-14 11:01 said:
summahtime

beanmuff @ 2005-06-14 11:21 said:
hummmmmm
wanna dive into it.
delicious shot, beebs!

*www.fotolog.net/**limone**/?pid=8123342*

pieplate @ 2004-07-02 09:28 said:
Beautiful illuminated pic – you even got the seeds!

barangonas @ 2004-07-02 14:43 said:
Sexy...

*www.fotolog.net/**beebs**/?pid=5385218*

selfportraits @ 2004-01-26 09:54 said:
dragon fruit? i dunno if that's the real name
but that's what they call it in japan!! xx

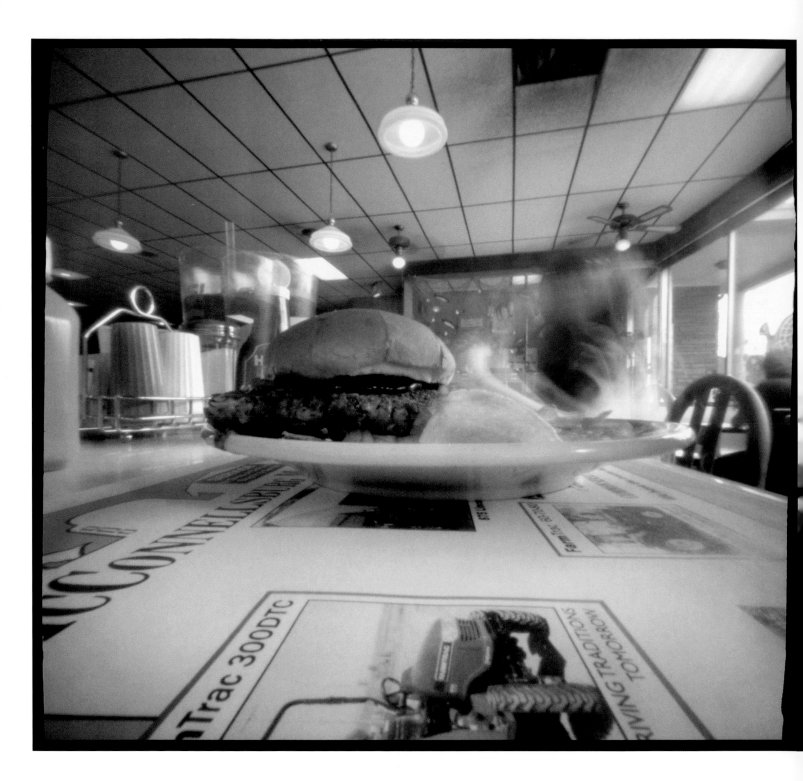

www.fotolog.net/**bonchan**/?pid=7711694
Plantain lily

opposite:
www.fotolog.net/**squaremeuls**/?pid=8088761
Lunch at the Hancock Truck Plaza, Hancock, Maryland. 12 second pinhole exposure.

daisyjellybean @ 2004-07-14 16:25 said: wow… only 12 seconds…you must have had really great ambient light!!! how are you?

uki_chan @ 2004-07-14 18:40 said: amazing…what kind of photo paper do u use?

pinholecamera47 @ 2004-07-15 00:17 said: Great shot, do you use a light meter too? I assume 400 asa film with only a 12 second exposure.

squaremeals @ 2004-07-15 10:23 said: I do use a light meter, and this is TMax 400 film. When I print these I use Ilford multigrade fiber paper, but most of the Fotolog images are scanned from negatives and then I adjust exposure and size in Photoshop.

www.fotolog.net/**bonchan**/?pid=6616253
deep purple onion

zerocalorias @ 2004-02-23 07:49 said:
Onion,
luminous flask,
your beauty formed
petal by petal,
crystal scales expanded you
and in the secrecy of the dark earth
– partial translation of
'The Ode to the Onion,' by Pablo Neruda

www.fotolog.net/**cakes**/?pid=8509766
*from www.fotolog.net/**omacroqueatudove***

cazinhaaa @ 2004-08-30 13:08 said:
positive that's a lemon pie!

midnight_snack @ 2004-08-30 23:25 said:
i love lemon pie!!!

a_hawaii_journal @ 2004-09-05 17:36 said:
must eat now!!!!
Peace, Joy

lmc @ 2005-03-28 00:17 said:
it's beautiful!

fsquared @ 2005-03-28 00:38 said:
In a terrifying kind of way.

wanderlock @ 2003-07-31 18:48 said:
who killed that pie?

hanalita @ 2005-03-08 04:52 said:
shudder
gross
seriously

jkh_22 @ 2005-03-08 06:35 said:
um, yeah, i'll take two pralined pigs,
please.

clr @ 2005-03-09 09:24 said:
oh wow oh wow
makes me want to travel

madmaxnyc @ 2005-03-15 02:51 said:
Do they also have it in blue, or is it
red or nothing?

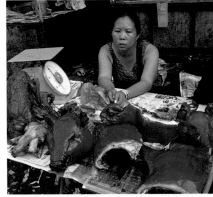

Dearest friend

zenbomb @ 2005-04-02 13:48 said:
this...is...horribly...fantastic.

squaremeals @ 2005-04-02 16:39 said:
Is it really a brain?

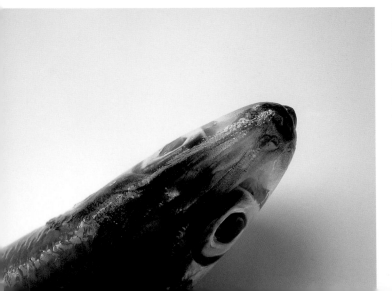

Urume-iwashi (Round herring)

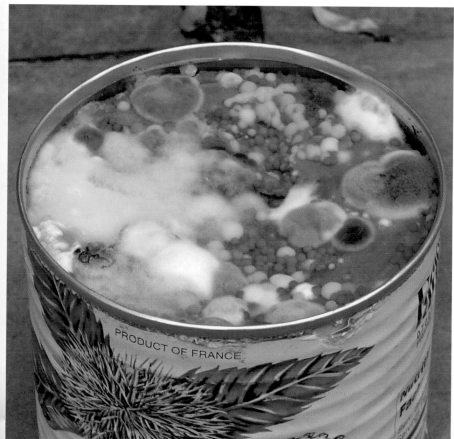

omeleteman @ 2003-11-23 14:49 said:
cooooool

arto @ 2005-03-12 22:26 said: I feel like I'm in the operating room, looking up, and the lights have turned to...eggs!

beebs @ 2004-01-06 10:02 said: perfect with the one broken yolk. gorgeous.

This was my goodluck, double-yolk birthday salad.

lauratitian @ 2003-04-26 11:14 said:
nobody could eat it, the double yolk.
we all decided it was good luck,
but the thought of eating
it was...creepy.

teragram @ 2003-04-26 23:41 said:
Love this shot, Laura!
Gotta tell ya, getting double yolks is
unusual because they're 'tested for'
at the large 'egg factories.' They are
prized by bakers and other cooks.

salmon @ 2003-04-27 14:14 said:
i'd totally eat twins.

youzoid @ 2004-09-19 05:28 said:
neon noodle soup. most unusual.

meshel @ 2004-09-20 22:47 said:
someone took acid. was it the *pho*
or the cam? i'd eat it.

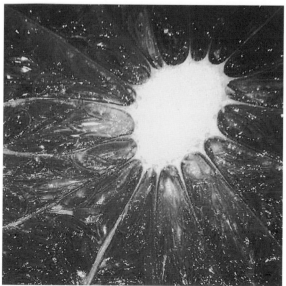

juliyap @ 2003-11-26 00:20 said:
Yea! Trying to trick us all into a world of loving
thoughts through orange skin. I think it worked.

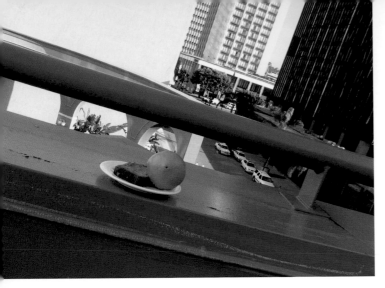

**Breakfast: At the Oreilly Emerging Tech Conference
—standard conference food.
I grabbed a piece of banana bread and an orange.**

aerte2 @ 2005-03-27 18:58 said: where's the banana? :P

nandoinorlando @ 2005-03-27 23:27 said: the banana jumped
off the building...didn't want to have a picture taken.

**Looks like the big guy was smiling down on my hot dog,
even if he wasn't smiling down on my Yankees :)**

brainware3000 @ 2003-10-16 07:40 said:
everyone knows god's a red sox fan

jkh_22 @ 2003-10-16 08:03 said:
the cubs didn't make it...there is no god.

artofgold @ 2003-10-16 10:16 said:
The divine hot dog! Ha, great shot! :)

2020 @ 2003-10-16 18:27 said:
baseball, a hot dog and an awesome sun flare...perfection!!

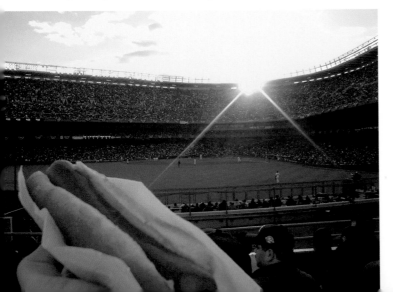

**Breakfast: The breakfast at the hospital was
yucky so I went out and got bacon, egg and
cheese sandwiches for Carrie and myself.
Mia just got mommy juice.**

dovidenja @ 2004-12-18 15:03 said: tenderness

umdiaumafoto @ 2004-12-18 15:04 said: Bravo!!!

magenta @ 2004-12-18 15:05 said:
so sweeeeeeeet :))

sandman44 @ 2004-12-18 15:06 said:
Yeah, she's probably not ready for a bacon, egg
and cheese sandwich yet. I am now though...

staciemerrill @ 2004-12-18 15:06 said:
i want that hat

magenta @ 2004-12-18 15:07 said:
Your 2 loves: food and Mia! Loved it!

tatianaf @ 2004-12-18 15:59 said:
Congratulations!! :)

nyxx @ 2004-12-18 16:00 said: so cute!
congratulations! really cute daughter! xD~~

jkh_22 @ 2004-12-18 16:18 said: if anyone ever
deserved an egg sandwich with bacon and cheese
today...it's carrie!!

teacher_martha @ 2004-12-18 16:20 said: She is
sooo adorable!!! Congratulations!!

skanodja @ 2004-12-18 16:34 said: Congratulations!
By the way, I LOVE your photoblog.

spookykid @ 2004-12-18 16:41 said: Congrats! A
new little photoblogger has come into the world... ;)

ann279 @ 2004-12-18 16:52 said: What a beauty...
and such a humbling experience...and you thought
you knew what love was. Congratulations.

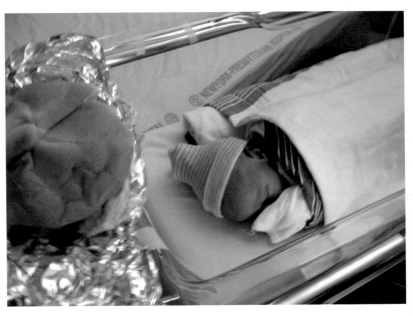

f_ish @ 2004-12-18 15:10 said:
Congratulations to you both!

broccoli @ 2004-12-18 15:13 said:
congrats :)
sweet, love that pic of your hands

jimmy10019 @ 2004-12-18 15:17 said:
OH MY GOD!!! DID YOU AND CARRIE HAVE A BABY???
I AM TRYING TO FIGURE THIS OUT. IT SURE LOOKS
THAT WAY! I am FLOORED! I guess I have been too
self involved to have known...but wow!!! Mia??
Lovely...and wow...I am so surprised! You rock,
Daddy!!! Congratulations! I am all crying here
over this, really sweet news! I should shut the fuck
up but I cannot...wow...lol, WOW!!!!!! Good for you!
I wish you so much love...for you and for Carrie and
especially for this adorable and beautiful and so
cute...Mia! You made my day! This is really great
news!!! Okay, I will calm down now...I just had no
idea and this is so nice.

grayzone @ 2004-12-18 16:54 said: How lovely!!!!
Congratulations on your beautiful baby girl, Mia!

johncoxon @ 2004-12-18 16:56 said: Dear Adam.
Seeing Mia lying there with the hat reminds me of
my three kids and, each time I was there and each
of them ended up in 'special care', nearly died but
survived and now they are handsome well-adjusted
men in their twenties. My ex-wife disappointed me
but it was awesome to be near her as each of my
children was born. Well good man, to be someone
who made a difference to this complicated world
is something to be very proud of. You did that and
well, welcome to the world this little person. Think
what Daddy did because he believed and followed
what he believed in and think what this little
person is going to do. Your lady stuck by you and
well i am just so happy for you both. Bless you both.

dchertok @ 2004-12-18 17:07 said: Congratulations
Adam & Carrie! Welcome Mia. Wonder what your
first camera will look like...

curry wrapped with egg sheet
white rice
'Chikuwa with ham and cheese'
strawberry
grapefruit

I got a new lunch box, Kitty!

wanderlust @ 2004-04-11 23:30 said:
hello kitty! it all looks so yummy!

drivebyshooting @ 2004-04-12 15:25 said:
OK, seriously...how much for you to make me
lunch and ship it to New Jersey, USA??? Delicious!!

teragram @ 2004-04-14 18:19 said:
I must not ever view this log when my daughter
is about. She is *obsessed* with Hello Kitty. We have a
Sanrio store about a 30-minute drive from home, but
I do not know if they have this item (probably not).
I would get no rest if my 3-year-old saw this.
You inspire me to make better lunches.
Thank you so much for that.

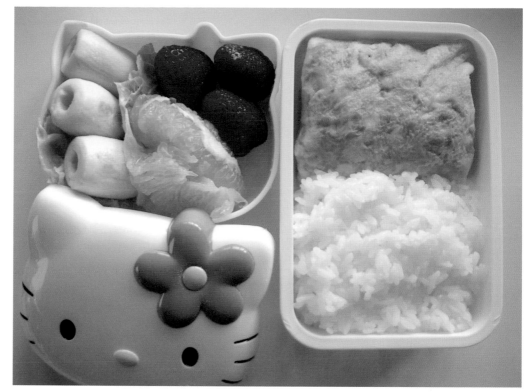

red_dirt_girl @ 2004-07-20 23:12 said:
how many different containers do you own?! :-)

mieko1 @ 2004-07-23 04:41 said:
What a nice obento. I also make two obento
for my daughters, now they are on summer
vacation, I have made them because they
attend to their club activities. how about you?

minmin @ 2004-07-23 05:48 said:
Hi, mieko1!
My daughter also goes to school almost
every day because she has club activity, too.
But she doesn't bring obento because she comes
back home two or three p.m. So she eats lunch at home.
In August, maybe she will need obento.
What's your daughter's activity?
My daughter is a member of a color-guard team.

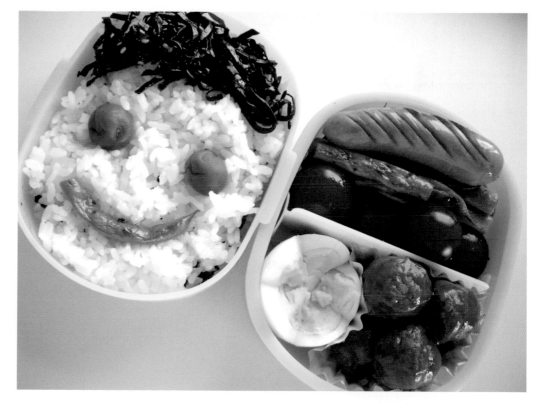

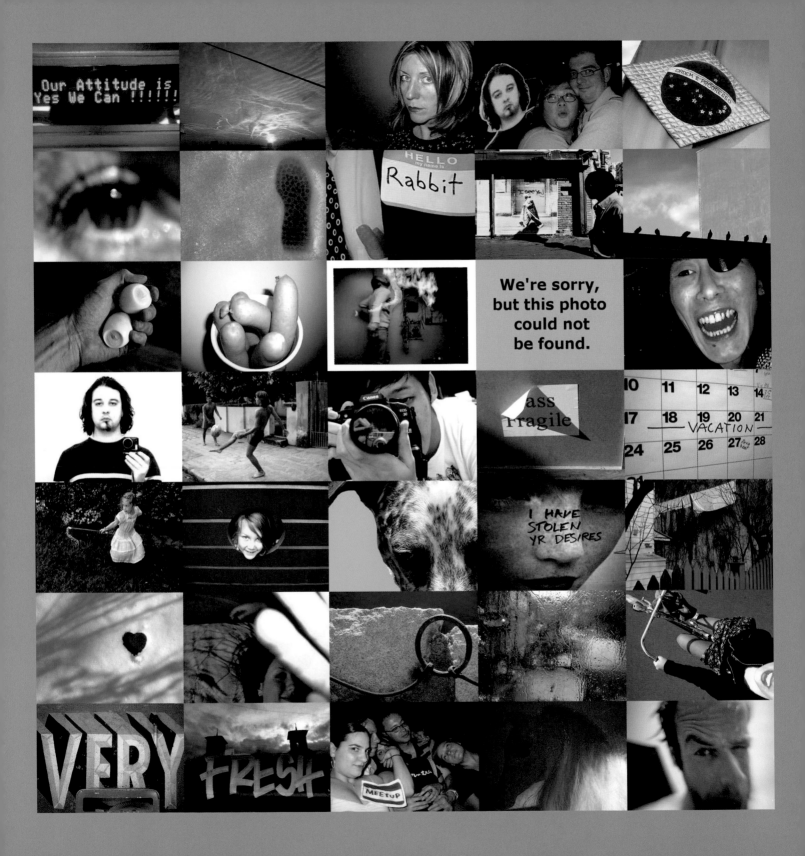

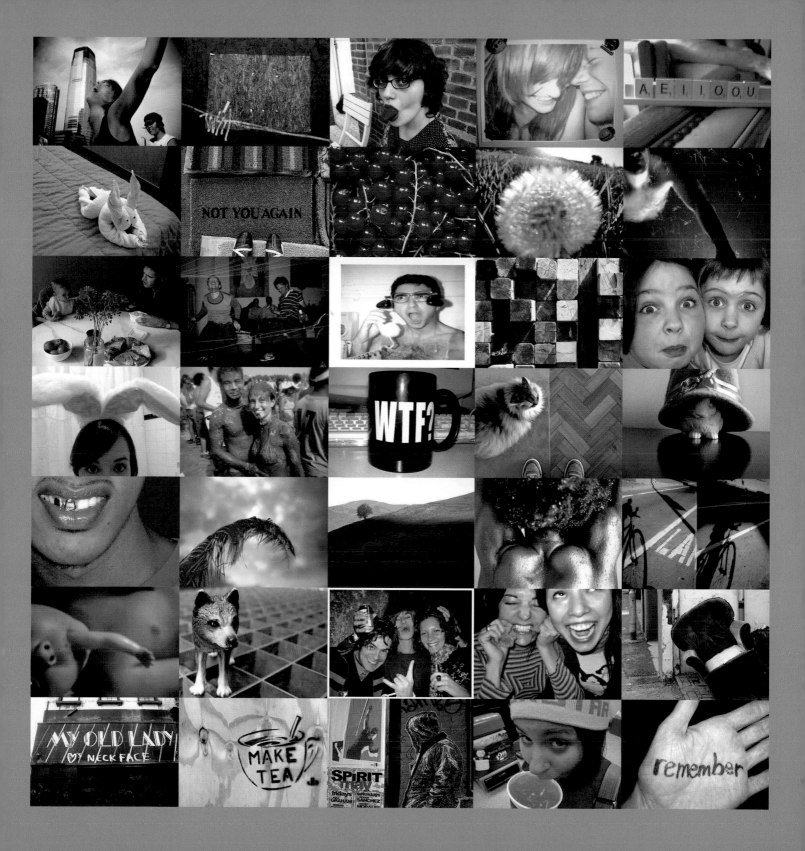

LIST OF CONTRIBUTORS AND PICTURES

0x99
Brooklyn, NY, USA | Kodak EasyShare CX7300 |
Red resides in brooklyn and loves taking pictures. |
Red | www.990000.com
15, 18

5points
North of the Notch, NH, USA | Cheap Point and
Shoot | **Peter Szawlowski** |
www.pbase.com/5points
262, 275

50mm
under the stars, India | Nikon D70, Nikon 5700,
Nikon FM10 | *twenty-seven is maybe not so bad.* |
Natasha Hemrajani | radiantbear@gmail.com |
www.202.134.160.41/radiant/stories/beginnings
8, 213, 215

adam_pants (see also johnnyphoto)
New York, NY, USA | *Pants is one of my nicknames
– like they call the actor Joe Pantoliano 'Joey Pants',
I'm 'Adam Pants'. I have a personal connection
to the photos on this site, whether they be of my
friends, family, or myself. A sort of running photo
autobiography.* | **Adam Pantozzi** |
adam@tozzer.net | www.tozzer.net
8

adject
San Francisco, CA, USA | *I talk to strangers
and prefer shark-themed amusement park rides.
Hobbies include touching my cat where he hates
to be touched (on his sides); saying things at
inappropriate times or saying nothing at all;
being heckled by those guys that ride the teeny,
tiny shetland motorcycles on the street;
daydreaming of a wondrous land where everyone
dresses in impossible haute couture and looks
utterly insane.* | **Amy Martin** | www.hypostatic.net
304

aeaflores
Rio de Janeiro, Brazil | *We are a couple. We are
Andrea Mendes and Aurélio Flôres – aeaflores. We
live in Rio de Janeiro. Andrea Mendes is an art
photographer and psychoanalyst; Aurélio Flôres
is a sculptor. Andrea Mendes uses 2 cameras:
a Hasselblad 500 cm, analog, and a Sony F828,
digital. Aurélio Flôres works with wood, steel,
titanium, acrylic, glass and stone in his sculptures.* |
Andrea Mendes and Aurélio Flôres |
aeafloresarts@click21.com.br |
www.flickr.com/photos/aeaflores
97, 98, 99

airmemories
Memory Lane, Neutral Zone | *An autobiography
in pictures.* | **Louisa Wah Hansen** |
airchild@wahansa.com | www.wahansa.com
75

alanmarra
Rio de Janeiro, Brazil | alan.marra@uol.com.br
95

albumyolima
The Hague, Netherlands | *I have been a member
of the Fotolog community since January 1, 2003.
Through it I have met wonderful people from all
over the world. My AlbumYolima pictures give a
glimpse of my life in the late sixties and early*

seventies when I was married to Marco Kalisch who
took some of the featured photos in that blog. |
Yolanthe Smit | ysmit@casema.nl |
www.fotolog.net/yolima
74

along
Brooklyn, NY, USA | Sony DSC-F707 | *'Coach'.* |
andrewlong@earthlink.net
19, 27, 50, 54, 270

alwayslookaround
Paris, France | Canon PowerShot Pro1 | *Pictures
taken with a slightly offbeat perspective of the
world and a lot of curiosity.* | **Mike Kunitzky** |
alwayslookaround@hotmail.com
156

amaw
Lafayette, LA, USA | *Love to photograph nature,
especially birds!* | **Darlene F. Boucher** |
dfboucher@mac.com | www.darleneboucher.com
10 (fourth from top), 214

anapaolo (see also laundry)
Monselice, Italy | **Paolo and Ana** |
paopul@tiscali.it
248 (row 1: 3 & row 4: 3)

andj
Asheville, NC, USA | *'The street becomes a
dwelling for the flâneur; he is as much at home
among the facades of houses as a citizen is in his
four walls. To him the shiny, enamelled signs of
businesses are at least as good a wall ornament
as an oil painting is to the bourgeois in his salon.
The walls are the desk against which he presses
his notebooks; news-stands are his libraries and
the terraces of cafés are the balconies from which
he looks down on his household after his work is
done.' – Walter Benjamin* | **Andrew Johnston** |
sulphurr@msn.com |
www.photoseen.com/gallery/view_album.php?set_
albumName=Asheville-Streets
118

andreamurphy
Citizen, USA | Canon PowerShot Elph S230 |
Andrea Murphy |
www.arrhythmaticanthems.blogspot.com
91

andy101
Arctic Circle, NH, USA | Panasonic DMC-FZ10,
Minolta X-series, Olympus 8080WZ | *I live in
a small New England town.* | **Andy** |
andynh101@yahoo.com
10 (fifth from top)

angar
Rio de Janeiro, Brazil | *Professional
photographer, mostly in these areas: movies,
sport, video clips, theater, expos, dance, shows.* |
André Gardenberg | angar3@terra.com.br |
www.flickr.com/photos/angar
98

an_ge_la
Los Angeles, CA, USA | *Taking pictures is a
delicious act like drinking fire.* | **Angela Wyman** |
angela@angelawyman.com | www.angelawyman.com
11 (third from bottom), 194

angelissima
Mostly, NJ, USA | Pentax Optio S4i, Sony Cybershot
DSC-S85 | *I specialize in candid and posed portraits
of everyday people in unique situations.* | **Angela
M. Groninger** | blopfrog@optonline.net |
www.acremonium.blogspot.com
8, 334 (row 1: 3)

anomalous
New York City, USA | Canon SD100 |
*'To what shall I compare thee that I may comfort
thee?' – Lamentations 2:13* | **Thomas Olson** |
anomalousthomas@hotmail.com |
www.flickr.com/photos/anomalous
192, 193

anon_ms_b (see also molly_jordan)
Astoria, NY, USA | Canon PowerShot S70, Little
Chami, Old Nik | *I'm a writer living in Astoria,
Queens.* | **Lisa Barelli** | lcbarelli@yahoo.com |
www.flickr.com/photos/lcb
9 (third from top)

anonymous__
Brooklyn, NY, USA
70

a_picture (see also polaroids_only)
Indianapolis, IN, USA | Palm Zire 71, Polaroid
Land Camera, Nikon D70 | *Artist and architect
working in Indianapolis, Indiana. Interests include
experimental photography, the history of modern
art, and 20th-century modern design.* | **Craig
McCormick** | mccormickstudio@yahoo.com |
www.craigmccormick.com
104

aponi (see also fotocats)
São Paulo, Brazil
205

arto
San Francisco, CA, USA | Olympus C-5050 | *Digital
photography and the birth of Fotolog reignited in
me a long-dormant need and an ability to express
my view of the world. Most of my pictures are taken
in San Francisco...* | **Art Siegel** | arto@well.com |
www.flickr.com/photos/artolog
300, 302–5, 308, 309

arwal60
Ein Hamifratz, Israel | Panasonic DMC-FZ20,
Pentax Optio 330GS | *A kibbutznik. Living in a
kibbutz, in western galilee.* | **W. Harris** |
wal4unow@yahoo.com
248 (row 4: 1)

auh
São Paulo, Brazil | **Audrey Hojda** |
audreyhojda@yahoo.com.br
75

batut
northern, United Kingdom | **Antony Chambers** |
antonychambers@hotmail.com
13 (second from top), 233–41

beanmuff
Funhouse, Brazil | *I'm Bean. I'm a big fan of big
cities and I heart rock 'n' roll.* | **Ana Monteiro** |
beanjean@hotmail.com
191, 334 (row 1: 5)

bea_trix
Graz, Austria | **Beate Katschnig** |
bea_trix@gmx.net
8, 9 (fourth from bottom), 12 (second from top),
334 (row 2: 1 & 2)

beebs
Vancouver, Canada | **Heather Maxwell** |
beebsylon@hotmail.com
9 (top), 10 (second from top), 11 (bottom), 12 (fifth
from top, and bottom), 13 (bottom), 52, 325, 331

bekon
Tokyo, Japan | Canon 10D, Canon G3 | *I am a
Canadian guy living in Tokyo.* | **Chris Koelbleitner** |
cko210@hotmail.com | www.flickr.com/photos/bekon
190

bigmuff
São Paulo, Brazil | HP M307-Photosmart, Siemens
MC60
9 (fifth from top), 335 (row 6: 3)

bonchan
Kanagawa, Japan | Nikon Coolpix 2500, mostly |
Cooking is my hobby. | **Kyoko Uchida** |
uchi@ac.mbn.or.jp
322, 327–29

brainware3000
Brooklyn, NY, USA | Nikon D70 | **Jeffrey Shay** |
brainware3000@gmail.com |
www.brainware3000.com
21, 195, 246

brillo
Cameri, Italy | *Thanks for all the collaboration
to Bruce Gallo & Vito Junior.* | **Marco Velardi** |
brillobollo@yahoo.com | www.room32.com
13 (fifth from top), 107, 110, 335 (row 3: 3)

bronko
São Paulo, Brazil | Canon 20D
199

bsamp
Rio de Janeiro, Brazil | Sony DSC-F828,
Nikon Coolpix 885 | **Bruno Sampaio Meireles** |
bsamp@bsamp.com | www.bsamp.com
6, 120–28, 130, 131, 269, 334 (row 4: 1)

bugsncritters (see also e3000 and tanzle)
Everywhere, Neutral Zone | *Bugs are bugs.
Critters are everything little, wiggly or winged
or leggy or scaly or slimy.*
213, 216

cakes (see also omacroqueatudove)
Kitchenland, CA, USA | *I realize that a lot of
people post pictures of cakes. Let's share them
all in one place.*
327

callalillie (see also swoon)
Brooklyn, NY, USA | Canon PowerShot G2, Canon
SD10 | *Without documentation, there is no history.* |
Corie L. Trancho | corie@callalillie.com |
www.callalillie.com
335 (row 7: 3)

cameron_1964
London, United Kingdom | Olympus C-60 |

e3000 (see also bugsncritters)
Sint-Katelijne-Waver, Belgium | Eddy Van Leuven | www.flickr.com/e3000
216

earlywarm
Pathum Thani, Thailand | FINEPIX S5500, CANON POWERSHOT A70 | I've lived in Thailand for about ten years and worked around the region, particularly in China. I live in the countryside, among the rice farms. The gradual changes to the patchwork of fields, the farmers, my family and our village are continuously vivid and sometimes startling to the eye. | Jonathan Peter | jonathanwpeter@hotmail.com
323

eau
New Orleans, LA, USA | Holga Divining Rod, Pinhole Trickster, Phonecam: Sony Ericsson Winky | I am a New Orleans gypsy. And I don't believe in inanimate anything – my cameras lead me around by the ring they've put in my nose. | Elizabeth A. Underwood | croweau@hotmail.com | www.elizabethunderwood.net
110, 119

ecosites
Juiz de Fora, Brazil | Claudio F. Kloss | ckloss@pobox.com | www.ecosites.fotopic.net
263

eduardo_dacosta
Liège, Belgium | Minolta Dimage A1, Minolta Dimage Xt, Canon A1 | 'Half of what I say is meaningless; but I say it so the other half may reach you'. – Khalil Gibran | Eduardo Da Costa | eduardo_dacosta@yahoo.com | eduardo1dacosta.multiply.com
8

ekavet
New York City, NY, USA | These pictures are courtesy of my addiction to action and drama. Flickr.com and Fotolog.net allow me to show you, the viewer, my true love of photography. | Ethan Kavet | ekavet245@yahoo.com | www.flickr.com/photos/ekavet
18, 27

eliahu
London, United Kingdom | I am a British freelance illustrator and artist, but I've always loved photography. I feel liberated by the new digital technology, but also enjoy making pinhole cameras out of old junk. | Ellis Nadler | info@nadler.co.uk | www.nadler.co.uk
8, 218, 219, 222–25, 228

emmy
Tokyo, Japan | Olympus EES, Canon G5, Olympus OM10 | Emi Satou | emmyfonfon@m2.pbc.ne.jp
198, 284, 286, 291

epmd
Washington, DC, USA | Eric Petersen | Canon 20D | epetersen19@gmail.com | www.flickr.com/photos/epmd
12 (fourth from bottom)

ernst01
Graz, Austria | Nikon D70, Nikon F100 | ernst01@gmx.at
249

eshepard
Jive, Turkey | Nikon D70. Before June 2004, a Canon Powershot S50. Before July 2003, a Canon

PowerShot S30. | Eliot Shepard | eshepard@slower.net | www.slower.net
2 (left), 16, 18, 27, 164–75, 261

ewolman
New York, NY, USA | Canon Rebel 2000 | I think of my photographs as instant paintings. | Eric Wolman | ewolman@grey.com
17, 23

ezra
Fairfield, CT, USA | images as psychic paralysis...
246

fabrys
Paris, France | Canon G5, Kyocera S3L, Canon Ixus 40, Canon G5 (5 MP), Kyocera S3L (3.2 MP) | Fabrice Massey | fabrysweb@hotmail.com
3 (left), 198

fackart (see also laundry)
en cualquier lugar, Argentina
248 (row 3: 4)

fakestar
Nowhere Town, Brazil | Canon A85, Pentax K1000 | in love with the world through the lens of my camera. | Mauricio Hiroshi Kubo | mauricio.kubo@gmail.com | www.fakestar.com.br
204

fetishfoto
Berkeley, CA, USA | These are not found images, rather they are images I make using 19th-century processes. I have converted a graflex polaroid pack film holder into a glass plate holder and am using a graflex 4x5 press camera as a wet-plate camera. Thanks for your interest. | Rachel Weeks | www.rachelanne.net
265

fgcwjh
Lyon, France
83

finalshot
Shanghai, China | Canon PowerShot G5, Canon Ixus 400, Canon 350D | Seeking and finding. | Rick Zhuang | rick_zhuang@hotmail.com | www.eyeballcollector.blogbus.com
52, 256

fleabilly
in transit, TX United Kingdom | Mamiya Universal 100mm 2.8, Konica Hexar, Canon 20D | To capture a moment is more important to me than creating a beautiful image. Every day I am fortunate to witness amazing moments seemingly staged for me, lost between seconds and second glances. | Ray Lewis | fleabilly@mac.com | www.homepage.mac.com/fleabilly
23

flishstar (see also laundry)
Ballarat, Australia
248 (row 1: 2)

flo_pie
Brooklyn, NY, USA | Sony DSCU20 Cybershot, Pentax ZX-5 35mm, Lomo Colorsplash 35mm | By day I work as a Web producer. In my free time I enjoy kite-flying, coconut cake, anything pink and marvelling at the absurdities of the world in which I live. | Heather Aschinger | flo_pie@hotmail.com
335 (row 4: 3)

forrest
San Francisco, CA, USA | Nikon D70, Mamiya 6, Nikon FE2 | I live in San Francisco and try to take

good boring pictures of nothing. | Forrest L. Norvell | forrest@driftglass.org | www.driftglass.org
305

fotocats (see also aponi)
Cat City, Neutral Zone
205

fotodogs (see also dogseat)
Dogsville, Neutral Zone
207

fotojohnnic
Vancouver, Canada | Canon G2, Pentax MZ 5N | Born in South Africa. (Portuguese part-time.) A Stradivarius doesn't make the violinist... Shakespeare wrote with a feather (I think). | Joao de Jesus | johnnyfoto@yahoo.com | www.flickr.com/photos/johnnyfoto
334 (row 4: 4)

frank_bklyn
Brooklyn, NY, USA | Canon S50, Polaroid Spectra SE | Frank James Milliron | frank_o_rama@hotmail.com
132, 135, 138, 139

frisjes
Rotterdam, Netherlands | I tell a story about my life by putting two or three pictures together, so you can sense the atmosphere better. | Haadjar Fris | frisjes@hotmail.com | www.haadjarfris.com
90, 138, 198, 334 (row 6: 5), 335 (row 1: 3)

_g
Paris, France | Canon EOS 500N; Rolleiflex Type T; Rollei 35S | Analogue capture. Digital scan. Samples of my daily photo walk. | Jerome G. Demuth | vurt@free.fr | www.human.ist.free.fr
159, 334 (row 2: 4)

gagah
North-East, Brazil | HP Photosmart R707 | I'm a college professor (teaching Literature written in the English language) and photography is my favorite hobby. | Garibaldi Dantas de Oliveira | gagahdantas@gmail.com | www.flickr.com/photos/gagah
6, 86, 87, 334 (row 4: 2)

gail
San Francisco, CA, USA | Fotolog reopened my eyes to composition and form, brought me new friends of remarkable talent, and provided a new outlet for casual snaps and glimpses of life like this one. What an assortment of simple fun and powerful visual learning! | Gail Ann Williams | www.flickr.com/photos/gail
306

galamander
cosmopolitanbarnliving, USA | documentary filmmaker on a slightly extended maternity leave... | Kamila Calabrese | galamanderworks@earthlink.net
88, 89

gardengal
Kingston, NY, USA | Olympus Stylus 300, Polaroid Joycam | There'salwayssomething. | Lori Baker | lori@loribaker.com | www.loribaker.com
135

garydann
Philly, PA, USA | pics mostly taken on a Samsung E715 cameraphone. i'm 25. when i'm old and i forget everything, i'll go back and look at these photos from the first page to the last. maybe it'll be a cool

story or something...taking cameraphone pics in a fashion that's tireless – my photographs were sent from a t-mobile wireless. | Gary Dann | gary@garydann.net | www.garydann.net
8, 334 (row 1: 1), 335 (row 4: 2)

gato_xeca (see also gato_zeca, below)
Rio de Janeiro, Brazil
100, 135

gato_zeca (see above, and also pattern)
Rio de Janeiro, Brazil | Fernando Lopes | artist@fernandolopes.net | www.fernandolopes.net
42, 94

gazelland
New York, NY, USA | I am a Gazelle! | Paulo Gazelle | mdgazelle@aol.com | www.gazelland.com
134

gcs (see also gcs1of2, below)
Brooklyn, NY, USA | Nikon 35mm/28mm lens, Canon AE-1 35mm/50mm lens, Fujica ST801 35mm/55mm lens, HP 318 Photosmart | I search for or create images that display a desire for equilibrium, an idealistic fantasy or magic realism, in a quest for meaning. I allow my subconscious to play, trusting my instincts, while trying not to let my artwork be burdened with intellectual rationale. | Gwendolyn C. Skaggs | gcs1of2@verizon.net | www.gwendolynskaggs.com
335 (row 4: 5)

gcs1of2 (see above)
335 (row 7: 5)

ginaremonda
London, United Kingdom | Nikon FE | I was born in Argentina, but living the last couple of years in London. I decided to do a fashion photography course, which I enjoyed but did not fulfill my expectations. I'd rather be a people's photographer, becoming a portraitist, than be a fashion photographer... '...THE MORE PICTURES YOU SEE, THE BETTER YOU ARE AS A PHOTOGRAPHER...' – Mapplethorpe. | Gina Remonda | gremonda@yahoo.com.ar
335 (row 5: 4)

glblanchard
Jackson, MI, USA | Art is fiction. | Gerald L. Blanchard | studioarts@comcast.net
279

goktokyo
Tokyo, Japan | Pentax MX, Nikon Nikomat EL, Phonecam: NEC Foma900i | Goji Kawai | kawai@tokyo-ninja.com | www.tokyo-ninja.com/studio, www.flickr.com/photos/gktokyo
285

golden
San Francisco, CA, USA | All the photos are from a cheap HP digital camera, my new Canon Powershot S45, or a very old 35mm SLR Minolta Maxxum. | Baruch Golden | baruchg50@hotmail.com
135, 306, 307

golightly
New York, NY, USA | Holly Lynton | hlynton@earthlink.net | www.jenbekman.com/holly_lynton_bio.html
88

goon
New York, NY, USA | Hi, welcome/bem-vindo/ bienvenue/bienvenidos/marhaban. I recently (last year) got a Canon S30 (my first digital) which mostly lives in my pocket but likes to come out and

play sometimes. Here are some of my happy accidents (well, some are happier than others...). What I like: beauty in common ordinary things, accidents that transform the common into the uncommon. I also like to photograph street art, which doesn't live long and should be preserved somehow. Ephemeral accidents occur on the street all the time. Life is also a very ephemeral accident and should be captured and held like a beautiful photo. I like taking photos, but even more I like looking at photos, and Fotolog is the place to do that. I also like listening to Robert Johnson ;) 'He saw tiny hands in prayer when he looked at a walnut under a microscope and it filled him with horror.' Mostly i am just goon, wandering the streets, looking for ops. the world is strange. strange things are beautiful. Fotolog is strange ;) | alexander_coon@yahoo.com
40

grantbw
Philadelphia, PA, USA | Olympus E-10, Phonecam: Treo 600 | *'A way less of seeing the world than of feeling it with one's eyes...'* | **Bruce Grant** | bruce@bruce-grant.com | www.bruce-grant.com
40, 51, 277, 302

hanalita
JC, NJ, USA | Canon PowerShot A75, Pentax MZ-30, Phonecam: Sony Ericsson T160i | *Photographic obsessions include chandeliers and sodium lighting.* | **Hannah L. S. Duncan** | Hannah@daysrunaway.com | www.daysrunaway.com
12 (second from bottom)

hartofocus
Rainland, Spain | *Media content developer. Consejería de Educación de Asturias (Spain).* | **Néstor Alonso** | nestor@educastur.princast.es | www.fotolog.net/xardes
51

heif
NYC, NY, USA | Canon SD500 | *Photoblogging can make the world a friendlier place. See my photoblog for why.* | **Scott Heiferman** | ilovespam@heiferman.com | scott.heiferman.com
10 (second from bottom), 13 (fourth from bottom), 48, 334 (row 3: 5), 335 (row 5: 1)

helenbar
Rio de Janeiro, Brazil | Canon PowerShot S45 | *Welcome to Wonderland! These illustrations are inspired by the original story of Alice in Wonderland by Lewis Carroll. I am the designer, photographer and model as well and make them by using a digital camera and Photoshop.* | **Helena de Barros** | helenbar@globo.com
140–48

hihihi *(see also pavement_pix)*
Liverpool, United Kingdom | **Benoît Jourdain** | hihihi@fastmail.fm | www.flickr.com/photos/hihihi
6, 38–44, 49, 50, 53, 250, 257, 263, 330

hominy
Brooklyn, NY, USA | Zero Image 2000, Olympus OM-10 | *Flowers of evil never die.* | **Aron Ahlstrom** | pegbarpunk@gmail.com | www.insideabox.com
108

honeycut
Brooklyn, NY, USA | *My photoblog serves as my digital sketchbook; most often I shoot the activity on the streets of midtown New York through binoculars out my office window during my lunch hour. The act of photoblogging maintains and feeds my artistic desires, as well as providing unlimited*

inspiration through the community of other photographers who are a part of the Fotolog world. | **Michelle Hines** | mhinesprojects@gmail.com
16, 208

hoyumpavision
Brooklyn, NY, USA | *We do art. We take pictures. We work. We take pictures. We do chores. We take pictures. We play. We take pictures. We are busy. We take pictures.* | **Benjamin & Trey Hoyumpa** | hoyumpa-vision@treyplay.com | trey@treyplay.com | www.treyplay.com
9 (fifth from bottom)

hunna
London, United Kingdom
252

ignatz_mouse
Marseilles, France | www.krazy.com/coconino.htm | ignatz@altern.org | www.fotolog.nct/lohees
43

interludio
Rio de Janeiro, Brazil | Nikon Coolpix 885 | *I'm a graphic designer and illustrator from Rio de Janeiro.* | **Mariana Newlands** | mariana@interludio.net | www.interludio.net
101, 252

inthegan *(see also jerusalem)*
in the Neutral Zone | Elsa Katana
264

ishiguro
Ota Tokyo, Japan | FinePix F710, Canon EOS 20D, FinePix F700 infrared | *Photo = healing. Nature, landscape, infrared and pinhole. Living in Tokyo but optimize my heart's playing in fields. I love photography, not cameras and techniques.* | **Tatsuya Ishiguro** | tatsuya.ishiguro@gmail.com | www.flickr.com/photos/ishiguro
288, 290, 291

isthisyou
Commuting, United Kingdom | *Hello. Is this you?* | isthis@isthisyou.co.uk | www.isthisyou.co.uk
3 (centre), 8, 89

jcfilizola
Rio de Janeiro, Brazil | *taking pictures since 1971, showing people interacting with other people and with the environment...* | **José Carlos Filizola** | jcfili@hotmail.com | www.flickr.com/photos/jcfilizola
95, 96, 101

jdiggle
London, United Kingdom | *To be honest it's not really about the end result for me, it's about opening my eyes to what I am really seeing around me, and then capturing it.*
204, 221, 229

jeanieforever
Brooklyn, NY, USA | Canon Elph S500, Konica 35mm, Phonecam: Audiovox PM8920 | **Jeanie Reyes** | jeanie.reyes@gmail.com
11 (top)

jerusalem *(see also laundry & inthegan)*
248 (row 2: 3)

jimmyjames
Londinium, United Kingdom | Canon A70, Sony DSC-W17 | *'Never for money, always for love. Cuddle up and say goodnight.'*
9 (third from bottom), 195

jimsk
Rio de Janeiro, Brazil | Sony DSC-F717, Canon PowerShot A70, Minolta X-300 | *Born in Scotland, now living in Rio de Janeiro (where the rain's warmer) and trying to capture the beauty of the city which has adopted him.* | **Jim Skea** | jimskea@yahoo.com.br | www.flickr.com/photos/jimsk
94

jinx
Iowa City, IA, USA | *into the light.* | **Aaron Cruse** | aaron@deadlettertype.com
111

jkh_22
Brooklyn, NY, USA...and Lyon, France | Canon S70 | *I'm a 16-year veteran of the old-school world of art galleries (though not as an artist) who, in 2002 – with ambitions to keep pace (ha) with my younger sister /laurattian – picked up a digital camera and joined Fotolog. For the most part, my participation has evolved into a record of my life in New York, a romance across the ocean (with /fycwfh) up to and including my pregnancy and the birth of our daughter, a move to France, and, well...the photos tell my histoire. Suffice to say, en fait, a portion of my sanity hinges on Fotolog, thanks to family, friends and strangers who participate in our visual and written dialogues. Merci, et a bientot.* | jkholder@hotmail.com | www.flickr.com/photos/jkh
82, 83, 217, 249, 322, 335 (row 3: 1)

johannaneurath
London, United Kingdom | Sony Cybershot T-33, Fuji FinePix E550 | *I like looking at things.*
44, 45, 50, 206, 219, 221, 225, 228, 229, 245, 256, 266, 268

johncoxon
Salford, United Kingdom | Nikon D70 | *I live in the city of Salford in the North-West region of England. I write feature articles and illustrate them with my digital photographs. I have an immense fondness for Fotolog as a genuine, warm and inspiring world community, through which I have learned so much about photography from the example others set, but more than that some great personal friendships and also wonderful dialogues with sincere people from all walks of life, cultures and different countries have developed too.* | johne.coxon@ntlworld.com | www.johncoxon.com
214

johnnieutah
Brooklyn, NY, USA | Canon Digital Elph S400 | *Artist living and working in Brooklyn. Founder of the Williamsburg Chess Club for Wayward Men and Ladies, and one-half of ambient post-rock duo Weapons of Mass Destruction.* | **Sharilyn Neidhardt** | sharilyn@sharilynneidhardt.com | www.sharilynneidhardt.com
13 (third from bottom)

johnnyphoto *(see also adam_pants and meetups)*
New York, NY, USA | Canon PowerShot G5, Canon EOS 1D Mark 2 | *Carrying a camera everywhere I go, my work consists mostly of street photography, with an emphasis on architectural abstractions.* | **Adam Pantozzi** | adam@tozzer.net | www.tozzer.net
20, 22, 334 (row 7: 3)

jonesgunn
Berkeley, CA, USA | Stephanie Jones-Gunn | www.adorefoto.com
106

joop
Paterswolde, Netherlands | Canon EOS 300D Rebel, Canon PowerShot G2, Pentax SF7 | *'Joop's Dog Log' is a series of images showing the life of Joop, a Farmers Fox Terrier. Joop was a true photostar. He lost his battle against cancer and passed away August 8, 2005.* | **Henk Binnendijk** | henkbinnendijk@hotmail.com | www.pbase.com/henkbinnendijk
200, 206

jopalane
Alentejo, Portugal | Nikon Coolpix 5700 | *My name is Paulo. My preferred subject is nature, but I like to photograph everything without exception the best way I can.* | **Paulo Jorge Neto Lança** | paulo.lanca@gmail.com
275

jucafii
Rio de Janeiro, Brazil | Sony F-717, Canon EOS 5000, Canon Digital Rebel XT | *I am a writer and musician using photography to compose songs and stories written with light.* | **Jose Fagundes Filho** | jucafii@gmail.com | www.flickr.com/photos/jucafii
98

juliyap
Los Angeles, CA, USA | Nikon F3, Canon S400, Holga | **Julia King** | Tuliyap@aol.com
116

jvoves
Evergreen Park, IL, USA | Sony F707 | *People ask, what is bonezen? It's the trance my dog goes into when chewing on a rawhide strip. Her eyes glaze over and you can snap your fingers, call her name, whatever, her eyes just stare and she just chews.* | **Joseph Voves** | jvoves@gmail.com | www.bonezen.com
201, 202, 203

jw_arch
Brooklyn, NY, USA | Bobby Digital, Alice Holga | *These are the things I think about when the box is in my hand: Architecture, Self, Narrative, Composition, and Instant Gratification.* | **Jon H. Whitney** | jw_arch@excite.com | www.vimeo.com/user=jw, www.flickr.com/photos/jw_nyc
14, 334 (row 1: 4)

kalloosh
Chicago, IL, USA | Holga 120 | *Photographer living in Chicago.* | **Kelly McCracken** | kelly@kalloosh.com | www.kalloosh.com
106

kandykorn *(see also krazykat)*
Kandyland, MA, USA | *Lived in Massachusetts my whole life.* | **Cynthia Meadows** |
11 (fourth from bottom), 45, 194, 272, 273

karolinka
London, United Kingdom
223

kayo
Berkeley, CA, USA | Olympus C5060 | *I like to look at things, and sometimes take pictures of them.* | **Katherine Hardy** | heyokayo@gmail.com | www.heyokayo.blogspot.com
305

kdunk
Brooklyn, NY, USA | *Blogger by day Fotologger by night.* | **Kristen Duncan Williams** | kdunk10@gmail.com

morbida (see also laundry)
248 (row 5: 1)

mothern
BHZ, Brazil | www.mothern.blogspot.com
81

moxie
248 (row 4: 4)

muckel
Berlin, Germany | SONY DSC-W1 | Matthias
Krümmel | Matthias.kruemmel@gmx.de
264

muta
San Francisco, CA, USA | NIKON COOLPIX 4500 |
www.tomapodaca.org/
303

na_areia (see also neene, neenna & luisacortesao)
Praia, Neutral Zone
120, 266, 267

nadia
Toronto, Canada | Nadia Belerique |
nadiabelerique@gmail.com
139, 190

natalie
somewhere in NY, USA | *Natalie was introduced
to us at a thriftstore in Greenpoint, Brooklyn. A
series of photo albums were found, containing a
lifetime of photographs documenting one woman
and her friends, her dog, her series of boyfriends...
Decades are spanned, the woman's hairstyle
changes through the '70s and '80s, her Doberman
Pincer grows from puppy to large beach-combing
dog. The only constant in the photos is her presence
on almost every yellowing, sticky, dated album
page. Her identity remained a mystery until,
among the stack, we discovered her wedding album
(so she ended up marrying *that* guy.) And there
we learned her real name, printed in scrolly gold
lettering: Natalie. We don't know why her entire life
in pictures ended up here...how could she and her
husband both be willing to give up their wedding
album?...Divorce for Natalie and Marcelo? Untimely
death? There are too many gems here to be left to
rot in a funky smelling shop with a cranky,
overweight, biting cat on Manhattan Avenue.
We thought these pictures should be seen. So
the Natalie photoblog was born...to share these
amazing photos from the previous 3 decades. In
interest of introducing her to the community on
Fotolog, we tried to find a voice for her. Natalie is
vain. Natalie is frisky. Natalie *loves* polaroid_billy,
her dog ('Mandy'), and Natalie equally loves pink.
We made up names for her friends and the Fotolog
community filled in the rest...fantasy stories to
bring the photos to life. But, ultimately, Natalie
remained elusive to us in voice, yet very present in
pictures. We hope she's still alive and will perhaps
one day click and see photos of her younger self on
'her Fotolog'.*
71

ndouvid (see also old_ness)
PDX, OR, USA | David Bellinger |
kalimbas@spiritone.com | www.ekalimba.com
53

neckface (see also cypher)
the world, USA | *Community photoblog for
neckface sightings.*
335 (row 7: 1)

neene (see also neenna, below, & na_areia)
New York, NY, USA | Nina Meledandri |
nina@meledandri.com | www.neene.blogspot.com
6, 129, 267

neenna (see above)

nelson369
Rio de Janeiro, Brazil | *Nelson Vasconcelos is
a Brazilian journalist.* | Nelson Vasconcelos |
nelsonva@oglobo.com.br
96, 97, 100

ninajacobi
São Paulo, Brazil | Nina Jacobi |
ninajacobi@terra.com.br
199

nishimuratsutomu
Niigata, Japan | FUJIFILM FINEPIX 6800Z |
www.flickr.com/photos/kensogol
9 (sixth from top), 46, 201, 205

norwegianmale
London, United Kingdom | NIKON F4S, SONY
CYBERSHOT DSC-F828, FUJI FINEPIX 7000 | *guy from
Norway, hence the name. now living in London since
8 years.* | harald_haugan@yahoo.co.uk |
www.photoh2.com
215

nosdamontanha
Rio de Janeiro, Brazil | CANON POWERSHOT S400
DIGITAL ELPH, CANON POWERSHOT S330 DIGITAL ELPH |
*I have always dreamed in colors. Take nothing but
pictures, kill nothing but time, leave nothing but
footprints...LEAVE NO TRACE.*
210

nosuchsoul
Sydney, Australia | FUJI FINEPIX S5100, FUJI
FINEPIX 3800, NIKON N55 | *Wannabe artsy fartsy girl
and whatever else you'd like to assume and such
and such.* | Jade Gedeon |
jade@wedreamincolour.com |
www.wedreamincolour.com
54, 324

nysama
13h ahead, Tokyo, Japan | *Welcome! I'm just a
guy born in the early '60s.* | Makoto Ninokata |
enino@yahoo.co.jp | www.fotothing.com/nysama
8, 288

ojo_blanco
San Francisco, CA, USA | *Photography for the
pleasure of seeing (myopically) and expressing
(elliptically).* | Lester Weiss |
lester@speakeasy.net | lesterweiss@sbcglobal.net |
www.pbase.com/ojoblanco
310–21

old_ness (see also ndouvid)
Notched Rush, TN, USA | *Old_ness is an unknown
legend in his own mind. It is his intention to do for
the history of photography what Paul Bunyan did
for de-forestation.* | David Bellinger |
kalimbas@spiritone.com | www.ekalimba.com
68, 73, 75

omacroqueatudove (see also cakes)
Macrovisto, Neutral Zone | CANON POWERSHOT A75 |
*Closeup pictures from gustavocarrijo and
claudiamelissa. wanna join???* | Gustavo Carrijo
327

onmywaytowork
Brighton, United Kingdom
335 (row 6: 5 & row 7: 2)

palla
Naniwakko, Japan | Kazuhiko Kawahara |
palla@pallalink.net | www.pallalink.net
41, 292–99

palmea
Chicago, IL, USA | *Among other things, I like to
photograph dogs. Fotolog introduced me to a fun
international community of imaging enthusiasts.
Why do we have to talk about cameras? Can't we
just talk about the pictures?* | Pamela Bannos |
palmea2@yahoo.com |
www.flickr.com/photos/palmea
209

patisfaction
Music is the Answer, Netherlands | NIKON D70,
SONY DSC-S50 | *Patisfaction is about Phun
Photography. Phun is my middle name, action is
my game! Music is the Answer.* | Patrick Strüwer |
spamsterdam1@yahoo.com | www.patisfaction.nl
132, 133, 134, 136, 137

pattern (see also gato_zeca and yukihisa)
Several, Neutral Zone
42, 50, 285

paulbeagle
Clovelly, Australia | DIANA PLASTIC *mmm tasty*;
LEICA M6 & M4-2 |
www.flickr.com/photos/92601857@N00
119, 215

pavement_pix (see also bsamp, hihihi, luisacortesao
& neenna)
Underfoot, Neutral Zone
38, 44, 45, 129

paysage (see also taniasimon)
Orebro, Sweden
278

petitepoupee7
Je t'aime Rio de Janeiro, France | SAMSUNG
DIGIMAX 202, SONY CYBERSHOT 5.0 DSC-P92 |
Daniele Vieira | petitepoupee7@gmail.com |
www.fotolog.net/petitepoupee7
132, 134

pico
Sausalito, CA, USA | *A boy, his dog, and a camera.* |
Myles Weissleder | pico@mylermedia.com |
www.mylermedia.com
300

pidge
Saint Louis, MO, USA | OLYMPUS D-490Z, NIKON
COOLPIX 5000, CANON EOS REBEL G | *This was the
land that he worked by hand. It was the dream
of an upright man.* | Pidge O'Brien |
pidge314@aol.com | www.pidges.com
11 (second from top), 334 (row 5: 3)

pixietart
New York, NY, USA | *I mostly shoot with a NIKON
D100 and a CANON S400 DIGITAL ELPH but I have
been known to use a SEAGULL, POLAROID, HOLGA,
ACTION SAMPLER, NIKON 90S, IZONE, camera phone,
etc. Anything camera is good. I'm a graphic
designer and photographer living in the heart
of New York City's Chinatown. Recent obsessions
include: bicycles, knitting, roof parties, Coney
Island, travel, and taking long walks at night
through a quiet NYC with a camera.* | Jenene
Chesbrough* | mail@jenene.org | www.jenene.org
9 (fourth from top), 26, 139, 190, 194

placeinsun
Middlebury, VT, USA | NIKON COOLPIX 8700, OLYMPUS
D-360L, MINOLTA MAXXUM 450SI | *Trying to find the
extraordinary detail amid the ordinary detritus of
everyday life in Vermont, Montréal, and wherever
my travels may take me.* | Ernest McLeod |
placeinsun@hotmail.com |
www.flickr.com/photos/placeinsun
6, 248 (row 3: 3), 334 (row 5: 5 & row 6: 1)

polaroid_billy
Nowhereland, CA, USA | *Most of my photos were
taken with one of these three cameras: POLAROID
LAND CAMERA MODEL 250, POLAROID LAND CAMERA MODEL
320 and POLAROID LAND CAMERA MODEL 420. I do this
for fun. I have been surprised to find people like
what I do.* | Mike Miller |
polaroid_billy@sacbeemail.com
83, 105, 334 (row 3: 3)

polaroids_only (see also a_picture)
nowhereland, Neutral Zone
*This is a group photoblog dedicated to Polaroid
photography. All Polaroids are welcome: old land
camera shots, one-step, spectra, SX-70, transfers,
emulsion lifts, even pinhole Polaroids! The prime
directive here is use of Polaroid film. Have fun!
Thanks, polaroid_billy.*
104

ponpon
Paris, France | Fabien Pondevaux |
pondevaux@noos.fr | www.repereurs.net
8, 156, 157, 162, 163

portraits (see also slow_down_kid)
Noggin Beach, Neutral Zone | *From the physical
face to the 'idea' of the person (as in Van Gogh's
portrait of Gauguin just as his chair), the portrait
is our first image of who someone is. Whether
accompanied by detailed narrative or explanation,
or letting the portrait speak for itself, here is a
place to let the person shine, even if it's a self-
portrait.*
334 (row 6; 2)

pro_keds
Vancouver, Canada | *I love beebs. Cogito Ergo
Sum.* | Chris Hall | prokeds4eva@yahoo.com |
www.flickr.com/photos/pro_keds
205, 335 (row 7: 4)

prunella
Bay Area, CA, USA | CANON POWERSHOT A40, Q-SEE
SUB-MEGAPIXEL MINI CAM | *Just a dog and her girl.* |
www.flickr.com/photos/prunella
203

puckles
Washington, DC, USA | NIKON COOLPIX 995;
HOLGAMOD | *This photo is dedicated to my true
love and fiancé, Philip 'Mr Phil' O'Donnell
7.26.71–10.18.05–∞ whose love, support and
encouragement make so much possible.* |
Caroline 'Puck' Deutermann |
www.flickr.com/photos/puckles
107

quetzal
Brooklyn, NY, USA | *wha??* | Raul Abrego |
quetzal419@aol.com |
www.homepage.mac.com/raulabregodesign
198

qurator
New York, NY, USA
248 (row 1: 4)

THE AUTHORS

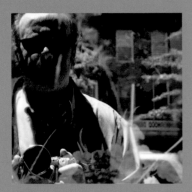

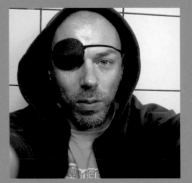

Andrew Long lives in Brooklyn. For many years he was a photography reviewer and editor at *The New Yorker*. His writings have also been published in *Departures* magazine and on *Salon.com*.

Nick Currie is a writer and well-travelled musician. Born in Scotland, he currently divides his time between Berlin and Japan. His weblog Click Opera has become a daily stop on the Internet for those interested in design, music, new media, photography and contemporary culture.

ANDREW LONG would like to express his deep gratitude to:

Everyone at Thames & Hudson, including Karolina, for her brilliant design sense, and most especially J, without whose inspiration this book would simply not exist.

And everyone at Fotolog.net, for creating an indispensable new way to look at pictures; All the contributors, whose fantastic work made this job so rewarding; All of our Fotolog friends who helped pull the book together, and especially Jenni, whose critical eye and unconditional support were so welcome; My own Fotolog crew — Adam, Aimee, Annie, Aron, Beach, Chris, Christina, Cynthia, Danny, DD, Eric, Frank, Heather, Heather, Jeanie, Jeff, Jenene, Jennie, Lisa, Michelle, Miriam, Randi, Raul, Robin, Sandra, Sharon, Stacie, Susannah, The Foam and Tom — who keep me going day after day.

Very special thanks go to:

Alice, who shares her joy in looking at pictures, and who believed in me; and Craig, the ultimate careful writer, who taught me how to listen to words.

And my deepest love and gratitude goes to my family:

To my Father, for everything; To Jennifer, for being the rock of the family; and most especially to my Mother, for making me believe in myself.
This is for you.

ACKNOWLEDGMENTS

The publisher would like to thank all the contributors and all at Fotolog.net for their patience ;)

Extra *BIG* thank yous are also due to:

David Brown • Antony Chambers • Molly Clarke • Luísa Cortesão • Bruce Grant
Chris Hall • Scott Heiferman • Jenni Holder • Laura Holder • Benoît Jourdain
Chris Larsen • Michael Lato • Fernando Lopes • Nina Meledandri • Stacie Merrill
Ana Carolina Monteiro • Yuki Murata • Nicky Peacock • Debbie Ripley
Lucien Samaha • Bruno Sampaio • Adam Seifer • Eliot Shepard
Reuben Turner • Courtney Utt • Sharon Watt • Lester Weiss • Kristen Williams

Your eyes, ears, advice and sense of fun have helped make this book.